German Photography 1870-1970

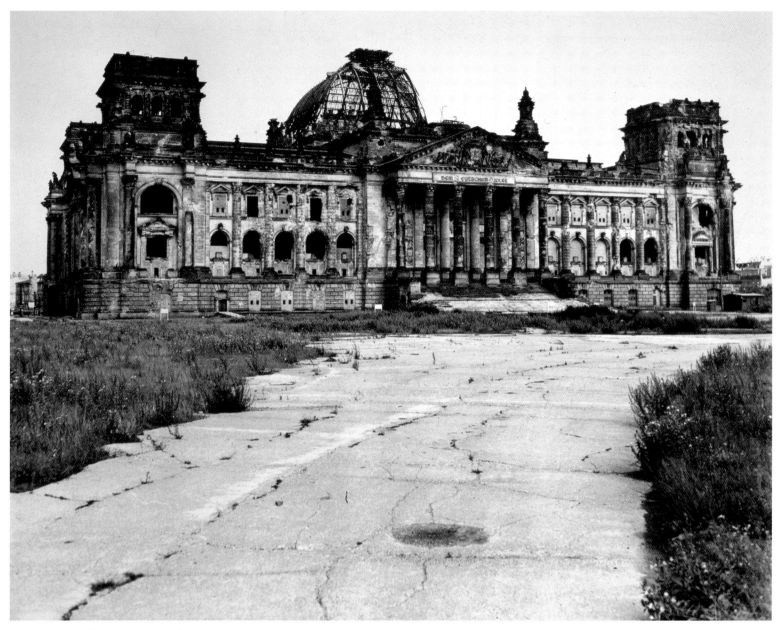

Jupp Darchinger, The ruins of the Reichstag, Berlin, 1955. Rheinisches Landesmuseum Bonn (cat. no. 288)

German Photography 1870-1970
Power of a Medium

Klaus Honnef, Rolf Sachsse and Karin Thomas (eds.)
and
Kunst- und Ausstellungshalle der Bundesrepublik Deutschland

With essays by
Volker Albus, Hermann Glaser, Klaus Honnef, Ulrich Keller, Hanno Loewy, Peter Reichel,
Wolfgang Ruppert, Rolf Sachsse, Bernd Weise, Heinrich August Winkler, Stefan Wolle

This catalogue is published to accompany the exhibition "Deutsche Fotografie. Macht eines Mediums 1870–1970", from 7 May to 24 August 1997 at the Kunst- und Ausstellungshalle der Bundesrepublik Deutschland in Bonn

Cover: Alfred Eisenstaedt, The Graf Zeppelin airship being repaired above the southern Atlantic on its flight to Rio de Janeiro, 1934; Rheinisches Landesmuseum Bonn, Gesellschaft Photo-Archiv (cat. no. 149)

Issued by
Kunst- und Ausstellungshalle der Bundesrepublik Deutschland GmbH

Catalogue concept
Klaus Honnef, Rolf Sachsse, Karin Thomas

Catalogue coordination
Petra Kruse, Helga Willinghöfer

Translation
Pauline Cumbers, Ishbel Flett

English copy editing
William Mickens, Vera Udodenko

Design
Matias Möller

Production
Peter Dreesen

Composition
gluske + harten, Köln

Lithography
Heinrich Miess, Köln

Printing
Rasch, Bramsche

Binding
Bramscher Buchbinder Betriebe, Bramsche

Distributed throughout the world by
Yale University Press

Library of Congress Catalog Card Number 97-60586
A catalogue record for this book is available from the British Library

© 1997 Kunst- und Ausstellungshalle der
Bundesrepublik Deutschland GmbH,
Klaus Honnef, Rolf Sachsse, artists and authors
English Translation © 1997 DuMont Buchverlag, Köln

ISBN 0 300 07172 8 (for the English language edition)
ISBN 3 7701 2652 1 (for the German language edition)

Kunst- und Ausstellungshalle der Bundesrepublik Deutschland, Bonn

Director
Wenzel Jacob

Curators
Klaus Honnef, Rolf Sachsse
Project director
Madeline Ferretti

Contents

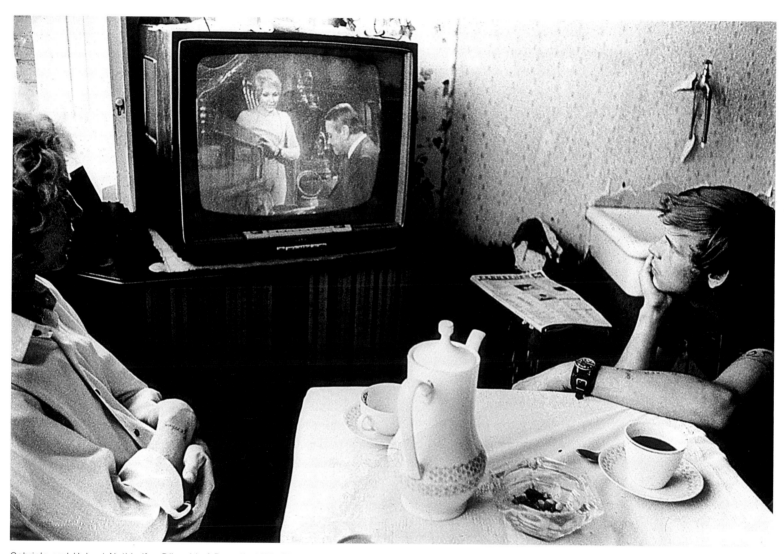

Gabriele and Helmut Nothhelfer, Düsseldorf-Benrath, 1970. Rheinisches Landesmuseum Bonn (cat. no. 366)

Wenzel Jacob

Foreword and Acknowledgements

"Photography has changed our consciousness more radically than any other pictorial medium in history, because it has fundamentally altered our perception of and relationship with the visible world." Klaus Honnef wrote these words in the catalogue to the exhibition *Pantheon der Photographie im XX. Jahrhundert* (Pantheon of Photography in the 20th Century) which was mounted in 1992 to mark the opening of this museum. With these words he summarized the power of the medium of photography. Photography has made the world accessible in a whole new way, has facilitated a direct and precise representation of both concrete phenomena and fleeting moments, and has turned us into eye-witnesses of history as it unfolds all around the globe. There are two ways in which photography can lay claim to being the first pictorial mass medium: photos can be disseminated on a mass scale due to their easy reproducibility, and photos can be taken by any individual thanks to an uncomplicated and affordable technology. Yet photography is not just a mass medium, it is also an important artistic medium.

The Kunst- und Ausstellungshalle has regularly provided photography with a public forum. Following the *Pantheon of Photography* exhibition in 1992, we then showed works from the Bonnemaison Collection in the 1993 presentation of *Sehsucht. Das Panorama als Massenunterhaltung des 19. Jahrhunderts* (The Desire to See. The Panorama as a Medium of Mass Entertainment in the 19th Century) which illustrated how photography's many and varied possibilities had been discovered and exploited at a very early stage in its development. In 1994 a solo presentation of works, particularly from the 1920s, by the photographer and cameraman Eli Lotar was shown parallel to the exhibition *¡Buñuel!. Europa, Europa,* an exhibition devoted to Central and Eastern European photography in this century, focused on yet another chapter in the history of this medium. At the beginning of 1996, in collaboration with the Museum of Modern Art, New York, we were fortunate to be able to show the later and less frequently exhibited works of Alfred Stieglitz. Last year, we availed ourselves of the opportunity of exhibiting a representative cross-section from the extensive photo collection of the Fotografiska Museet in Stockholm which included the highlights in the history of photography, from its beginnings up to the present day.

German Photography, the most comprehensive exhibition we have dedicated to this medium so far, represents a first attempt to systematically present photography in Germany. The exhibition comprises approximately 400 works by 150 photographers, covering the period from 1870 to 1970, one hundred years in which photography had its greatest impact and progressed to become the dominant pic-

torial medium. Its supremacy in important fields of visual communication eventually waned with the emergence of television, video, and later, computer technology. Photography continued to play an outstanding role, however, especially in the realm of art, where above all the younger generation discovered and learnt to value it as an expressive medium.

The exhibition curators have divided this one hundred year period into four sections and lent structure to the expansive terrain by selecting central themes. The exhibition and the accompanying catalogue address the issue of the existence of a specifically German photography on the basis of photos from the realms of politics and current events, art, design and private everyday life, and through international comparison and scholarly analysis.

I would like to take this opportunity to sincerely thank all those who worked on the project and contributed to its success.

With Klaus Honnef and Rolf Sachsse we were fortunate to engage two curators whose previous exhibitions and publications have repeatedly demonstrated their expertise on the theme of photography. In jointly developing the exhibition concept they were able to combine their respective wide-ranging experience. They too are responsible for the exhibition catalogue on which they co-operated with Karin Thomas of DuMont publishers in Cologne, who devoted considerable energy to the project. The exhibition's organisation and co-ordination were in the reliable hands of project manager Madeline Ferretti. My sincerest thanks to them all.

Thanks are also due to the numerous authors whose contributions to the exhibition catalogue have helped to produce a work that is not only an essential complement to the exhibition but also represents an important scholarly source on the theme of German photography.

For their valuable advice at the preliminary stages of the exhibition I would also like to thank Fritz Gruber and Wolf Strache, and Karl Steinorth and Gert Koshofer, president and secretary general of the Deutsche Gesellschaft für Photographie.

An essential prerequisite for any exhibition are the works given on loan, and expressing thanks for these is not only a duty but a great pleasure for me. We are greatly obliged to all those who placed their photographs at our disposal and in this way supported the exhibition so generously. The institutions in question are the Stiftung Archiv der Akademie der Künste, Berlin, the Bauhaus-Archiv am Museum für Gestaltung, Berlin, the Berlinische Galerie, the Rheinisches Landesmuseum, Bonn, the Kupferstich-Kabinett in the Staatliche Kunstsammlungen Dresden, the Ministry of Urban Planning, Culture and

Sport in Northrhine-Westphalia, Düsseldorf, the Museum Folkwang, Essen, the Museum für Kunst und Gewerbe, Hamburg, Der Spiegel, Bild-Dokumentation, Hamburg, the Sprengel Museum, Hannover, the Agfa Foto-Historama, Cologne, the Galerie Karsten Greve, Cologne, the Galerie Rudolf Kicken, Cologne, the Museum Ludwig, Cologne, the Kunst- und Museumsbibliothek der Stadt Köln, the Herbert List Estate, Los Angeles, the Museum Schloss Moritzburg, Halle, the Fotomuseum im Münchner Stadtmuseum, the Galerie Françoise Paviot, Paris, and the Museum Wiesbaden. Private lenders include Ursula Arnold, F. C. Gundlach, Robert Häusser, Manfred Heiting, Gottfried Jäger, Arno Jansen, Jürgen Klauke, Robert Lebeck, Manfred Leve, Angela Neuke, Floris M. Neusüss, Michael Ruetz, Max Scheler, Lothar Schirmer and J. G. Schurig.

Leica Camera AG and the Frankfurter Allgemeine Zeitung were equally generous in their material and moral support for the project and provided *German Photography* with access to further interested circles. For this too I would like to express my heartfelt thanks.

Rolf Sachsse

A Concept of German Photography

A compendium entitled "German Photography" is obliged to approach the term "German" from two directions: with a view to national state borders and developments, including their ideological implications, and with a view to the language that serves the people in this country as a means of communication. It is the latter viewpoint that has informed the concept for this book, which addresses the issue of the power of a medium, though without being able or willing to provide a simple explanation.

Photography is often compared with language. The range of languages in question extends from the worn-out buzz words of international advertising and industry, to the political idiom of global understanding, to more complex semiotic procedures. The differences between these languages have so far received only relatively superficial attention when being applied to visual objects and media. In the realm of German design, various magazines, trendy authors, and economics experts are still struggling to find the right, i.e. sales promoting, definition. In the history of the nineteenth and twentieth centuries, German art entered into disastrous relations with ideology and politics, relations which cannot be dissolved even by the kind of well-meaning re-assessment undertaken, for example, by Hans Belting. Once again, as in the field of literature which is concerned with at least two languages, what we are left with is a mere negation: the intrinsic is explained by the extrinsic, especially in the realm of photography.

German photographers were subject to linguistic influences that left their mark on their photographs. This truism runs into difficulties the moment one seeks to render those influences legible on the basis of the photographic material. For this very purpose, the classical iconography of aesthetics and art history provides us with various instruments, of which the authors contributing to this book have also availed themselves. Photographs that capture and symbolically condense set-pieces of German history, from the Kaiserreich's spiked helmets to Ebert's swimming trunks and from Hitler's moustache to Honecker's glasses, are easiest to analyse. The same applies, mutatis mutandis, to photographs of specific scenes, buildings, furnishings, and cars. However, in determining what is German about German photography in a linguistic or aesthetic sense, this is of little assistance.

It would seem to be as difficult as it is ultimately meaningless to establish themes that are specific to, or even typical of, German photography in what might be broadly termed an iconography. One could of course look at formal artistic aspects instead: non-German authors tend to praise the handling of light in German photography as in German cinema, usually with reference to the expressive use of gloomy shadows and isolated spotlights. Another equally conspicuous aspect

of the German photographic gaze may well be found in compositional features that result in a distended and often fragile planar structure. Though numerous photographs do indeed confirm these pre-judgements, just as many refute them. Form and content in Schiller's sense must surely be ruled out as criteria for German photography.

I would like to put forward two hypothetical levels which are occasionally interwoven, but which ought to be viewed individually when interpreting and defining individual photographs: colour and body language. When dealing with photos in terms of linguistic analogies, these two levels constitute only part of the problem, though an obvious part as regards its history and effect. German photography was coloured from the very beginning, despite Alexander von Humboldt's wish to restrict its function to that of a rationally positivistic record of nature, as the Daguerreotype saw itself. As of 1870, no other country searched as resolutely as Germany for a "photography in natural colours"; in very few other countries did the fine colour print assume such importance for the Art Photography movement. The specific German variation of romanticism was thus continued not only negatively in the picturesque motif, but positively in the tonal values.

Important criteria for defining what is German about German photography from a linguistic point of view may be found in that mixture of facial expression, gesture, demeanour, and movement generally referred to literally as "body language". The enormous problem that the German language and mind set have in recognizing this category is rooted in an almost total negation of the existence of body language symbolism and a negative evaluation of every kind of visual rhetoric, both of which are part and parcel of a pathos aimed solely at verbal communication. Nowhere in the world is the sign language for the deaf as fiercely resisted as it is in Germany by teachers of such people with special needs. For more than 70 years Germany has failed to acknowledge this sign language as an independent linguistic form, unlike most other countries worldwide. From the very outset, the linking of symbolic action with key words obviously leaves no room for graphic, even physical gestures.

Yet care should be taken not to jump to hasty conclusions: it would be unfair, and indeed wrong, to pass directly from the body language in German photographs to the German state of mind. The "people of poets and thinkers" have always known how to move elegantly and even pursue their self-imposed ideologies ad absurdum, often with a subversive irony. Here too, the analogy between language and photography has to be handled discriminately: obvious meanings are apparent at first and possibly truthful in the last instance. The very

essence of the power of the medium of photography has always been its capacity to illustrate again and again the deceptive simultaneity of orchestration and documentation in each individual photo – and even in the language from which it emerges and through which it is observed, discussed and deemed true. Given that this compendium is the product of a concept that was verbally established in advance, this naturally means that its form and premise must remain comprehensible – though not to the detriment of the enjoyment of the individual photograph.

The book is sub-divided into four epochs and several thematic areas. Taking its chronology as the vertical and its themes as the horizontal axis, a pattern emerges that need not necessarily be perceived or pursued in a linear fashion. On the contrary, it calls explicitly for all manner of "mental leaps". The chronological structure does not necessarily coincide with the respective political epochs in German history. It is more by coincidence that the industrialization of photography begins worldwide at about the same time as the foundation of the second German Kaiserreich. Here, this is described along with the First World War, whereas the 1920s end with the Film and Photo exhibition mounted by the Deutsche Werkbund in 1929 in Stuttgart, though, historically, this ought to be seen as a retrospective rather than as the dawn of *Neues Sehen* in photography.

The global economic crisis of 1930 stifled the experimental impetus of avant-garde photography definitively; from there it was only a short step to the widespread anticipatory obedience to the National Socialists and their reign of terror. A sudden relinquishment of all aspects of aesthetic modernism after the NS regime's accession to power can only be ascertained in the works of specific individuals and thus cannot be looked upon as a structural phenomenon. As an important propaganda instrument, photography availed itself of the whole gamut of established compositional mass media techniques, even, or rather especially the most modern, in order to ensure maximum effect. The monopolization of photography was gradual but lasting – and culminated in unambiguous photographs that bear witness to the worst crimes of the Holocaust and were taken by (at the least) naive photographers.

Just as the established techniques of international photography continued to be applied during the Third Reich, so too entrenched pictorial norms were further adhered to after 1945. The photographers in the occupied zones and in both German states photographed what moved them. Only very few of them developed their own personal mode of artistic expression and if so, then much later than their colleagues in other countries. In West Germany it is only possible to speak of the re-emergence of an independent German photography after the two *fotoform* exhibitions of 1950 and 1951, and after the first public showings of works by the "subjective photography" movement. In the GDR, a romantically motivated adherence to the traditions of the *Arbeiterfotografie* movement, plus Stalinist guidelines, meant that photography there arrived at independent forms much later. However, these were then to dominate there for about 20 years.

Around 1970, photography changed fundamentally worldwide, both in terms of its technical preconditions and as an artistic genre. Television, video and computers finally dissolved the visual information monopoly of the photographic image, while giving rise to greater autonomy in each of the respective forms. An exhibition of photographs from the last three decades would be an enticing challenge. However, that is not the task of a historical overview such as this, intended to take into account the cultural, political and social moments that marked the history of the genre.

The vertical division of the concept aims to do justice to this particular aspect. To put it simply, the medium of photography touches upon, and occasionally even manages to exert a strong influence on four realms of social communication: politics, art, design, and everyday life, including personal memory. In addition, there is the view from abroad: the question of the international significance of German photography. In their theoretical treatment, these four realms are not confined to their respective branches of scholarship but are approached with a more interdisciplinary interest – a central theme throughout the compendium. Any such assignment to specific disciplines is easiest in the case of politics and art: political scientists and contemporary historians on the one hand, and art historians on the other, reflect, from their respective scientific viewpoint, on the extent to which that viewpoint alters their knowledge. Choosing the mode of observation determines the fact, and not vice versa. The resulting rifts that loom between the different theories of knowledge, scientific principles, and methods of approach will hopefully increase the pleasure gained in reading the book, and the interest engendered by the topic.

What is more difficult to deal with, and therefore all the more interesting, are those realms in which the power of the medium of photography was subcutaneously perceptible: in its unreflected use in everyday life, in design and communications, and in family memories and personal identity acquired via the mirror of the image. Here there is still a demand for a broad definition of culture that shuns neither the depths of kitsch nor century-old ritual treatments of images. The most plausible determination of what is German about German photography may well be found here: the innocent attitude with which Germans once presented, and still present themselves to the eye of a reproduction apparatus that is merciless in its treatment of space and time. It comes as no surprise that the inherent power of the medium evident here introduces a further example of the intrinsic explained by the extrinsic, and one that swiftly stimulated the interest of artists. The process by which the human capacity for memory achieved independence through photographic images, particularly in the context of fleeting electronic media, has almost become a general metaphor of German photo theory, comparable in this sense only with the French.

In keeping with the aspirations of the connoisseur, exemplary photographers have been selected for inclusion in this compendium, and in most cases they are represented by several of their works. Of course this means that many of their colleagues have thus been con-

demned to the Hades of oblivion – though no book can dare to render more than a preliminary account of its theme. Yet hopefully this helps to make its argument in favour of a photographic attitude expressed as pictorial language more plausible.

Between 1870 and 1970, photography in Germany was a potent and sometimes impotent medium, though only when utilized in the private sphere or technically inflated in the realm of mass communications. In these two realms, the individual photograph ceases to function independently and becomes closely linked with graphic, printing, typographic or design elements which exert a decisive influence on its effect. This reference to the material constraints of mass media communications is of more than just didactic significance; it is also a pointer to where one can and must look to find autonomous photos, i.e., works of art.

When it comes to the actual effect of a photograph – its *punctum* in Roland Barthes' sense, or its "shock" in the sense implied by Charles Baudelaire, Raoul Hausmann and Walter Benjamin – the physical location of the photograph is unimportant one way or the other. It is by its very existence that the photograph evokes a memory, which is all the more painful the closer the memory comes to the observer, and the less he or she is able to share it with someone else. For all the other levels at which an image can be observed, conventions are available that come close to a literary translation or transposition and are thus analysable. Above and beyond our concept of presenting an image of history and of Germany through the medium of photography, in the face of each individual photograph one might also proclaim the maxim once given by Peter Rühmkorf for his life and his poetry: "Stay shockable and resist!"

Klaus Honnef

German Photography – Mirror of the German Mindset?

Photography was invented by pioneering spirits and innovative minds in France and Britain, while Germany's contribution was limited to a few technical improvements in the field of optics. Consequently, as the photographer, collector and historian Helmut Gernsheim recounts with relish in his *Origins of Photography,* the newspaper *Leipziger Stadtanzeiger* maintained that this process by which reality projected itself in its own image, as it were, was tantamount to blasphemy.[1] To add insult to injury, the new, apparently automatic and therefore revolutionary pictorial technique had been born of the experimentational curiosity of a couple of subversive French thinkers – a retired military officer and an artistically minded entrepreneur – a fact that must have been particularly galling to the newspaper in 1839, the official "birth date" of photography. The article went on to say that even if some M'sieur Daguerre in Paris were to claim a hundred times over that his newfangled machine could capture human mirror images on silver plates, he would be telling an outright lie a hundred times over, and that it was not worth the energy of upright German masters of the science of optics to allow their heads to be turned by so impertinent a claim.[2] The tone of resentment is impossible to overlook. People had had quite enough of such high-flying French notions as European unification, Napoleonic style.

Admittedly, this was a lone voice in the choir of the many German-speaking states at the time, and one that could not halt the triumphant progress of photography on the "other" bank of the Rhine, as seen from Saxony. It was first and foremost French, British and, not least, North American photographers who wrote the history of photography in the nineteenth century, just as they were to write the history of its industrial development. The German-speaking states and the Austrian empire had no artistically creative figures comparable to Nadar, Carjat, Baldus, Nègre, Fenton, Cameron, Brady or O'Sullivan.

In this respect, one may be justified in asking whether such a thing as "German photography" even exists. Although some important impetus towards an independent aesthetics of photography did originate amongst the innovative and versatile photographers and intellectuals in the Weimar Republic, one hesitates to describe their achievements as a German contribution to international photography. There are some obvious grounds for hesitation. German nationalists and National Socialists perverted the very concept of the term "German", giving it a bitter aftertaste. One immanent argument against the term "German photography" might also be that the most decisive chapters in its history were not written by German photographers alone. Was not German photography, even in the twentieth century, subject to the many and varied influences that affected the country before and after

its two lost wars? Yet this very argument itself is double-edged. For it ignores those photographic authors who contributed the most characteristically "German" aspect of what might be termed "German" photography – the photographers and theoreticians of Jewish origin. The burden of National Socialist dictatorship inevitably colours this debate.

On the other hand, when it comes to discussing German literature, nobody hesitates to include the writers of Austria and Switzerland, simply because the language they all write in is German. When Rainer Werner Fassbinder was still alive, "German cinema" was a household word, and even the label "German art" gradually lost its stigma with the advent of Gerhard Richter, Georg Baselitz, Anselm Kiefer, Sigmar Polke and Hanne Darboven. The National Socialists had had a distinct idea of what "German art" should be and in their manic zealotry they eliminated much of what had given German art its name *avant la lettre.*

It is therefore hardly surprising that there should be a direct connection between the question of "German photography" and the way that Germans actually see themselves. A number of historians and philosophers have referred to Germany as a *"verspätete Nation"*[3] (a belated nation), amongst them the influential philosopher Helmuth Plessner. What, then, is Germany? As we have learned from the difficult process of unifying East and West Germany following the disintegration of the Communist bloc led by the Soviet Union, it is not a nation that has forged its identity through a more or less binding historical experience. The consequences of National Socialist ideas and actions have exacerbated the problem. In respect of photography alone, one can ask whether Alfred Eisenstaedt, the great journalistic photographer, is a German or an American. Is Helmut Newton, the major society portraitist who was born in Berlin and later took Australian citizenship, a German? The former was one of the legendary protagonists of German photographic journalism and was able to pursue his profession until 1935, even in Nazi Germany, because he had been awarded the Iron Cross first class in the war. The latter hardly worked in Germany at all, having fled from Berlin, the capital of the Reich, when he was still a young trainee photographer, two years before the Second World War. He escaped the Nazi persecution, whereas Yva, in whose studio he had trained, was first barred from her profession, then deported to a concentration camp and murdered.

At first glance, no distinctive similarities can be identified in the works of Eisenstaedt and Newton. The difference in what Siegfried Kracauer would term their "photographic approach" is striking. Are the photographic images by colleagues and rivals such as Erich Salomon,

Felix H. Man, Wolfgang Weber, Harald Lechenperg, Tim Gidal and Martin Munkàcsi (born in Hungary) commensurable simply because they are all informed by a journalistic interest? Are the photographs by Yva comparable to those by Newton because they concentrate primarily on the phenomena of fashion and society? Or is there a bridge between them that might actually lead to the photographic images of arguably more ambitious authors such as August Sander and Albert Renger-Patzsch, not to mention the experimental images, with and without a camera by László Moholy-Nagy? Such a link might be forged by the images of Umbo and Werner Mantz, for they combine professional application with sophisticated aesthetics.

The journalistic photographers, too, were quick to adopt the formal achievements of a photography that had cast off the fetters of traditional art photography in the early twenties and had concentrated instead on its own potential. To ask whether it was the architectural photographers or the journalistic photographers who first used the bold angles, bird's eye views, diagonals and metallic precision is like asking which came first, the chicken or the egg. After all, the journalistic photographers with their "high-speed" cameras were using the very latest products of a rapidly developing technology that was also making rapid progress in Germany. Their visual language was correspondingly innovative. And the visual language of the architectural photographers benefited primarily from their subject matter, namely, the constructivistically functional designs that represented the cutting edge of a new architectural style known as *Neues Bauen* in which, as in photography, industrial technology merged with aesthetic ambition. In this field of photographic practice referred to variously as *Neues Sehen* or *Neue Sachlichkeit,* contemporary art is relatively seldom represented. One exception is László Moholy-Nagy, who regarded himself as a "light-artist", and who published a highly regarded and influential treatise entitled *Malerei Fotografie Film* (Painting Photography Film) in the Bauhaus Books series.[4] He borrowed most of his illustrations from those branches of photography mentioned above.

German cinema probably exerted a stronger influence and fascination on the photographic avant-garde, even where its aims ran counter to the ideas of the artistic avant-garde,[5] in terms of expressionist variations which, incidentally, had nothing in common with what is termed Expressionism in the field of painting. The photographers Helmar Lerski and Hans G. Casparius[6] even worked as stills photographers in the film industry, taking stills and portraits of famous actors in various roles. The dramatic chiaroscuro of the expressionist film was also echoed in the portraits produced by the famous photographic studios on Berlins Kurfürstendamm, which so inspired the young Helmut Newton.[7]

The extent to which there was an aesthetic exchange between the functionalist tendencies of *Neue Sachlichkeit* and the expressive tendencies of commercial portrait photography is difficult to ascertain. Both, at any rate, had in common a distinct leaning towards artificiality. What is certain is that, in the field of film, at least, there was a considerable overlap. The enthusiastic novices who created that masterpiece

of *Neue Sachlichkeit* documentary, *Menschen am Sonntag* (People on a Sunday) – Robert Siodmak, Edgar Ulmer, Billy Wilder, Fred Zinnemann and, most notably, Eugen Schüfftan – were to go on to become the main representatives of the expressive "film noir" with its uncanny contrasts of light and shade in France and Hollywood.[8]

Film theorists seem to have no qualms whatsoever in speaking of a specifically German cinematic idiom. Siegfried Kracauer and Lotte H. Eisner, in *From Caligari to Hitler*[9] and *The Haunted Screen*,[10] respectively, published after the capitulation of the National Socialist Third Reich, pinpointed so many symptomatic traits of a specifically German mentality and iconological tradition that they leave their readers in no doubt whatsoever as to the existence of a German cinema, as opposed to an American or a British cinema. Whereas Kracauer explored the contextual implications of German cinema before Hitler came to power, revealing its subliminal authoritarian structures, without entirely neglecting the language of the images, Eisner examines the formal elements. In respect of lighting, set, presentation, camerawork and editing, she defines a distinctly German cinematic style that has no parallels in the works of other film-making countries at the time. Has the research conducted by film theorists, who apparently possess a much more differentiated instrumentarium than historians of photography, provided access to the visual language of German photography, that is to say, the photography created in Germany in the course of the twentieth century?

Technically speaking photography and film are closely related. Both are children from the lowest rank of the cultural hierarchy. For a long time, their artistic legitimacy was denied and, compared to the aesthetic standards of the artistic avant-garde, both photography and film adopted aesthetic practices which the artistic avant-garde had long since banned to the furthest recesses of history. Both were based on a technical process that maintained the primacy of the reproduction and, by reiterating visible reality in this way, they prolonged those figurative forms of portrayal – whether academic, naturalistic or realistic – from which a significant portion of the artistic avant-garde sought to liberate itself. There was a more serious shortcoming. Photography and film are mass media. What had begun with the woodcut, the copperplate engraving and the lithograph was perfected by photography, whose technical features soon paved the way for the industrialization of the visual arts – a process nurtured by advances in printing techniques around the turn of the century. Photography thus became the world's first truly mass medium, permeating all social strata to some degree. With photography, the arts entered what Walter Benjamin described in his famous essay as the "age of mechanical reproduction". What is more, artists lost their privileged position as the sole producers of adequately recognizable images. The photographic camera granted that ability, potentially, to any amateur, however mediocre.

No-one dealing closely with the visual world of photography can ignore the extraordinary complexity of the medium. A purely aesthetic approach, filtered through the view of progressive contemporary art, does not do justice to photography. At most, it provides findings rather

than insights. Such an approach is all the more misguided, the more persistently it upholds the position of an ahistoric and immutable concept of art. According to the premises of autonomy on which western ideas of art are based, irrespective of all standards of quality, photography is not an art. If it is an art at all, then it is what Kracauer describes as an "other" art.[11] By the same reasoning, the art of Classical Antiquity, the Middle Ages or the Renaissance and Baroque would also be forfeited to an aesthetic verdict. Photography does in fact unite new elements from the technical structure of the medium with several aspects of the art of earlier epochs to create a distinctive aesthetic. In contrast to the consciously elitist aesthetics of autonomous art, photography is open to social influences of varying intensity and also bears considerably more popular traits. As a result, photography, like film, is more susceptible to political misuse than progressive art. This has the inevitable consequence that its images, in comparison to the autonomous work of art, look extraordinarily ambivalent. They are often irritatingly equivocal and open to interpretation, so it is hardly surprising when commentators feel bound to call upon the ethos of the author in judging photographic works. Needless to say, what applies to the political misuse of the medium applies all the more to its cultural malleability. The horizon of general social expectations determines the character of photographic images which, as a rule, are published, as they always have been, outside the established art scene. That horizon is conveyed by patrons and clients, be they advertising agencies or magazine editors and its level is geared towards commercial success.

Morally, photography and film have a distinctly flexible aesthetic. "However, if commercial art be defined as all art not primarily produced in order to gratify the creative urge of its maker but primarily intended to meet the requirements of a parton or buying public, it must be said that noncommercial art is the exception rather than the rule, and a fairly recent and not always felicitous exception at that. While it is true that commercial art is always in danger of ending up as a prostitute, it is equally true that noncommercial art is always in danger of ending up as an old maid."[12] These are the drastic terms in which the great art historian Erwin Panofsky outlines the dilemma of photographic and filmic aesthetics.

Just as a photograph is made up of a wealth of different layers of chemical substances, so too is the visible result a substratum of different factors, and the photographic aesthetic must necessarily appear as a blend of different perceptual patterns. The American art historian Svetlana Alpers has noted the striking affinity between photography and Dutch painting of the so-called Golden Age.[13] She sees photography as a variation of descriptive art that demands to be read because it embodies a kind of text. In this respect, she shares the view of Siegfried Kracauer[14] who, unlike Alpers, is not satisfied with the mere optical evidence of the photographic image, but who deliberately emphasizes the underlying groundswell that influences it on account of its particular technique and the specific form of its no less socially mediated form of presentation. Kracauer posits a strictly "material" aesthetic[15] and, within the context of a media-specific image, he

accords a significant independent value to what Volker Breidecker terms the "raw material" of photography – namely, physically and empirically tangible reality. "This requires an 'empathetic' penetration into the external, material world shaped by contingency and discontinuity, fragmentation and indeterminacy, and calls for a careful offsetting with those formal impulses according to which the photographer selects and probes, arranges and forms his material. This "stubborn" material emanating from a "world that was not created according to the will of the photographer" is one to which Kracauer does not wish to see the "straitjacket of pictorial composition" applied.[16]

If, in the light of his theoretical statements, one wishes to trace the attributes from which it is possible to deduce that a German photography does indeed exist, the respective German situation plays an important role: the Kaiserreich, the Great War, the chaos following defeat, the ill-starred Weimar Republic, National Socialism, the breakdown in the wake of unconditional surrender, the division of Germany and its reconstruction. As long as similarities and correspondences, social correlations and cultural continuities arise, and as long as these manifest themselves in photographic images, photographs taken in Germany will inevitably have a German flavour. It is of little consequence whether a German photographer or a photographer from France, Hungary or the USA has taken the picture. Given this background, whether or not this vast quantity of images of things German can indicate a certain way of seeing that reflects a specifically German mentality or tradition must remain a moot question. On the other hand, given the aesthetic problems of photography, it is quite conceivable that a foreign photographer, in spite of his subjective alienation, might photograph his motifs from a German viewpoint if he has been briefed to do so. On closer inspection, it is actually possible to distinguish between the Hungarian, German and American photographs taken by the leading photographic journalist Martin Munkàcsi – even though the individual vision of the photographer or, as Kracauer puts it, his "photographic approach", lends the entire work a stylistic coherence. Additional components should not, however, be ignored. After all, did not Siegfried Kracauer characterize photography in the twenties as a medium of alienation – a concept he was to develop still further in his quest for a coherent definition during the bitter years of exile. The stranger often has a keener eye. He approaches his environment like a historian researching his subject matter from the vantage point of another era.

The reality of a suddenly republican Germany following the catastrophe of the First World War may also have seemed strange to many, and some, including the highly sensitive historian Eugen Rosenstock, felt that the history of revolutions had fulfilled itself in the world war as a world revolution. Rosenstock-Huessy formulated his controversial theory of the repetition of disaster in his epochal work *Die europäischen Revolutionen und der Charakter der Nationen.*[17] Those who had enlisted in the army straight from school, volunteering enthusiastically to serve Kaiser and Vaterland, had returned from the battlefields, if they returned at all, physically and psychologically

damaged. Many of them were artists and intellectuals whose later work reflected a blend of disappointment, rage and despair that was only gradually replaced by a determination to start afresh. Nothing was the same anymore. The familiar world of bourgeois security and cultural diversity had been shattered. "The war has furthered the insights of pessimistic anthropology, that man is by nature bent on destruction and that civilization has a barbarian core."[18]

Dada proved the point by wiping the slate in the world of art. The intellectuals of the republic propounded and propagated behavioural theories of coldness that served as a psychological defence against the humiliation of defeat, creating a shield for the individual against any threat of psychological injury. The "cold persona"[19] became a literary figure that took definite shape in the character of Ernst Jünger's idealized worker-soldier. "Jünger made his reckoning with bourgeois society and the liberal Western spirit of Enlightenment . . . at the same time, he drew a utopian portrait of the 'transformed' individual in the technological age of the twentieth century. The First World War triggered and even embodied the experience of crisis in the modern world. In this crisis lies the possibility of a serene anarchy that coincides with a stringent order – a drama already hinted at in the great battles and the huge cities . . . in this respect, the motor . . . is the metaphor of a power for which explosion and precision are not opposites."[20]

In many ways, the view of this conservative, monarchist writer[21] corresponds with the views of democratic authors. The most striking similarity is the extraordinarily positive attitude to the role of technology, even though industrialization had transformed the war into an inferno of gigantic material battles. On the other hand, the liberal minds of the day saw no alternative to technology and felt that only the widespread use of machinery promised better conditions, not least in the social life of the individual. Only a handful of dreamers feared technology, conjuring up the myth of nature and adopting a stance that was critical of progress. In Germany, on the whole, the highly technological World war had sown the seeds of an awareness that "a technology capable of producing bombs and tanks could also be used to produce goods for society. The machines would now be used to manufacture simple yet elegant kitchenware, lamps or vehicles. Industrial architecture emphasized the technical structure of the buildings it designed, and artists and designers took a growing interest in the precision of cogwheels, pipelines and aircraft built of corrugated aluminium and for the structures of other materials. In Germany, a heightened awareness of the technical possibilities of geometric form, be it that of machinery or buildings, led to an avant-garde tendency in photography, widely referred to as *Neues Sehen*."[22]

The end of the bourgeois world of the prewar era also meant that the bourgeois view of things had lost its cultural foundations. Like gathering clouds, the sudden formal changes in painting, from Impressionism to Cubism, were harbingers of the imminent storm that was to sweep across the political and social map. With the onset of such profound change, painting – hitherto the traditional pictorial medium of bourgeois self-awareness – also became the subject of debate. In

Germany and Russia, especially, where the Bolsheviks had unleashed and consolidated their tyranny, while seeking at the same time to create a new society in accordance with their ideology, it became the subject of vehement verbal attack. In the eyes of a constructivist, functionalistic avant-garde, painting bore the blemish of self-reflective vanity and even dishonesty, unlike the technical medium of photography, which promised precision, objectivity, clarity and anonymity, not to mention its undeniable communicability. "Each and every one will be obliged to see that which is visually true, that which can be interpreted from within, that which is objective, before being able to arrive at any possible subjective statement,"[23] proclaimed "light-artist" László Moholy-Nagy. What is more, the photographic image with its clearly focused and detached reproductive quality seemed the appropriate foil for the projection of the "cold persona". It was therefore no coincidence that Ernst Jünger should have taken such a considerable and well-founded interest in this technical medium and that he furnished the Weimar Republic's flourishing and extensive market for photographic books with a number of publications written both under his own name and under a pseudonym.[24] It is one of the most astonishing and incomprehensible omissions in the historiography of the photographic medium in Germany that his eminent contribution to an aesthetics of photography has gone virtually unnoticed, as has the highly effective media practice of conservative and right wing circles in the Weimar Republic.

In selecting the photographic images for the books he edited, this controversial writer was at the cutting edge of photographic aesthetics. Unconventional angles, unprecedented perspectives and unusual motifs are the characteristic features of his almost exclusively journalistic photographs, addressing themes that reflect his unerring instinct for danger and threat. An explosive mix of the aristocratic, the reactionary and a faith in progress tinged with pessimism are reflected in the categories of published photographs, and most of the images could quite easily have illustrated what were, at the time, critical remarks by Siegfried Kracauer. Jünger's visual approach was inspired by contemporary cinema, most notably by Russian films and above all by Eisensteins *Battleship Potemkin*. The fact that the Soviet filmmakers had placed photographic and filmic images in the service of an effective rhetoric and even a specific purpose, was something Jünger regarded as an aesthetic merit – "especially as it fulfilled the most important criterion of any political propaganda, namely, that it should not be boring".[25] Jünger was speculating on something that his intellectual opposite, Walter Benjamin, condemned as an "aestheticization of politics". In the Weimar Republic the ship of photography was constantly pitched and tossed between the Scylla of aesthetic seduction and the Charybdis of analytical dryness. It all depended on the context in which the photographic images appeared, the context being more important to the message conveyed than the specific content of the individual shot.

Nevertheless, many individual images of the era oscillate strangely between supposedly incompatible attitudes. Even the photogra-

phy of Neue Sachlichkeit was by no means as "objective" as its interpreters believed. To judge by intention and composition, August Sander's phenomenal record of German society in the Weimar Republic – from which Kurt Wolff/Transmare publishers selected 60 photographs in 1929 for publication under the title *Antlitz der Zeit* (Face of Our Time) with a foreword by Alfred Döblin[26] – should have been the decisive visual representation of the "cold persona" because the typological portrait of the persons photographed was emphasized at the expense of individual physiognomy, while the use of nuanced halftones softened the contours of the photographed masks. Behind them, individual traits shine forth. The Rhenish constructivist Franz W. Seiwert, politically to the left of the social-democratic Sander, voiced his criticism: "Here, the aim should be a herbarium of human existence, as it were, stating location, year, activity and class status, as in the words of Marx: 'but these are people only inasmuch as they personify economic categories as bearers of certain class relationships and interests' ..."[27] The slightly dubious social model of the photographic author was also a hindrance to conceptual precision.

When the photographic journalist Felix H. Man requested an audience with the Italian dictator Benito Mussolini for a report commissioned by *Münchner Illustrierte Presse,* he was clearly unable to resist the questionable charm of power and, in his now legendary feature of 1931, there is an undeniable sense of the fascination which the photographer, who emigrated from Germany when Hitler became Chancellor, clearly felt. No less ambivalent are the supposedly objective photographic images in what is considered to be the most influential book of German photography: *Die Welt ist schön* (1928) by Albert Renger-Patzsch. Walter Benjamin poured scorn and rage on the work and the photographic approach of the author, without even bothering to mention his name: "The further the crisis of today's social order spreads and the more intransigently its individual aspects clash in dead opposition, the more creativity – essentially a variation, its father being contradiction and its mother imitation – becomes a fetish whose traits owe their existence solely to the changing highlights of fashion. *Die Welt ist schön – the world is beautiful* [Benjamin's emphasis] – this is precisely its motto. In it, photography – though capable of montaging any tin can in space – is revealed as being incapable of capturing a single one of the human contexts within which it operates and, in its most dreamlike subject matters, foreshadows their marketability rather than their insight."[28] Had Renger-Patzsch had his way, the title of the compendium of one hundred photographs would have been *Die Dinge* (Things). The title chosen by the publisher is undoubtedly more appropriate. Portraits, still lifes, animal and plant photographs, landscapes, technical and architectural photographs and advertising shots are grouped according to category, and only the relatively sober gesture of staging them before the backdrop of art photography, whose painterly appeal still dominated the photographic scene, explains its short and long term success.

The style of the book, however, is not unique; Sander and Karl Blossfeldt also pursued an objective pictorial language appropriate to the technical medium and Moholy-Nagy, Germaine Krull and, not least, the Soviet photographers such as Alexander Rodchenko and Boris Ignatovich offered bolder angles still. Kurt Tucholsky pointed out the parallel developments in American photography.[29]

The difference between avant-garde photography in Germany, the Soviet Union and America was, admittedly, fundamentally a question of principle. In spite of his energetic call for a "photographic photography" (Renger-Patzsch) there is a remarkable indecisiveness in the finished work that betrays a hidden romanticism, in strange contrast to the alleged clarity of the photographic approach, revealing a largely apolitical and ahistorical approach. Just as Sander and Blossfeldt made contemporary photographic prints that were distinctly more nuanced and uncontoured than later prints suggest, so too does Renger-Patzsch indulge more in surface effects and in virtuoso graduations of the grey tones in the medium of black-and-white photography. His few and largely unsuccessful portraits are comparable in their aesthetic approach to the nationalistically racist typologies of Erna Lendvai-Dircksen and Erich Retzlaff. Was it mere coincidence that the National Socialists gave this photographer two major exhibitions?

Siegfried Kracauer described the socio-psychological texture of *Neue Sachlichkeit* as ". . . a state of paralysis. Cynicism, resignation, disillusionment: these tendencies point to a mentality disinclined to commit itself in any direction. The main feature of the new realism is its reluctance to ask questions, to take sides. Reality is portrayed not so as to make facts yield their implications, but to drown all implications in an ocean of facts, as in the Ufa *Kulturfilme.* 'We have lost the power of faith', August Ruegg confesses in 1926, 'and, since the wheels of the world mechanism seem to continue to move on their own impetus, we accustom ourselves to living on without trust or a feeling of responsibility. . . . One slides along either elegantly or wearily and lets the others slide along in a similar manner.' This is the language of a paralyzed mind."[30]

Although, in his many writings, Renger-Patzsch rails against any attempt by photography to imitate art, emphasizing instead its documentary character, he excludes social reality from his photographic work. The bourgeois illustrated press also reported on the events at the fringes of existence and in far-flung places, on film stars and famous politicians – a "speciality" of master photographer Erich Salomon – rather than on the misery of the unemployed, the street fights and running battles, instigated by the NSDAP hordes, but not only by them, during the period of the great economic crises: Walter Bosshard was received by Mahatma Gandhi privately, as reported by the *Münchner Illustrierte Presse* (18 May 1930), Tim Gidal (then still known as Ignaz Gidal) photographed Karl Valentin, also privately (1929) for the same paper, but also made a report on Palestine (*MIP,* September 1930), Kurt Hübschmann (who later changed his name to Hutton) recorded Charles Chaplin at a children's party in Berlin (*MIP,* 1931), Harald Lechenperg created a feature on Paris (*Atlantis,* 1930), Felix H. Man recorded the Berlin boulevard of Kurfürstendamm "Between Midnight and Dawn" (*MIP* 1929), Martin Munkàcsi captured the "divine"

Greta Garbo under a parasol on holiday (*Berliner Illustrirte Zeitung* 1932), Willi Ruge covered jungle warfare between Paraguay and Bolivia (*BIZ*, 1934), and Umbo entered the big top to document trapeze artists at their hazardous work (*BIZ*, 1932). A less frequent type of feature is the one on the closure of the Bauhaus in Dessau, published by Alfred Eisenstaedt (*Die Weltwoche*, 1932) or on the March for Bread by 30,000 unemployed in Georg Gidal's harrowing report (*Kölnische Illustrierte Zeitung*, 1930). These may be random highlights, yet they are representative in their own way. In the years of National Socialism and in the early postwar period of the still young Federal Republic, the general pattern did not change, though the extravagant angles and decidedly formal-aesthetic approach was no longer pursued. Despite its penchant for idyll, a more critical note was sounded by the *Arbeiter Illustrierte Zeitung*, occasionally publishing mordant montages by John Heartfield whose satire was aimed at the National Socialists and the reviled Social Democracy alike.

On the whole, during the twenties and early thirties, when photography was setting aesthetic standards in Germany, German photography presented as ambivalent an image as German film. Its language was characterized by what was at times a tense relationship between form and content, with an obvious tendency towards artificiality. This was reflected on the one hand in the dramatic lighting techniques of an expressively romantic photography, traces of which survived, even after the destruction of the country, in Hermann Claasen's images of ruins and Liselotte Strelow's portraits of the famous and was expressed on the other hand through the constructivist-functionalist aesthetic concept of *Neues Sehen* that was to become established in the avant-garde photography of the fifties.

The most striking images of German photography expose rather than conceal the stuff of conflict that has shaped it: the constant alternation between individual physiognomy and collective type in Sander's "serial" portraits, the contradiction between an objective technological approach and a flight from reality in the work of Renger-Patzsch, the gap that separates avant-garde photographic practice from its sentimentally romantic driving force in Blossfeldt's *Urformen der Kunst* (Prototypes of Art). "The aesthetics of *Neue Sachlichkeit* would hardly have gained such popularity in intellectual circles if its worship of things and functions had not been linked to that call for an open-minded approach to mystical experience."[31] Idealistic premises and empirical insights intersect each other. There is also an astonishing underlying fascination for power, evident not only in Man's homage to Mussolini. Even Salomon's famous photographs are not free of this, and Munkàcsi enhances the infamous Potsdam Day on which the Prussian military publicly sealed its pact with the Austrian Adolf Hitler instead of denouncing the dubious ceremony – only the Berlin *Gauführer* Josef Goebbels' clubfoot was strikingly out of place in a photographic feature published in a special issue of the *Berliner Illustrirte Zeitung*. Whether this and other examples of German photography can be found, in the wake of Kracauer's studies, to indicate an undercurrent of authoritarianism from which conclusions might be drawn

about the German mentality is something that can only be answered by systematically analyzing the published photographs. Much would appear to support such an assumption. Photography was subject to the same social and cultural conditions as film – most images were reproduced several thousand times. Studio photography in the days before the dark years of National Socialism radiates a special atmosphere, veiled in heavy shadow, evoked by a characteristic handling of light. It strengthened photography's immanent capacity for transforming each constellation of the real into a pose, even one that had not been previously practised.

Helmut Newton's strongly visual memory enables him to conjure up just such an atmosphere in his fashion and society photographs – described by Andreas Kilb as "hot-cold" – more than twenty years after his emigration from Berlin. These are images charged with conflict, as elegant as they are violent, as sensual as they are cerebral, and to some people they appear profoundly "German". His photographs blend a cornucopia of impulses in the form of an "inner montage". Many and varied memories of images and incidents, and of the experience of emigration, coupled with images of an obsessive imagination – these prove photography's aptness as the appropriate medium by which to visualize such an artificial construct. The deliberately artificial character of the images lures the gaze of the realist. It is hardly surprising that Newton's work inspired the question as to whether there is a "German photography".

Notes

1 Helmut Gernsheim, *The Origins of Photography*, New York 1982, pp. 47–50.

2 Helmut Gernsheim, *Die Photographie*, Vienna 1971, p. 24.

3 Helmuth Plessner, *Die verspätete Nation*, 1959.

4 Facsimile, Mainz 1967.

5 The most radical of the photographic avant-gardists pursued a kind of "anonymous" art, an "objective" art whose authenticity was not hindered by any subjectivist moment, i.e. the emphasis of the artistic subject, the artistic authority.

6 Cf. exhib. cat. ... *sie haben Deutschland verlassen*, Bonn 1997.

7 According to the photographer in a statement given to the author.

8 Fred Zinnemann retained a certain affinity with *Neue Sachlichkeit*, which may have been due to his collaboration with the great American photographer Paul Strand. Like the others involved in making the film *Menschen am Sonntag* (1929), he had to leave Germany after Hitler was appointed Chancellor.

9 Siegfried Kracauer, *From Caligari to Hitler*, Princeton 1947.

10 Lotte H. Eisner, *L'Ecran démoniaque*, Paris 1952.

11 Siegfried Kracauer, *Theory of Film*, New York 1960, pp. 3 ff. See especially pp. 22–23 where the author suggests that "it would be more fruitful to use the term 'art' in a looser way".

12 Erwin Panofsky, "Style and Medium in the Moving Pictures" in *Three Essays on Style/Erwin Panofsky*, ed. by Irving Lavin, Cambridge (MA) and London, 1995, p. 119.

13 Svetlana Alpers, *Kunst als Beschreibung*, Cologne 1985, p. 394 f., note 37.

14 Klaus Honnef, "From Reality to Art", in this publication, pp. 141 and 145, note 19.

15 Siegfried Kracauer, p. 11 (see note 11).

16 Volker Breidecker, "Ferne Nähe, Kracauer, Panofsky und 'the Warburg tradition' in *Siegfried Kracauer – Erwin Panofsky Briefwechsel*, Berlin 1996, p. 168.

17 Eugen Rosenstock-Huessy, *Die europäischen Revolutionen und der Charakter der Nationen*, Stuttgart 1951.

18 Helmut Lethen, *Verhaltenslehren der Kälte. Lebensversuche zwischen den Kriegen*, Frankfurt am Main 1994, p. 7.

19 Ibid. The entire book addresses the phenomenon of this literary figure.

20 Brigitte Werneburg, "Die veränderte Welt: Der gefährliche anstelle des entscheidenden Augenblicks. Ernst Jüngers Überlegungen zur Fotografie" in *Fotogeschichte*, no. 51, 1994, p. 54.

21 Cf. Ernst Jaeckel, *Das deutsche Jahrhundert*, Stuttgart 1997.

22 Coke van Deren, *Avantgardefotografie in Deutschland 1919–1939*, Munich 1982, p. 8 f. Cf. Klaus Honnef, "Fotografie" in *Kunst des 20. Jahrhunderts*, ed. by Ingo Walther, Cologne 1997.

23 László Moholy-Nagy, *Malerei–Fotografie–Film*, ed. by H. M. Wingler. Facsimile reprint of the original 1927 edition, Mainz 1967, pp. 26 f.

24 See note 20.

25 Cited by Brigitte Werneburg, p. 59 (see note 20).

26 August Sander, *Antlitz der Zeit*, reprint, Munich 1976.

27 Helmut Lethen, p. 196 f. (see note 18).

28 Walter Benjamin, "Kleine Geschichte der Photographie" in *Das Kunstwerk im Zeitalter seiner technischen Reproduzierbarkeit*, Frankfurt am Main 1963, p. 90.

29 Peter Panter (pseudonym of Kurt Tucholsky) in "Altes Licht". The magazine in which his Parisian article was published could not be traced. Cited by Klaus Honnef, "Der Zeitgenosse" in the exhib. cat. *Albert Renger-Patzsch, Fotografien 1925–1960*, Bonn 1977, p. 23 f. which also details the problems of the work of Renger-Patzsch. See also Volker Kahmen, *Albert Renger-Patzsch*, exhib. cat. Rolandseck 1979, pp. 3 f.

30 Siegfried Kracauer, *From Caligari to Hitler*, Princeton 1947, pp. 165–66.

31 Gert Mattenklott, *Karl Blossfeldt Photographie*, ed. by Ann and Jürgen Wilde, Munich 1991, p. 12.

I. 1870–1918

Wolfgang Ruppert

Images of the Kaiserreich
The social and political import of photographs

I

Human beings are actors marked by their culture. The course of their lives is determined not only by social structures, but to an equal extent by the cultural appurtenances that form the basis of their actions, function as their points of reference as individuals, and mould their perceptions. Among these cultural appurtenances are the specific instruments of rationality which – as means of conscious orientation – moulds the mental character of each subject, as do images, ideas, experiences, emotions and values. Images of history too, are handed down within the process of civilisation, encoded in the media, individually assimilated, and preserved in collective memory.

Behind the extraordinary quantitative increase in the number of pictures in circulation in the nineteenth and twentieth centuries lies the revolution in "technical reproduction" (as described by Walter Benjamin) in the various media, triggered primarily by the invention of photography in 1839.[1] From that moment on, photographs served as information carriers and became integrated into the overall ensemble that material culture constitutes. More and more areas of human experience and perception were deemed worthy of being visualized, of being captured in photographs. In turn, those photos contain specific signs and aesthetic codes which are capable of expressing meaning only when decoded by an observer.[2] Their information value, therefore, is bound up not only with a reading process but also with the "cultural capital"[3] that the observer must possess in order to interpret the historical semantics of what has been photographed. Consequently, a photograph can be understood as a visual text made up of signs. According to the French historian Marc Bloch's definition, what we see in a photograph is a "trace", a "sensually perceptible sign that leaves behind a phenomenon which in itself" is not tangible. [4] The complex nature of the simultaneity of the visual contained in a photograph demands that its references be classified and explained, and that its historical location and the semantics that informed the respective cultural context be determined.

For this reason, an approach to photographic material from a historiological perspective is dependent on two preconditions. First of all, historical photographs can only be deciphered as one supplementary source among others. To be able to read the "viewpoints" [5] inherent in the photographs and the signs contained in the photographed scenes, it is especially helpful to have information about the occasion on which they were taken and a knowledge of their historical context. Secondly, one is dealing with documents that themselves contain the history of the development of this modern pictorial medium and have been shaped by the cultural conventions of its social utilization. In as far as these photographs portray people, they involve two complementary actors whose perceptions, attitudes and intentions influenced how the photograph was taken. The scene to be photographed is arranged by the photographer according to his technical means, his aesthetic perception of what is worthy of being photographed, and according to his particular "viewpoint". The people photographed, on the other hand, are no mere objects. Through demonstrative poses, unconscious gestures, concrete signs or symbolic codes, which all form part of the stage-managed scene, they too are active subjects who introduce their own specific statements into the photograph.

Although the people captured in the wealth of photographs that has survived from the time of the German Kaiserreich all had the same epoch and its prehistory in common, nevertheless, what we see are actors in very different social positions. To a large extent these positions were imposed on them by the prevalent social structures, political stances, mind-sets and habitual patterns of their particular configuration. A knowledge of these circumstances is indispensable in understanding the photographs. The patterns of social inequality meant that each social group was allotted a certain scope for action that implied different degrees of freedom in their decision-making. This is not immediately evident in the photographs and can only be gauged from a knowledge of the context. Yet within these social restrictions the individuals acted in many and various ways, depending on their political and cultural standpoints. In order to discover what photographs taken between the second half of the nineteenth century and 1914 have to say about political supremacy, labour forms, social conflicts, everyday life, and the status of the history of civilisation at that time, we had best turn our attention to those examples that not only visualize our historical knowledge, but which are interesting in themselves as a source of specific information.

Above and beyond the more abstract general context, these photos render certain details accessible and facilitate insight into the complex structures of the various social realms of action. The fact that a photograph is linked to a specific place often means that the photographer unintentionally captures the non-simultaneous in compressed and superimposed forms. The photos I have chosen highlight the social polarity that existed between the realms of experience and action open to the different groups of people they portray. However,

they also lend the historical subjects a human aspect and present a precise image of the conditions under which they functioned.

Longer-term social and political developments contributed towards the formation of the second German Kaiserreich. Since the second half of the eighteenth century, corporative society had been undergoing a process of modernization. The bourgeoisie advanced to become the dynamic force that in the nineteenth century gradually transformed social relationships in accordance with the order it envisaged as the model of a bourgeois society. Nevertheless, until 1918 the aristocracy remained the powerful and socially dominant class, holding on to the key political roles and guaranteeing the preservation of the monarchy. Various technical innovations and the restructuring of professional labour in keeping with the requirements of a capitalist market economy marked the various stages in a historical process of change that not only defined the contemporary conception of "progress", but also found expression in everyday visual emblems and the outward appearance of the historical actors. If treated as "traces", in the sense outlined by Marc Bloch, photographs constitute informative sources in the analysis of a particular stage in history.

At the start of industrialization's first phase, around 1834/40, mechanical engineering and industrialized textile production became new and important professional sectors. Here the new actors – entrepreneurs, skilled workers and engineers – were confronted not only with each other, but also with their complementary functions within the industrial division of labour.

A photograph taken by the Royal Bavarian court photographer Joseph Albert in 1864 showing one of these new work locations and the people employed there, represents an early document of the decade of political preparation that ushered in the second German Kaiserreich.[6] The photograph was taken on the grounds of the Maffei machine factory in Munich and can be read at several different levels. It is a precise depiction of the status of historical transformations, of contemporary material culture, of the type of staff employed in an early machine factory, and of a product regarded as a symbol of modernity. To be able to read these various levels, it is essential to have specific knowledge of the context.

The photograph was taken on the occasion of the completion of the company's 500th locomotive, marking an important moment in the company's history. Borsig in Berlin, the leading manufacturer in the sector at the time, had already reached this number in 1854. At that time, its competitor Maffei held a good position in the middle field. In the 1860s it was still relatively novel to use the medium of photography for a company's advertising purposes.[7] In order to lend visual expression to the Munich company's engineering achievement, the photographer – regarded as an expert in the application of the new medium – stage-managed a specific scene composed of people and

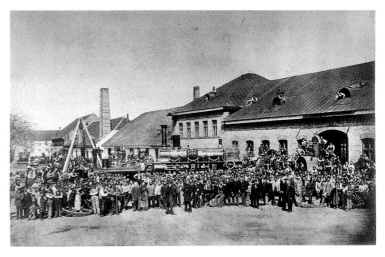

Joseph Albert, Staff of the Maffei factory, 1864

things. His work was aimed not just at creating an aesthetic viewpoint, but at delineating the order of symbolic meanings. The machine is placed at the centre of the photograph, visualizing the company's area of manufacturing activity. Grouped around it are the people involved in its production. What better way to illustrate the simultaneity of the non-simultaneous than in the black coach standing in the yard on the left edge of the photograph. Its essential difference concretizes the historical position of the machine.

In the way it is presented to the camera, the locomotive is clearly recognizable as a steam engine constructed for use on railway tracks and thus unable to move around the factory grounds "on its own steam". It has been jacked up on a gun-carriage and driven out of the factory by a locomobile, a vehicle commonly used at the time for transporting heavy loads. The Maffei factory was situated on the river Isar several kilometres from the railway line, so that the journey there had to be made by road with the help of the locomobile.

The technical achievement of the locomotive stimulated far-reaching associations that were immediately present in the mind of the contemporary observer. The locomotive, like the steam engine in general, was looked upon as an icon of Germany's modernization process and represented technical progress per se. In the phase of industrial "take-off" between the 1840s and 1860s, the railway was of central importance to the expanding German economy. Investments of private capital in this key industrial sector guaranteed private investors high returns. Soon machine factories, quick to diversify, were also providing the railway with other essential products such as railway carriages, signals and bridges. Their industrialized production went hand in hand with a process of internal mechanization and rationalization.

The locomotive too was being continually perfected, given that ever greater importance was attributed to engine acceleration in the process of bridging the geographical gaps between Germany's cities. One consequence of the resulting "transport revolution" was increasing mobility. The speed of rail travel increased greatly by comparison

with coach travel, and the attendant experience of spatial transience, plus the panoramic view, brought with them culturally new forms of perception.[8] Such alterations in cultural sense experience help to explain the fact that contemporaries saw this machine as having a highly charged, mythical aura.[9]

Behind the locomotive we see a manufacturing plant consisting of a number of workshops housed in specially constructed buildings. The various working stages located in these buildings, be that moulding, foundry or assembly (in the hall on the right), constituted essential stages in the production of complex machinery. The clothing and tools of the assembled staff members are indicators of their respective position within the division of labour. The difference between the various grades of workers on the one hand, and the engineers and sales people responsible for the ever more differentiated and theoretical fields of technical development and sales on the other, is visually manifest in the dress codes. Industrial society's professional hierarchy was the structuring principle according to which borderlines, even visual ones, were drawn.

We see workers in protective clothing such as aprons and overalls. Some of them are carrying the hammers used for metal beating, or the pounders for compacting sand in the moulds. The three-legged crane illustrates a transition. This was an older instrument used for lifting heavy parts. On the left edge of the photo we see factory children who were employed to do unskilled labour because of the low payment they commanded. The gentlemen in black tails and white collars clearly demonstrate their membership of the successful managing elite of the time. Their position at the front of the photo underlines their social status, which in turn was linked with their leading function in the work process. The gearwheels, also in the foreground of the photo, are of particular iconographic significance to the mechanical engineers' self-image; they can be read as ciphers for the mechanical power required for mobility, and as references to the importance of those who produced them.

A photograph taken twenty years later in the Zeise factory in Hamburg allows a closer view of the assembled employees, so that we can more easily study how people looked in the 1880s. Here the scene is dominated by skilled workers, who, as highly paid specialists, represented the worker elite. Here too, the factory workers and their tools demonstrate membership of their specific professions: the woodworkers with their saws, or the foundry worker with the rod and "stopper" required for the initial stroke and for closing the oven. Through their body language the blacksmiths with their folded arms in the back row exhibit a self-esteem based on muscle power and experience. In the front row on the left the observer's attention is drawn to a drilling machine which at the same time symbolizes the "progress" inherent in the mechanization of work processes. At the edge of the scene we see unskilled workers, for example, the old man at the gate on the left. Although the status of the various groups of workers was evaluated by the difference in their wages, they still developed a collective self-awareness that found expression in the term "worker" and

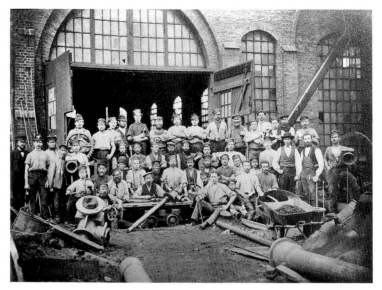

Workers employed by Zeise, c. 1880

constituted the opposite pole to the factory entrepreneurs, owners, shareholders or directors. From then on, both parties were caught up in a dynamic struggle for appropriate portions of the returns from their labour.

In a way, this photograph confounds the widespread notion of the "proletariat" as a uniform mass. Here we see a variety of people whose working and living conditions may have been subject to common social structures, yet who were nevertheless able to develop their respective self-images within the field of action available to them. Whatever typical features they may also represent, these are individuals looking at the camera. Their facial expressions, their different shaped beards, their clothing (shirts, waistcoats, jackets or caps) imbue their outward appearance with individuality. The time off work necessary to have this photo taken constituted a short break to recuperate. Their pipes, cigars, bottles and mugs can be seen as indicative of their different consumption habits and forms of enjoyment.

Fürst Bismarck and Kaiser Wilhelm II are two figures who, in a very specific way, represent not only their epoch but also the top echelons of the social hierarchy. Both were members of the higher nobility and both had wide-ranging possibilities for action in their respective spheres. This photo was taken on 30 October 1888, a date that hints at the circumstances of the encounter. The Berlin photographer M. Ziesler arranged this photographic scene presumably for official purposes, namely, to communicate to the public the image of an intact relationship. The context cannot be read directly from the photo. A few months prior to this meeting, on 15 June 1888, Wilhelm had succeeded his father, the liberal Kaiser Friedrich III, who had governed for only ninety-nine days. During the encounter captured here – the monarch's visit to Friedrichsruh, the family seat of Chancellor Bismarck, political manager of the German Kaiserreich – the strained, ambiguous relations between the two men, that finally contributed to Bismarck's

The obvious concern of the photo was to show the two uniformed representatives of state power in a formally correct pose; the 73-year-old experienced chancellor standing in front of the 29-year-old Kaiser to whom he was answerable, and who was obviously anxious to live up to his new position. The angle of vision, which captures the two men from the side, was deliberately chosen to ensure that Wilhelm's left side was turned away from the observer. From birth his left arm was shorter than his right and this disability possibly gave rise to a certain tenseness in his personality, coupled with a strong need for recognition. The dominant mentality during the German Kaiserreich laid great store by outward appearances. In that society's scale of values, a stylized demeanour, uniforms, and military insignia were rated very highly and seen by contemporaries as representative of a person's position within the power elite.

Differences in the symbolic forms utilized at the time become evident when one compares the body language and dress code in this scene with those in a photograph taken around the same time of members of the Social Democratic parliamentary party. The Social Democrats represented the growing counter-force, the social and political workers' movement, which fundamentally questioned the Kaiserreich's authoritarian class system and the power of the *Junker* or landed gentry. The aims of Social Democracy were derived from a belief in the natural equality of all human beings, the right to self-development, to an equal vote, to protection against social hardship, the emancipation of women, and freedom of action in society. The deputies gathered for this photo had not been permitted to go forward for election to the Reichstag as representatives of their party but only as individuals; Bismarck had not only defamed them openly as "enemies of the Reich", but in 1878 had banned all political left-wing groupings by means of the "law against the dangerous intent of Social Democracy".

For sympathizers of the workers' movement, the people in the photograph – and their more casual appearance, so different from the

M. Ziesler, Otto von Bismarck and Wilhelm II

dismissal in 1890, may have been perceptible, though this was not supposed to be evident in the photo. Several layers of meaning are superimposed here. Wilhelm II had the greatest of respect for the chancellor who had created the second German Kaiserreich with the full confidence of his grandfather Wilhelm I. Bismarck's "revolution from above" had been engineered by means of the deliberate use of military force in 1866 and 1871. This was to have long-term consequences in Germany, fostering an authoritarian society and limiting the amount of parliamentarian control exerted over the leadership by the Reichstag, whose competence was more or less restricted to budgetary matters. This formed the basis of Bismarck's strong political position. His sole responsibility was to his Kaiser. At the time of the photograph, however, the statesman's reputation was rapidly declining. In the course of 1889 and 1890, Wilhelm II distanced himself from him, even taking contrary political positions, especially on social policy and the prohibition of the Social Democrats.

Members of the Social Democratic parliamentary party

uniform cult of the upper classes and the distinctive dress code of the bourgeoisie – meant much that is not immediately visible to the naked eye. In the centre at the back is Wilhelm Liebknecht, editor-in-chief of the main Social Democratic party newspaper *Vorwärts* until his death in 1900. Like August Bebel, seated in the centre, he stood for the will for change in the way wealth was distributed within the class system, for the concepts of equality and greater social justice, and for the utopia of a new society. As deputies, both of them had opposed Bismarck's power politics and the war against France in 1870/71, for which they had been punished with confinement in a fortress.

Bismarck's world view, with its concept of an authoritarian state and power based on military might, had penetrated the self-understanding of the new German Kaiserreich of 1871. The nation founded in the following years was based on a celebration of the military and the pathos of military victory (the Sedan cult). The ethnically mixed region of Alsace-Lorraine had been annexed as a Reich state. In September 1870 German troops had laid siege to the fortress of Strasbourg until it capitulated. The force of German artillery had broken all opposition. In its function as a "trace", the photo of Steinstrasse seen from the Steintor the day after capitulation, 28 September 1870, documents the reality of war and the destruction of the town: 220 citizens had died, 350 buildings had been razed to the ground. This war had demonstrated the superior technical quality of steel, in particular the steel of the cannons manufactured by the leader in the field, Krupp. The modernity of the German Kaiserreich's armaments furthered not only the country's political aspiration to recognition, but also the aggressive delusions of superiority that imbued nationalist notions of omnipotence *(Alldeutscher Verband)*. Monumental machines such as the steam-hammer called Fritz, representative of the status of technological developments in the 1860s, were perceived as symbols of the potential of German industry.[10] With the aid of such machines it was possible to manufacture large, high precision gun barrels. The steering and operating of these machines depended to a considerable extent on the

Steinstrasse seen from the Steintor the day after capitulation, 28 September 1870

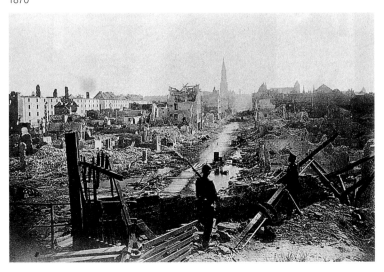

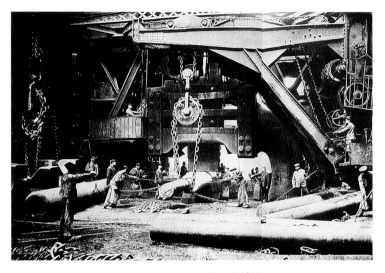

Last shift for steam hammer Fritz, 4 March 1911

experience and physical strength of the workers, as the photo was intended to demonstrate. The photograph of steam-hammer Fritz' last shift on 4 March 1911 was taken by the works' own photographer with the aim of documenting a technology that was already outdated, thus making it available for the company's advertising purposes. As a consequence of German armaments and naval policy, Krupp was able to consolidate not only its leading position in armaments technology, but also its role as Germany's largest employer.

A photo of a factory floor in the electrical engineering industry which had emerged in the 1870s and 1880s provides a view of completely different working conditions. The photo, taken in 1906, shows women at long work benches employed in mass production for the AEG company. Electrification had created a steadily growing need for new installations, appliances, and technical products required in large quantities both for industrial and private use. New procedures were installed that mechanized work processes. The photographic angle chosen here underlines the principle of industrial serialism illustrated in the rows of similar workplaces. There were various reasons why women were preferred for employment in the mass production of electrical appliances. Even for tasks requiring semi-skilled labour their wages were significantly lower, in keeping with the patterns of the sexual hierarchy. Furthermore, socially prevalent notions asserted that women were particularly suited to handling small components, something that required a high degree of digital dexterity. In 1907 women accounted for 35.8% of the working population.[11]

Since 1860/70, the process of urbanization had been advancing, and as their populations rapidly grew, towns began to take on a whole new aspect. Subsequent to the fundamentally new balance between rural and urban areas, space for the expanding modern cities was usually acquired by constructing around older town centres. The photo taken in 1884 by the Hamburg photographer G. Koppmann shows a street with old dwellings and a storehouse (second from the

right), easily recognizable by its symmetrical, warehouse architecture. The lifeworld captured in this photo has not yet been affected by the process of modernization. The people pause in what they are doing, probably at the photographer's instigation, except for the little girl in the foreground on the right; the street is still available as a playground and has not yet been subjected to accelerated twentieth century traffic. In the *Consum-Geschäft Naschke* you can buy tobacco, cigarettes, and bleach. The commercialization of consumer habits was restricted largely to items that could not be produced at home. In the yard on the left are two workshops, that of a cabinet maker and of a "chair and sofa maker".

The continual process of social segregation taking place in cities became manifest in the emergence of different city quarters inhabited by different classes:[12] working class areas with numerous tenement blocks versus bourgeois areas with private houses. The architectural design and function of the different buildings signalled the inhabitants' positions within the social hierarchy, their financial resources, and their potential for self-development.

In some cases photographs were taken of such city quarters with the explicit aim of drawing attention to inhuman living conditions, illustrating the social causes of illnesses such as tuberculosis, and consequently underlining the urgent need for help. As of 1903, commissions were given for documentary photographs that were to be appended to the Berlin Housing Enquete's report.[13] These photographs exerted a considerable influence, and have since occupied a

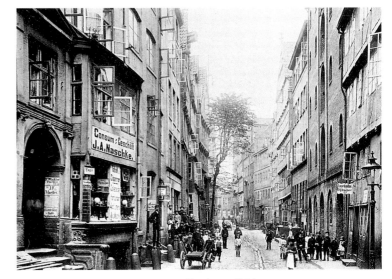

G. Koppmann, Street scence, Hamburg, 1884

place in the twentieth century's collective visual memory, concretizing the living conditions of the poor. The view of the courtyard at Berlin Alt-Moabit 73 was taken in 1903 to exemplify poor housing conditions.[14] The Berlin photography company Heinrich Lichte and Company was commissioned to take the photographs by the Berlin health insurance scheme for merchants, traders and apothecaries. The commission specified that not just "crass cases" were to be documented but rather examples "which are met with regularly and show only slight variations".[15] The people gathered at the centre of the photo are obviously only a portion of the house's inhabitants, as suggested by the others visible in the window frames. Houses such as these were erected as purely functional architecture to be rented out as small apartments. They were usually overcrowded, and the population density left practically no scope for individual self-development.

This image of poverty contrasts starkly with the image of wealth embodied in the historical upper class villa in Nuremberg with its different storeys and separate sections for housekeeping, private, and social purposes. Bedrooms, dining, living, music and drawing rooms, as well as a salon, were standard requirements for the wealthy bourgeois class associated with this kind of architecture. The ornamentation of the facade signals their aspiration to social status and their access to education and culture. Whereas the servant girl remains at a distance on the veranda, symbolically illustrating her social relationship to "the master and mistress" of the house, the latter, clad in bourgeois style, take up their position in the foreground, not far from the photographer. In the *Gründerzeit* in Germany (1871–73) there was a boom in the construction of villas with gardens, a representative pattern that lent symbolic form to professional success.

A comparison of two photos of interiors also illustrates the polarity in the prevailing living conditions. The photo of the living room in a basement flat was also commissioned by the Berlin Housing Enquete

Female employees at AEG, 1906

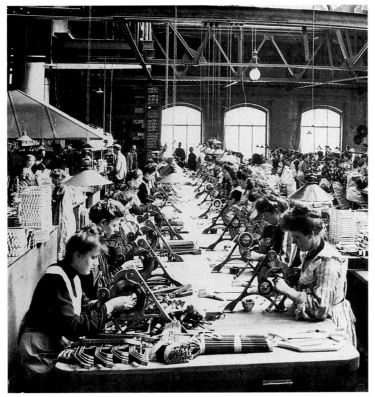

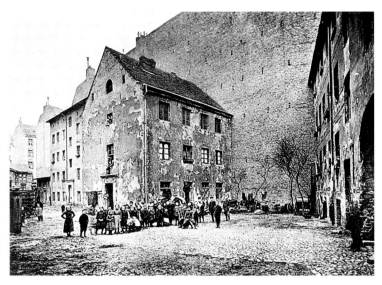

Heinrich Lichte and Co., Tenement house in Moabit, 1903

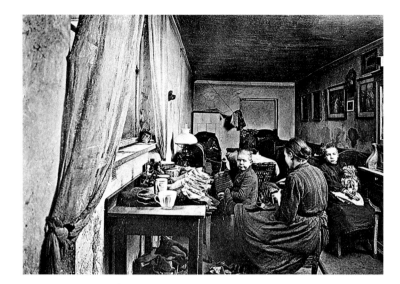

Rheinsberger Strasse 62, basement flat, Housing Enquete 1906

Bourgeois villa in Nuremberg

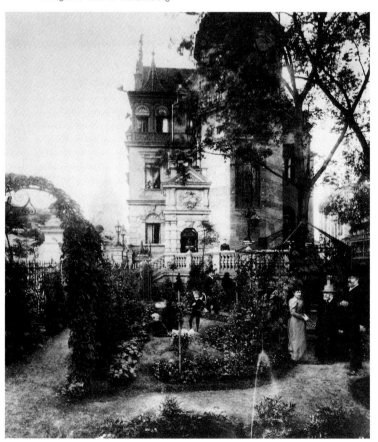

in 1906; the flat had another room with a cooking area. In order to take the photograph, the room had to be artificially lit so that this photo does not reproduce the actual light conditions. To facilitate a precise categorization of the signs captured in the photo, the most important related data were noted down:[16] "The woman makes felt slippers and has to work at the window because the rest of the room is dark. There are two beds for five persons. The entrance to the flat is dark and the stairs dirty." Presumably the piece-worker had to keep her two children busy while she was working. One can also assume that there is a baby in the pram in the centre of the room.

By contrast, the photo of Frau Krupp's work-room in 1889 shows an interior decor in the standard upper class taste: historicist furniture, carpets, and pictures with a family relevance. In addition to daylight, this room could also be lit by gas-light, the most modern form of artificial lighting available at the time.

In the last third of the nineteenth century, a new middle class of clerical workers formed between the working and the upper class. The number of salaried employees involved in the tasks of planning, calculating, constructing, bookkeeping, correspondence and sales was constantly growing. They too demonstrated their social status in symbolic forms that distinguished them from the working class. The photo of the salary office at the Riedinger machine factory in Augsburg underlines the emblematic value of suits, ties and white collars. Integrated into the office decor is the most modern form of contemporary communication available at the time, the telephone. Hanging on the wall to the right, it was utilized demonstratively. This factory's various sections were documented in a series of photos taken in 1912.[17] When photographing the company car and the people at whose disposal it was, the choice of location was of great significance. These people presented themselves, not least in their clothing, as members of the modern professional elite; they were responsible for business rela-

Frau Krupp's work-room, 1889

Salary office at the Riedinger machine factory, Augsburg, 1912

tions with the outside world. In this particular historical context, the utilization of the automobile in the business sphere implied the new rationale of employing time economically. It also alluded to the expansion of the physical range of business activities, and of course to the freedom of individual mobility. In the background of the photo there is a bicycle leaning against a wall – for the worker, the most important means of accelerated transport.

It was from the class tensions which existed in the German Kaiserreich that the vision of a more socially just and democratic society acquired its thrust. The authoritarian Wilhelminian state only granted franchise to men for Reichstag elections, and excluded larger sections of the population from the right to political participation by means of a three class franchise system at local government level. The protest marches of 1910 demanded the vote for women and opposed the categorization of the lower classes as second class citizens. Although the political content of the gathering is not evident in the photo, it does however show the large number of participants – an important point, as the campaigns were aimed at mobilizing a great number of similarly-minded people. In the midst of the demonstrators, here in Brandenburg on the Havel, we can distinguish a speaker. The working class in particular, having no economic or administrative power at its disposal,

adopted the protest march as a symbolic manifestation of their will to fight. Inevitably, they clashed with the police, the force of order that guaranteed the status quo, with the help of repressive measures, surveillance and informers. The Social Democratic left, and their spokeswoman Rosa Luxemburg, hoped that these mass actions would initiate a process of politicization and education among the workforce that would bolster the political judgement of those they hoped would be the "subjects" of a dynamic democratization of society.

The photo shows an arrested demonstrator being led off by policemen, who availed themselves of "violations of public order" to hinder exponents of the demand for change in their efforts to articulate their goals. The dress codes again represent the opposing models of order and identity: the worker in a jacket and white vest with a cap on his head; the "constabulary" in uniform with the spiked helmet that symbolized the forces of order in the authoritarian Wilhelminian state.

The managers in the company car, 1912

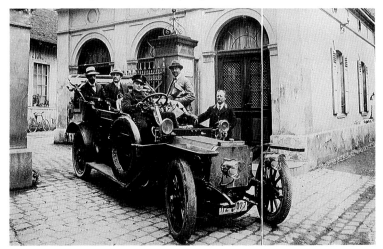

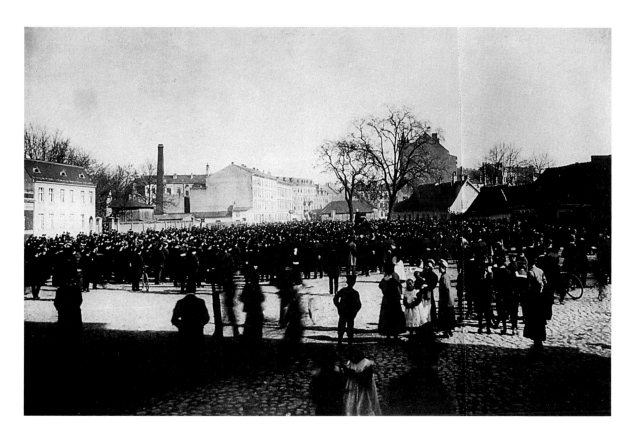

Demonstration in Branden-
burg/Havel for the right to vote, 1910

The policeman on the right also sports the kind of broad moustache which was often associated with Wilhelm II and can be read as a symbolic form of identification with the Kaiser.

When such photographs are read with the express intention of gaining more historical insight, and not perceived as merely aesthetic or nostalgic, then deciphering their information content hinges on a reconstruction of their historical semantics. In order to be able to avail oneself of the signs inherent in these "traces" when reconstructing historical reality, it helps to place the complementary media of image

Arrest of a demonstrator

and text in a relationship to one another that is both productive and mutually explanatory.

Notes

1 See the classic analysis by Walter Benjamin, "The Work of Art in the Age of Mechanical Reproduction" in his *Illuminations*, transl. by Harry Zorn, New York 1969.

2 Cf. Wolfgang Ruppert, "Photographien als sozialgeschichtliche Quellen – Überlegungen zu ihrer adäquaten Entschlüsselung am Beispiel der Fabrik" in *Geschichtsdidaktik* 11 (1986) 1 (= Geschichte erfahren), pp. 62–76, here pp. 73 f.; Rainer Wohlfeil, "Das Bild als Geschichtsquelle" in *Historische Zeitschrift* 243 (1986), pp. 91–100; Brigitte Tokemitt/Rainer Wohlfeil (eds.), *Historische Bildkunde. Probleme – Wege – Beispiele*, Berlin 1991.

3 This term, current since the reception of Bourdieu's works, drew attention to the cultural circumstances both of the historical actors and the recipients. On "cultural capital" see Pierre Bourdieu, "Ökonomisches Kapital, kulturelles Kapital, soziales Kapital" in Reinhard Kreckel (ed.), *Soziale Ungleichheiten*, Göttingen 1983, pp. 183–98 (= Soziale Welt Sonderband 2)

4 Marc Bloch, *Apologie der Geschichte oder der Beruf des Historikers*, Stuttgart 1980, p. 71.

5 On the shaping of the "viewpoint" as a part of cultural history see Thomas Kleinspehn, *Der Flüchtige Blick. Sehen und Identität in der Kultur der Neuzeit*, Reinbek bei Hamburg 1989, in particular pp. 262 ff.

6 Illustrating work processes for company advertising used to be the domain of the media woodcut, lithography or steel engraving as reproduction media. Being able to portray persons authentically introduced a whole new quality. It would seem that no photographs were taken when the 1000th locomotive was completed at Borsig in 1858. Cf. Dieter Vorsteher, "Das Fest der 1000. Lokomotive. Ein neues Sternbild über Moabit" in Tilmann Buddensieg/Henning Rogge (eds.), *Die Nützlichen Künste. Gestaltende Technik und Bildende Kunst seit der Industriellen Revolution,* Berlin 1981, pp. 90–98.

7 An early example is the panorama photo of the Krupp cast steel plant in Essen in 1861 distributed as a supplement to a pattern book. Cf. Bodo von Dewitz, "'Die Bilder sind nicht teuer und ich werde Quantitäten davon machen lassen!' Zur Entstehungsgeschichte der Graphischen Anstalt" in Klaus Tenfelde (ed.), *Bilder von Krupp. Fotografie und Geschichte im Industriezeitalter,* Munich 1994, pp. 53 f.

8 Wolfgang Schievelbusch, *Geschichte der Eisenbahnreise. Zur Industrialisierung von Raum und Zeit im 19. Jahrhundert,* Munich 1977, pp. 51 ff.

9 In many ways the steam engine stirred people's capacities for association and metaphor. It was visualized as the driving force behind bourgeois progress. Cf. Tilmann Buddensieg, "Das Alte bewahren, das Neue verwirklichen. Zur Fortschrittsproblematik im 19. Jahrhundert" in Tilmann Buddensieg/Henning Rogge (eds.), 1981; cf. note 6, p. 62.

10 For illustrations of the hammer "Fritz" cf. Jürgen Hanning, "Fotografien als historische Quellen" in Klaus Tenfelde (ed.), 1994; cf. note 7, pp. 269–88.

11 Gerd Hohorst/Jürgen Kocka/Gerhard A. Ritter, *Sozialgeschichtliches Arbeitsbuch. Materialien zur Statistik des Kaiserreiches 1870–1914,* Munich 1975, p. 66.

12 Adelheid von Saldern, *Häuserleben. Zur Geschichte städtischen Arbeiterwohnens vom Kaiserreich bis heute,* Bonn 1995, pp. 40 ff.

13 Gesine Asmus (ed.), *Hinterhof, Keller und Mansarde. Einblicke in Berliner Wohnungselend 1901–1920. Die Wohnungs-Enquete der Ortskrankenkasse für den Gewerbebetrieb der Kaufleute, Handelsleute und Apotheker,* Reinbek bei Hamburg 1982.

14 Ibid., p. 50.

15 Gesine Asmus, "'Mißstände . . . an das Licht des Tages zerren.' Zu den Photographien der Wohnungs-Enquete" in ibid., 1982; cf. note 13, p. 32.

16 Gesine Asmus, 1982; cf. note 13, p. 227. The address was noted as "B.-N. Rheinsbergerstrasse 62, basement".

17 Cf. Wolfgang Ruppert, *Die Fabrik. Geschichte von Arbeit und Industrialisierung in Deutschland,* Munich 1983, pp. 126 ff.

Ulrich Keller

The Art Photography Movement around 1900.
Painting as a model

According to a report by one of the participants in the first exhibition organized by amateur photographers in Berlin in 1896, the occasion was slightly marred by "Kühn's entry, which contained some of the first samples of the so-called gum print technique and dropped like a bombshell in the midst of our peaceful exhibition and the relatively tame discussion on the new aims of art photography that accompanied it. There was considerable opposition not only to the technique itself but to the bold consistency with which the primitive aspect of that technique was utilized to create Impressionistic studies as in modern art." This was no isolated case. For example, a soft-focus landscape taken by George Davison with a pinhole camera had already caused quite a controversy in London in 1890, and in 1902 Ernst Juhl, pictorial editor of the *Photographische Rundschau,* unleashed another scandal by publishing several portraits by Edward Steichen which were not only blurred – a feature to which people had already become accustomed – but whose overall effect was extremely murky. That was the last straw, and Juhl was obliged to leave his editorial position at the magazine as a consequence.[1]

Art scandals were not exactly infrequent occurrences, either then or now. At the end of the nineteenth century, however, a turning point was reached in as far as such scandals tended to be deliberate: If an avant-garde movement was to be credibly orchestrated, one indispensable instrument in the overall score was a public outcry. Whether the examples referred to above in the realm of photography were the result of innocence or method is still an open question. What they do reflect, however, is a photographic practice that adhered remarkably closely to contemporary practices in the world of the fine arts, more specifically, of painting. Initially this meant that the more ambitious amateur photography clubs set themselves artistic goals both in their choice of subject and technical procedure. They had also learnt from the example of the fine arts that the production of photographic images required an institutional framework if it was to be able to command the status of art with any credibility. Consequently, they initiated an exhibition programme for art photography that was supported by internationally linked associations and accompanied by lavishly illustrated magazine and book publications in which a critical discourse on photography was able to develop. Their efforts were so successful that between 1890 and 1910 pictorial photography seemed poised to become a legitimate branch of the fine arts and lay claim to presentation rights in museums. The fact that the movement later failed to fulfil the great expectations it had awakened and fizzled out before the start of the First World War would seem to point to a lack of both vitality and substance which, in the end, rendered it

incapable of bridging the gap between it and the world of "genuine" art.[2]

How is one to explain the phenomenon of art photography, which had seemed so promising at the start and which has only begun to be taken seriously again in the past twenty years? It goes without saying that from the very moment they first appeared, camera images were subjected to the reproach of being merely mechanical, and therefore soulless, registrations of nature.[3] The logical counter-strategy for photography was to assimilate recognized artistic norms. Once numerous studios had put this strategy to the test, albeit in a rather mechanical, formulaic manner, an ambitious minority of photographers raised it to the status of an ideological programme at the very moment when the craft of photography had become more or less industrialized thanks to the mass production of stereo photographs and carte-de-visite portraits at the end of the 1850s. The main dissenters were to be found in England, where people like Oscar Rejlander, Henry Peach Robinson and Frederick Hollyer insisted on a photograph having a careful artistic composition. As emulsion and lens techniques were still underdeveloped, this could only be achieved initially by means of complex and time-consuming montage procedures, especially in compositions involving several figures.[4] At the same time, an ideologically unburdened, craftsmanlike photography of high aesthetic quality could only be carried on in a few social enclaves where the general pressure towards quasi-industrial production was alleviated by personal wealth, official commissions, and other special circumstances. The majority of commercial photographers, however, was not in a position to resist that pressure. As a result, portraiture, which was by far the main focus of photography in the nineteenth century, more or less degenerated to the level of a mass produced item with retouched scenic backdrops against which at least the educated middle class did not wish to see itself permanently portrayed.

The decisive impetus to photographers, even those outside the isolated elite studios, to reflect on artistic quality again came from the emulsion sector. In the 1880s gelatin dry plates and roll film reduced the long exposure times required by the previous collodion negative process to fractions of a second. This also facilitated the introduction of small hand-held cameras to replace the otherwise large cameras requiring tripods. Gelatin negatives also did not have to be treated on the spot and developed immediately after the take; the photographer could buy pre-processed negatives and have them developed later by the supplier. In practical terms, these innovations amounted almost to a second invention of photography. 35 mm and snapshot photography brought the amateur photographer onto the scene. Even a child

could handle cheap pocket cameras, so within a few years millions of snapshots were being taken. Many amateur photographers organized themselves into clubs, and, later, when educated amateurs with higher aesthetic ambitions broke away from the popular clubs and formed their own societies, these became the driving force behind an astonishingly wide-ranging art photography movement that was soon to draw numerous commercial studios in its wake. [5]

The maxim of the ambitious amateur associations was to explore both their own private sphere and their rural surroundings with the aim of learning to recognize and capture on film their picturesque, painterly aspects. Although a distinctly pioneering spirit was at work here, the stronger motivation was the quest for a refuge from the noise and vulgarity of a rapidly expanding industrial society. The beneficiaries of the bourgeois economic boom were thrown into a state of unease by mass-produced, tasteless consumer goods, a hectic life style, the separation of densely populated urban living space from nature's free spaces, and various other aspects of modernity. Their middle class contentment was disturbed by intrusive elements experienced as alien and threatening. Defensive strategies were called for, and in a turnabout not uncommon since the time of Friedrich Schiller, many people decided to confront the social challenge with an aesthetic programme. The active pursuit of art was to help regain personal integrity, the medium of aesthetics to eliminate social alienation. In the words of an advocate of painterly portrait photography: In the "age of machines, centralization, and the division of labour", the development of an artistic viewpoint and a corresponding photographic image pointed the way towards the "salvation of personality". [6]

To fully comprehend how photography could be assigned such an ambitious mission it is necessary to take a brief look at the extraordinary advance of art, and art history, from being the exclusive terrain of collectors and connoisseurs to the status of a general social possession of the highest human value. Alongside the large-scale construction of splendidly stocked public museums, the nineteenth century also experienced the triumph of art history, as can be seen from the wealth of related publications in circulation. These ranged from the learned, constantly re-edited and increasingly well-illustrated handbooks by Kugler, Schnaase, Lübcke, Burckhardt and their like, to Seemann's illustrated art historical broadsheets aimed at a broader public. [7] In the long term, anyone primarily concerned with an aesthetic reform in the sense of reconciling art and life – a goal first propagated by William Morris in England but which gradually became popular on the continent as well – must have had some cause for concern on being confronted with all these books. Things reached a climax around 1890 when vociferous criticism was directed at overloading both young and old with the ballast of art historical knowledge.

Alfred Lichtwark, director of Hamburg's Kunsthalle and one of the main initiators of the aesthetic reform movement in Germany, polemicized against the general trend towards professionalization and specialization in people's working lives, seeing it as the cause of a one-sided development of personality, rigid social structures etc. He warned in particular against the monster of academic erudition in the world of art. For him a personal and unimpeded experience of original works of art was eminently preferable to the indolent study of books and reproductions. Better still than the study of art was the creation of art. Not that everyone was to become a professional artist. On the contrary, the widest possible circles were to cultivate the fallow ground of their creative talents on an amateur basis. The gist of his argument was that this could even lead to a revitalization of the fine arts: Professional artists would again be able to find appreciative private clients and the debate on public art projects would benefit from high-level expertise. [8]

In pursuit of this national educational programme Lichtwark turned, unavoidably, to the phenomenon of amateur photography. Here he recognized a mass potential which, as he liked to emphasize, was not only economically relevant (due to the immense consumption of photographic products) but which also, and above all, seemed to offer enticing possibilities for artistic self-development. Amateur photography, some of whose ambitions were highly aesthetic, had snowballed since the early 1880s. This was something that could be built upon; intelligently promoted it promised widespread success. Shortly after the foundation of the *Gesellschaft zur Förderung der Amateur-Photographie* (Society for the Promotion of Amateur Photography), Lichtwark opened the doors of the Kunsthalle to an *International Exhibition of Amateur Photography,* complete with illustrated catalogue. That was in summer 1893; ten more annual exhibitions were to follow. This marked the beginning of an organized and programmatic art photography movement in Germany, despite the fact that initially the majority of entries came from abroad. [9] Vienna, with its Camera Club patronized by archdukes, was a few years ahead of Hamburg, but as Lichtwark pointed out in a series of lectures accompanying his exhibition, England was the home of the amateur art photography movement and thus Hamburg's true model. In the mid-1880s, for example, the British photographer Peter Henry Emerson had already drawn aesthetic conclusions from the new technical possibilities and, with exquisite photograph portfolios and a polemical treatise, had begun to advocate "naturalistic photography", a label he gave to his own particular approach which was underpinned by the physiology of visual perception. The *Linked Ring Brotherhood,* which was founded in England in 1892, ensured that its first exclusive exhibitions, called "photography salons", were accessible to artistically ambitious amateurs. By contrast, with its 6,000 exhibits Lichtwark's first show in Hamburg aimed at more broad-scale promotion; no entry was rejected if it was well-meaning and fulfilled certain minimum technical requirements. [10]

There were, however, considerable obstacles in the way of the "education of the eye", the development of artistic sensitivity that amateur photography was supposed to achieve. To put it in the simplest of terms: the camera produced photographs, not paintings or works of art in any contemporary sense of the term. Given photography's aim of adapting to contemporary concepts of art, what had to be remedied

were its own inherently photographic features. This meant, for example, that for a photograph to become a *landscape* the photographer had to carefully select, group, and balance the ratio of soil to vegetation, have a foreground leading via a middle to a background, enclose the image in a frame, and ensure harmony by means of a unified tonality. A photographed face, on the other hand, only became a *portrait* when momentary facial expressions were suppressed in favour of lasting features indicative of personality, when there was no unscheduled rivalry between cultural ciphers such as graphic art folders, pianos or floral decorations and items from the world of the everyday, and when the overall image was enhanced by an inspired utilization of light etc. Anyone who had difficulties with these fundamental requirements for 'pictorial' photographs could seek advice in all sorts of handbooks. Henry Peach Robinson's *Pictorial Effect in Photography. Being Hints on Composition and Chiaroscuro for Photographers,* written in 1869 (and published in German in 1886), is the forebear of a whole genre that flourished around 1900. In this way, rules of thumb derived from the tradition of the Old Masters were popularized in order to force the camera to be 'pictorial'. [11]

In the decades immediately following the invention of photography there was little urgent need for such aesthetic demands to be made of photographs. The more artistically conscious may have criticized the abundance of unnoticed and undesired descriptive detail captured in photographs, but a careful pictorial composition was made all but indispensable by the technical difficulty of the procedure, the unwieldy apparatus, and the long exposure times. Spontaneous snapshots overflowing with chance effects and defying any kind of compositional rules only became possible with the decisive technical innovations in photography in the 1880s. Suddenly photographs began to look totally different, and sensitive observers reacted to them with as much astonishment as they had to the first Daguerreotypes and calotypes in 1839. It was this innovative thrust at the turn of the century that Marcel Proust had in mind when he included the following passage in his famous novel *Le Côté de Guermantes:* "... the most recent applications of photography – which huddle at the foot of a cathedral all the houses that so often, from close to, appeared to us to reach almost to the height of the towers, which drill and deploy like a regiment, in file, in extended order, in serried masses, the same monuments, bring together the two columns on the Piazetta which a moment ago were so far apart, thrust away the adjoining dome of the Salute, and in a pale and toneless background manage to include a whole immense horizon within the span of a bridge, in the embrasure of a window, among the leaves of a tree that stands in the foreground and is more vigorous in tone, or frame a single church successively in the arcades of all the others – I can think of nothing that can to so great a degree as a kiss evoke out of what we believed to be a thing with one definite aspect the hundred other things which it may equally well be, since each is related to a no less legitimate perspective." [12]

The arbitrariness of the camera, welcomed by Proust as an inspiration to abandon conventional perspectives, put artistically zealous amateurs in an extremely awkward position. The chaos of detail, the anarchy of the constellations made possible by the snapshot camera, though not always utilized in practice, seem to have exerted an almost threatening effect. How else is one to understand the amateurs' recourse to artistic conventions, to which they then subjected the camera. Where chance once reigned, rules were to prevail; the particular had to give way to the general. In the case of art photography around 1900, one could in fact speak of the "dictatorship of the general". Typical of this attitude was the treatment of the nude, the depiction of which, according to the handbooks on pictorial photography, could not be blurred enough; here recognisability was particularly reprehensible, indeed it was seldom welcome in any of the other thematic areas either. [13]

The enormous knock-on effect unsharpness had in photography suddenly becomes understandable against this background. The question of what degree of unsharpness was admissible in artistic photographs and which techniques guaranteed which soft-focus effects, gave rise to endless debates, during which the scandalous cases referred to at the beginning of this essay were also discussed. It soon became an accepted fact that, in Demachy's blunt and brief formula, "a straight print may be beautiful ... but it cannot be a work of art" [14]. Consequently, in an unspoken reversal of this dictum – to the effect that an unphotographic, blurred print reminiscent of a painting or lithograph must automatically be art – most of the pictorially ambitious amateurs concentrated their main efforts on testing various 'fine print' techniques, on diffusion lenses and the like, all of which were lauded in the respective photography literature as ideal means of suppressing precise detail and aesthetically enhancing otherwise often trivial subjects. The production of gum print papers for manually manipulated prints assumed industrial dimensions. Juries at exclusive photographic 'salons' hesitated to award medals to photographs "which did not look more or less mouldy, for fear of being suspected of being philistines". [15] Advocates of pictorial photography derided precise photographic renderings of sheep herds and farmers' wives while celebrating hazy images as art. It was all that simple. To paraphrase Marshall McLuhan's famous claim, one could say that the medium of the blurred fine print had advanced to being the principal, though necessarily cosmetic message of the art photography movement.

There is not much point in attempting to outline the exact correlation between the pictorial genres in painting and photography – except for the emblematic value of unsharpness, chiaroscuro and composition generally called upon to underpin photography's artistic ambitions – especially as little remained of the extensive subject catalogue of the Old Masters by the end of the nineteenth century. The history painting, for example, which once ranked highest in the pictorial hierarchy, had been practically abandoned the moment active heroes on battlefields were ousted by parliamentary committees and ministerial directors contending on the home front. The depiction of life among the lower classes, typical of genre painting, was seriously impeded by the polarization of bourgeoisie and proletariat, although

certain vestiges – tinged with an-agrarian-to-anthropological romanticism – did survive, even leaving their mark on art photography. Still lifes were scarcely undertaken in painting anymore, especially as the capitalist merchandising of goods had done away with the symbolic value of natural produce. They are also rare occurrences in art photography, with the exception of some formally didactic camera studies by Heinrich Kühn. The female nude on the other hand, in a wealth of decoratively undulating variations, became a leitmotiv in Symbolism and Art Nouveau, and was also marginally accepted in American and French art photography; by contrast, the naked body remained a taboo in amateur photography clubs in the German-speaking countries. These had begun to concentrate their attentions on two main themes, namely, the homely urban world of the upper middle class, focused on in portraiture, and its counterpart, the world of nature, focused on in landscape photography. It is to these main genres that one has to turn to discover what contributions German art photography made; it is here that any meaningful examination must begin. [16]

As for portraiture, well into the twentieth century the middle class's need for representation guaranteed that sound combination of social commission and economic return without which a pictorial genre is incapable of survival. The sudden appearance of the snapshot camera in the 1880s offered artistically open-minded amateurs the opportunity of taking family photographs in the privacy of their own home, an ideal alternative both to the stiff and no longer highly regarded commercial photographs and to largely unaffordable painted portraits. The results – elated faces of children apparently engrossed in books or games, wives at windows or sewing tables bathed in streams of light, even the photographer's own profile in front of a bookshelf or against Art Nouveau wallpaper – cannot seriously be measured with the yardstick of innovative avant-garde art, despite any ambitions they may have had in this direction. However, they do combine to produce an impressive historical self-portrait of the educated classes.

Yet to search among these photographs for the wealth of characters that once peopled camera portraits by Felix Nadar or Julia Margaret Cameron in the 1850s and 60s would be a vain undertaking. In photographic practice the individual, lauded so often in the literature on art photography, disappeared completely behind social signifiers – the gentlemen's distinguished suits, the ladies' reform-style dresses, the tasteful furniture, the fitting and decorous painting or porcelain. That popular sub-category of the portrait, the study of anonymous models, served exclusively to present supra-individual values such as authoritative masculinity, feminine grace and childlike innocence. Like photography itself, deportment, clothing, home interiors all spoke their own particular idiom. Everything depended on selecting the appropriate word, hitting the right tone. [17] Whoever mastered this idiom confirmed his or her adherence to a better social class, to the cultural elite. The people most concerned to demonstrate this were representatives of the educated middle to upper classes, that is to say, teachers, doctors, military officers. What the sociologist Bourdieu has demonstrated

for more recent times also applies to art photography as practised by amateurs at weekends around 1900: It was something the educated classes had both the time and the money to afford and by means of which they could copy the socially higher classes, that is to say, those people who really had enough time and money and could thus afford to hang an original Liebermann on their wall and not just an impressionistic photograph. [18]

It is not always easy to establish the artistic genealogy of pictorial portrait photographs. Occasionally they included some strange and highly detailed imitations of famous paintings which caused the American critic S. Hartmann to groan: "What is the point of this? Any intelligent art lover will immediately recognize the like as an imitation and surely prefer to own a normal photographic reproduction of the original painting than this type of second-hand reproduction." [19] Most pictorial photographers, however, took a more eclectic approach. As already mentioned, compositional recipes from the whole history of art from Dürer and Holbein to Rembrandt and Van Dyck were in general circulation. The most popular were provided by the time-honoured Old Masters, historically tried and tested and sanctioned by inclusion in museums. Imitations of contemporary art were not particularly frequent, but the relatively rare examples that do exist leave no doubt as to the elective affinity between amateur art photography clubs and various artists' secessions in the German-speaking region. The secessionists in Berlin, Munich and Vienna, as well as the parallel groups in Dresden, Hamburg and other cities, felt obliged to distance themselves from the inescapable proliferation of mediocre work emanating from the Wilhelminian studios, much as the 'pictorial' photographers had distanced themselves from mass produced commercial photography. Both groups, the secessionists and the art photographers, vied with one another for the favour of the same 'enlightened' supporters of the reform movement. They even joined forces on exhibitions and publications, for example in Vienna and Munich. In as far as art photographers turned their attentions to contemporary painting at all, their models were primarily late Impressionist pleinairists such as Hans Thoma, Friedrich August Kaulbach, Fritz von Uhde, Leopold von Kalckreuth, Leo Putz, Max Liebermann and Heinrich Hübner. By contrast, Lovis Corinth was too unconventional, and the Parisian Fauves or even early Cubists too far removed, and too alarming, to exert any influence. [20]

As a rule, art photography meant engaging in a debate with the art of past epochs. That in the course of this debate considerable achievements were made can be seen from the *Presidents' Portrait* taken by the amateur photographers Theodor and Oscar Hofmeister in Hamburg and easily recognizable as a paraphrase of Rembrandt's *Staal Meesters*. The slightly low-angle view of the table, the documents in the figures' hands, and the contrast between the profile of the person sitting and the frontal view of the other standing leave the observer in no doubt as to the descent of the group photograph from the famous Amsterdam painting. It would be insufficient, however, to merely track down the formal relations. After all, the Hofmeister

Rembrandt van Rijn, *Staal Meesters*, 1662, Amsterdam, Rijksmuseum

brothers were also concerned to reconstruct social prestige by aesthetic means: Hamburg and Amsterdam were major trading cities where political and social affairs were in the hands of patrician merchant committees. Correspondingly, the *Presidents' Portrait* can be seen as an attempt to position the directors of the Hamburg *Gesellschaft zur Förderung der Amateur-Photographie* (Society for the Promotion of Amateur Photography) in the same tradition as those venerable citizens: art photography as a means of improving social status.

It is also worth mentioning that the portraiture now being undertaken by the amateurs, be they snapshot or artistically more ambitious photographers, posed a huge problem for the commercial studios.

Theodor and Oscar Hofmeister, Portrait of the presidents of the *Gesellschaft zur Förderung der Amateur-Photographie*, 1899, Hamburg, Kunstgewerbemuseum

These were accustomed to portraying their sitters in stereotype poses and in regular stage settings, surrounded by arbitrary and interchangeable backdrops, splendid wooden furniture etc. The department stores with their mass production had already cornered a section of the cheap market from the commercial studios, only to suffer the loss of their higher class customers who now produced their own family portraits with the help of the new hand-held cameras. Only very few of the large commercial studios survived this dual erosion process; there was no more money to be made with assembly-line portrait production. [21] Anyone in the photography business intent on survival and willing to learn could find the recipe for future competitiveness as a professional photographer in the magazines and exhibitions organized by the artistically-inclined amateurs. By 1900 the aesthetic reform movement – aimed at reconciling art and life, among other things, by aestheticizing the lifeworld – had taken a strong hold on Germany's middle class. Although many amateurs in these enlightened circles frequently used a camera, there were still enough commissions, especially for portraits, on offer for professional photographers, that is, provided their work was of high artistic quality and guaranteed just the right social nuance. Around the turn of the century, therefore, high-class photographic studios for an aesthetically discriminating clientele began to open up throughout Germany: Rudolph Dührkoop in Hamburg, Nicola Perscheid in Leipzig, later Berlin, Wilhelm Weimer in Darmstadt, Jacob Hilsdorf in Bingen, Erwin Quedenfeld in Düsseldorf, Frank E. Smith in Munich. The list may not be all that long, but the larger cities in particular were able to accommodate at least one establishment of this kind. [22]

Hugo Erfurth is a case in point. His superbly stylized portraits gained him considerable success in Dresden around the turn of the century, so that he was even able to rent out the elegant Palais Lüttichau, after its former tenant Höffert, Erfurth's teacher and a dinosaur of photographic mass production, was forced to declare himself bankrupt. The décor of these elite studios, reputed to be quite homely and furnished in the best of taste, has been documented in photographs. One has only to think of the beautiful Art Nouveau studio *Elvira* designed by Endell in Munich, [23] where a small but affluent clientele chose to have their photographs taken. The familiar features of mass commercial production have been so consistently eliminated that these portraits, all printed on high quality paper, are almost indistinguishable from the family portraits taken by artistically inclined amateurs. It ought to be pointed out, therefore, that the most important contribution made by the amateur photography movement was the aesthetic re-orientation of commercial photography. The dialogue between these two took on an especially intensive form in Germany. Among other things, Fritz Matthies-Masuren issued a photography year-book intended as a forum for debate between the two groups; an exhibition of portrait photography mounted in Wiesbaden in 1903 was consciously aimed at presenting the public with the best portraits from the two sectors and prizes were awarded both to professional and to amateur photographers. [24]

Anton Joachim Christian Bruhn, *Moorburg Landing Stage*, c. 1910, Hamburg, Kunstgewerbemuseum

The landscape, that second cardinal theme of art photography, was even more subject to the so-called "dictatorship of the general" than the portrait. Landscapes, even city-scapes, were expected to have atmosphere and show non-identifiable locations, unless, of course, these had already become part and parcel of the general stock in trade of the educated classes, as was the case with Venetian canals and Parisian boulevards for example. *Nature* ranked highly here, be it as a refuge from urban traffic chaos or a resonance chamber for the utterances of the soul. This is reflected in a considerable number of elegiac storm and evening studies, bucolic shepherd processions and swelling seascapes. All this had very little to do with today's preferred leisure needs, such as boat rentals or keep-fit circuits. The aim was a silent, personal encounter with nature in its capacity as a medium that nurtured sensitive subjectivity. Industrial plants, traffic, and other accessories of the modern age were to be excluded. With an eye to the French Impressionists, wives and children in airy summer dresses occasionally served as an enlivening foreground feature. In the main, however, art photography relied for its staffage on indigenous figures – wind-tanned fishermen, stolid reapers, pious farmers' wives – that is to say, untimely, socially non-competitive characters who pursued an economically subordinate but reassuringly stable way of life. Here the hegemony of the sensitive and wealthy city-dweller remained unchallenged.

The respective models for this, apart from the landscape painting of past centuries, were clearly the contemporary secessionists, more especially the artists in the colonies of Worpswede and Dachau. These had retreated from the large cities, albeit to a distance that potential clients could cover by train. It is now a well known fact, for example, that an avenue of birch trees in Worpswede photographed by Oscar and Theodor Hofmeister owes a debt to a painted version of the same subject by Paula Modersohn-Becker. Art photography exhi-

bitions and publications around 1900 were rich in examples of women repairing nets à la Liebermann, scenes of domestic piety à la Hölzel, hardworking farmers and fishermen à la Kalckreuth. [25]

Unlike the portrait, there was no need for the landscape to battle with an aesthetically inferior commercial mass production. A few interesting examples, however, prove that here too the amateurs paved the way for reform-orientated professional photographers. Once landscape photography indicated a willingness to abandon general atmospheric portrayals for a more concrete depiction of local history and customs, all with an eye to the preservation of the rural environment, a marginal niche opened up. This niche demanded professional camera work of a 'greener' hue, in which the painterly receded to the renewed advantage of useful and aesthetic descriptiveness. The Hamburg photographer Anton J. Ch. Bruhn belongs to this particular category. Contrary to many other professional photographers, he never took part in art photography exhibitions and club activities. Instead he worked closely with the driving force of the Hamburg amateur movement, Ernst Juhl, on a series of photographs commissioned by the city's senate and entitled *Hamburg – Land und Leute an der Niederelbe* (Hamburg – landscape and people of the Lower Elbe). The sensitive objectivity that characterized this photographic project is best illustrated in the sharp matt albumen prints of *Rönnequelle von der Schleuse aus* (Rönnequelle from the locks). In the Ruhr district, Erwin Quedenfeld was involved in a documentary project devoted to local architecture and decidedly nostalgic and soft-focused in style. Elsewhere too, the fruits of similar undertakings occasionally found their way into illustrated book series such as the Langewiesche *Blaue Bücher* or Velhagen & Klasing's *Land und Leute/Monographien zur Erdkunde*. [26] It is only fair to acknowledge such photographic achievements as lasting contributions towards sensitizing wider social circles to aesthetic viewpoints and the practical conservation of landscape and cultural structures inherited from pre-industrial times.

Nevertheless, it would seem that art photography's narrow range of portrait and landscape motifs captured in predictable compositional and tonal variations was not in a position to attract greater creative energies. In less than twenty years the art photography movement had petered out. By 1910 the enthusiasm of the amateur associations had waned and the previously dizzying pace of the exhibition rounds had ground to a halt. Some of the magazines had ceased to appear, while others were again turning their attentions to technical and economic issues. Then came the First World War. Hugo Erfurth was one of the very few exceptions who, having made certain economic adjustments, managed to preserve the fine print market niche after the war. Otherwise the 1920s turned their attentions not to art photography but to technical photographic work which, to a large extent, was photography with practical applications in industry, advertising and the press. [27]

If art photography's overall balance sheet leaves much to be desired, there is certainly no doubt that this also has something to do with the fact that the movement was thwarted by internal contradic-

tions right from the very start. According to Lichtwark, amateur art and photography were instruments for shattering the professional ossification of bourgeois society. This link with art, however, steered the amateur photographers on a contemplative rather than an active course; the path to inwardness had very little explosive power. In the end, the instrumentalization of photography to educate the masses failed to make clear what in fact was the means and what the end. Looked at from the standpoint of society as a whole, amateur creativity and art appreciation ought to have been given top priority among a wide public. However, without saying so explicitly, Lichtwark seems to have been concerned above all with the well-being of a small professional group. Raising the public's taste was not seen as a goal in itself but as an advantage first and foremost for portrait artists. That is to say, artists were in effect more important to Lichtwark than the average citizen. Within the world of the arts, the traditional order of merit also remained unchanged. This is clearly demonstrated by the fact that although the amateur photography exhibitions took place in the Kunsthalle their considerable profits were invested in promoting the art of portraiture in Hamburg. [28]

Be that as it may, once it had profited gratefully from Lichtwark's early impetus, the art photography movement went its own way. This can be seen, among other things, in the way Hamburg's annual exhibitions developed. In 1893 a total of 6,000 exhibits were hung, ten years later only a few hundred, and those were mainly works by reputed elite photographers who had distanced themselves from the mass of amateurs. [29] From then on, the fate of the art photography movement was in the hands of a coterie of talented administrators and publicists – people like F. Matthies-Masuren and F. Loescher in Germany, H. Kühn in Austria, R. Demachy in France and A. Stieglitz and E. Steichen in America. This international network succeeded in elevating the pictorial camera style to the status of a ritual practised by an ingenious elect. Considering their exclusive exhibitions selected by juries of 'genuine' artists, their prestigious awards and lavishly illustrated magazines (in Germany above all the *Photographische Rundschau* and *Die Kunst in der Photographie,* not to mention their critical discourse on photography (towards a specific history and aesthetic of the art), it is true to say that these activists notched up considerable successes in terms of their public self-presentation. [30]

In many ways this was quite a normal development. Since the eighteenth century an anonymous market system had gradually replaced the system of personal patronage which, at the time of Rembrandt, had made the consumption of art a matter of personal contact between artist and purchaser. The market system meant that the widening gap between art producers and consumers had to be bridged by a whole variety of mediating institutions (the art trade, art criticism, exhibitions etc.). Art photography had set up equivalent institutions for itself as a matter of urgency around 1900, needless to say in imitation of painting. What was unusual about the realm of art photography was that its mediating institutions lacked autonomy. Exhibitions were largely under the control of the exhibiting photographers.

Cover page of *Die Kunst in der Photographie,* vol. 7, 1903

The important magazines were also edited by those photographers and carried their photographs and articles. Thus in the spring issue of *Camera Work,* the leading international journal of art photography edited by Stieglitz, the photographer and critic A might shower praise on the latest works by his friend the photographer and critic B, while in the summer issue, B in turn would enthuse on the latest works by A. [31] It is hardly necessary to point out that this compromised photography criticism's aspiration to be a credible arbitrator.

This lack of autonomy went much further. A closer examination shows that it was the giants of the photography industry – which had emerged in the course of the technical innovations of the 1880s – who financed the impressive and costly art photography exhibition and publication programme and thus turned them into a kind of advertising campaign aimed at promoting the wider consumption of photography articles by amateur photographers. In Dresden for example, where a large section of the German photography industry was concentrated, one can observe the curious phenomenon of local sponsors enabling Hugo Erfurth to pursue outstanding, and for his career highly advantageous, activities both as an exhibition organizer and as an exhibitor:

Advertisement for Elliott & Sons photography commodities (from: *American Amateur Photographer,* vol. 16, 1904)

By contrast, the Dresden members of the Expressionist artists' group Die Brücke had to be content with permission to mount exhibitions in a lamp factory on the outskirts of town, and were forced to ask their supporters to pay annual dues of 12 Marks; the manufacture of canvas and pigments was not a large industry worthy of promotion.[32] An English advertisement offers a concise visual formula for the commercial functionalization of art photography by the photography industry.

That the painterly style constituted only a short episode in the history of photography also had to do with changes in the general cultural situation and the bearing these had on advertising. In the 1920s, as the middle class's traditional intellectual obsession with art was gradually replaced by a general fascination with technology, the photography industry was able to sell cameras, lenses and film directly to potential customers as technical libido objects. This meant that not only photography's detour via the model of painting became superfluous, but also its complex mediating system which, when looked at historically, tends to magnify the significance of the phenomenon of art photography.

Notes

1 This reference to Kühn's revolutionary gum prints is to be found in Fritz Matthies-Masuren, *Künstlerische Fotografie, Entwicklung und Einfluß in Deutschland,* Berlin 1907, p. 45. The other scandalous cases are mentioned in Margaret Harker *The Linked Ring. The Secession Movement in Photography in Britain, 1892–1910,* London 1979, p. 31; Rüdiger Joppien " 'Eine schöne und auf dem Kontinent wohl einzige Sammlung' – die Sammlung Ernst Juhl", in *Kunstphotographie um 1900. Die Sammlung Ernst Juhl,* exhibition catalogue, Museum für Kunst und Gewerbe, Hamburg 1989, p. 23.

2 For more information on the strategy of provoking sensations at art exhibitions see Ulrich Keller, "The Myth of Art Photography: A Sociological Analysis" in *History of Photography,* vol. 8, Oct.–Dec. 1984, pp. 253 ff. That the "great expectations" art photography gave rise to in 1893 "were not fulfilled" is emphasized by Fritz Matthies-Masuren, 1907; cf. note 1, p. 103. For a discussion of German art photography cf. Enno Kaufhold, *Bilder des Übergangs. Zur Mediengeschichte von Fotografie und Malerei in Deutschland um 1900,* Marburg 1986; *Kunstphotographie um 1900,* cf. note 1; furthermore Marlies von Brevern, *Künstlerische Photographie von Hill bis Moholy-Nagy,* Berlin 1971; plus the works on outstanding individual figures mentioned below. On international art photography see Margaret Harker's study mentioned in note 1, and *Pictorial Photography in Britain 1900–1920,* which includes a text by John Taylor, exhibition catalogue, Arts Council of Great Britain, London 1978; Weston J. Naef, *The Collection of Alfred Stieglitz. Fifty Pioneers of Modern Photography,* New York 1978; plus the useful anthology edited by Peter C. Bunnell, *A Photographic Vision. Pictorial Photography,* 1889–1923, Salt Lake City 1980.

3 On this theme cf. the anthology compiled by Wolfgang Kemp (ed.), *Theorie der Fotografie I,* 1839–1912, Munich 1980, pp. 64 ff., in particular the famous polemical text by Baudelaire, pp. 110 ff.

4 On art photography in the early phase of the history of photography cf. Helmut Gernsheim, *Geschichte der Fotografie. Die ersten hundert Jahre*, Berlin 1983, pp. 293 ff.; Margaret Harker, 1979; cf. note 1, pp. 15 ff. On Rejlander and Robinson see Edgar Y. Jones, *Father of Art Photography. O. G. Rejlander 1813–1875*, London 1973; Margaret Harker, *Henry Peach Robinson. Master of Photographic Art 1830–1901*, Oxford 1988.

5 For a detailed treatment of the photo-technical revolution of the 1880s and the amateur movements which emerged thereafter see Helmut Gernsheim, 1983; cf. note 4, pp. 529, 553 and 715 ff.

6 This Loescher quotation is taken from Enno Kaufhold, 1986; cf. note 2, p. 110, who had access to the third reprint of Loescher's *Bildnisphotographie*. Similar thoughts were already expressed in the first print: Fritz Loescher, *Die Bildnisphotographie. Ein Wegweiser für Fachmänner und Liebhaber*, Berlin 1903, p. 15. For a detailed treatment of the flight from urban noise see Ulrich Keller, 1984; cf. note 2, pp. 249 ff.

7 Cf. Udo Kultermann, *Geschichte der Kunstgeschichte. Der Weg einer Wissenschaft*, Vienna/Düsseldorf 1966; Heinrich Dilly, *Kunstgeschichte als Institution. Studien zur Geschichte einer Disziplin*, Frankfurt am Main 1979.

8 Cf. Alfred Lichtwark, *Wege und Ziele des Dilettantismus*, Munich 1994; On Lichtwark's historical importance see *Kunst ins Leben. Alfred Lichtwarks Wirken für die Kunsthalle und Hamburg von 1886 bis 1914*, exhibition catalogue, Hamburger Kunsthalle, Hamburg 1986.

9 On Lichtwark's cultural and political instrumentalization of photography see his collection of lectures *Die Bedeutung der Amateurphotographie*, Halle 1894, in particular pp. 4–24; also Margret Kruse and Helmut R. Leppien, "Von der Amateurphotographie zur Kunstphotographie" in *Kunst ins Leben*, cf. note 8, pp. 104 ff.

10 "An elite exhibition was not what was planned", Lichtwark pointed out in *Die Bedeutung der Amateurphotographie*, cf. note 9, p 4. See also p. 10 for the reference to the "education of the eye". For further information on the Viennese Camera Club see their own publication *Wiener Photographische Blätter* (vol. 1, 1894, pp. 217 f. carries a list of the honorary archducal members; vol. 4, 1897 p. 22 a description of the new club premises in the centre of Vienna, including the reception, reading, conversation and library rooms, and the cold/warm buffet). On the Linked Ring cf. Margaret Harker, 1979; cf. note 1. Emerson's theory of photography is outlined in *Naturalistic Photography for Students of the Art*, London 1889. On Emerson's life and work see Nancy Newhall, P. H. Emerson, *The Fight for Photography as a Fine Art*, New York 1975.

11 The original title of Robinson's book is *Pictorial Effect in Photography. Being Hints on Composition and Chiaroscuro for Photographers*, London 1869. The German translation mentioned here was published in Halle. Another handbook imported from England and translated was A. Horsley Hinton's *Die Praxis der künstlerischen Photographie*, Dresden 1900. German works of this kind include Hans Wilhelm Vogel, *Photographische Kunstlehre, oder Die künstlerischen Gründsätze der Lichtbildnerei. Für Fachmänner und Liebhaber*, Berlin 1891; Julius Raphaels, *Künstlerische Photographie*, Düsseldorf 1895; Adolf Miethe, *Künstlerische Landschaftsphotographie. Zwölf Kapitel zur Ästhetik photographischer Freilichtaufnahmen*, Halle 1897; Fritz Matthies-Masuren, *Bildmäßige Photographie. Mit Benutzung von H. P. Robinsons Der malerische Effekt in der Photographie*, Halle 1903.

12 Marcel Proust, *Le Côté de Guermantes*, Bibliothèque de la Pléiade, vol. II, pp. 365 f. The reference to Proust here is taken from Pierre Bourdieu, *Photography.*

A Middle-Brow Art, Polity Press 1990, Cambridge, pp. 74–75 (Proust transl. by Terence Kilmartin).

13 The following is one such statement: "Nude photography is forbidden to take the pure objective beauty of the human body in itself as the subject of a depiction" (Willi Warstatt, *Die Künstlerische Photographie. Ihre Entwicklung. Ihre Probleme. Ihre Bedeutung*, Leipzig/Berlin 1913, p. 60.) The constant insistence on "harmony" and "taste" in photographic composition also amounted to a "dictatorship of the general". For more on this theme see Enno Kaufhold, 1986; cf. note 2, p. 70. For examples from art photography outside Germany see Ulrich Keller, "The Myth of Art Photography. An Iconographic Analysis" in *History of Photography*, vol. 9, Jan.–March 1985, pp. 1 ff.

14 Robert Demachy, "On the Straight Print" in *Camera Work*, no. 19, July 1907, p. 21. What the art photographers tried in desperation to "eradicate" and "eliminate" with their painterly aesthetic was the snapshot's wealth of detail so celebrated by Proust. The all revealing phraseology is to be found in Willi Warstatt, *Allgemeine Ästhetik der photographischen Kunst auf psychologischer Grundlage. Für Künstler und Freunde photographischer Kunst*, Halle 1909, pp. 51 ff.; by the same author *Die Künstlerische Photographie*, cf. note 13, p. 24.

15 *From Pictorial Photography in Britain*, cf. note 2, p 16. A gum print paper factory is mentioned by Matthies-Masuren, cf. note 1, p. 86. For more on the sharp-unsharp controversy see Ulrich Keller, 1985; cf. note 13, pp. 16 ff.

16 For a wealth of relevant material on both themes cf. Enno Kaufhold, 1986; cf. note 2, pp. 27 ff. and pp. 65 ff. He also provides a plausible treatment of a third group of themes (life and/or genre scenes) which I will not deal with separately as it coincides to a large extent with the landscape and portrait themes.

17 A British art photographer put the mutual accreditation of aesthetic principle and social status in a nutshell by demanding "happy tact" in the use of the camera, adding in explanation: "An artistic photograph must have qualities similar to those of an ideal gentleman." (Arthur J. Anderson, *The Artistic Side of Photography in Theory and Practice*, London 1910, pp. 204 ff.) Kaufhold quotes a comparable German statement, cf. note 2, p. 19: "The amateurs . . . all have higher school and social education and most of them have time and money. In short, they unite all that is necessary to produce something artistic."

18 Cf. Pierre Bourdieu, among others, 1990; cf. note 12, pp. 46 ff., in particular pp. 64 ff.

19 Sadakichi Hartmann, "On Plagiarism and Imitation" in *The Valiant Knights of Daguerre. Selected Critical Essays on Photography and Profiles of Photographic Pioneers* ed. by Sadakichi Hartmann, Harry W. Lawton and George Knox, Berkeley, CA. 1978, p. 65. For more detail see Keller, cf. note 13, p. 5.

20 For more on the secession movements in the German-speaking countries see, among others, Werner Doede, *Die Berliner Secession. Berlin als Zentrum der deutschen Kunst von der Jahrhundertwende bis zum Ersten Weltkrieg*, Berlin 1977; Berliner Secession, exhibition catalogue, Neuer Berliner Kunstverein, Berlin; Maria Makela, *The Munich Secession. Art and Artists in Turn-of-the-Century Munich*, Princeton, N.J. 1990; Robert Waissenberger, *Wiener Sezession*, Vienna 1971. *Ver Sacrum*, the select organ of the Viennese Secession, welcomed the Viennese Camera Club as "an inestimable comrade in the propagation of an artistic view of life, a cause we too serve" (*Ver Sacrum*, vol. 1, issue 4, April 1898). *Ver Sacrum* regularly reproduced art photographs by Kühn, Watzek, Henneberg and others, and included pictorial photographs in secession exhibitions. (Cf. Ch. M.

Nebehay, *Ver Sacrum 1898–1903*, Vienna 1975, pp. 297 ff.) On the Munich Secession's concept of art cf. Ulrich Pohlmann, "'Im Einklang mit den Großen der Zeit'. Anmerkungen zur Rezeptionsgeschichte des Erfurthschen Porträtwerkes in Ausstellungen und Publikationen" in *Hugo Erfurth 1874–1948. Photograph zwischen Tradition und Moderne,* ed. by Bodo von Dewitz and Karin Schuller-Procopovici, exhibition catalogue, Agfa Foto-Historama. Cologne 1992, p. 120. For information on an artists' association in Hamburg with secession features see Carsten Meyer-Tönnesmann, *Der Hamburger Künstlerclub von 1897,* Hamburg 1985.

21 For an excellent analysis of this market problem see Rudolf Herz, "Ökonomische Krise und ästhetische Reform der Atelierfotografie" in *Hofatelier Elvira 1887–1928. Ästheten, Emanzen, Aristokraten,* ed. by Rudolf Herz and Brigitte Bruns, exhibition catalogue, Fotomuseum im Münchner Stadtmuseum, Munich 1985, pp. 145 ff.

22 For more on Dührkoop and Weimar cf. the catalogue entries and various text references in *Kunstphotographie um 1900,* cf. note 1. For more on the other names mentioned cf. Fritz Kempe, *Nicola Perscheid. Arthur Benda. Madame d'Ora.* ed. by Odette Appel-Heyne, Marburg 1980; Erwin Quedenfeldt 1869–1948, exhibition catalogue ed. by Elke and Hubert Müller, Museum Folkwang, Essen 1985; Franz Toth, *Jakob Hilsdorf 1872–1916. Photograph im Jugendstil. Eine historische Wiederentdeckung,* Bingen, no year given (revised new edition of the exhibition catalogue, Mittelrheinisches Landesmuseum, Mainz 1984); Ulrich Pohlmann (ed.), Frank Eugene, *The Dream of Beauty,* exhibition catalogue, Fotomuseum im Münchner Stadtmuseum, Munich 1995.

23 For more on Erfurth cf. the extremely informative volume *Hugo Erfurth 1874–1948,* cf. note 20, in particular pp. 14 f. On the Atelier Elvira see the excellently researched catalogue *Hofatelier Elvira,* cf. note 21, especially the contributions by Nikolaus Schaffer and Rudolf Herz on the history of architecture, pp. 5 ff. and 25 ff.

24 In his preface to the first volume of the year-book Matthies-Masuren refers to its aim of overcoming the separation between amateur and professional photographers by "generally raising" the quality of both their work: Fritz Matthies-Masuren (ed.), *Die Photographische Kunst im Jahre 1902. Ein Jahrbuch für künstlerische Photographie.* On the portrait exhibition in Wiesbaden see Enno Kaufhold, 1986; cf. note 2, p. 85.

25 Cf. Gerhard Wietek (ed.), *Deutsche Künstlerorte und Künstlerkolonien,* Munich 1976; Hans-Christian Kirsch, *Worpswede. Geschichte einer deutschen Künstlerkolonie,* Munich, no year given; Ottilie Themann-Stoedtner, *Dachauer Maler. Der Künstlerort Dachau von 1801–1946,* Dachau 1981. The reference to the link between Modersohn-Becker and the Hofmeisters is in Enno Kaufhold, 1986; cf. note 2, pp. 151 ff. Reference to the net-menders à la Liebermann is in Ulrich Keller, 1985; cf. note 13, pp. 3 and 10 f. Also useful in this context is Klaus Bergmann, *Agrarromantik und Großstadtfeindschaft,* Meisenheim 1970.

26 For more on Bruhn see Fritz Kempe's preface to the reprint of the portfolio *Hamburg – Land und Leute an der Niederelbe,* Hamburg 1981, pp. 1 ff.; Rüdiger Joppien, 1989; cf. note 1, p. 24; also the plates and the stock catalogue in the same publication. As Enno Kaufhold shows (1986; cf. note 2, p. 53) there was a link between the art photographers in Hamburg and the Hamburger Lehrervereinigung zur Pflege künstlerischer Bildung. The art photographers donated a selection of landscape photographs to the teachers' association with the aim of "making broader circles more artistically sensitive to the local landscape".

27 On German photography in the 1920s see Van Deren Coke, *Avantgarde-Fotografie in Deutschland 1919–1939,* Munich 1982; Jeannine Fiedler (ed.), *Fotografie am Bauhaus,* exhibition catalogue, Bauhaus-Archiv, Berlin 1990; Wolfgang Kemp (ed.), *Theorie der Fotografie II, 1912–1945,* Munich 1974, pp. 72 ff.; Christopher Phillips (ed.), *Photography in the Modern Era. European Documents and Critical Writings,* 1913–1940, New York 1989, pp. 79 ff.

28 Cf. Carsten Meyer-Tönniesmann, 1985; cf. note 20, p. 40.

29 For statistical information on the Hamburg amateur photography exhibitions see the literature mentioned in note 9. The abandonment of mass educational ideals presumably had its roots in the specific dynamic of aesthetic reform movements which tended to be elitist; the same thing happened to the Arts and Crafts Movement around William Morris in England. See Elizabeth Aslin, *The Aesthetic Movement. Prelude to Art Nouveau,* New York 1969, pp. 63 ff.

30 For a more detailed international perspective see Ulrich Keller, 1984; cf. note 2, pp. 253 ff. For a specific theory and history of the emerging self-image of art photography (including forbears such as David Octavius Hill and Julia Margaret Cameron whose portraits were presented in exhibitions and magazines) see Willi Warstatt, *Allgemeine Ästhetik der photographischen Kunst;* cf. note 14; also the chapters on the history of its development in Willi Warstatt, *Die künstlerische Fotografie;* cf. note 13, pp. 7 ff., and Matthies-Masuren's similarly titled volume, cf. note 1, pp. 19 ff.

31 More on this in Ulrich Keller, 1984; cf. note 2, p. 267.

32 There are numerous useful references to the links between art photography exhibitions and the photography industry in Germany in Ulrich Pohlmann, 1992; cf. note 20, pp. 119 ff. Reference is also made to Matthies-Masuren's claim (cf. note 1, pp. 14) that the publishers of the German photography journals, which of course lived from advertising, were a driving force behind the development of art photography. For a detailed treatment of the entanglement of art photography and the photography industry, especially in the Anglo-American world see Ulrich Keller, 1984; cf. note 2, pp. 268 ff. On the early exhibition policy and the annual contributions of the so-called "passive" members of the *Brücke* cf. Roman Norbert Ketterer and Wolfgang Henze (ed.), *Ernst Ludwig Kirchner. Drawings and Pastels,* New York 1979, p. 234.

II. 1918–1933

Heinrich August Winkler

Images of Revolution and the Weimar Republic

1918–1923

"Brothers! Don't shoot!" What happened on 9 November 1918 in front of the Garde Ulanen barracks in Berlin has been documented in a photograph: revolutionaries, workers and soldiers demanded that their comrades inside the barracks not use their weapons but join them instead. Fraternization took place; the barracks were handed over to the revolutionaries. Elsewhere in the imperial capital, equally little was undertaken to defend the old order. The following day, 10 November, in a leading article in the liberal newspaper *Berliner Tageblatt* of which he was editor-in-chief, Theodor Wolff wrote about the "greatest of all revolutions" that had toppled "the imperial regime and everything to do with it" in a "sudden gale". "It can be called the greatest of all revolutions because never before has such a solidly constructed bastion guarded by such strong walls been taken in one offensive." [1]

The revolutionary consensus of November 1918 could be summarized in two words: peace and democracy. Germany had lost the First World War; it could only hope for a just peace if it became a democracy, at least that is how the American President Woodrow Wilson was understood. By the end of September 1918 even the German Military's strong man, General Ludendorff, had finally realized that the war could not be won. However, the Army High Command was not to be burdened with responsibility for the defeat. Instead, the peace-mongering majority parties in the Reichstag were to be scape-goated: the Majority Social Democrats, who had granted the Reich war credits up to the very last, the Catholic Centre Party, and the liberal left Progressive People's Party. On 1 October 1918 Ludendorff urged the highest ranking commander, Kaiser Wilhelm II, to let those parties "make the peace that must now be made. They should bear the brunt of what they have brought upon us." [2]

Thus, the *Dolchstoßlegende* (the myth of the stab in the back) was born: the claim that it was the forces on the home front who, in their readiness to come to an understanding, had deprived the army and navy of a military victory. Under the influence of this lie the Imperial Reich was transformed into a parliamentary democracy in October 1918. However, the new chancellor, Prince Max von Baden, who enjoyed the support and confidence of the Reichstag majority, was only theoretically in charge of state policy. Neither the Kaiser nor the army and navy commands seriously considered subordinating themselves to the Reichstag and the Reich government. On 30 October, with the endorsement of the Kaiser but not of the Chancellor, the navy command ordered the high-seas fleet to set sail for England. This

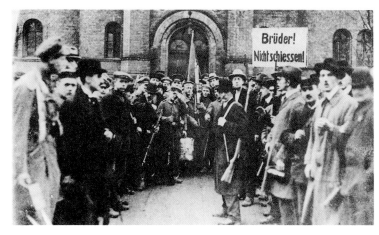

Revolutionary workers and soldiers demand the surrender of the Garde-Ulanen Barracks, Berlin, 9 November 1918

amounted to nothing more or less than a coup against the new government. The sailors refused to carry out the order and consequently triggered a revolutionary movement that spread throughout Germany. When the Majority Social Democrat Philipp Scheidemann proclaimed the Republic from the balcony of the Reichstag building in the early afternoon of 9 November, he was met with enthusiastic applause: the fall of the monarchy promised a turn for the better. Above all, it promised to bring about a much longed-for peace.

The proclamation of the Republic was immediately followed by an armistice concluded on 11 November in the forest of Compiègne. Meanwhile, in Berlin a six-man Council of People's Representatives under the chairmanship of the Majority Social Democrat Friedrich Ebert governed the country. This Council was made up equally of representatives from both social democratic parties, the Majority Party, which had been participating in government since the beginning of October 1918, and the Independent Social Democrats, who had rejected the war credits and formed their own party in 1917. Ebert and the Majority Social Democrats did not consider themselves to be revolutionaries, nor even to be founding fathers of a democracy, but rather "administrators of the bankrupt old regime", as Ebert put it himself in his report to the Constituent National Assembly in Weimar on 6 February 1919. [3] It was, therefore, important that the people themselves decide their own fate as soon as possible. This view was shared by a great majority of the workers' and soldiers' councils that had been for-

Robert Sennecke, "Administrators of the bankrupt old regime": The Council of People's Representatives 1918/19. From left to right: Otto Landsberg, Philipp Scheidemann, Gustav Noske, Friedrich Ebert, Rudolf Wissell (old contact copy)

med spontaneously. Consequently, on 19 December 1918 at a congress held in Berlin, the date for Constituent National Assembly elections was set for 19 January 1919.

A photograph taken either at the end of 1918 or the beginning of 1919 shows the Council of People's Representatives as constituted on 29 December 1918. The previous day, the three representatives from the Independent Social Democrats had quit the committee so that the revolutionary government was made up solely of Majority Social Democrats. Representatives Friedrich Ebert, Philipp Scheidemann and Otto Landsberg were joined by the newly-elected Gustav Noske and Rudolf Wissell – the former responsible for military affairs, the latter for economic and social policies. Being a lawyer, Otto Landsberg was the only academic among them. All the others just had secondary school education or were former skilled workers with practical training. However, as long-standing party functionaries and mandate-holders, they were professional politicians with considerable experience and expertise. They represented and embodied the majority of German workers who wanted to change the existing social order gradually, not overthrow it violently. It was self-evident to the governing Majority Social Democrats, therefore, that they would have to cooperate over a longer period with the old military, administrative and business elites. Parliamentary democracy, as Ebert and his friends envisaged it, demanded something that pre-war Marxist social democracy strictly rejected as being in contradiction to the theory of class struggle, i.e., a willingness to strive for a "class compromise" between moderate forces within the working class and the bourgeoisie.

The radical wing of the German proletariat saw things quite differently. The Spartacists around Karl Liebknecht and Rosa Luxemburg, who in the last days of 1918 had united with other groups on the extreme Left to form the German Communist Party, accused the Majority Social Democratic leaders of betraying the cause in their willingness to make such a compromise – hence, abandoning everything that was sacred to the revolutionary working class. The founders of the Communist Party were not alone in this view. A minority of Berlin workers, associated with the metal industry's Revolutionary Representatives, also thought very little of a parliamentary democracy, in which, they believed, only the bourgeoisie would have a say. They saw their salvation in the realization of the slogan "All power to the Councils!" They looked to the example given by the Russian Bolsheviks in January 1918 when they broke up the freely elected Constituent Assembly. As far as the extreme Left was concerned, the Constituent Assembly was not even to be given the chance to convene in Germany. This was in fact the real aim of the January 1918 uprising in Berlin which – with rather questionable justification – has gone down in history as the "Spartacist Revolt".

The press photographer Willy Römer captured many scenes from this proletarian uprising, some of which are intensely symbolic: armed workers and soldiers behind barricades of huge paper rolls. The newspaper rolls came from the occupied Mosse Publishing House where, among other things, the *Berliner Tageblatt* was printed. By occupying the editorial offices, printing works and material stores, including those of the Social Democratic newspaper *Vorwärts*, the rebels had literally silenced their opponents. However, the paper barricades were no protection against machine guns, tanks and artillery. The outcome of the rebellion was a foregone conclusion. The Council of People's Representatives was forced to put down the revolt, but that unavoidable step was taken with an excessive use of force.

Willy Römer, Armed workers and soldiers behind barricade of newspaper rolls in front of the Mosse publishing house in Schützenstrasse, Berlin, 11 January 1919 (new print from an old glass plate)

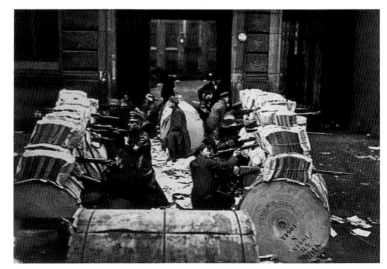

On 11 January, the day Römer took his photograph in front of the Mosse Publishing House, government troops first captured the *Vorwärts* section after hours of bombardment, and then gained gradual control of the other occupied sections of the building. Eight negotiators and messengers from the rebels were executed summarily. Both Karl Liebknecht, who on 5 January had called for the "overthrow of the Ebert-Scheidemann government", and Rosa Luxemburg were murdered. The split in the workers' movement became a gaping chasm.

The conservative bourgeoisie showed no gratitude to the Majority Social Democrats for all they had done to preserve Germany from imminent civil war and a descent to "Russian conditions". Friedrich Ebert, elected acting president of the Reich by the National Assembly on 11 February 1919, was made to feel the arrogance of the political Right on an almost daily basis. His advancement from being a one-time journeyman saddler to successor of the Hohenzollern Kaiser was felt by many as a personal insult, given their own higher social standing. At the end of August 1919, a few weeks after the Weimar constitution came into force, a front page photograph in the *Berliner Illustrirte Zeitung* sent conservative Germany into a state of moral indignation: it showed President Ebert and Defence Minister Noske on summer holidays, standing in the shallow waters of a lake with nothing on but their swimming trunks. The intention behind the publication of this private photograph was to arouse contempt for these working class "parvenus" who now ruled Germany, and it was certainly successful in achieving that aim. Once again, many of those who considered themselves to be from "better circles" thought they had every reason to feel eminently superior to the representatives of the Republic and the democracy for which they stood.

The Weimar Republic was born of Germany's defeat in the war and burdened with the mortgage of a difficult peace treaty, the Treaty of Versailles. That alone was enough to turn the young democracy into an object of hate for the radical Right. That hate found expression in counter-revolutionary violence, such as in the Kapp Putsch of March 1920, and in assassination attempts which claimed the lives of the republican politicians Kurt Eisner, Matthias Erzberger and Walther Rathenau. The Republic was blamed for the rampant depreciation of the currency, which in fact had its origins in Imperial policies, that is to say, in the way the German Reich had financed the war. Inflation reached its high point in the catastrophic year of 1923 when the Ruhr district was occupied by the French and the Belgians. The decline in the currency value brought with it a decline in traditional moral values. Farmers and the landed-gentry began to hoard their produce as money was scarcely worth anything anymore; hunger drove workers out into the fields where they dug potatoes from the ground; in the large cities grocery stores were repeatedly looted. On 29 September 1923 the exchange rate for an American dollar was 160 million marks. A photograph taken at the time illustrates better than any words what inflation meant on a practical everyday level in Germany: a newspaper vendor needs a washing basket to hold her day's earnings.

Consequences of inflation: a newspaper vendor replaces her purse by a washing basket

Another photograph taken around the same time, obviously for the official record, shows a very different scene: seated at a festively decorated table, important-looking gentlemen are gathered; others have to stand so that the photographer can include them in his picture. They are at a banquet given by the *Deutsche Industrie- und Handelstag* (German Conference of Trade and Industry Chambers) in August 1923. Leading business people attended the banquet, among them Carl Duisberg, chairman of the *Verein zur Wahrung der Interessen der chemischen Industrie Deutschlands* (Association for the Protection of the German Chemical Industry's Interests), and two members of the new cabinet, the first Grand Coalition constituted on 14 August: Chancellor Gustav Stresemann, Chairman of the right-wing

Crisis talks: a banquet given by the German Conference of Trade and Industry Chambers in August 1923 was attended, among others, by Chancellor Stresemann (seated fourth from the left in the back row), Finance Minister Hilferding (seated second from the left in the back row), the industrialist Duisberg (seated fifth from the left in the back row)

liberal, industry-friendly German People's Party, and Rudolf Hilferding, Social Democratic Finance Minister, who as a Viennese Jew, Marxist theoretician, and former Independent Social Democrat was the cabinet member most hated by the political Right.

The Grand Coalition was under pressure to terminate the "passive opposition" to the occupation of the German Ruhr region as quickly as possible, as it threatened to lead to economic and financial disaster. For the sake of this unpopular necessity, many business people were in favour of the Social Democrats participating in government. Once the Stresemann cabinet made its move on 26 September, the more right-wing representatives of heavy industry grouped around Hugo Stinnes called for a break with the SPD and the establishment of a "national dictatorship". When the coalition actually fell apart on 2 November 1923, restabilization of the currency was so far advanced that two weeks later Germany witnessed the so-called "Rentenmark miracle". On the night of 8 November, the leader of the then still small National Socialist German Workers' Party, Adolf Hitler, made an involuntary contribution towards saving the Republic: his improvised and subsequently failed Munich Beer Hall Putsch thwarted the "more serious" plans of the nationalist Right to install a dictatorship.

Even more important was the fact that the United States once again actively intervened in European politics in autumn 1923: they signalled their willingness to make concessions to their former war allies with regard to inter-allied debts, thus making it easier for France to modify its reparation demands on Germany. This easing of tension in foreign policy ushered in the end of the post-war period. In spring 1924 the Weimar Republic began a phase in its history which historians usually describe as a period of relative stability.

1924–1930

This period is more commonly referred to as the Golden Twenties and lasted from 1924 to the New York stock-exchange crash on 25 October 1929, better known as "Black Friday". American loans flowed into Germany on the basis of the Dawes Agreement and led the country into a period of economic recovery, albeit one which critics were quick to warn was only an "illusory up-swing". Actually, short-term loans had often been used for long-term investments in the hope that they would be prolonged automatically. Local authorities in Germany were the ones to use these loans most liberally. Local authorities had been the real victims of the centralized financial reform of 1919/1920, and thus now pushed ahead with plans that had not been possible during the inflation years: public-sector construction projects. In the mid-1920s new swimming pools and sports grounds, town halls, hospitals and schools shot up everywhere, not to mention public-sector housing financed largely from house rates introduced in 1924.

At that time, new buildings in both the public and private sectors often bore the aesthetic mark of the *Neue Sachlichkeit* (New Objectivity), a revolutionary movement in architecture, the repercussions of

Neue Sachlichkeit in housing construction: Uncle Tom Estate on the Argentinische Allee, Berlin-Zehlendorf, 1933

which are still being felt today. Originating in the Bauhaus in Dessau, Neue Sachlichkeit's functional aesthetic established itself within a few years in the realms of product design and architecture. In housing construction, the old back-courtyard form of building was replaced by a system made up of blocks or terraces of buildings, sometimes asymmetrical and of varying depths, depending on the number of rooms per apartment. This resulted in better ventilated and sunnier housing. Some examples of the housing built according to this principle are the Otto Stolten estate in Hamburg, the Weißenhof estate in Stuttgart, and three large housing schemes constructed in Berlin under the direction of Bruno Taut: the Hufeisen estate in Britz, the Carl Legien estate in Prenzlauer Berg, and the Uncle Tom estate along the Argentinische Allee in Zehlendorf.

The demonstrative modernity of these buildings elicited considerable opposition. The champions of traditional architecture came out in defence of the "German" pitched roof as opposed to the flat roof of Neue Sachlichkeit. The so-called "Zehlendorf Roof War" ended in a stalemate: in 1928, in immediate proximity to the modern Uncle Tom housing project in Fischtalgrund, a model apartment and housing estate with traditional pitched roofs was erected under the direction of Heinrich Tessenow.

This "cultural struggle" was not only confined to the realm of architecture. The 1920s saw the emergence of a new mass consumer-goods and leisure-orientated culture which did not recognize the boundaries of social class or milieu. The most important vehicles in the new mass culture were paperback novels, illustrated magazines, records, films, and after 1923, radio. The new media ignored the boundaries between poor and rich, Protestant and Catholic, city and country, proletariat and bourgeoisie. The latest hit song was whistled not only by secretaries but also by their bosses; people from all social

classes went to the cinema; the Charleston was danced not just in Berlin but in the provinces too. To a certain extent this mass culture also signified democratization. The country's cultural heritage, which until then had represented "upper classes" status symbols, now became accessible to the broadest sections of the population. On the other hand, popular entertainment products forced their way into the ranks of the "educated" classes. It was equally impossible for the latter to be protected from everything that was "vulgar" as it was for socialist workers to seal themselves off from the products of a capitalist leisure industry: most importantly from Hollywood or the Universum Film AG studios, otherwise known as UFA, in Babelsberg near Potsdam.

What conservative critics saw in all this was a trivialization, a levelling down, or Americanization of culture, in a word, a dismantling of all that was genuinely German. Berlin, which became a metropolis of the classical modern era in the twenties, was regarded by the guardians of tradition as a veritable den of iniquity: scantily dressed women at studio parties, Josephine Baker, the African-American dancer with her banana loin-cloth, "Nigger jazz", and even the modern bobbed haircut. Everything the "right" regarded as decadent began its conquest of Germany from Berlin. Anyone determined to be outraged easily found occasion to be so, and could also localize the apparent cause of all kinds of "social subversion": Jewry.

Berlin and its Jews: this combination made up the very essence of all that conservative Germany hated about the Weimar state. Jews played a prominent role among those people generally associated with the spirit of Weimar. That these Jews did not lean to the political Right was due to the fact that the Right was anti-Semitic. Anyone opposing the discrimination of minorities had little choice but to be liberal or left-wing. The involvement of numerous Jews in the workers' movement can be explained by the fact that nowhere else were masses of people to be found willing to fight for equal rights. Yet since the Weimar Republic was far removed from being an egalitarian state, it could not possibly satisfy the Left. Consequently, one of the most characteristic features of left-wing intellectuals in the Weimar Republic, whether they were Jewish or not, was their criticism of prevailing conditions.

The First World War, revolution and inflation had given considerable impetus to anti-Semitism. The need to look for scapegoats arose from the refusal or inability to grasp the underlying causes of the crisis. Anti-Semitism was not so widespread or radical during the period of relative stability as it had been in the first five years of the Republic. Yet German society was still permeated by strong anti-Semitic resentment. This was directed in particular against an assumed dominance of the Jews in cultural life, against the role Jews played as journalists and publishers, in the world of theatre and cinema. Anyone making a connection between the Jewish spirit and subversive intellectuality could count on support from the right-of-centre. However, the kind of aggressive racialist campaign pursued by the National Socialists was regarded in moderate conservative circles as vulgar and a serious breach of proper behaviour. Although anti-Semitism was socially

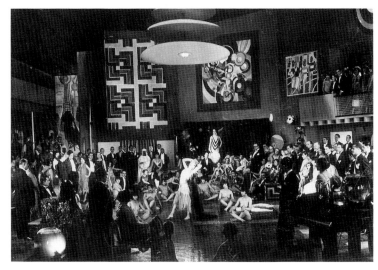

Artists' festival in Herwarth Walden's gallery 'Der Sturm' on Potsdamer Strasse in Berlin, 1923

acceptable, it was so only as long as it did not exceed the limits of public decency.

Most of the intellectuals in favour of the Weimar State were well aware of its inherent instability. During the First World War Thomas Mann – a photograph by Erich Salomon shows him among a circle of writer friends at a meeting of the Literature Section of the Academy of Arts in Berlin in 1929 – had been an eloquent defender of Germany's authoritarian state and its "state-protected inwardness". In October 1922, however, on the occasion of the author Gerhart Hauptmann's 60th birthday, Mann made a much-esteemed declaration of faith in the German Republic in front of a partially opposing audience in Berlin. Four years later, in Munich in November 1926, he spoke in anger and sadness about how much the relationship between the Bavarian capital, the city of his chosen residence, and the Reich capital of Berlin had changed since pre-war times. In those days Munich had been democratic and Berlin feudally militarist in spirit. In the meantime, however, the situation was almost reversed: "We were ashamed of the refractory pessimism that Munich opposed to Berlin's political insight, to the political longing of the whole world; we looked on in consternation as its healthy and spirited blood was poisoned by anti-Semitic nationalism and God only knows what other sinister follies. We had to listen as Munich was decried both in Germany and beyond as a hot bed of reaction, as a nucleus of stubbornness and defiance of the will of the time, had to listen as it was called an ignorant city, the very epitome of ignorance." [4]

At that time a former Prussian Field Marshall General had been head of state for a year and a half. Paul von Hindenburg had won the first direct presidential election on 26 April 1925, with 48.3 % of all the valid votes cast. If the Communists had not insisted on the hopeless candidacy of Ernst Thälmann in the second ballot, and had the Bavarian People's Party not come out in favour of the war hero, then the joint

Erich Salomon, A session of the Literature Section of the Academy of Arts, from left to right: Alfred Döblin, Thomas Mann, Ricarda Huch, Bernhard Kellermann, Hermann Stehr, Alfred Mombert, Berlin 1929

candidate of the democratic "Weimar" parties, the Centre Party politician Wilhelm Marx, would have been elected to succeed the first president of the Republic, Friedrich Ebert, who had died at the end of February. Marx received 45.3% of the votes. On 11 May 1925, Hindenburg, a supporter of the black-white-red colours of the Imperial Reich, was sworn in by the Social Democratic Reichstag President Paul Löbe in front of the black-red-gold presidential standard and took an oath to the Weimar constitution. The next day, the seventy-seven year-old inspected a guard of honour made up of formations of the Reichswehr and police force. Carrying himself erect he was still very much the old general, although not dressed in uniform.

It was a photograph that cheered the hearts of many a German. Hindenburg was a fervent monarchist. He owed his election victory, however, not only to the minority who wanted to have a Kaiser reinstated. His election also lent expression to a desire for national greatness and strong leadership – a need the Weimar parliamentary democracy could never have satisfied and one also felt by many people who wanted nothing at all to do with a restoration of the monarchy. That Hin-

Parade for the victor: the newly-elected President Paul von Hindenburg inspecting an honorary formation of the Reichswehr and police force, 12 May 1925

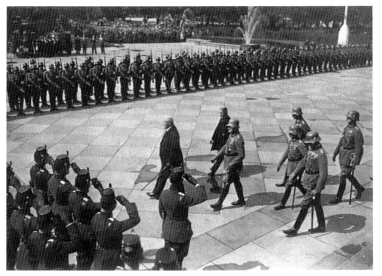

denburg promised to respect the republican constitution made it difficult for many of the Republic's detractors to persist in their implacable hostility to the new state. The monarchists, however, could rest assured: since it had been possible to elect an ersatz-Kaiser by legal means, the people would one day also accept, or even desire, the return of the monarchy. Yet perhaps this would not even have been necessary in order to achieve what the black-white-red camp aimed at: the establishment of a strong state that would put both parliament and political parties in their place just as effectively as the Imperial Reich had done prior to October 1918.

The social group most satisfied with Hindenburg's election was the one the second president of the Republic belonged to and the one to which he still felt duty bound: the military and the Junker land-owning nobility east of the river Elbe. It was of the greatest importance to the Reichswehr and to the landed-gentry to have continued and direct access to the highest authority in the country, the man to whom the role of ruler fell in times of crisis. The balance of power in German society did not change abruptly after 26 August 1925. Yet, as of that day the old, pre-republican, Prussian ruling class was once again equipped with effective leverage in the event of the Reichstag's unwillingness to accept what they saw as the order of the day. From a right-wing viewpoint, this represented a major step forward, and without a doubt it was a step away from the Weimar of 1919: What took place in spring 1925 was nothing less than a tacit change to the constitution, a conservative re-inauguration of the Republic.

Although the spirit of the Weimar constitution may have been foreign to Hindenburg, he adhered to the letter of its laws. Gustav Stresemann, foreign minister from August 1923 until his premature death in October 1929, was able to continue his foreign policy of peaceful rapport even under the new president. The Social Democrats, in opposition since November 1923, were of indispensable support to him. In November 1925 they helped to secure the Reichstag's acceptance of the Pact of Locarno by which Germany recognized its western borders and at the same time was re-admitted into the circle of the world's major powers. One year later, Germany joined the League of Nations and immediately became a permanent member of one of its most important organs, the Council of the League of Nations. When the Social Democrats became by far the strongest party in the Reichstag in the May 1928 elections, Hindenburg did not hesitate to entrust Hermann Müller, one of the two chairmen of the SPD, with the formation of a cabinet. Actively supported by Stresemann, Müller formed a Grand Coalition made up of ministers from the SPD, the German People's Party, the German Democratic Party, the Centre Party and the Bavarian People's Party.

This was the last government of the Weimar Republic to enjoy a parliamentary majority. Hermann Müller's cabinet – from the very start a fragile, crisis-ridden construction – was on the brink of collapse more than once. After Stresemann's death on 3 October 1929, his party, the German People's Party, gradually shifted to the right, thus entering on a confrontation course with the SPD and the trade unions.

As a result, a settlement of the long-smouldering dispute over the reform of compulsory unemployment insurance, a social achievement of the year 1927, was hardly to be expected. On 27 March 1930, the Grand Coalition crumbled – supposedly because the partners could not agree on a half, and finally quarter percent increase in the State's contribution to the insurance scheme.

There were of course deeper reasons for the last cabinet's disintegration, a cabinet that was supported by a majority in the Reichstag. The right-wing German People's Party was frustrated by constant concessions made to the workers, which was the price to be paid for a government alliance with the Social Democrats. Like the German People's Party, large sections of the business community, the landed-gentry, the Reichswehr, the President's closest associates, and Hindenburg himself, were striving for a government that was less dependent on parliament than the ones to date. The instrument to achieve this was Article 48 of the constitution which gave the president extraordinary powers in the case of crisis, without defining exactly what constituted such a crisis. The Social Democrats might have provided Müller's cabinet with a reprieve of perhaps six months by a greater willingness to compromise, but they were not strong enough in the end to save parliamentary democracy. With the appointment on 30 March 1930 of Müller's successor, the Centre Party politician Heinrich Brüning, Germany's first democracy entered a phase of dissolution, a development greatly feared by some though much longed-for by others.

1930–1933

At first, Brüning's middle-class majority government was more or less a covert or latent presidential cabinet. In his first few weeks in office the new Chancellor governed with changing majorities in the Reichstag. Brüning was aware, however, that in an emergency Hindenburg would grant him what he had refused Hermann Müller: recourse to the special emergency powers set out in Article 48. In mid-July 1930 the situation for which Brüning had been appointed arose: the Reichstag rejected a government finance bill; the first two emergency decrees were passed in accordance with Article 48; the SPD tabled a motion for the Reichstag to demand the decrees' repeal; the President complied with the motion (which he was obliged to do by the constitution) and dissolved the Reichstag, setting 14 September 1930 as the date for new elections. On 26 July Hindenburg signed a new "emergency decree to curb financial, economic and social crises".

It was in this period when parliament had been disbanded that a cabinet meeting took place in an unusual setting (photographed by Erich Salomon): on a hot and sunny August day the government convened in the garden of the Reich Chancellor's residence on Wilhelmstrasse. The photograph conjures up an almost idyllic atmosphere, but that impression is illusory. Germany was on the threshold of a fateful election. In June 1930, 2.7 million workers were officially registered as unemployed, 1.2 million more than in the same month of

Erich Salomon, The Brüning cabinet meets in the garden of the Reich Chancellery. From left to right: a leading official in the Finance Ministry Wachsmann, Food Minister Schiele, Minister of the Interior Wirth, Finance Minister Dietrich, Chancellor Brüning, Permanent Secretary in the Reich Chancellery Pünder, opposite Dietrich the Prussian Welfare Minister Hirtsiefer, August 1930

the previous year. All the indications showed that the rise in unemployment would lead to election gains for the Communists, which was not all. In state parliamentary elections in Saxony on 22 June, Hitler's National Socialists were able to triple their number of seats. It was not difficult to forecast that they would also make considerable gains nationally. To dissolve the Reichstag under these circumstances was a leap into the dark, yet Brüning's government faced the election outcome with remarkable serenity.

The Reichstag elections of 14 September 1930 brought a landslide victory such as Germany had never experienced. The National Socialists won 107 instead of 12 seats, and the Communists increased their number of seats from 54 to 77. The Prussian prime minister Otto Braun, one of the most popular Social Democrats, consequently demanded a "Grand Coalition of all reasonable parties". Shortly afterwards, in a lecture he gave bearing the sub-title "A Call to Reason", Thomas Mann appealed to the German middle classes to unite with the Social Democrats.[5] However, though still the strongest party, the SPD's return to government was unthinkable, not only because Hindenburg and the moderate Right were unwilling, but because a formal coalition with conservative parties would have split the Social Democrats. The way out of this dilemma, and one which both the governing parties and the SPD finally agreed to, was for the Social Democrats to give tacit support to the Brüning cabinet.

The SPD had three reasons for tolerating the Brüning government. First, it was the only way to avoid a more rightist cabinet dependent on the National Socialists and the monarchist German National

People's Party. Second, the Social Democrats had to reckon with the fact that the fall of Heinrich Brüning would also mean the fall of Otto Braun in Prussia. In bringing down the Centre Party Chancellor, they would provide the Centre – which along with the SPD and the German Democratic Party formed the government in Germany's largest state – with a cause to withhold their support from Braun. The Social Democrats would, therefore, have lost control over the Prussian police force, the most important instrument of state control in the struggle with the National Socialists and Communists. Third, moderate forces within the SPD and the middle classes were agreed that Germany had to correct the devastating consequences of the so-called *Pumpwirtschaft* (loan economy) of the second half of the 1920s. Hence a policy of toleration, continuing up to Brüning's dismissal at the end of May 1932, was based on a fundamental consensus to restore economic profitability, even though there was much disagreement on details.

The first session of the newly-elected Reichstag on 13 October 1930 opened with a bang. In protest against the Prussian Government's ban on uniforms, the 107 NSDAP deputies appeared in the chamber dressed in the brown shirts of the SA (*Sturmabteilungen:* storm troopers). This scene, which caused a sensation worldwide, has been captured in a photograph by Erich Salomon. Thousands of National Socialists gathered in front of the Reichstag: "Since the National Socialists were able to scorn the Prussian police inside the Reichstag, outside their supporters believed they could do the same on the street," wrote Otto Braun in his memoirs. "On the day of the Reichstag's first session they staged a small pogrom against Jews, breaking the windows of Jewish shops, warehouses and cafés and harassing Jewish people on the street, a provocation which first took the police by surprise but which they then vigorously put an end to."[6]

By tolerating Brüning the SPD had to bear responsibility for the social consequences of a rigorous savings policy particularly effecting the unemployed. Official unemployment figures rose to 4 million in June 1931 and by June 1932 increased to 5.6 million; in reality there was a great number of "invisibly" unemployed not included in this figure. In July 1931 Helmut Lehmann, a doctor and nutrition scientist, stated in the magazine *Die Tat* that Germany was experiencing a period of "hidden famine of enormous proportions that threatened to have serious consequences for physical and mental health. What we are seeing imminently endangers the next generation. People from all strata of society – all over Germany – are already eating less than half of the nutritional minimum!"[7] Semolina, boiled potatoes, and bean salad were the typical ingredients of a main meal eaten by the family of an unemployed person. If ever meat happened to be on the table, it was usually cow or horse meat.

People waiting in a queue outside an employment office or an urban soup kitchen; protest marchers demanding work and bread; men sitting on a curb staring into emptiness: all these images come to mind in the context of the Great Depression of the early 1930s. One photographer who tried to give that period of misery a human face was

Erich Salomon, Brown-shirt provocation: National Socialist deputies appear in SA uniform at the first session of the newly-elected Reichstag on 13 October 1930

Walter Ballhause. His photograph of brooding, seemingly apathetic unemployed men was taken in Hannover, but in 1931/32 "Hannover" meant everywhere in Germany.

Since the autumn of 1930 the Reichstag had only convened on rare occasions, and when it did, the sessions were usually accompanied by disturbances and brawls. The governing parties and the Social Democrats who tolerated them all agreed that "this Reichstag (was) a monstrosity and that one could be glad not to have anything to do with it". This quote is not taken from some radical newspaper but from the 13 December 1930 issue of the Social Democratic weekly Vorwärts.[8]

The National Socialists were the ones to benefit most from the fact that, as of 1930, the parliamentary system had degenerated into a farce. They were able to take advantage of two things: widespread German resentment towards the new parliamentary democracy forced upon them by the victors of the First World War and generally considered to be "un-German"; the people's long-standing aspiration to participate in political decision-making by universal suffrage, guaranteed since the Bismarck era. Yet the Social Democrats had no other choice but to continue to tolerate Brüning, unless they wanted to hand over power in the Republic and in Prussia to the extreme Right. In July 1931, in the Social Democratic magazine Die Gesellschaft, Rudolf Hilferding referred to his party's "tragic predicament": "To uphold democracy against a rejecting majority, and to do so with the political means provided by a democratic constitution, which presupposes a functioning

Walter Ballhause, Unemployed men in Hannover

parliamentarism, is an impossible task that Social Democracy has taken upon itself, nothing less than squaring a circle – a truly unique state of affairs." [9]

Spring 1932 brought the greatest vindication to the partners in the toleration pact and their "politics of the lesser evil": On 10 April, in the run-off election for the presidency, Hindenburg, who in the meantime was 84 years old, defeated his most dangerous opponent Adolf Hitler. The incumbent was the only candidate with any prospects of uniting the votes of the Weimar parties and of the moderate Right, thus relegating the leader of the National Socialists to second place. If the SPD and the Centre Party had not called upon their supporters to vote for the aged Field Marshall, the "Third Reich" would have been proclaimed on the evening of 20 April 1932. Hindenburg was victorious because, in contrast to Hitler, he was regarded as non-partisan. During the election campaign, the architects of his re-election, first and foremost Chancellor Heinrich Brüning, had deliberately appealed to the widespread anti-party feeling in Germany in order to hinder the establishment of a National Socialist Party dictatorship.

Nevertheless, it was a painful thorn in Hindenburg's side that his re-election was not indebted to the Right, as had been the case seven years previously, but primarily to Social Democrats and Catholics. In order to regain the sympathies of the Right he dismissed Brüning on 30 May 1932 and replaced him by the widely unknown arch-conservative Franz von Papen. In one fell swoop Papen's "cabinet of barons" fulfilled two demands Hitler had made in exchange for a provisional acceptance of the new government: the Reichstag elected in September 1930 was dissolved, and the ban imposed by Brüning on the SA and SS on 13 April 1932 was lifted.

The Reichstag election campaign of summer 1932 was the bloodiest Germany had ever experienced, with the Communists and National Socialists being held responsible for most of the acts of violence. On 20 July 1932, eleven days before the vote and on the grounds that it would restore public security and order, Hindenburg dissolved the Otto Braun cabinet in Prussia, which had lost its parliamentary majority in the state parliamentary elections on 24 April and was thus practically only a caretaker cabinet. The Social Democrats and the trade unions protested but put up no opposition. Given the existence of about six million unemployed, a general strike was illusory, and the deeply split Left would not have had the slightest chance of victory in an armed confrontation with the Reichswehr and the right-wing paramilitary groups. Thus fell *Bollwerk Preußen,* the Prussian bulwark that had in fact ceased to exist after the last state parliamentary elections. The republican forces' only hope was that the electorate would convincingly declare their faith in democracy at the Reichstag elections on 31 July.

By the evening of election day such dreams had been dashed. The NSDAP achieved their best results in free elections to date, winning 37.4 % of the valid votes cast and increasing their number of seats from 107 to 230. Together with the Communists, who had increased their percentage of the votes from 11.8 % to 12.5 % and their number of seats from 77 to 89, the National Socialists won a negative totalitarian majority in the new Reichstag. Consequently, the Reichstag was no longer a constructive instrument of the constitution. Germany's state crisis thus entered a phase contemporary experts on constitutional law have described as "constitutional paralysis" and a "state of constitutional emergency".

In talks with Hitler, Hindenburg refused categorically to hand over power to the leader of by far the strongest political party. For a time, he and the influential members of the government considered proclaiming a state of national emergency, dissolving the Reichstag, and postponing new elections until the internal situation had settled, that is to say, for an unspecified period of time. Such a violation of the

Large posters on house fronts at Potsdamer Platz in Berlin before the first ballot in the presidential election on 13 March 1932

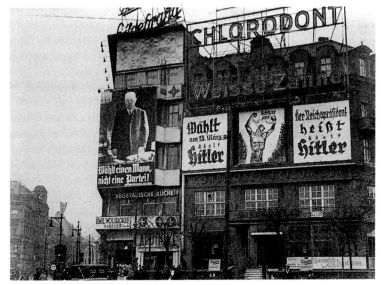

constitution, however, found no majority in the cabinet. But on 12 September, the Reichstag was in fact dissolved once again and Hindenburg set 6 November 1932 as the date for new elections – a date still within the constitutional limit of sixty days.

The second Reichstag election campaign in 1932 took a less bloody course than the first. However, the autumn of that year saw more strikes than the summer – among them rent strikes in which both Communists and National Socialists took part. A photographer captured a scene that documents the apparently peaceful coexistence of symbols belonging to the opposing parties. This photograph was taken in the back-courtyard of a picketed building in Köpenick Street in Berlin. The Berlin transport strike at the beginning of November 1932 represents one of the most spectacular cases in which the National Socialists and the Communists made a tactical joint effort, and it was not the least of the reasons why, for the first time, the NSDAP lost votes in the Reichstag election on 6 November. Compared to the 31 July election, the party forfeited more than 2 million votes and 34 seats, decreasing its percentage of the votes by 4.3% to 33.1%. By contrast, the Communist Party gained an additional 600,000 votes and increased its number of seats from 89 to 100, corresponding to 16.9% of all the valid votes cast.

Hitler appeared to be beaten. Yet paradoxically, he owed the fact that he still came to power to the coincidence of his own set-back and the increase in votes for the Communists. The fear that new elections in winter 1932/33, a high point in mass unemployment, might mean the Communists outdoing the Social Democrats for the first time and this being understood as a call to revolution and civil war, worked very much to the National Socialists' advantage. Papen, who had been forced to hand over the office of chancellor to the Reichswehr Minister General Kurt von Schleicher on 3 December 1932, made every effort to convince Hindenburg of the advantages of coming to some sort of an arrangement with Hitler. He was supported in this by sections of heavy industry in Rhineland-Westphalia. Representatives of the Junker elite, who still had an influence on the President, also argued in the same vein. On 30 January 1933 the time appeared to be ripe: Hindenburg appointed Hitler to the office of chancellor. A conservative cabinet majority was to "tame" the leader of the National Socialists and thus guarantee that the Trommler (drummer) not do anything that would constitute a threat to the interests of his conservative allies.

Hitler did not get into government by means of free elections, but his wide support among the masses was certainly one of the reasons why sections of the old power elites helped him to power over Germany at the beginning of 1933 as the leader of the country's strongest party. Not only did the short history of Germany's first democracy come to an end on 30 January 1933; on the same day Germany also ceased to be what it had long been before Weimar: a constitutional state based on the rule of law. It was then that a whole new chapter began: twelve years of National Socialist dictatorship which, in a review undertaken in 1946, the historian Friedrich Meinecke called the "German catastrophe".[10]

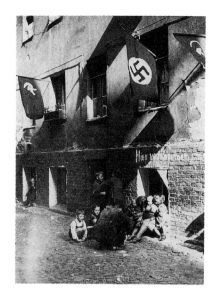

Opposing parties united in the rent strike, and children playing: Berlin, Köpenicker Strasse 34/35, October 1932

Notes

1 Heinrich August Winkler, *Von der Revolution zur Stabilisierung. Arbeiter und Arbeiterbewegung in der Weimarer Republik 1918–1923*, Berlin 1985[2], p. 58. For a more general treatment see Winkler, Weimar 1918–1933. Die Geschichte der ersten deutschen Demokratie, Munich 1994[2].

2 Ibid., p. 23.

3 Gerhard A. Ritter / Susanne Miller (ed.), *Die deutsche Revolution 1918–1919. Dokumente*, Hamburg 1975[2], pp. 208 f.

4 Heinrich August Winkler, 1994, p. 304.

5 Ibid., pp. 391 f.

6 Otto Braun, *Von Weimar zu Hitler*, Hamburg 1949[2], pp. 179 f.

7 Helmut Lehmann, "Deutsches Volkselend. Auch eine Statistik" in *Die Tat* 23 (1931), pp. 317–19, here p. 319.

8 Heinrich August Winkler, *Der Weg in die Katastrophe. Arbeiter und Arbeiterbewegung in der Weimarer Republic 1930–1933*, Bonn 1990[2], p. 271.

9 Rudolf Hilferding, "In Krisennot" in *Die Gesellschaft 8* (1932/I), p. 1.

10 Friedrich Meinecke, *Die deutsche Katastrophe*, Wiesbaden 1946.

Bernd Weise

Photojournalism from the First World War to the Weimar Republic

At 6 p.m. on 31 July 1914, the newspapers of the German Kaiserreich issued extra editions announcing a state of war. Photographs of the mobilization order being read out publicly by officers and of the first troops being deployed appeared next day in the illustrated press nationwide. At the time, there were some 20 illustrated weeklies with a circulation of more than 1.5 million, as well as twelve weekly illustrated supplements to daily newspapers which did not themselves carry halftone pictures, with a circulation of more than 1.7 million. Photographs were no longer the accompaniment to a text, but the main component of the report. In presenting a topic, pictures and texts were united and spread over a full or double page. Not only were individual photos by different photographers juxtaposed, but also series of photos for pictorial features by a single photographer, such as the report on the "Emigration Halls in Hamburg" by Johann Hamman, published in the *Leipziger Illustrirten Zeitung* of 27 February 1908. Filip Kester, who had turned to press photography after studying philology, also submitted reports during this period to the *Münchner Illustrierte Zeitung* on such themes as rural life in Bavaria. The static layout of the early days became increasingly varied both in terms of the typography and in the arrangement of the pictures, once picture editors, rather than the typesetters themselves, were entrusted with the task.

1. Photos for the press during the First World War

By 1914, press photography had already become a firmly established journalistic medium. Whereas, until then, the role of the press photograph had been one of documentation, evidence and a sign of the objectivity of the news message, in a war situation it suddenly became apparent that the photo could be used just as manipulatively in the press as any text.

Misguided press policy

The freedom of the press was compromised no later than 31 July 1914 when the *Reichskanzlei* issued a 26-point index of topics that could no longer be reported on.[1] This meant that press photographers were no longer permitted to photograph certain events in public that were to be regarded henceforth as military secrets. Unauthorized photography led to the immediate confiscation of the camera and the exposed film.[2] Photographers' organizations were specifically

Haeckel Bros., "Public announcement of the 'declaration of a state of war'" published as the cover page of the *Illustrierte Kriegs-Zeitung – Das Weltbild*, no. 1, 1914

instructed not to entrust foreign firms with the development and printing of war pictures.[3]

At the beginning of the war, the German Reich had no organized state press policy. As the government had no press office, its policy was publicly represented by the press department of the Foreign Office. Gradually, and without any coordination, press offices began to

emerge in civilian institutions. However, as the focus of government policy was now on military rather than political matters, all press work was coordinated by the military authorities. For example, the existing news department (III B) of the acting general staff had sole responsibility for the illustrated press, although prior to 1914 the same department had only been involved in disseminating news and photographs during imperial manoeuvres. The first ordinance of censorship, therefore, was issued by the chief of the general staff on 12 October 1914.[4]

Restrictions on photographers

At first, press photographers were not allowed to take photographs in the war zones. This fact was criticized by the editorial staff of the *Berliner Illustrirte Zeitung* in the name of the *Verein von Verlegern Deutscher Illustrierter Zeitschriften* (Association of Editors of German Illustrated Periodicals). In a letter to the Ministry of the Interior on 16 September 1914, they claimed that the German illustrated press would not have become so dependent on foreign photographic material had photographers been admitted earlier. Instead, they had to obtain their photos of the first war damage in Belgium through the magazine *Het Leven* and the *Vereenigde Photo-Bureaux* in Amsterdam.[5]

Not until 6 October 1914 did the general staff issue an official announcement (No. 569 Pr.) stating that photographs could be taken in the war zone and in the areas occupied by German troops, only with the permission of the chief of the armed forces and according to the conditions stipulated by him. After this, photographs could only be reproduced, disseminated or published after submission to and clearance by the military censor. Photographers without a permit issued by the general staff would not be allowed to work.[6]

To qualify as an official war photographer, application had to be made in writing to the general staff, preferably backed by references from the editor of a magazine. The applications were also screened by department III B to ascertain "whether they were rooted in a will to serve the cause".[7]

Within a short time, so many applications had been filed that no more could be considered.[8] In 1914, a total of 39 photographers were admitted to the war zones, ten on the western front and twenty-nine on the eastern front. Most of the photographers came from Berlin and amongst them were some of the most famous names of the day. In the east were Alfred and Karl Gross, Erich Benninghoven, Berliner Illustrations-Gesellschaft, Ludwig Boedecker, F. Gerlach, Gebr. Haeckel, Hohlwein & Gircke, Konrad Hünich, International Illustrations Co. Sanden, Franz Kühn, Photo Union Paul Lamm and Eduard Frankl, all from Berlin, and Alfred Kühlewindt of Königsberg, Kester & Co. of Munich and L&A Schaul of Hamburg. In the west were Richard Guschmann, A. Menzendorf, Wilhelm Braemer, Robert Sennecke and Walter Gircke, all from Berlin, Eugen Jacobi of Metz, and Max Löritz of Leipzig.[9] In early 1915, the court photographers Paul and Hans Tellgman of Kassel and

Langensalza were also inducted as so-called *Feldfotografen* (field photographers).[10]

The official war photographers were issued with an I.D. card and a white armband emblazoned with the words *Presse-Photograph* (press photographer). They had to adhere to the "directives for war photographers and cinematographers"[11] issued on 8 October 1914 and drawn up by the film pioneer Oskar Messter,[12] who was working in the "film and photo office" at the time and who, during the first few months, also censored the photographs.[13] The directives called for patriotic behaviour by the photographers and, in particular, demanded photographs illustrating the fairness of the German troops and the destructive cruelty of the enemy.[14]

Censorship

At the front, the press photographers, like all war reporters, had to report to the press quarters in the eastern and western war zones and had to operate from this base in producing their photo features. As a rule, they would spend eight days there every fortnight, returning to their home towns in the interim period with hundreds of photographs to prepare for publication.[15] They could photograph anything on location. Before publication, however, each photo had to be submitted to the relevant censor's office in triplicate with a precise inscription on the back. One print would then be returned to the photographer stamped with the words *Zur Veröffentlichung zugelassen* (Cleared for publication) or *Zur Veröffentlichung nicht zugelassen* (Not cleared for publication). The two other prints were kept on file in the censor's office.

Apart from department III B in Berlin, there were censor's offices at the respective regional military headquarters. Given the resulting

Haeckel Bros., troop transportation at a Berlin railway station; in the centre are two German soldiers in captured French uniforms (stamped on back "*not* cleared for publication"), 1914

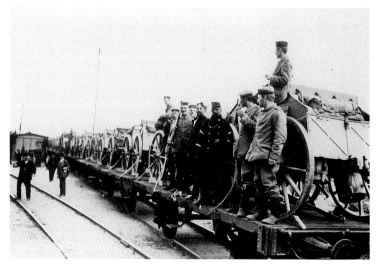

lack of coordination in press supervision, a central censorship office and a war press office were set up at the Ministry of War in 1915.

Having issued no fewer than twenty-three censorship decrees between October 1915 and August 1916, these three offices began drawing up a standard set of regulations for the handling of press photographs. Taking into account the interests of the newspaper publishers, these regulations were adopted on 8 January 1917 as "guidelines for picture censorship"[16] and included in the central censorship office's *Zensurbuch* (index of censorship) which was also published in 1917.[17] Some 60 references indicate the limitations imposed on photographs showing a range of motifs from bridge-building to motor vehicles and regiment numbers.

The manipulation of journalism in Germany mainly took the form of censorship, i.e. the repression of news items. Propaganda in the sense of a deliberate channeling of information was pursued with the aim of influencing opinion abroad. While the military leadership built up a dense network for the press supervision of German newspapers,[18] the Foreign Office, which had set up its Central Office for Foreign Services on 5 October 1915, concentrated more on foreign propaganda. Believing photography to be the most truthful form of reporting,[19] it focused mainly on visual propaganda. The vehicle for its "educational work" in neutral foreign countries was the weekly *Der Illustrierte Kriegs-Kurier*[20] and other illustrated periodicals, most notably the *Leipziger Illustrirte Zeitung* and an English-language edition of the *Illustrierte Rundschau,* which was the colour supplement of the *Hamburger Fremdenblatt,* published under the title *Illustrated American Edition.*[21] The German ambassadorial staff in The Hague described these illustrated weeklies in 1916 as "one of the best propaganda means we have".[22] In the spring of 1915, a depeche service and war photography agency under the name of *Transocean GmbH* was founded, involving the Foreign Office press chief Otto Hamman, to supply photographs with a German slant to overseas newspapers and periodicals. The company was financed by a syndicate of three hundred German firms, organized by Alfred Hugenberg.

Bufa photography troops

Constant conflict between the general staff and the Foreign Office in questions of photographic and cinematic foreign propaganda prompted the Ministry of War to merge the film and photo offices in January 1917 in the *Bild- und Filmamt* (Photo and Film Office) which came to be known by its abbreviation *Bufa.* One year later, *Bufa* was finally placed under the jurisdiction of the news department of the Ministry of War.[23] *Bufa* was responsible for supplying the press with all photographic material of the war effort. What looked like a step towards centralized pictorial propaganda actually turned out to be an unwieldy bureaucratic apparatus that was ineffective in its use of the media.[24] All available illustrative photographers were conscripted into the twenty photographic and film troops set up by *Bufa,* consisting of

an officer, cameraman, photographer and two aides, and were dispatched to the front with the active troops in military style.[25] Although the use of these photography troops meant an increase in the number of reports from the front, it did not satisfy the printed media's demands for realistic reporting on the war. For the most part, the photographs showed harmless military scenes from behind the lines, such as marching columns, smiling patients in military hospitals, munitions production lines, or the proud bearers of military medals.

Much of the photographic material from the front remained unpublished. The illustrated press, however, showed considerable understanding for the war press department in this regard.[26] For example, both the *Berliner Illustrierte Zeitung* and the *Münchner Illustrierte Zeitung* explained to their readers that images of the atrocities of war had to be kept back for military reasons.[27] Even so, the more the war press department became a cover-up instrument, the less the public believed in the objectivity of the press.[28]

The freelance press photographers were mainly diverted to "home front" reporting. Though this meant no scenes of actual combat, it allowed the effects of the war to be shown all the more clearly. Soup kitchens for the starving populace, bread rationing and coal distribution could no longer be overlooked.

In military circles, it had become clear from the beginning of the war that the high command was not in a position to determine what should be published and what should be covered up in the interests of public morale.[29] Yet even as knowledge of forged photographs from abroad became increasingly widespread, with a regular column in the *Deutsche Photographen Zeitung* reporting on "the photographic lies our enemies tell",[30] no journalistic change occurred. The real photographs of the war were not published until the late 1920s, amongst them *Der Weltkrieg im Bild – Originalaufnahmen des Kriegs- Bild- und Filmamtes* (The World War in pictures – original photographs from the War Photo and Film Office),[31] though at this point in time they were instrumentalized as propaganda against the victors of the First World War.

Peacetime – Revolution – Republic

With the arrival of the first revolutionary soldiers in the centre of Berlin, at the latest, the press photographers had a new field for their camerawork. The same photographers who had previously documented events on the front were back in Berlin to document the revolution. The illustrated newspapers published page after page of briefly captioned photos giving a blow-by-blow account of the meetings, proclamations, strikes and street fighting that took place between 9 November and 12 March 1919. The *Berliner Illustrirte Zeitung (BIZ)* devoted an entire 24-page special issue to the fighting in and around the newspaper district in Berlin between 5 and 12 January 1919 alone.[32] In the autumn, the *BIZ* ran an illustrated report featuring photos by Waldemar Titzenthaler showing the transformation of Prussian palaces into civic halls and holiday homes for children.[33]

2. Press and photography in the Weimar Republic

Of the twenty illustrated periodicals published in 1914, eighteen were still in business at the end of the war. The paper shortage of the wartime economy, the crisis of 1919/1920 and the incalculable financial situation of the inflation years 1922/1923 meant that a further eleven had to close down. The major illustrated periodicals such as *Leipziger Illustrirte Zeitung*, *Berliner Illustrirte Zeitung*, *Die Woche*, *Das Illustrierte Blatt* (later renamed *Frankfurter Illustrierte*) survived unscathed. The market for illustrated periodicals soon recovered, however.

The illustrated press of the workers' parties

Since 1892, the German Social Democratic Party (SPD) had published *Die Neue Welt* as an illustrated supplement to the social democratic daily papers. By 1906 its circulation had increased to 302,000 and, after changing its title in 1919 to *Volk und Zeit,* it continued to be published until March 1933. The Independent German Social Democratic Party (USPD), which had split from the SPD in 1917, launched its own illustrated magazine, *Die freie Welt*, on 1 May 1919. Even before the well-known *Arbeiter Illustrierte Zeitung,* it carried illustrated features (generally consisting of a cover page photo and a double page spread) on the life of the working classes, such as the feature *Aus der Hölle des Berliner Proletariats* (From the hell of the Berlin proletariat) published in issue no. 32 of *Die freie Welt* in 1920. When the USPD disbanded in 1919/1920 the magazine continued until 1921 as a weekly supplement for SPD newspapers.

On the Social Democratic side, the Republican defence organization *Reichsbanner Schwarz-Rot-Gold* published another illustrated magazine under the title *Illustrierte Reichsbanner Zeitung*. The fourth highest circulation in the Weimar Republic was achieved by the *Arbeiter Illustrierte Zeitung* (AIZ) in 1930 with a circulation of 450,000. It was not directly a publication of the Communist Party of Germany (KPD) founded in January 1919, unlike the *Roter Stern* published from 1924 onwards as a supplement to the KPD newspaper *Die Rote Fahne*. Instead, the AIZ was an offshoot of *Sowjetrußland im Bild*, a magazine launched in November 1921 as the organ of the *Internationale Arbeiterhilfe*, an international workers' welfare organization which had been founded in the summer of that year under the auspices of the KPD to express solidarity with the famine-struck Soviet Union. After its twelfth issue, the magazine changed its title to *Sichel und Hammer – Illustrierte Internationale Arbeiterzeitung*. From 30 November 1924 it was published under the title *Arbeiter Illustrierte Zeitung* by Neuer Deutscher Verlag, a publishing house owned and managed by KPD member and Reichstag deputy Willi Münzenberg. From October 1925 onwards, the magazine was printed by copper gravure process and from November 1926 it appeared weekly.[34]

Otto Reich, "Hamburg demonstrators driving the collaborators of the food falsifiers through the streets. The disgusting falsification of foodstuffs involving the corpses of dogs, rats and mice caused severe riots in Hamburg", published on the cover of *Freie Welt – Illustrierte Wochenschrift der Unabhängigen Sozialdemokratie Deutschlands*, no. 10, 1919

In pursuing its editorial aims of showing the darker side of society in pictures as well as words, the *AIZ*, having no photographers of its own, had to rely at first on photos supplied by the bourgeois photo agencies in compiling its picture features. It was for this reason that a competition was announced in the 12 March 1925 issue, urging readers to act as photoreporters. They were asked to submit shots of the revolutionary workers' movement, the social situation and daily life of the workers, and photos of their working conditions and workplaces. The competition led to the formation of a *Vereinigung der Arbeiter-Fotografen Deutschlands* (Association of Worker-Photographers of Germany). Based on the structural principle of the KPD, more than one hundred local groups were formed and communicated with each

"Heroes of Labour. At dizzying heights, a worker inspects the crane on a London building site", published on the cover of *Arbeiter Illustrierte Zeitung*, no. 15, 1926

other via their newsletter *Der Arbeiter-Fotograf*. Apart from information on technical and compositional techniques, the emphasis lay on conveying the significance of worker photography in Marxist propaganda and developing principles of social photojournalism. Not only the photograph and the photographic series, but also photomontage were the express aim and task of the class war waged with the camera. The worker-photographer as a producer of images for the workers' press was to undermine the influence of the bourgeois press and break its aesthetic mould. It was unusual for the bourgeois press to address the socio-economic situation of the working class, as the *Münchner Illustrierte Presse* did in Felix H. Man's picture feature on unemployment amongst Silesian weavers.[35] The worker-photographer movement developed into a photo agency service, primarily supplying the *AIZ*. Incidentally, the photo reports did not carry the name of the photographer, but merely bore the comment that they were "specially photographed for the *AIZ* by a worker-photographer". The overall layout, like the photos themselves, initially tended to be more or less static with detailed copy. In this light, it is all the more remarkable to find features, from 1927/28 onwards, which, instead of adhering to a chronological sequence of individual photos, visualize the political view of the discrepancy between capital and working class by juxtaposing and emphasizing contrasting images. Such an approach owed much to John Heartfield's work on the editorial staff. With his photomontages, especially on the *AIZ* covers, he turned text and image into an aggressive weapon of class struggle.[36]

The nationalist and liberal illustrated press

It cannot be said with any certainty whether the enormous success of the *Arbeiter Illustrierte Zeitung* was due to the type and the content of its photojournalism. At any rate, the magazine had a considerable potential readership amongst the supporters of the KPD, which gained 4.5 million votes in the Reichstag elections of 1930.

The *Illustrierte Beobachter (IB)* published from 1926 owards by the National Socialists had a considerably lower circulation. Originally intended as a visual documentation of the National Socialist movement, the *IB* – which was published weekly from October 1928 onwards – was to convey political events to a wider public from a National Socialist point of view. The popularity of the *IB* did not, however, keep pace with the electoral success of the party. Whereas the NSDAP increased its share of the votes from 810,000 to 6.4 million between the Reichstag elections of 1928 and 1930 respectively, the *IB*'s circulation rose only from 40,000 to 60,000. This proportion remained until 1933. The main supplier of photographs to the *IB* during this period was press photographer and NSDAP member Heinrich Hoffmann, who was also initially named as an editor. The standard of the reports was generally comparable to the rest of the illustrated press. Its most distinctive trait was its tendency to run illustrated features over several pages, especially when reporting on party rallies such as the 1927 party rally in Nuremberg, photographs of which took up most of the issue (IB 1927 / No. 16). Another distinctive characteristic, rarely practised by other illustrated magazines, was the repeated use of panorama photographs printed as double page spreads to emphasize the attendance at "Hitlerite assemblies" (as in *IB* 1927/ No. 7, in 1930/Nos. 40, 41, 44, and 1931/No. 22). Attempts were also made to use photomontage as a propaganda vehicle. Unlike the photomontages in the *AIZ,* which used contrasting imagery to achieve its aims, the NS photomontage tended to show Hitler surrounded by seemingly endless masses, insinuating the appeal of the Führer and the harmony of the Nazi movement (for example, the cover page of the first issue of *IB* 1926 and *IB* 1930/No. 32).[37]

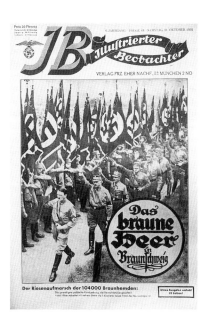

"The brown-shirted cohorts in Brunswick – the vast march past of 104,000 brown-shirts. The biggest political rally ever seen in Germany! Adolf Hitler with his staff inspects the one kilometre long front of flag-bearers", published on the cover of *Illustrierter Beobachter*, no. 44, 1931

Two other publications remain to be mentioned in this context: *Die Woche* and *Deutsche Illustrierte Zeitung*. Though they were not directly affiliated to any political party, this did not mean they were politically neutral. *Deutsche Illustrierte Zeitung* was one of a number of nationalistic publications and was first issued on 29 March 1925 under the title *A.B.C. Die Deutsche Illustrierte* by the Dr Selle-Eysler AG publishing company in Berlin with the aim of consolidating Germany's nationalist groupings and supporting the election of Hindenburg as president. The publisher's jubilee essay of 1930 summed up: "At last, the nationalistically minded German newspaper readership had been given an illustrated newspaper that reflected their views and aims."[38] Incidentally, *Deutsche Illustrierte* was the first illustrated newspaper to be printed entirely (all 16–24 pages of it) in the offset process.[39]

Die Woche, with a circulation of 320,000 in 1927, had belonged to the Hugenberg group of companies since 1916. The Hugenberg group was founded in 1914 as a lobby of heavy industry with the aim of promoting business by improving communication. At the helm was Alfred Hugenberg, a leading figure in the German Nationalist Party (DNVP) since 1919. Through the acquisition of publishing houses, agencies and film production companies, he established the country's largest media group and influenced public opinion in Germany with conservative to reactionary ideas. In 1928, Hugenberg acquired a picture and matrix agency which supplied hundreds of provincial newspapers for a monthly fee of 25 Reichsmarks.[40] The Scherl picture agency was already part of the group, supplying some 3,300 pictures to the newspapers and periodicals of its own publishing company in 1932, and some 31,000 prints for reproduction to other clients.[41]

In 1928, the publishing house of Knorr & Hirth was added to the consortium, bringing the *Münchner Illustrierte Presse (MIP)* within the sphere of influence of Alfred Hugenberg. That year, the *MIP* achieved a modest profit of just 188,000 RM, reflected in a slight increase in circulation from 534,000 to 570,000 that had been gained through a considerable and costly advertising campaign.[42] The newfound financial clout allowed circulation to be increased to a peak of 700,000 by 1931. In view of the change of ownership, the later highly acclaimed photo feature by Felix H. Man on Mussolini (1931) appears to trivialize the situation, especially given the *MIP* claim that "This report does not show the dictator posing as we are accustomed, but as the creative man – the mentor of the fascist revolution."[43]

The *Berliner Illustrirte Zeitung (BIZ)*, which increased its circulation to more than 1.8 million in 1930 and described itself as "cosmopolitan",[44] "was best able to convey mainstream conformism".[45] The photo feature of 1926 "against the political incitement of youth"[46] appears more like an accidental political statement. Apart from the titles already mentioned, a number of others were also published between the end of the inflation years in 1923 and the end of the Weimar Republic in 1932/33. However, their contents have not been analysed, their political position cannot be specified. Of these, the following ranked amongst the fifteen leading titles (peak circulation given in

Dietrich, "Sporting competition steels body and soul. Sports instructor Dietrich exercising with a medicine ball", published on the cover of *Deutsche Illustrierte*, no. 19, 1930

brackets): *Frankfurter Illustrierte Zeitung* (285,000 / 1926), *Hamburger Illustrierte Zeitung*, *Illustrierte Westdeutsche Wochenschau*, *Hackebeils I.Z.* (360,000 / 1931), *Stuttgarter Illustrierte* (126,000 / 1931) and *Illustrierte Kölnische Zeitung* (3000,000 / 1932).

Press photography shifts from illustrated periodicals to daily newspapers

The widespread belief that daily newspapers and illustrated weeklies only began printing photographs shortly before the First World War[47] is not tenable and is apparently the result of an incorrect application of terms. Although most of the illustrated publications called themselves *Zeitungen* (newspapers), they were in fact *Zeitschriften* (periodicals or magazines). Few, if any, German newspapers were illustrated, whereby the word "newspaper" is used here to refer to daily newspapers.

The decisive difference between developments in Germany and in other countries was that, in Germany, topical photographic reporting initially took place in the illustrated weeklies and not, as in other countries, in the daily newspapers. In the USA and England, respectively, the first daily newspapers to print half-tone photographs were the *New York Tribune* on 21 January 1887 and the *Daily Graphic* in 1891. In France, the newspaper *Le Français* carried its first photos in 1902. That same year, the German daily newspaper *Der Tag* also printed photos for the first time, albeit on special pages. Although further experiments were made to include the photos within the actual type, from the turn of the century onwards the German newspaper editors tended to relegate their photo features to weekly illustrated supplements such as the *Welt-Spiegel* (issued from 1896 by the *Berliner Tageblatt*), *Bilder vom Tage* (issued from 1909 by the *Berliner Lokal-Anzeiger*), *Illustrierte Familien-Zeitung* (issued from 1910 by the *Berli-*

ner Morgen-Zeitung) or *Zeitbilder* (issued from 1914 by the *Vossische Zeitung).*[48]

Photos in the daily press and illustrated supplements

With the advent of war, the progress of photography in daily newspapers ground to a halt, and even in the early 1920s there was no discernible innovation. The editors of the newspapers were of the opinion that "the educational task of the press" would be "supported by the visual didactics of the illustrated supplement".[49]

Supplements therefore continued to flourish.[50] In the Weimar Republic there were at least 40 illustrated supplements with political and general themes, most of them supplied to the daily newspapers by publishers who had specialized in producing supplements, such as the *Illustrierte Woche* in Berlin. Under this system, however, the individual newspaper publisher had no influence on the content. Only the major daily newspapers were able to publish their own supplements. The *Berliner Tageblatt* not only issued a twice-weekly supplement entitled *Weltspiegel,* which was considered the best illustrated supplement of the day, but also published no fewer than ten weekend supplements on such subjects as fashion, art, technology, sport, film, photography etc. Other high-circulation supplements included *Volk und Zeit* launched in 1919 as a supplement to *Vorwärts; Bilder zur Zeitgeschichte* launched in 1920 as a supplement to *Deutsche Tageszeitung; Der Rote Stern* launched in 1924 as a supplement to *Rote Fahne; Die Weite Welt* launched in 1925 as a supplement to *Berliner Lokal-Anzeiger; Bilder-Courier* launched in 1925 as a supplement to *Berliner Börsen Courier* and *D.A.Z. im Bilde* launched in 1925 as a supplement to *Deutsche Allgemeine Zeitung.*

It was not until around 1924 that efforts were concentrated on improving the quality of photographic printing in newspapers. However, the use of the autotype process in daily newspapers still involved problems that were not only technical but were also explained by the fact that "we Germans are not geared to topicality and speed in the same way as the Americans".[51] Even in 1928, it was hailed as "record-breaking photojournalism" if a photographer could take a photograph at midday and have it appear in the Sunday edition of the *Kasseler Neueste Nachrichten,* which rolled off the presses at two o'clock in the morning.[52]

Foreign dailies had the advantage of larger-format illustrations, which allowed them to use a less dense halftone screen of 20–22, whereas the smaller German illustrations would have looked too grainy using this matrix.[53] Looking towards America, where the photograph constituted a major component of any newspaper, German newspaper editors bewailed the fact, as late as 1926, that "the illustrated daily newspaper already exists there".[54]

The illustration of daily newspapers was also curtailed by the fact that they lacked an up-to-the-minute source of photographs. Most of the German press had to make do with the pictures supplied

"First the powder puff and then the ocean flight! Miss Elsie Mackey, daughter of Lord Inchale, set off for an ocean flight with pilot Hinchcliffe (left) from England to America. Airplane and passengers have disappeared", published on the cover of *Bilder-Courier,* no. 12, 1928

by some block engraver. It was not until 1930 that newspaper publishers began producing their own printing blocks[55] which they could adapt much more precisely to their printing presses, allowing them to achieve a far better print quality. What is more, few editorial offices had archives of photographs as an immediate source of topical illustrations for news articles.[56] The increasing need for illustrations in daily newspapers made the lack of available up-to-date material for daily journalistic needs glaringly evident. Moreover, too many of the picture agencies were merely middlemen supplying foreign photographic material. The ratio of foreign photos to German photos was between 2:1 and 3:1. As most of the picture agencies were in the hands of photographers and businessmen, the newspaper publishers complained about the journalistic handling of photographs, which they felt should be in the hands of the editors. The time seemed to have come for the

daily newspapers to start taking on their own photographers. It was suggested that publishers should organize their own nationwide photojournalistic service covering the entire German Kaiserreich in order to put photojournalism on a par with journalistic and editorial standards.[57] Only in this way, it was claimed, could "the illustrated part of the newspaper be adapted to the texts in a didactic way."[58]

A constant theme among publishers and editors in this respect was the question of whether photos should be printed within the main body of the text or grouped in a separate section. Karl Jaeger, editor-in-chief of the *Rheinisch-Westfälische Zeitung* and a driving force behind the promotion of newspaper journalism as a communications science,[59] prophesied as early as 1925 that contemporary photojournalism would break away from the illustrated supplements and become integrated into the main body of the newspaper, though he actually argued in favour of separate pages of illustration with accompanying texts to avoid breaking up the pages of text.[60] He also noted the effort and cost involved in the decentralized supply of photographic material.[61]

In spite of all endeavours, until the late 1920s, the daily newspapers had few illustrations, and those they did have were often of such poor quality that many publishers chose not to illustrate their newspapers at all.[62] Nevertheless, by 1928, the photograph had become such an accepted component of newspapers that, of a total of 4,000 newspapers, no fewer than 600 to 800 illustrated their texts.[63] Particularly well regarded illustrated newspapers in 1929 included Scherl's *Nachtausgabe*, Ullstein's *Tempo* and Mosse's *8Uhr-Abendblatt*.[64] These tabloids with their lively layout and illustrations paved the way for the illustrated daily newspapers.[65] They took their inspiration from the American model in particular. What America had, unlike Germany, however, was decades of experience in publishing photos in daily newspapers and a much more up-to-date system of supply through photographic agencies.[66]

Problems in obtaining topical photographs

Until 1925/26, German press photographers sent their photographs mainly to periodicals which did not necessarily demand quick service as long as the photos arrived on time to meet the weekly copy deadline. For the daily newspapers, topical photographs had to go straight to the editorial staff. This was a requirement which "obviously not all photojournalists immediately understood."[67] In contrast to Germany, other countries had large photo agencies, a supply of photographs for a fixed monthly fee, while daily newspapers had their own photo departments and staff of trained photojournalists. The major international agencies included *Underwood & Underwood*, *News Reel* and *Herbert, Kadel & Herbert* in New York, *Topical Press Agency*, *Central News*, *Keystone* and *Pacific & Atlantic* in London, *Meurisse* in Paris and *Press Illustration* in Tokyo.[68]

Cover page of *8Uhr-Abendblatt*, no. 177, 31 July 1925

As early as 1913, Paul Knoll, head of the Scherl illustration centre, pointed out that up-to-date photographs of Germany were more readily available in London than in Berlin.[69] In the 1920s, the major picture agencies *International News Photo* and *Wide World GmbH* (1919), *Keystone View Company* (1926), *Associated Press Newsphotos* (1927) and *Pacific & Atlantic* (1928) set up their own offices in Berlin, where the only comparable agencies were *Scherl-Bilderdienst* and *Atlantic Photo*.

The German editors noted with resignation that "German photojournalism has not got off the ground yet. It is a small-scale craft that

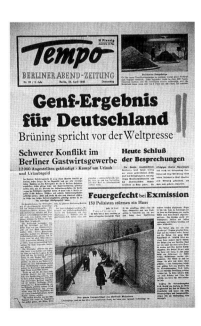

Cover page of *Tempo*, no. 99, 28 April 1932

reaches industrial standards only where it is headed by a foreign company."[70] During the war, *Bufa* had put an end to most of the picture agencies. With greater financial resources, longer experience and international connections, the major American companies led the field and brought American speed and generosity to the German photo agency business.

By 1928/29, newspaper publishers and editors had realized that photographs were indispensable to the daily newspaper, and that this fact would no longer be disputed. Readers wanted illustrations of all current affairs in order to be able to envisage the events. What is more, they found that the reports published in the periodicals, usually with a delay of some eight to ten days, were too slow for the speed of modern life.[71] The public's appetite for news, already whet by radio announcements, called for a picture to illustrate all the major events of the day.[72] The newspaper photograph published in connection with a news text was to be regarded as a "consolidation of event and image" that could not be achieved in illustrated periodicals because of the time lapse involved.[73]

3. The rise and fall of German photojournalism

The inadequate press work by the German governmental offices during the First World War continued during the phase of peace negotiations, affecting the illustrated papers as well. On 3 June 1919, Heinrich Pfeiffer, director of the *Illustrierte Zeitung,* complained in the name of the *Vereinigung der Leipziger Illustrierten Presse* (Association of Leipzig Illustrated Press) that in selecting press representatives to attend the negotiations in Versailles, the illustrated periodicals had been entirely overlooked. At the last minute, the Foreign Office allowed a press illustrator from the Leipzig *Illustrirte Zeitung.*[74]

The fact that the idea of including press photographers was not even considered seemed to be a bad omen. In 1919, on the one hand, photographers feared that the situation was hardly likely to improve for press and illustrative photography after the war and the months of revolution. On the other hand, given that there were still some 7,000 periodicals in Germany at the time, of which some 3,000 were illustrated with drawings and photographs, it could be assumed that press photography was likely to remain an almost inexhaustable source of income for photographers.[75]

At any rate, the *Berlier Illustrierte Zeitung (BIZ),* in the last edition of 1919, propagated the "photographer as journalist" and defined his future task as follows: "Illustrative photography is the world citizen's microscope on the events that will shape history. The photographer travels the world for you, bringing it closer to you. He stands at the crater's edge as the volcano erupts, negotiates the rapids of the Niagara, climbs to the very tip of skyscrapers, flies in an airplane over the Himalayas, comes under fire in the trenches, and braves shoot-outs between the Spartakists and the government troops. And he does all this so that you can be present where you were not, so that you can discover all the angles and appearances of this world, from outside and inside. And seeing is knowing. So make way for the photographer! Open all roads and doors to him! He is the photojournalist of your history. In England and America, the photographer is given a much freer rein. In Germany, official institutions and individuals place hurdles in his path. They say he is a nuisance. No, he is not a nuisance, he is doing his duty, and a very important duty at that!"[76]

In the self-styled freedom of the picture story, the *BIZ* nevertheless provoked considerable controversy with the publication of one particular photograph. On 24 August 1919, the *BIZ* printed a front page photograph showing Germany's defence minister Gustav Noske and president Friedrich Ebert in swimming trunks near Travemünde. *BIZ* editor-in-chief Kurt Korff had already rejected the photograph for publication on 21 July. While he was on a short holiday, the editorial staff placed it on the front page after all. The SPD newspaper *Vorwärts* regarded this as a travesty of good taste and called for a socialization of the press to avoid such abuses in future. In fact, the same photograph had already been published a few weeks previously, on 9 August, on the front page of the conservative daily *Deutsche Tageszeitung,* which undoubtedly had a vested interest in denigrating the representatives of the Weimar Republic's government. The photograph had been taken by a local commercial photographer, Wilhelm Steffen, on 15 May when the two politicians were visiting Haffkrug for the inauguration of a children's home and had taken some time off for a refreshing dip. The original horizontal-format photograph showing four other gentlemen was probably discovered during the summer in the photographer's shop and passed on to the press, where it ended up in vertical format on the front page of *BIZ.*[77] The idea was hardly new. The 1 April 1910 edition of *BIZ* had carried a front-page photomontage of two men in swimming trunks with the heads of Fürst Bülow and chancellor Bethmann-Hollweg as a joke. The *Berliner Illustrirte's* risqué publication of Ebert and Noske had done the periodical no harm. A few years later (1926), the press noted that "the initial reluctance of outstanding personalities to pose for photographs for the purposes of illustration has long since gone."[78]

On the whole, press photography in Germany was plunged into crisis after the First World War. Wilhelm Schwedler, editor-in-chief of *Transocean* summed up in 1922 that people would have to get used to the fact that, in this respect, the press had lost its credibility in the public eye and that it would be difficult to regain it. War front photography had been severely limited, at times monopolized and never entirely fere of influence, even though the actual manipulation of photographs had been a relatively rare occurrence on the German side. In fact, there had been no need to resort to such measures, as the Germans had been winning for most of the war. Then, political and military collapse came so suddenly that there was little time to organize press campaigns. Schwedler realized that business would be difficult in the postwar period, especially for topical photojournalism from Germany. The burgeoning nationalism that emerged in the wake of the war

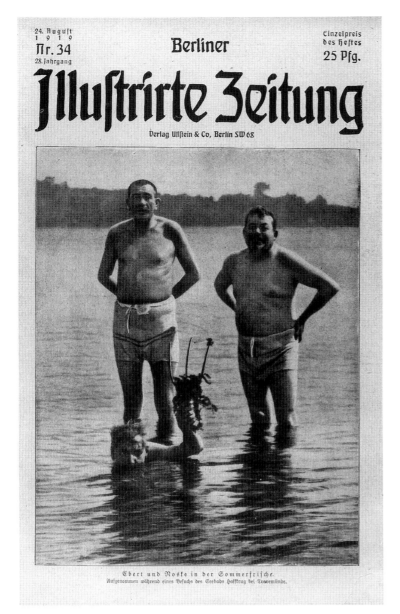

24. August 1919
Nr. 34
28. Jahrgang

Berliner

Einzelpreis
des Heftes
25 Pfg.

Illustrirte Zeitung

Verlag Ullstein & Co, Berlin SW 68

Ebert und Noske in der Sommerfrische.
Aufgenommen während eines Besuchs des Seebads Haffkrug bei Travemünde.

"Ebert and Noske taking the fresh summer air. Taken on a visit to the bathing resort of Haffkrug near Travemünde", published on the cover of *Berliner Illustrirte Zeitung*, no. 34, 1919

meant that the illustrated press in all countries would be less willing to accept foreign photographs.

There were other reasons, according to Schwedler, for the unsatisfactory development of German press photography. Although the press photography business blossomed once more during the revolution, because of the enormous interest these events – like the Spartakist uprising and the Kapp Putsch – held for other countries. Interest waned, however, as the figures in the political arena changed too quickly and the novelty appeal wore off. Schwedler believed that the disappearance of topical pictures from the illustrated periodicals was due to a dearth of events that might have supplied photographers with

an effective motif for their work. Also, there was no longer any demand for picture features from Germany. He felt that the demise of imperial pomp and circumstance with its parades, manoeuvres, court festivities and royal visits had broken the back of photojournalism.

Photographs of royal hunting parties with the Kaiser on horseback had, after all, been of interest to the foreign press as well, whereas the only motifs now were catastrophes. Strikes and demonstrations were neither interesting nor exciting enough for readers abroad, where the concept of "the freedom of the common man" was far more firmly established than it was in the German Kaiserreich. Instead, demonstrations by veterans of the front would more likely be used abroad to convey an image of militarism in Germany. It was for this reason, during the inflation years, that German press photographs met with so little international acclaim and why German periodicals such as *Die Woche* began to resort increasingly to the use of drawings. Moreover, photographers were suffering the setback of rising costs, which made it prohibitively expensive to distribute their photographs in bulk and cut the profit per photograph sold. Under these circumstances, he found it hardly surprising that times were hard for press photographers and picture agencies and felt that many of them would be likely to enter other professions, such as the cinema. He felt that people would simply have to accept the fact that once law and order returned to Germany, as it inevitably would, the situation would simply be too humdrum to meet with much interest abroad.[79]

With the end of inflation, the daily newspapers added more and more illustrated supplements, reaching a circulation of at least nine million. According to Fritz Hansen, "the age of the picture" had dawned. Things had, he claimed, already reached a stage where every act by members of the government was presented to an awestruck world from at least six different angles. The photograph showing the German president besieged by press photographers was, for Hansen, a characteristic illustration of the "call for pictures".[80]

In 1924, it was already clear that illustrative photography had undergone an enormous boost in the two preceding decades and the enormous success of many illustrated periodicals "shows the great value of an immediate and constant interaction of words and photographic images ... for we live in fast-moving times. We want to grasp the events of the day and items of general interest within a short time and if possible at a few glances."[81] In other words, the picture was to play a leading role in the press.

From 1919 onwards, the *BIZ* ran an increasing number of double page spreads, granting more space to the kind of picture story or photo feature long since adopted by other illustrated periodicals. The page layout called for new solutions to the new emphasis on the image and accompanying text. In 1926, Korff was credited in retrospect with showing how a report could be presented to superb aesthetic effect. "It was undisputably Korff who systematically paved the way".[82] It was above all in "teaching the photographer to be a photojournalist" that Korff's reform had made its mark.[83] The most outstanding picture editors, apart from Korff of *BIZ*, included Gustav Dahms,

Paul Dobert and Carl Rahn (*Die Woche*), Alfred Lorek (formerly *Zeit im Bild*).[84] It was Arthur Brehmer, however, who was regarded as "the father of the modern picture editor". He had worked for the *Berliner Illustrirte Zeitung* in the 1890s and later for the *Deutsche Illustrierte Zeitung*.[85]

At the same time, around 1926, the picture editors were "hot favourites" sought by the daily newspapers because "the picture as a visual news item" was increasingly finding its way into the German newspapers.[86] The illustrated periodicals were thus cut off from the publication of current news photos, as the lapse of a full week meant that such photographs were no longer news. Until then, the illustrated periodicals had had the task of providing "visual reports on current affairs".[87] They were going to have to change their tack.

The success of the *Berliner Illustrirte Zeitung*, which increased its circulation from 800,000 during the war to 1.75 million by the end of 1926, overcoming a temporary drop to 450,000 during the inflation years, was explained by Kurt Korff in his 1927 article on the *BIZ* as the result of an increasing demand for the visual, influenced by the development of cinema, whereby the picture itself became the news item. Because the pace of life was becoming more hectic with less time left for leisurely reading, and because the public was becoming more accustomed to grasping events through the impact of the image than the word, Korff stressed the need to find a clearer and more hard-hitting form of visual presentation. The maxim of the *BIZ* editorial staff was that "it was not the importance of the material that decided the selection and choice of pictures, but the appeal of the picture itself." The arrangement of the pictures and their relationship to the text was equally important. Korff still assumed that the illustrated periodicals had a special significance as "a necessary complement to the daily papers" because they supplied a broad readership with an understanding of events, while the brief reports in the daily newspapers could not command the same attention and the context could only be conveyed when presented visually. During this period, between 1926 and 1928, the current news photo found its way into the daily newspaper. The illustrated periodicals were no longer chronicles of the time. They treated topics, as Korff put it, while the *BIZ* set itself the task of showing what was really new. The presentation was now based not so much on the news as on the portrayal of what was interesting."[88]

The photojournalists – the photographs – the features

The illustrated press increasingly addressed the subject of press photography itself. Reports such as *Der Illustrations-Photograph bei der Arbeit* (The illustrative photographer at work) in *Das Illustrierte Blatt*, 1921, *Die Waghalsigen Pressephotographen* (The daring press photographers) in *Die Große Berliner Illustrierte*, 1922, *Der Illustrierte Photograph bei der Arbeit* (The press photographer at work) in *Hamburger Illustrierte Zeitung*, 1923, *Pressephotograph – Ein schwerer Beruf* (Press photographer – a tough profession) in *Die*

Woche, 1925, *Die Jagd nach dem Ereignis* (The hunt for the event) in *Münchner Illustrierte Presse*, 1929, were intended not only to draw attention to the people behind the pictures, but were also meant to draw the readers' attention to the weekly visual experience.

In 1929, the *Deutsche Illustrierte Zeitung* published an article on the "art of the photojournalist" pointing out that this was still a relatively new profession in Germany, whereas it was already long established in America, England and France. As a result, it went on, such reporting was still more or less in its infancy in Germany, due to a lack of journalistically trained photographers. Although standards of photography in Germany were quite good, the journalistic eye that could capture the spirit of the times in a picture or show the distinctive aspect of an event, was something the Americans and British had simply developed better. This explained the high proportion of Anglo-American photographs in Germany's illustrated press, though things had improved in recent years. On a rather nationalistic note, the article claimed that the Germans had been much quicker in learning to photograph than the French, who had brought very poor quality material onto the market. It was better, the article went on, to replace the words "photojournalist" and "photojournalism" with the purely German words *"Bildberichterstatter"* and *"Bildberichterstattung"*.[89]

Between the 1880s and the end of the First World War, some 40 photojournalists and 24 photo agencies were operating in Germany, more than half of whom continued to work in the Weimar Republic. From 1919 onwards, some 50 new picture agencies were set up, and there were a further 120 or so press photographers. In the 1920s, about 60% of the photographers and 40 of the photo agencies were based in Berlin alone.[90] Some of the more famous names who began after 1919 were Berliner Bild Bericht (1920), John Graudenz (1921), Georg Pahl (1923), Max Schirner – Presse-Illustration (1924) and Carl Ferstaedt (1926).

Because most biographies are incomplete, there is no way of ascertaining whether the freelance photographers originally came from within the trade as trained photographers or entered the profession because of the economic situation of the inflation years, as in the case of Max Schirner, who had previously been a clerk in a magistrates' court,[91] or whether they had come from the newspaper trade, where the employment situation was also uncertain.[92]

The appeal of this particular branch of the photography trade lay not only in the increasing demand for photographs triggered by new illustrated publications, but also, given such difficult times, in the relatively modest investment required for the tools of the trade. Another factor was the unemployment rate. In 1926, there were 1 million unemployed, and after a brief respite that figure rose to 2.8 million in 1929 then 6 million in 1932,[93] which undoubtedly also goes some way towards explaining why some of the photojournalists who later became famous had originally been employed in other professions. Amongst the newcomers to press photography in these years were Erich Salomon, who, with a doctorate in law, left his job in the advertising department of the Ullstein publishing house, the former salesman

Nummer 16. 5. Jahrgang

Berlin, den 15. April 1928

Bilder-Courier

ILLUSTRIERTE BEILAGE ZUM BERLINER BÖRSEN-COURIER

*Der Mann,
der überall dabei ist!*

*Ballonhüpfen eines Pressephotographen
am Volksflugtag in Staaken*

"The man who is everywhere! A press photographer takes a balloon ride at the Staaken flight fair", published on the cover of *Bilder-Courier*, no. 16, 1928

Alfred Eisenstaedt, the ethnographer and musicologist Wolfgang Weber, the educationalist and art historian Walter Bosshard, the portraitist and industrial photographer Kurt Hübschmann (later Kurt Hutton).

Among the Berlin-based agencies whose names were mentioned frequently in the illustrated press was the *Weltrundschau* founded by the Viennese Rudolph Birnbach at the end of 1927, which described itself as the "leading production firm for photographic series and illustrated articles"[94] and for which the Bauhaus student Erich Comeriner worked. Others were *Deutscher Photo-Dienst (Dephot)* founded by Simon Guttmann in 1928, for which the Bauhaus student Umbo and Felix H. Man (Hans Felix Baumann) both worked (the latter had previously been a draughtsman and retoucher at the Ullstein publishing house). *Dephot*, which was mentioned only once in the trade listings,

not under photo agencies but under "enlarging services and art institutes",[95] was financially less successful and went bankrupt in 1932, starting up again shortly afterwards as *Degephot – Deutsche Photogemeinschaft*. In 1929, the brothers Georg and Tim Gidal entered the field of photojournalism, initially in order to finance their studies. In 1927, the sports photographer Martin Munkacsi came to Berlin from Hungary. Berlin, as a centre of the press, attracted a number of photographers from abroad, not least because so many illustrated periodicals were based in the city. In spite of the difficult economic situation, their sales had not suffered. The circulation of the fifteen most popular illustrated periodicals increased from 3.5 million in 1926/27 to 5.3 million in 1930/31.

Few of the "new photo-reporters" were actually journalists, and most of them used some aspect of their former profession in their photographic work. Erich Salomon, for example, who, as an amateur photographer, had what was presumably his first published photograph printed on 1 December 1926 in the *Berliner Morgenpost*,[96] began his new career as a photojournalist by covering ground in the field he was already familiar with as a lawyer. His photographs of the Krantz trial, the Barmat trial and the Hein murder trial were published in the *Berliner Illustrirte Zeitung* on 19 February, 15 April and 29 July 1929 respectively. His photographs of the Immertreu trial appeared in issue number 7/1928 of *Hackebeils Illustrierte Zeitung*, and his report entitled *Der Mensch vor den Schranken des Gerichts* (The individual before the gates of justice) was published in *Welt-Spiegel* no. 30/1928. The widespread claim that these were the first photographs of a trial in a German court of law is incorrect. In 1922, Robert Sennecke had taken photographs of the Rathenau murder trial, which were published in the *Große Berliner Illustrierte*. He had been arrested as a result.[97]

After the Krantz trial ended, the *Reichsarbeitsgemeinschaft der Deutschen Presse (RAG)*, the association of the newspaper trade and journalists, issued a resolution on the reporting of courtroom trials, stating that sensationalist exploitation of such trials was to be avoided.[98] That same year, the headquarters of the Berlin constabulary issued a decree ensuring that the press photographers would be granted greater freedom of movement wherever there were police roadblocks.[99]

Between 1925 and 1930, a number of technical improvements were introduced in the field of photography. With the trend towards professional use of small roll-film cameras on the increase since the war years, the new cameras on the market – such as Leica, Ermanox, Plaubel Makina and Rolleiflex – found particular favour amongst photojournalists, as their high-speed lenses and sensitive film made them more versatile than the classic 13 x 18 cm press cameras.

More unconventional handling and new compositional ideas influenced by the Bauhaus led to a new approach in photojournalism. The criteria of "action" photographs and "instructive" series, and of capturing the essence of an event, still applied in press photography, just as they had before the war.[100] What had changed was the fact that the technical means of fulfilling these criteria had been vastly improved.

"Capturing events in their natural circumstances without any intervention",[101] i.e. a strictly documentary approach to photography, was extended to include an experimental visual element.

Converting the picture feature into a legible page layout, arranging headlines, photographs, captions and text to create an overall impression, remained a field of experimentation for the picture editors. Stefan Lorant, editor-in-chief of the *Münchner Illustrierte Presse,* formulated his maxim for the layout as follows: "The construction guiding the eye is exactly the same as the way I look at at picture."[102] The photographers submitted their photos to the editorial staff and saw the results in the next edition. They were not involved in the actual layout of the feature. As far as is known, some 250 features by Dr Erich Salomon were published in Geman periodicals and about 80 in the foreign press, some 150 features by Felix H. Man[103] and about 50 features by Tim Gidal.[104]

The illustrated periodicals did not particularly emphasize the photo features, but attracted their readership mainly with novels published in serial form.[105] Nevertheless, in 1932, the newspaper theorist Emil Dovifat claimed that the development of photo features had doubtless paved the way for unheard-of sensationalism.[106]

Criticism – pessimism – animosity

Poor quality or even unusable photographs in the daily newspapers, in particular, triggered a debate on the shortcomings of photojournalism. Press photographers felt that the low quality was the result of the lower pay granted to photographers as the newspapers printed ever more photographs, while attempting to cut their rising costs by keeping the fees down. What is more, the number of foreign photo agencies setting up offices in Germany meant that their subscription supplies, which they were able to provide at low fees, included a considerable proportion of unusable material. These large photo agencies, which had arrived in recent years from London, Paris and the USA, had succeeded in all but ousting the small press photographers thanks to their financial strength and their greater versatility in obtaining and marketing their photographs.[107] Many newspapers and periodicals – not only the publishers, but also the printers who produced the illustrated supplements – obtained most of their material from these agencies, which is why they had achieved such a dominant position. One of the largest foreign photo agencies had more than 900 full-time photographers on its payroll in all the major cities of the world. These press photo agencies supplied the publishers on a DM 150–250 subscription basis with some 600 photos each month, which meant that each photo cost between 25 and 35 pfennigs.[108] Photographers also complained that such copious supplies to the German press had resulted in a fall in standards, and that this was also to blame for the superficiality of photojournalism. The foreign photo agencies, they concluded, were therefore unnecessary.[109]

While newspaper publishers were of the opinion that Germany had very few good press photographers,[110] the editors felt that the Germans might be good photographers, but that they generally did not make good journalists. It was for this reason, according to one of the very few statements by publishers and editors on the subject of "modern photojournalism", that the work of Erich Salomon seemed so novel. His only precursor, the statement maintained, had been Alfred Groß, who, before the war, had enjoyed the privilege of admission to all events as court photographer. Salomon's achievements would not have been possible without the latest technical advances, but he was also one of the first to exploit the advantages of the high-speed camera. He was one of the first to take photojournalism indoors. The conquest of this new field was of enormous importance and had supplied the illustrated press with a wealth of new and valuable motifs. Theatre performances, courtroom scenes, parliamentary debates, banquets etc. expanded the field of action of the photoreporter considerably.[111] The statement went on to say that Salomon "fills a gap in capturing contemporary events," but added that the difficulty of his craft bore "no relation to the generally dissatisfactory result of all these conferences." "... We do not want any man, however talented, to become a kind of court reporter in the old style." Even in Salomon's book of *Berühmte Zeitgenossen* (Famous Contemporaries)[112], according to one contemporary critic writing in the *Deutsche Presse,* "not everything has a touch of improvisation and, in my opinion, there are very few pictures taken at 'unguarded moments'." Moreover, "in the trade of the press photographers, there is currently an inordinately high number of foreigners. ... There are undoubtedly some very capable men among them. But that they, of all people, might be able to forge a communicative link to the public at large seems to me to be doubtful at the very least."[113]

On this, photographers and editors agreed. They noted "a shocking over-representation of foreign, especially American, photo agencies" and demanded that it should be the aim of the German press to stand on its own feet in the field of photography.[114] At the same time the daily newspapers had a much-discussed problem with posed photographs, incorrect captions and called for a greater sense of responsibility, truth and topicality on the part of the press photographers and the picture editors. Whereas, in the early days, there was talk of "shortcomings in photojournalism" or "pictorial transgressions", by 1930 it was the extent of sensational reporting that was lamented. The "self-discipline" Emil Dovifat called upon the German press to exercise[115] was to culminate three years later in the "cleansing" of the press under the National Socialist regime. Instead of following the principle of sensationalism, the press was now to become "a mirror image of the German character and the German spirit".[116] When, in June 1933, the *Deutsche Nachrichten* rolled off the press with the headline *Deutschlands Bildpresse soll deutsch sein!* (Germany's illustrated press should be German!)[117] lists of names had already been published of all the photographers who had played a part in shaping photojournalism, but who were now barred from working, per-

secuted, driven out of the country or, in some cases, murdered by the Nazis.

Notes

1 Printed in Kurt Koszyk, *Deutsche Pressepolitik im Ersten Weltkrieg,* Düsseldorf 1968, pp. 22 f.

2 Cf. *Der Photograph,* 68/1914, p. 272.

3 Cf. *Photographische Chronik,* 1/1915, p. 3.

4 Cf. *Reichsamt des Innern, Bildzensur,* Bundesarchiv Potsdam, file no. 12289, doc. 41.

5 Cf. *Reichsamt des Innern, Presse- und Nachrichtenwesen,* Bundesarchiv Potsdam, file no. 12292, doc. 37–40.

6 Cf. *Deutsche Photographen Zeitung,* 42/1914, p. 450 and *Photographische Chronik,* 5/1914, p. 513.

7 W. Nicolai, *Nachrichtendienst, Presse und Volksstimmung im Weltkrieg,* Berlin 1920, p. 61.

8 Cf. *Deutsche Photographen Zeitung,* 41/1914, p. 444.

9 Cf. *Auswärtiges Amt, Zentralstelle für Auslandsdienst* in Bundesarchiv Potsdam, file no. 1706, unnumbered (docs. 44 f.).

10 See *Deutsche Photographen Zeitung,* 3/1915, p. 18.

11 Cf. Stellvertretender Generalstab Abt. III B, Presse Nr. 1205 in Bundesarchiv Koblenz, estate of Oskar Messter, NL 275, file 446.

12 Cf. Martin Koerber, "Oskar Messter – Stationen einer Karriere" in Kesseler/Lenk/Loiperdinger, *Oskar Messter, Filmpionier der Kaiserzeit. Kintop-Schriften 2,* Basel/Frankfurt am Main 1994, pp. 66 f.

13 Cf. Wolfgang Mühl-Benninghaus, "Oskar Messters Beitrag zum Ersten Weltkrieg" in *Kintop-Jahrbuch 3,* Basel/Frankfurt am Main 1994, pp. 103 ff.

14 Cf. Stellvertretender Generalstab Abt. III B, Presse Nr. 1205 in Bundesarchiv Koblenz, estate of Oskar Messter, NL 275 file no. 446, cited by Martin Koerber, p. 67 (see note 12).

15 Cf. Kurt Hahne, *Die Illustrations-Photographie,* Bunzlau 1914, p. 134.

16 Cf. *Reichsamt des Innern, Presse- und Nachrichtenwesen,* Bundesarchiv Potsdam, file no. 12289, especially docs. 41, 68–69, 71–72.

17 Foreword of the *Zensurbuch für die deutsche Presse* (German press censorship handbook) published by the Oberzensurstelle des Kriegspresseamtes (Head office of censorship of the war press department), Berlin 1917.

18 Cf. Isolde Rieger, *Die Wilhelminische Presse im Überblick 1888–1918,* Munich 1957, pp. 173–192.

19 Cf. self-description of *Illustrierte Kriegs-Kurier,* 1/1916, p. 11.

20 Cf. Kurt Koszyk, 1968, pp. 241–245 (see note 1).

21 Cf. Isolde Rieger, 1957 (see note 18).

22 Cited by Kurt Koszyk, 1968 (see note 1).

23 Cf. Hans Traub, "Die Gründung der Ufa" in Wilfried von Bredow and Rolf Zurek, *Film und Gesellschaft in Deutschland – Dokumente und Materialien,* Hamburg 1975, pp. 105 f.

24 Cf. Kurt Koszyk, 1968, p. 248 (see note 1).

25 Cf. Ludwig Boedecker, *Pressephotographie und Bildberichterstattung,* Bunzlau 1926, p. 5.

"Germany's illustrated press should be German", published in *Deutsche Nachrichten,* no. 23, 1933

26 Cf. W. Nicolai, 1920 (see note 7).

27 Cf. *Berliner Illustrirte Zeitung,* 30/1915, pp. 409–411 and *Münchner Illustrierte Zeitung,* 36/1915, pp. 422–423.

28 Cf. Wilhelm Schwedler, *Das Nachrichtenwesen im Krieg,* Gotha 1925.

29 Cf. "Die Bedeutung der Presse im Kriege" in *Militär-Wochenblatt* 103/1914, columns 2308–14.

30 Cf. *Deutsche Photographen Zeitung,* 4/1914, p. 23; 11/1915, pp. 71–73; 27/1915, p. 192; 8/1916, pp. 65–66.

31 Published by National-Archiv Berlin, Berlin/Oldenburg, 3 vols., 1927–1931; and Hermann Rex, *Der Weltkrieg in seiner rauhen Wirklichkeit* (600 illustrations), Oberammergau 1926, and Franz Schauwecker, *So war der Krieg – 230 Kampfaufnahmen aus der Front,* Berlin 1928.

32 On press photography during the revolution in Germany, see *Revolution und Fotografie – Berlin 1918/19*, exhibition catalogue of Neue Gesellschaft für bildende Künste, Berlin 1989, and Rudolf Herz and Dirk Halfbrodt, *Revolution und Fotografie – München 1918/19*, Berlin 1988.

33 Cf. *Berliner Illustrirte Zeitung*, 42/1919, pp. 426–27.

34 Heinz Willmann, *Geschichte der Arbeiter Illustrierten Zeitung 1921–1938*, Berlin 1975.

35 Cf. *Münchner Illustrierte Presse*, 37/1930.

36 Eckhard Siepmann, *Montage: John Heartfield – vom Club Dada zur Arbeiter Illustrierten Zeitung*, Berlin 1977 and *John Heartfield* issued by Akademie der Künste zu Berlin, Cologne 1991.

37 Rudolf Herz, *Hoffmann & Hitler – Fotografie als Medium des Führer-Mythos*, Munich 1994.

38 *25 Jahre Dr. Selle Presse 1905–1930*, Berlin 1930.

39 Cf. Reinhold Krüger, "Druckverfahren" in *Handbuch der Zeitungswissenschaft* edited by Walther Heide, Leipzig 1940, vol. I, column 849.

40 Cf. Klaus Wernecke and Peter Heller, *Der vergessene Führer Alfred Hugenberg*, Hamburg 1982, p. 93.

41 Cf. jubilee publication by Scherl-Verlag to mark the 50th year of publication of the *Berliner-Lokal-Anzeiger*, Berlin 1933 (p. 46).

42 Cf. Kurt Koszyk, *Deutsche Presse 1914–1945*, Berlin 1972, pp. 187–88.

43 *Münchner Illustrierte Presse*, 9/1931 of 1 March, front page.

44 Kurt Korff, "Die Berliner Illustrirte" in *50 Jahre Ullstein 1877–192*, Berlin 1927, p. 294.

45 Cf. Harry Pross, "Presse – 14 Jahre zwischen Glanz und Ignoranz" in *Die Kultur unseres Jahrhunderts 1918–1933*, edited by Hilmar Hoffman and Heinrich Klotz, pp. 212–13.

46 Cf. *Berliner Illustrirte Zeitung*, 22/1926, pp. 677–78.

47 Cf. Rolf Sachsse, "Der Beginn des Bildjournalismus und die kommunikative Aufwertung der Photographie" in *Photographie als Medium der Architekturinterpretation*, Munich 1984, p. 131.

48 Cf. chapter 3.1. on the illustrated supplements of the daily newspapers in Bernd Weise, "Pressefotografie – II. Fortschritte der Fotografie- und Drucktechnik und Veränderungen des Pressemarktes im Deutschen Kaiserreich" in *Fotogeschichte* 33/1989, p. 44 ff. and pp. 55–58.

49 *Zeitungs-Verlag (ZV)*, column 720.

50 Cf. Otto Groth, *Die Zeitung*, Mannheim 1928, vol. I book 2, pp. 349 ff.

51 *ZV*, 28/1924, column 1235.

52 *ZV*, 9/1928, column 446. A similar statement can be found in *ZV*, 37/1930, column 1506.

53 *ZV*, 5/1925, column 270.

54 *Deutsche Presse (DP)*, 21/1926, p. 69.

55 *ZV*, 4/1930, column 147.

56 *ZV*, 24/1924, column 913.

57 *ZV*, 42/1927, columns 2417 f.

58 *ZV*, 1/1927, column 22.

59 Cf. Karl Jaeger, *Von der Zeitungskunde zur publizistischen Wissenschaft*, Jena 1926, reprint of the original edition first published under the title *Klassische Texte der Presse und Kommunikationsgeschichte*, ed. by Bodo Rollka, vol. 3, Berlin 1996.

60 *ZV*, 3/1927, pp. 115 ff.

61 *ZV*, 14/1925, columns 899–900.

62 Cf. Rudolf Russ, "Bilder Tageszeitung" in *Klimsch's Jahrbuch*, Frankfurt am Main 1927, pp. 102 ff.

63 *ZV*, 13/1928 columns 637 ff.

64 *ZV*, 25/1929, columns 1277 f.

65 *DP*, 14/1929, p. 165.

66 *ZV*, 5/1927, columns 2865 ff.

67 *Photographische Chronik*, 23/1928, pp. 222 f.

68 *Der Photograph*, 2/1929, p. 5.

69 Paul Knoll, *Die Photographie im Dienste der Presse*, Halle 1913, p. 48.

70 *DP*, 7/1932, pp. 75 ff.

71 *DP*, 23/1928, p. 320.

72 *DP*, 14/1929, p. 165.

73 *ZV*, 13/1928, columns 637 ff.

75 Cf. *Deutsche Photographen Zeitung*, 7/8/1919, pp. 22–24.

76 *Berliner Illustrirte Zeitung*, 50/1919, pp. 522–23.

77 Cf. Kurt Koszyk, "Wie Ebert und Noske baden gingen – oder... was passiert, wenn ein Chefredakteur Urlaub macht" in *Beruf und Berufung*, ed. by Rolf Therheiden, Mainz 1988, pp. 88–95.

78 *DP*, 6/1926, p. 8.

79 Cf. Wilhelm Schwedler, *Die Nachricht im Weltverkehr. Kritische Bemerkungen über das internationale Nachrichtenwesen vor und nach dem Weltkriege*, Berlin 1922, pp. 47 ff.

80 *Der Photograph*, 22/1925, p. 217.

81 *Deutsche Photographen Zeitung*, 5/6/1924, pp. 57–62.

82 *DP*, 5/1926, pp. 2 f.

83 *DP*, 6/1926, p. 8.

84 *DP*, 5/1926, pp. 2 f.

85 *DP*, 10/1926, pp. 5–6 and 12/1926, p. 5.

86 *DP*, 21/1926, p. 69.

87 Paul Knoll, 1913, p. 11 (see note 69).

88 Kurt Korff, 1927, pp. 290–91 and p. 294 (see note 44).

89 *Der Photograph*, 60/1929, pp. 238–239.

90 Cf. Bernd Weise, "Zur Geschichte der Bildagenturen in Deutschland" in *Fotovisionen 2000*, issued by the Bundesverband der Pressebild-Agenturen und Bildarchive, Berlin 1995, pp. 8–13.

91 Cf. Katja Protte, "Die Olympischen Spiele 1936 im Sucher – Fotografien aus dem Bestand der Bildagentur Schirner" in *DHM-Magazin*, issued by the Deutsches Historisches Museum, Berlin, 18/1996, pp. 28 ff.

92 Cf. Marie Matthies, *Journalisten in eigener Sache – Zur Geschichte des Reichsverbandes der deutschen Presse*, Berlin 1969.

93 Cf. Frank Niess, *Geschichte der Arbeitslosigkeit*, Cologne 1982.

94 Cf. *Der Pressedienst 1929*, Stuttgart 1929.

95 *Photo-Adreßbuch*, Cologne 1932.

96 In the archives of Ullstein Bilderdienst, Berlin.

97 *Große Berliner Illustrierte Zeitung*, 84/1922, p. 2.

98 Cf. *ZV*, 10/1928.

99 *Der Photograph*, 53/1929, p. 211.

100 Paul Knoll, 1913, pp. 7 ff. (see note 69).

1918–1933 67

101 Ibid., p. 5.

102 According to Stefan Lorant in a conversation on 8 September 1987 in the Photographische Sammlungen der Berlinischen Galerie, Berlin (tape recording).

103 *Felix H. Man – Bildjournalist der ersten Stunde*, Archiv Preußischer Kulturbesitz, Berlin 1983.

104 *Tim Gidal, Bilder der 30er Jahre*, exhibition catalogue of the Museum Folkwang, Essen 1984, pp. 57–58.

105 Cf. Bernd Lohse, "Als der Bildjournalismus noch jung war" in *Camera* 10/1976, p. 27.

106 Emil Dovifat, *Auswüchse der Sensations-Berichterstattung*, Stuttgart 1930, p. 5.

107 *ZV*, 29/1930, columns 1181 ff.

108 *Der Photograph*, 80/1932, p. 317.

109 *Der Photograph*, 59/1930, p. 236.

110 *ZV*, 36/1931, column 655.

111 *DP*, 7/1932, pp. 75 ff.

112 Cf. Erich Salomon, *Berühmte Zeitgenossen in unbewachten Augenblicken*, Stuttgart 1931.

113 *DP*, 1/1932, pp. 9 ff.

114 *DP*, 6/1932, pp. 63 ff.

115 Cf. the foreword to Emil Dovifat, 1930 (see note 106).

116 Cf. Kurt Koszyk, 1972 (see note 42).

117 *Deutsche Nachrichten*, 23/1933, p. 5.

Peter Reichel

Images of the National Socialist State
Images of power – power of images

National Socialist Germany impressed itself on the memory both of those who lived through it and of subsequent generations above all visually: in images of the double-edged power of the NS-regime[1], images of its monumental and apparently boundless shaping force, and of its extraordinarily destructive force. Also manifest in these images of power is the power of the medium itself, the power of images. For large sections of the German population at the time, National Socialism constituted the auspicious dawning of a supposedly new era, a preview of which was presented to them by the Nazis in photographs of spectacular mass meetings and specially staged ostentatious demonstrations of power. For their descendants and subsequent generations on the other hand, the images of National Socialist atrocities make this period seem like a turning-point in history, a deep caesura in the process of modern civilization.

Not only do these two images of the NS regime stand apart from the continuum of time, they also stand apart from each other, apparently unconnected. It is little wonder, therefore, that these two sides of the National Socialist state – the splendour of its facade and its superficial appeal, and the repellent horror of its violent crimes – are still repeatedly played off against one another. Only when the NS-state is viewed as a modern reactionary regime can these two aspects of the Third Reich be fused into one, contradiction-ridden unit: a state that pitted itself against the ideas, institutions and representatives of the political and aesthetic modern era embodied in the Weimar Republic, while at the same time availing itself of the controlling instruments of modern mass communications and social technology in its promise to rectify – with an authoritarian hand – the unsolved problems of the time. This it aimed to do with the aid of the modern capitalist system, but without the despised parliament, the hated political parties, and a much-feared civil war. Its aim was not only to restore Germany to national greatness and esteem, but to overcome the country's internal turmoil in the interests of a politically united and ethnically homogenous national community or *Volksgemeinschaft*. The means used to bring this about were largely repressive and expressive.

Both the aggressive and the aesthetic features of the two faces of the Third Reich had their origins in the specific character of its governing system and ideological principles. The central constituent of that system, the "racial theory", demanded illustrations, be they in the image of the "Nordic man", "racial hygiene" or the "national community".[2] Its ideology was presented in images that distinguished strictly between "us" and "them", the "superior" and the "inferior", between German comrades and politically, biologically and medically stigmatized foreigners who were seen as alien to the national community. Under

the primacy of race ideology, aesthetic issues were treated as medical issues and vice versa.[3]

This ideology's urgent need for visual forms had ambiguous consequences for photography and the fine arts. Their upgraded status within the framework of wide-ranging state-controlled propaganda campaigns was inseparably linked with the elimination of their autonomy. Once instrumentalized by politics they became trivialized. The fine arts and photography were under pressure to embellish and harmonize the Nazis' racist and monist view of the world in accordance with its specific holistic ideals – man and nature, technology and culture, the past and the present. The pictorial worlds of the fine arts and photography became interchangeable, each serving "to officially certify the other". Art's "naturalization of the ideal" corresponded to photography's "idealization of nature".[4] Not only National Socialist ideology, its power strategy too was dependent on visualization. The reasons for this are inherent in the system. Public acceptance of an authoritarian use of power depends primarily on that power being visualized, whereas in a democracy the legitimation of power – among other things – is achieved by means of transparent decision-making procedures, that is to say, by the lucidity of the process.[5] In principle, an authoritarian state can only point to the means by which it imparts form and imposes order, for which reason it is constantly forced to stage spectacularly elaborate presentations of its power. The NS-state proved to be as inventive as it was unscrupulous in visualizing that power, its architectonic monumentalization and its mystification – be that in the "providence" to which Hitler appealed or in the military cult of the dead. The NS-regime also demonstrated its shaping force in large-scale emotionally-charged gatherings and stirring evocations of a future modern industrial society in which mass consumerism and mass communications, mass motorization and mass tourism would be the order of the day.

The NS-regime's apparently unlimited capacity for action was also manifest in its efforts to invent its own tradition. This too was achieved by visual means, by erasing or reinterpreting history in images of an ideal world and a heroic past, or in the hate-inspired, distorted caricatures of the supposedly ugly, sick and "degenerate" aesthetics and politics of the modern era. Due to their biologically and aesthetically coloured world view, their anti-Semitism, and their religiously heightened nationalism, the National Socialists were incapable of subtle differentiation in their perception either of history or of the society of their time. Nor could they tolerate that society's ambivalences, contingencies and complexities. Their world view was radically polarized, one-sided and simplified. For the Nazis, therefore, the Wei-

mar democracy, which they denigrated as a *Judenrepublik* (Jews' republic), was as diametrically opposed to the coming of the "Pan-Germanic Reich" as apocalypse was to re-birth.

Visual propaganda against Weimar

In the course of consolidating its position as a political party, the NSDAP resorted to the important strategic tool of visual propaganda which soon became as crucial as verbal propaganda, especially in projecting their public image. Gradually, the NS propaganda experts began to place more emphasis on the evocative power of Hitler portraits and the emotive force of cleverly dramatized political gatherings, and less on the persuasive power of the mere spoken or printed word. Hitler himself had been fully convinced of the "magical power of the spoken word", particularly his own. Nevertheless, in *Mein Kampf* he had also pointed out that the significance of a mass gathering was to be found not least in the "image" it presented of the "greater community".[6] This image could be particularly inspiring and attractive for those people who have always proved decisive in any battle for political power, namely, the undecided, those who remained doubtful and hesitant on the sidelines of the Movement. In projecting its self-image and mobilizing the masses, the NSDAP set its hopes on the compelling power of the image to a much greater extent than any of the other Weimar parties, and in a manner that often surprised and from time to time overwhelmed contemporaries. They made copious use of swastikas, uniforms, flags, posters, caricatures, photographs, films, and not least, depictions of mass gatherings, street demonstrations, and above all, columns of SA troops as "tangible and popular" expressions of the strength and force of the National Socialist movement.[7] In this too, the Nazis – in particular the young Berlin Gauleiter Joseph Goebbels – had learnt from their observations of the workers' movement. Goebbels quickly recognized how important it was to "publicly demonstrate the acceptance of the state", for "whoever can conquer the street can conquer the masses" and "in time the state as well".[8]

In their implementation of this strategy and in their struggle with the Weimar parties, there can be no doubt that the NSDAP remained highly vulnerable, both during its violent activities and during elections. Nevertheless, the party quickly became conspicuous, first in Bavaria, then as of 1929/30 at the latest, throughout the rest of the country. The whole choreography and liturgy of its public gatherings and demonstrations, however, only gradually assumed their definitive contours, giving rise to the cult of the Führer, and to huge military parades with drums, fanfares, the *Blutfahne* (blood flag), standards, general inspections and rhetorical rituals, music, decorations and public festivities. The history of the *Reichsparteitag*, the party's national convention, and the *Reichstrauertag der Bewegung* (the Movement's day of mourning on 9 November) provide ample evidence of this.[9] These two public occasions were of vital importance to the National Social-

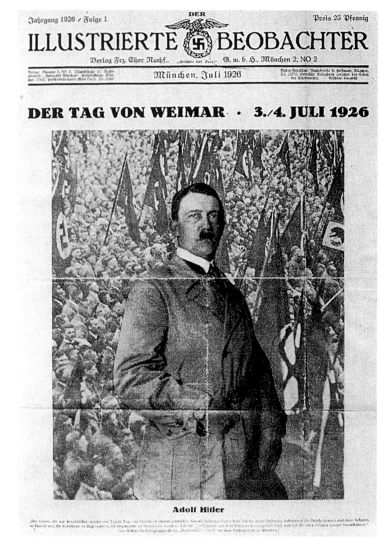

Heinrich Hoffmann, Weimar Day 3/4 July 1926 in *Der Illustrierte Beobachter* no 1, July 1926 (front page)

ists, serving to shape their tradition and their identity, to overcome internal dissension and integrate the party's various regional fractions, to enhance the party's image, and in particular its leader's image, and to mobilize new members and voters.

However great the direct propaganda impact of these meetings and demonstrations was in the early stages, pictorial propaganda slowly gained in importance. In good time for the NSDAP party convention in Weimar in summer 1926, the first in the party's reconstitution phase, the first illustrated book about Hitler appeared, as also did the first issue of the *Illustrierte Beobachter* (IB) – a complement to the *Völkische Beobachter* (VB) which at first carried more or less no photographs. With its large-format photographs, the first issue of the IB aimed to present a positive image of the reunited Movement, offering its supporters all over the country a hope-inspiring view of the party's renewed advances, while at the same time giving the lie to the opposi-

tion press. The latter had written off the NSDAP after it had been out-lawed, claiming that the party had no more support among the masses. "Who is lying? The photograph or the Jew-paper?" reads the hypo-critically scornful headline of that first slim issue of the IB, referring to a relatively modest protest march by about 7,000 National Socialists from all over Germany.

This is a clear example of how the National Socialists' propaganda experts operated. They relied to a great extent on the vivid suggestiveness of photographs, working on the assumption that the majority of the readers would regard them as an authentic depiction of reality – endorsed, so to speak, by the technical apparatus – and not realize that one "can improve on the truth of a photograph" by more or less shrewdly manipulating the relationship between its visual content and the wording of the caption. In contrast to the printed word, the photographic image was considered to have obvious advantages as a "journalistic tool of leadership": a successful photograph caught people's eyes, was forceful, easily understood, and, thanks to its direct-ness, more convincing than any text.[10] The Nazis made full use of something the German writer Kurt Tucholsky had warned his picture-hungry contemporaries against: "From the advertisement to the politi-cal poster, the picture forces, boxes, whistles, and shoots its way into people's hearts and, if well chosen, always proclaims a new and single truth."[11] This was exactly what the propagandists and totalitarian sim-plifiers of the time, be they on the left or the right, wanted to achieve. By 1927 a more voluminous version of the IB was appearing on the market at two week intervals. A year later it proclaimed itself the "photographic weekly of the National Socialist Movement". Impressed by the Arbeiter-Illustrierte-Zeitung, Willi Münzenberg's proletarian mass newspaper of the class struggle, and by the success of the middle class illustrated magazines with their millions of readers and their deliberately non-political, entertaining approach, Hitler was deter-mined to turn the IB into "the great illustrated newspaper of a young, nationally-minded Germany". Until 1933 its circulation of about 180,000 copies still lagged behind that of all the other illustrated publi-cations. Though the gap could later be significantly reduced, the other large illustrated newspapers were nevertheless able to hold their own right up until the final years of the war, maintaining high circulation figures by adapting to the new power structures.[12]

In a section called Judenspiegel (Jewish mirror) the IB regularly carried anti-Semitic articles and photographs, while its National-sozial-ismus marschiert (National Socialism on the march) section it high-lighted the Movement's projects and activities in articles and photo-graphs courting the favours of the discontented masses by presenting the NSDAP as a young, anti-bourgeois, anti-Semitic, anti-republican, national, socialist and even revolutionary party, which it certainly was not. National Socialism was a counter-revolutionary movement; its revolutionary gloss served to distinguish it from the traditionally nationalist Right and at the same time approximate it with the extreme Left. As an all-embracing national protest movement, the NSDAP com-peted as much with the "old" Right as with the "young" Left, for which

reason it could help itself liberally to the political ideologies and expressive forms of both camps.

From the outset there had been one outstanding event that had helped to gather together and shape the anti-republican protest: the revolution of 1918/19. In the course of their agitation the Nazis repeat-edly used the image of what they called the "stab in the back by the November criminals", the betrayal of Germany to "Jewish Marxism" and the "enslavement" of the fatherland that had resulted from the accept-ance of the Versailles "peace diktat".[13] Fixated on what they saw as the beginnings of the Judenrepublik (Jewish republic), they wanted to overthrow this in a "national uprising" and replace it by the "Third Reich". For the Nazis it was a unique historical event on which they could concentrate all their political perspectives and strategies, pro-tests and propaganda, their anti-Marxism, anti-Semitism and, in the early stages, anti-capitalism. They had many names for the 9 Novem-ber: the "Stock Exchange Revolution", the "Jewish Putsch", the "Ban-dits' Coup". The date was also referred to in their defamation of Weimar politicians – whose outward appearances they ridiculed both verbally and visually, most notably in the distorted facial features of Hans Schweitzer's (Mjölnir) caricatures.

The National Socialists' pictorial protest and propaganda activ-ities were directed to a large degree against specific persons. Their agitation took the form of a constant and eye-catching stigmatization of various groups of people as "big-wigs", "traitors", "wire-pullers", "parasites", and "red criminals", to say nothing of their defamatory ste-reotyping of Weimar politicians. Goebbels' long-standing propaganda campaign in the magazine Angriff against the Jewish vice-president of the police in Berlin, Bernhard ("Isidor") Weiss, is notorious.[14] How-ever, the visual propaganda was also designed to personify the NSDAP and its political agenda; and long before 1933 that agenda had just one name, Adolf Hitler.

Heinrich Hoffmann was the photographer who translated that particular agenda into images.[15] He was as important to the party's general photographic propaganda as he was to the photographic popularization of the Führer myth, though he was not the first and not the only person to photograph Hitler and the NSDAP. After the war, the denazification court ranked Hoffmann among the main guilty partners, expressing the opinion that he had "contributed essentially to Hitler's accession to power". Hitler's former personal photographer saw his function in quite a different light. Like many other leading artists and scholars in National Socialist Germany, he tried to shake off any kind of responsibility by falling back on what he saw as his purely artistic function. The one-time Reichsbildberichterstatter (Reich photo-repor-ter), who became a member of the DAP/NSDAP in 1920 having already made a name for himself with an extreme right-wing illustrated brochure about the Munich Revolution, declared that his main con-cern had always been photography and that he had "never been inter-ested in politics"; he subsequently entitled his memoirs Ob Rot ob Braun – ich war immer dabei (Whether red or brown – I was always there).

Portraits of the Führer

There is a striking dearth of photographs from the early stages of the Führer cult. At first scarcely any photographs of Hitler were in circulation; he was said to be camera shy. However, he was also concerned to avoid recognition and possible harassment, especially as the NSDAP had been outlawed after Rathenau's murder, and the state of Prussia, among others, had passed a Law to Protect the Republic. In early summer 1923, Th. Th. Heine, illustrator for the magazine *Simplicissimus*, could give no satisfactory reply to the question of what Hitler looked like: "Hitler is not an individual at all. He is a state of mind." A "German state of mind", "a poor imitation of an ideal type that only existed in people's imaginations", as one of Hitler's first biographers, Konrad Heiden was to write.[16] Before Hitler could become a fascination for the masses he had first to don the mask of the "representative individual" specially created for him by the propagandists. This was a decisive precondition for turning him into the personification of their resentments, their longings, and their own self-understanding.[17]

Of course it was not possible to stay out of public view for too long. The failure of the putsch and the spectacular trial for treason brought Hitler more and more publicity, and he was quick to grasp the opportunity this presented: the defendant became a demagogue, slipping effortlessly into the role of prosecutor. In the pose of the future Führer, he scorned the judges and appealed self-assuredly to the "goddess of the everlasting court of history" who would acquit him and his comrades-at-arms. The court seems to have been impressed by the defendant's "patriotic spirit and noble will", only imposing the minimum sentence of five years fortress arrest, which Hitler had to serve in Landsberg. He only remained there until the end of 1924, yet during that absence from the public arena the demand for portraits grew. Hoffmann had taken his first Hitler portraits before the putsch. Further sittings soon followed. The photographs were circulated in postcard form, in illustrated brochures such as *Deutschlands Erwachen* (1924 and 1926), and of course in the *IB*.

The Hitler portraits from this early period show him in various poses – as a "prisoner thirsting for freedom", a "genuine Bavarian", a successful public speaker, a "prophet of the future Reich", a fighter and commander of a private army, and a resolute and reputable party leader. Although the roles were varied, the face was merely "an expressionless ground" with strands of hair and a clipped moustache, an "unhewn mask", to quote Konrad Heiden for whom Hitler was an upstart, a born failure with neither title, nor financial means, nor family pedigree (which caused him much psychological suffering), a man who only gained access to "good society" late in life, had no desire whatsoever "to be agreeable" but the courage and the ability "to be conspicuous". Hitler succeeded in attracting attention not through his outward appearance, which was quite insignificant, but through his behaviour, often arriving late for appointments and leaving early, scarcely participating in conversation but well able, given the appropriate cue, to launch into a vehement monologue. "Masked as a normal

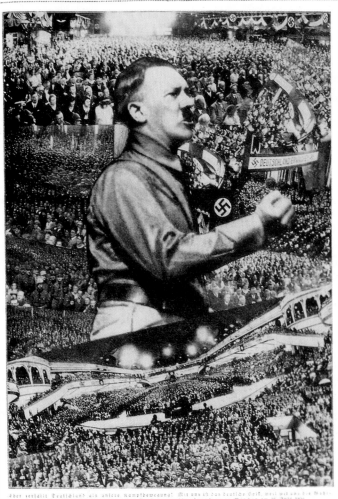

Heinrich Hoffmann (?), Hitler at the first Reichstag election meeting on 18 July 1930 in *Der Illustrierte Beobachter* no. 32, 1930

mortal" he was determined to come "as close as possible to the average and yet remain as far removed as possible from the individual", be that in lederhosen, trench-coat, SA-uniform or dark double-breasted suit complete with a small party badge pinned discreetly to the lapel.[18]

The image of the Movement too remained ambiguous and masked. In their "red murder" campaigns, the *VB* and the *IB* repeatedly denounced the violence perpetrated by the Communists while glossing over that of the SA. Photographs depicting the striking power of the Brownshirts were placed alongside others demonstrating the NSDAP's legalistic strategy in the battle for power by showing its members as city councillors, state parliamentarians and Reichstag deputies. The party press's preferred method of visually rendering Hitler's growing popularity was to carry double-page diagonal panorama photographs of his mass audiences.

The September 1930 elections represented a breakthrough to mass publicity with Hitler's party dominating the headlines for a time. It was then that his image as "Führer of the future Germany" crystallized. Thanks both to his considerable success in the spring 1932 presidential election and his spectacularly modern American-style election campaign that same year, this image gained in strength and popularity. Four flights across Germany undertaken in 1932 brought Hitler all around the country; within a few months he spoke at about 150 mass rallies, often in several towns on the same day, so that in that year alone millions of Germans saw and heard him personally.

March 1932 saw the publication of two volumes of photographs taken by Hoffmann – *Hitler über Deutschland* (Hitler over Germany) and *Hitler wie ihn keiner kennt* (The unknown Hitler). These represented not only a quantitative step forward in the propagation of Hitler's image but also an obvious qualitative change in that image: from the party leader capable of mobilizing and polarizing the masses, to the supra-party national identification figure. However multifaceted and graphic the image of the new idol may have been, it was nevertheless highly contrived and idealized: Hitler on the family sofa, soldier Hitler at the front, Hitler the car enthusiast, Hitler surrounded by children, Hitler with dog whip and binoculars, Hitler in "his" mountains, among the farmers and the youth of Germany, Hitler at the edge of the forest, at his desk, on the telephone, reading a newspaper, Hitler with Nietzsche-bust or Goebbels' piano, Hitler as the "good man" (B. v. Schirach), the "irresistible" (K. Reinhold), the tribune of the people.

This carefully devised mis-en-scène of the Führer myth received added impetus from the "great miracle" of the "historical change" – as Goebbels noted with a certain justified enthusiasm in his diary at the end of January 1933. The VB was already casting Hitler in the role of *Volkskanzler* and "Führer of all Germans". For a time, many Germans had seen in Hitler little more than the "new man" who, like his predecessors, would probably only last a short term and whose public appearances they observed with sceptical curiosity, not taking them all that seriously. The NS-propagandists were very much aware of this fact and therefore availed themselves of every possible opportunity to increase Hitler's popularity and give the Führer's profile a populist touch, above all, by means of photographs.

Potsdam Day was the first National Socialist highlight. The spectacularly orchestrated opening of parliament on 21 March 1933 coincided with the day on which Bismarck opened the first Reichstag of the second German Kaiserreich in 1871.[19] After the arson attack, the Reichstag building was no longer available. However, as their concern was not parliamentary legitimation, the Nazis did not need it anymore. Instead they chose to call upon tradition and exploit appropriate historical settings, in this case the Garrison Church and the tomb of Frederick the Great, which were eminently suited to their purposes. Here Hitler could bow to the heritage of the old Reich, while its aged representative, Reichspresident and former field marshall Hindenburg, gave his blessing to the "new Germany". With mendacious consistency the Nazis turned the occasion into a "festival of national unity" –

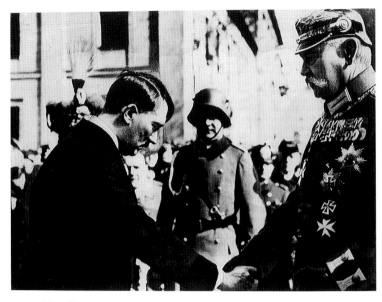

Theo Eisenhart, Hitler greets Hindenburg on "Potsdam Day", 21 March 1933

excluding both Social Democrats and Communists. No one had experienced the likes of this festival since the days of the Kaiserreich, an era marked by uplifting festivities and national holidays. Potsdam Day was not all. The sequence of elaborately staged presentations that followed seemed endless – huge military parades and exhibitions, dramatic appearances by the Führer, and festive spectacles. From that moment on the eyes of the masses, more than any other sense, were kept constantly preoccupied. Yet before those very same eyes something else was also taking place that was anything but festive and that clearly delineated the limits of the national community in the making: the ostracism and persecution of the Jews – from with the boycott of Jewish shops to the Nuremberg Laws, the *Reichspogromnacht* and the deportations.

Potsdam Day was followed by Hitler's 44th birthday on 20 April, an event marked by flags and torchlight processions, Hitler photographs, Hitler oaks and Hitler limes. Not only were these intended to underline the statesman-like image of the national leader but also his more human and modest features. Hitler was now to be presented as a *Volkskanzler*, a "kind-hearted, simple man of the people", the father-figure of the nation, the tirelessly active architect of the new Reich, indeed the very "incarnation of Germany". An eminently suitable place for this was Berghof on the Obersalzberg, Hitler's private mountain refuge, and the venue for plebiscitary and representative gestures. It was here that he received his closest colleagues, prominent personalities, and official foreign guests; and it was there that he accepted the homage of his "devoted comrades".[20]

Exactly how populistically-orientated the Führer images were became particularly evident during election campaigns; in 1933 after Germany left the League of Nations, in 1935 when the Saarland was

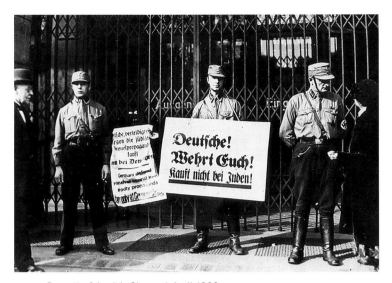

Boycott of Jewish Shops, 1 April 1933

propagandists used elections as something akin to photographic ple-biscites, much as they did the NS public holidays (the *Helden-gedenktag,* the First of May, the Party Convention, Thanksgiving, or the commemoration of "those who fell for the Movement"). Yet the mood among the general population remained prone to fluctuation – from euphoria to sobriety. Social and political evils were attributed to the government, even more so to the party, whereas improvements were ascribed to Hitler, as of course were foreign policy and military successes, or what was portrayed as such. It was Hitler who was cred-ited with overcoming the "humiliation" of the Versailles "peace diktat", the "economic miracle" and the elimination of unemployment, and he had long since become the "symbol of the unity of the German people". By the end of the 1930s, a large portion of the population may well have identified with him. Be that as it may, Hitler's 50th birthday offered another welcomed occasion to present his "successful charisma" (I. Kershaw) to great visual effect.

Hitler's role of statesman now made room for that of future milit-ary commander. The parade of "the most modern of all armed forces" (Hitler) was intended to impress the world at large and accustom the Germans to the notion of war, despite the fact that for years peace had been the alleged goal and the Sudeten crisis had demonstrated just how unwilling the population was to wage war. The Hitler myth reached

returned, in 1936 after the invasion of the Rhineland, and in 1938 after Austria's *Anschluss* – an event that allowed Hitler to be projected as the "creator of Grossdeutschland". On these occasions Hitler mobi-lized the "maximum consensus potential".[21] At the same time, the

Abraham Pisarek, The day after the *Reichskristallnacht:* Jews on their way from the Oranienburg railway station to the concentration camp in Sachsenhausen

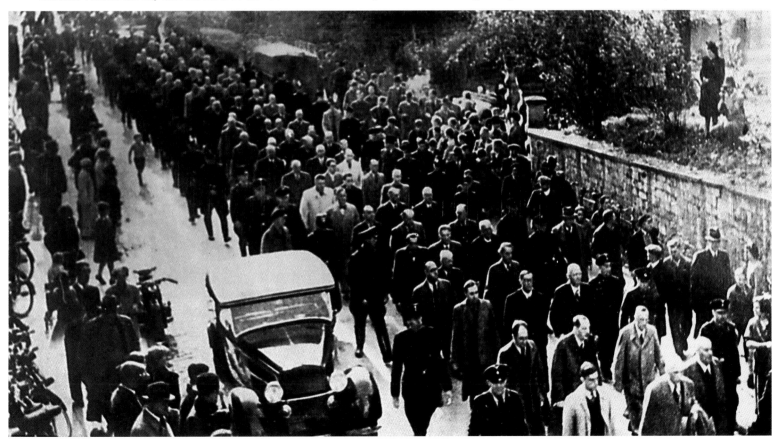

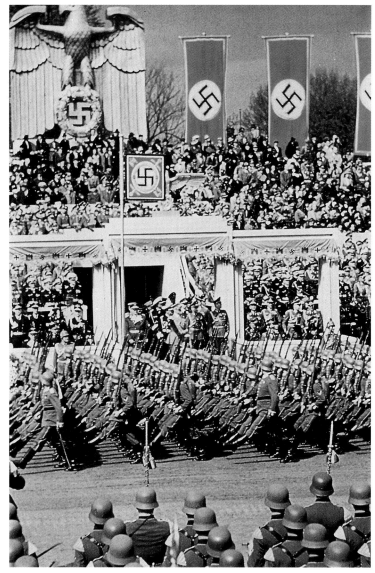

Heinrich Hoffmann/H. Jäger (?), Hitler inspecting Wehrmacht troops on his 50th birthday, 20 April 1939

a new and final zenith as German troops entered Paris in summer 1940. In the early years of the war Hitler appeared in various roles, preferably that of "soldier among his soldiers" and "commander with his generals". With the beginning of the Russian campaign he made fewer public appearances. The photographs too were fewer – mainly of visits from representatives of allied and occupied states, order and medal presentations, and strategic discussions held in the far-distant Führer headquarters. Gradually the Führer's populist profile was remodelled into that of the publicity shy military commander. In April 1942 Goebbels even tried to make propaganda gains from this by calling upon the German people to turn their "mind's eye to the Führer" on his birthday. Older photographs of Hitler were readily available but unsuitable; Hitler had long since become a "problem case" (R. Herz) for his propaganda apparatus. Reports of military successes, which had nur-

tured his myth, were becoming less frequent. Defeats on all the military fronts and widespread devastation throughout Germany were increasingly jeopardizing his image. Hitler's potential had already been exhausted when he took his life in the ruins of the Reichskanzlei. Yet to this very day, the disparity between the real and the media personality and the memory of the fascination that personality had on the masses have kept alive an interest in the "living phenomenon" (T. Mann) of Hitler and his images.

Images of community, images of the future

The emotionally charged cult and myth of the people's Führer went hand in hand with the myth of the no less glorified national community. For many people that community was the auspicious counterimage of the class-conscious Weimar state's inner turmoil. As of 1933, however, it was no longer sufficient just to evoke that community as part of a political programme, the National Socialists had to render it credible, perceptible, that is to say, they had to at least partially realize and visualize it. From Mussolini's fascists and from their own struggle for power, they had learnt a lot about the instrumental value to politics of the visual, colourful, symbolic and theatrical. Once they had gained power, therefore, they not only consolidated it through physical force but even tried to control the masses' perceptions of it by inaugurating specific places in which a sense of community might be promoted and elaborate visual worlds conjured up.[22] As in the case of the Führer myth, numerous settings and occasions were available in which that sense of national community might be publicly evoked. These included not only social and political institutions such as the *Winterhilfswerk* relief fund, the *Kraft durch Freude* leisure-time organization, large-scale industrial and urban planning projects, municipal housing, mass motorization and mass communications, but also a wide variety of large-scale cultural events, in particular exhibitions and festivals.

Among the national holidays of major political importance to the NS-state's self-understanding were not only the *Heldengedenktag*, Thanksgiving and the day commemorating those who fell for the Movement, but also the First of May.[23] Politically, the former *Maientag der Arbeit*, the international workers' movement's day of action and protest, may have been the most awkward, but symbolically it was the most significant. That the Weimar Republic had only once (by a decree of the National Assembly in 1919) proclaimed the First of May a national holiday, though not a permanent one, reflects the Reichstag's anti-republican majorities and the luckless Republic's failure even to handle political symbolism. The Nazis, on the other hand, were as prudent as they were unscrupulous in their particular utilization of political symbols. Goebbels quickly realized that were they to suppress the First of May, the "reds" could turn it into a day of opposition; were the Nazis to turn that "national workers' holiday" into a festival of "national camaraderie" this would take the wind out of the Communists' sails. So with the greatest of military efficiency he orchestrated

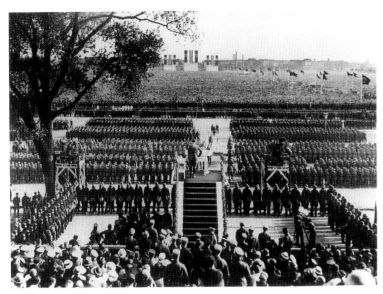

1 May as a "national holiday of work", mass gathering on the Tempelhofer Feld, 1933

this first large-scale event in the interests of the "national community", noting that "The whole nation is to unite as an expression of a single will and a single-minded readiness." On the First of May more than one million people gathered on the Tempelhofer Feld, entrepreneurs and workers, employees and self-employed, all in specially marked sections and forming a "mass ornament" (S. Kracauer) with lots of May greenery, march music, and bunting, thousands of swastikas, plus the black-white-red flag that had already supplanted the unloved black-red-gold flag of the Weimar Republic. The event ended with a torch-light procession and a huge fireworks display. Hitler appeared on the scene late, and in the blinding glare of the floodlights spoke of the "snobbery and class delusion" of past times, promising a "work programme for millions" and invoking "national solidarity" in a "single community" as a prerequisite for national "advancement".

The NS-regime made a national holiday out of an international workers' day of action. One reason why this May-day mis-en-scène had to be so spectacular was because it had to veil the old class structures and conceal the new power structures. Here too the Nazis used their dual strategy of brute force and beautiful illusion. On the one hand they behaved as if they wanted to win over the workers, on the other, they dismantled their organizations; on 2 May, SA and SS men occupied trade union premises all over the country, confiscating their assets and taking their functionaries into "protective custody".

However, it was not enough just to give the First of May a new function, smash the workers' organizations, and persecute Communists and Social Democrats. The NS-regime knew it was dependent on the workers' compliance. Its gigantic re-armament programme could not be carried out without the workers' readiness to adapt and co-operate, let alone against their opposition, so the subsequent "taming"

of the workforce took place in a force field of repression and material and symbolic concessions.[24] The "valuable" sections of the workforce, those willing and able to work, were to be integrated into the national community with the help of a nationalist, racist and work-orientated ideology. Thus the ideologically split working class was to be de-politicized and its potential for opposition – already weakened by the destruction of their organizations – neutralized. With the help of material incentives and the prospect of promotion and improvements in their quality of life, at least part of the workforce could be integrated.[25]

The importance of the socio-political agenda and propaganda can be underestimated, even disregarded as "pseudo caring" (T. W. Mason), or else it can be overestimated, as was the case in the reports filed by the SPD in exile. It is no mere coincidence, however, that the NS holiday organization *Kraft durch Freude*, founded by the German Workers' Front after the Italian model, was so popular, even among the workforce.[26] By early 1934 the first *KdF* trains were travelling the country taking a few thousand "worthy workers" and "old veterans" on holiday. Shortly afterwards the first chartered KdF ships put to sea. There is no doubt that these sea voyages were the most attractive and effective items on offer by this new form of social state tourism. The Weimar trades unions had promised the workers that one day they would "travel the seas in their own ships"; the Nazis ensured they did exactly that. Even though there were only about 100,000 privileged passengers each year, the propagandists still managed to turn the Germans into a "nation of seafarers". The workers were very much under-represented among these voyagers: Not even 1% of the German work force actually took such a voyage, yet this did not prevent a headline in the *Völkische Beobachter* from claiming, somewhat exaggeratedly but not totally incorrectly, that "German workers" were "putting to sea".

Even NS-regime opponents admitted that *Kraft durch Freude* tourism had "by far the greatest power of attraction".[27] Not only did the organization cater for the masses' recreational needs, it was also a symbol of socialism on a national scale. It circumvented the issue of solving social problems by promising the workers more social prestige instead of more wages, more fun instead of more freetime, a "petit bourgeois joie de vivre" instead of better living conditions. Yet one should not underestimate the socio-political importance of all this. Where better to effectively demonstrate that "work ennobles", where better to entertainingly stage the "demolition of bourgeois privileges" by the "national community", than aboard a holiday cruiser. These initially somewhat improvised excursions were fraught with organizational and technical difficulties and a lot of fun was made of them. It is also absolutely impossible to speak of them as a democratization of travel. The actual figures lagged very far behind the promised 14 million *Volksgenossen* supposed to be able to take a 12-day holiday every year. Of the almost eight million KdF holidaymakers in the last year before the war, about six million took either a 1 to 2-day voyage or went on a walking tour in the Harz mountains, a trip on Lake Constance or to the Munich Oktoberfest. Nevertheless, these visible beginnings of national tourism gave concrete form to a promising

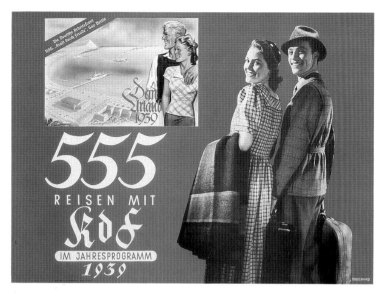

K. Petersen, 555 trips on offer in the 1939 "Strength through Joy" programme

Otto Illauer, Autobahn landscape on the Hirschenberg, 1936

future-orientated vision. The leap forward from early modern mass tourism to tourism by the masses did not seem all that great. An annual holiday became the symbol of a new life-style. By the time the war started, *KdF* tourism had already initiated an ambitious holiday programme: The outer shell of a gigantic seaside resort for 20,000 guests at Prora on the island of Rügen was already complete and plans existed for *KdF* recuperation centres and holiday villages for families with numerous children, to say nothing of the *KdF* hotels and overseas trips for people with higher aspirations. With the outbreak of war, this flourishing project designed to organize workers' freetime had to be modified; the pleasure boats were transformed into troop transport ships and floating military hospitals.

Motorization and the *Autobahn* were also part and parcel of the new pre-war way of life[28], with Goebbels declaring that they too were an expression of modern life in Germany. Here again the NS regime fell back on Weimar plans: Neither the *Volksauto* nor the *Autobahn* were Hitler's ideas; his achievement in the case of the people's car was to allay any reservations industry may still have had. As for the construction of the *Autobahn,* several kinds of strategic considerations came into play here all with a bearing on employment and energy policy, the wartime economy and the aesthetics of propaganda. Fritz Todt understood Hitler's commission "to build a network of linked motorways" as an "artistic task". He was determined to create a "colourful succession of alternating landscape images" and "to form the overall character of the motorway in a single spirit, impressing on it the mark of grace, durability and purposefulness". He made repeated references to the cultural and aesthetic value of technical construction and architectural form as prerequisites for a new experience of mobility and space. The beauty of the German landscape would be enhanced, not defiled, because in addition to the mobility it facilitated, the motorway would make the landscape's "overall features and con-

nections" more accessible – in the sequence of images and spaces, in the rhythm of hill and dale, distance and elevation, rest and motion.

The architects, engineers, "landscape advocates" etc. involved in the *Autobahn's* construction did not conceal the fact that with this *Gesamtkunstwerk* they were not only satisfying society's visual and emotional needs but also pursuing a political aim. As Todt explained, the *Reichsautobahn* was to be something akin to an internal network linking Germans throughout the country. It was a "clasp around the national community", an "instrument to shape the Reich". Furthermore, it could promote the Germans' *Wanderlust* and in times of peace direct the attention of that "people without space to live" to where the new *Lebensraum* lay. Among Germany's neighbours this monumental construction unleashed as much distrust as it did admiration. At the time, the *Autobahn's* military potential was overestimated, as was its importance for Germany's employment policy. In the Wehrmacht's logistics the railway network played a more crucial role than the roads,

and given the comparatively small number of vehicles available, the Autobahn's relevance for the transportation of either people or goods was insignificant.

The photographs taken of the first completed stretches of the German motorway all have one striking feature, their emptiness. There were simply too few cars on the roads and vehicles had to be rented for the photographers' and filmmakers' propaganda purposes. Yet this in no way detracted from the myth of the *Autobahn*, on the contrary, it even profited from the situation. To communicate an impression or mediate an image of this monumental but unobtrusively feature-less architecture – in the words of the exiled Ernst Bloch, "a somewhat flat construction thousands of kilometres long" – it had to be brought to life visually. No other monumental construction of the period received as much media attention as the *Autobahn*. It was featured as a *Gesamtkunstwerk* on which engineers, craftsmen and forced labour-ers, artists, photographers and film makers, novelists and composers toiled: When the Autobahn was still a building site, they worked on the myth of its construction, creating a first auspicious image of the future; at the outbreak of war, with several thousand kilometres of these "streets of the future" completed, they conjured up an image of mass motorization. Hitler was quick to appeal to the longing of millions of people for a car, not least because he regarded mass motorization as a decisive prerequisite for the modernization of the Wehrmacht. In the 1930s, motorization was given a considerable material and spiritual boost by the paramilitary NS motor corps. However, the approximately 300,000 *KdF* members saving to buy a car had to wait till the 1950s for their Beetle. During the war it had only been possible to build and deploy a few tens of thousands of *Kübelwagen* jeeps. Nevertheless, the vision of a "nation on wheels" had at least begun to assume tan-gible form.

Enemy images, war images

Pictures, especially photographs and films, have been impor-tant strategic instruments of war in our century.[29] Whichever of Paul Virilio's pictorial strategies of the "armed eye" one chooses to focus on – aerial photography for military reconnaissance, demoralizing picto-rial demonstrations of military power, propaganda pictures of mass military mobilization, or the mass media's attempts to strengthen a people's power of endurance during a war – the functions of photogra-phy and film in modern warfare are many and varied. The perpetration of modern wars is largely media-supported. This was nothing new to the NS propaganda experts and the Wehrmacht; they had learnt something from the First World War.

Long before the invasion of Poland, German political and milit-ary leaders were convinced that in any future military conflict the "pro-paganda war" would be as important as "armed combat" and "eco-nomic war". In winter 1938/39 Keitel, head of the Wehrmacht High Command (OKW), and Goebbels had reached an "agreement on how

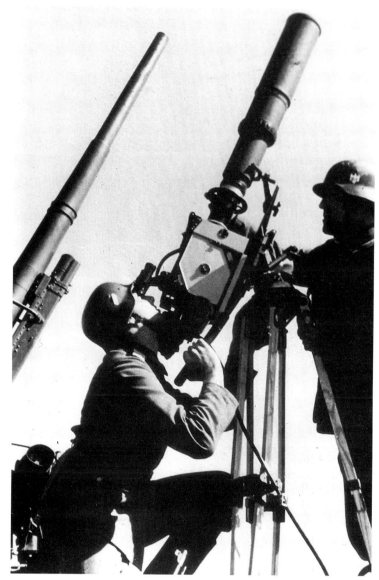

Heinrich Hoffmann, The "armed gaze": Two long-distance weapons, the long-distance camera and the heavy anti-aircraft gun, aimed at the enemy

to carry on propaganda during the war". Goebbels had already begun to recruit wartime photographers, filmmakers and reporters and to draw up propaganda companies. Long before the Second World War started, the NS-regime had already initiated its complicated strategic game of revelation and concealment, visually and verbally deceiving both the Germans and the potential enemy. The latter was to be bom-barded with demonstrations of German strength, whereas Hitler Ger-many's aggressive intentions and intensified armament efforts were to remain hidden. At the same time, the German people's "willingness to defend themselves" was to be strengthened and their fear of war dissipated.[30]

Unlike in August 1914, there was no widespread enthusiasm for war in Germany in summer 1939. On the contrary, a "general war psy-chosis" prevailed.[31] In the early 1930s a glut of war books and films

gave some impetus to an influential anti-republican "soldierly nationalism", superseding the prominent pacifist movement which had found expression in the spectacular success of Erich Maria Remarque's novel *Im Westen nichts Neues* (All quiet on the Western Front). The Nazis' socio-political guiding principle, the "national community", had a direct, because "inner" link with the "front community" and was thus synonymous with the "defence community" promoted by the National Opposition and the Reichswehr in the Weimar period. At first the NS leaders had tried to give this image of the "defence community" a more defensive hew, with Hitler and Goebbels constantly insisting on Germany's desire for détente and peace and frequently referring to the peaceful revision of the Treaty of Versailles. The overall message was that Germany was primarily concerned with re-establishing its "honour", its "equality" and its "ability to defend itself". However unable or unwilling contemporaries may have been to perceive the warring intentions behind such and similar protestations, once mention was made of the second propaganda theme, namely anti-Bolshevism, these intentions became quite blatant.

The aggression concentrated in this particular enemy image left little to be desired, either before or after 1933. Hitler made the confrontation between Bolshevism and nationalism and/or National Socialism an issue of national survival, declaring Germany to be the last "bastion" against "Jewish Bolshevism". Goebbels spoke about the "Germans' deadly enemy" describing the "fight against global Bolshevism" as Germany's "global mission". In his March 1937 propaganda directive he pronounced this to be the "general line of German policy". The NS leaders were exploiting the widespread fear of a "Bolshevization" of Germany, indeed of Europe. Furthermore, with their demand for *Lebensraum* in the east they had also tuned in to the traditional German "drive to the east". This guaranteed them the agreement of the national conservative elites in the Wehrmacht, the business community, the universities and the church. The anti-Bolshevist enemy-image fused stereotypes that both overrate ("global Bolshevism") and underrate ("colossus with feet of clay") the supposed Russian threat. For that very reason it exhibited an ideological radicalism and absolutism absent from the images painted of the enemies to the west.

Yet NS anti-Russian propaganda was also subject to fluctuations,[32] and like the fluctuations between foreign policy peace protestations and ostentatiously intimidating propaganda, this too had tactical reasons. On the occasion of the demilitarization of the Rhineland, the return of the Saarland, and the reintroduction of obligatory military service, the propagandists may still have been able to make Hitler appear as the peaceful executor of the revision of the Treaty of Versailles; they may even have been able to celebrate the Wehrmacht's invasion of Austria as a "friendly visit" and an "act of peace" by Hitler. As of spring 1938, however, Hitler himself was no longer able or willing to conceal the aggressive intentions behind his peace rhetoric. In his February 1939 account to the Reichstag of his first five years in office, Hitler made an announcement to the nation: "The German peace army has been drawn up!", referring to Germany "defending itself to

the very last breath". In November he personally exposed the year-long peace propaganda camouflage, declaring to journalists and propagandists alike that the "pacifist song" had been "played out".

From then on the propagandists resorted to themes and images that had already taken shape before and during the First World War and formed the experiences of sections of the German population. They appealed to the Germans' fear of threat and humiliation, speaking of Germany as "surrounded" by the international powers and referring to the "lie about who was responsible for the war". They attacked England as the initiator of this policy and as the agent of "global Jewry" and "global democracy". The anti-Polish campaign began in April 1939 with the termination of the German-Polish non-aggression pact. The invasion of Poland initiated a propaganda war against that country. The excuse for the German "counter-attack" had been provided by false claims about Polish border violations. The onset of war on 1 September 1939 and the Wehrmacht's swift victory over and occupation of Poland unleashed a wave of terror, exploitation, resettlement, enslavement, and mass murder, during which some three million Polish Jews and as many non-Jewish Poles lost their lives. At the same time Poland became the deployment area for the war Hitler intended waging against the Soviet Union after his victory over the western powers. Hitler had never left anyone in doubt about his intention to wage that war, despite the German-Soviet non-aggression pact and the partial discontinuation of anti-Soviet propaganda.

The German invasion of the Soviet Union on 22 June 1941 saw the reappearance of Goebbels' "anti-Bolshevist steamroller" image which had come into its own during the Spanish civil war. The visual propagandists were instructed to portray – preferably on the front pages of the wartime newspapers – an image of conditions in the Soviet Union that suggested extreme poverty and showed the Red Army soldier as "subhuman" and the German soldier as a heroic and of course victorious lone fighter; photographs of German soldiers killed in action were undesirable. While the enemy was shown retreating, the *Wochenschau*, controlled by Goebbels, and the propaganda magazines *Wehrmacht* and *Adler*, controlled by the Wehrmacht and the Luftwaffe, depicted German units in an unchecked advance to the east with photographs of them surging forward usually from left to right, especially in the case of the *Blitzkriege*. The organ of NS foreign propaganda, *Signal*, deliberately exploited its modern appearance and a variety of interesting topics to present an advantageous image of Germany. Part of *Signal* was printed in colour and its layout was modelled on the American magazine *Life*. It was issued in several languages and at one time had a circulation figure of more than 2.5 million.

Reports on the miseries of war, devastation, exploitation, mass murders and mass deaths at the front and in the camps did not conform to an image of war which until then had either glorified or played down the reality, choosing instead to show soldiers in "heroic action" or on home leave. The material published was the responsibility of a special propaganda troop initially made up of seven army, four airforce

and two navy propaganda units. These were well equipped with the appropriate technical appliances and vehicles, and provided reports, photographs and film footage suitable for publication, broadcast and cinema. The troop grew as the Wehrmacht's operational area expanded, so that by 1942/43, at the height of the propaganda battle, it was almost the size of a division.[33]

Once the German advance on Moscow in winter 1941 had been halted and the Russian opposition that had formed in the north and south was able to assert itself the following year, the promised swift subjugation of the Soviet Union drifted far out of reach and the mood among the German population began to deteriorate. As a result, the anti-Bolshevist propaganda on the home front, in newspapers, on radio, in cinemas and exhibitions, became more radical with the German retreat being reinterpreted as a heroic battle in defence of western civilization.

The exhibition *Bolschewismus ohne Maske* (Bolshevism Unmasked) had been shown in several German cities in 1936/37 and Bolshevism declared "global enemy number one". A further anti-Russian exhibition, *Das Sowjet-Paradies* (Soviet Paradise), was mounted in 1942 and served to justify Germany's war against the Soviet Union. This too was shown in numerous German cities and in the occupied territories, and according to NSDAP propaganda was seen by millions of people. Russia had been constantly derided as a "colossus with feet of clay" and Goebbels had forecast a "unique triumph". Now, however, anti-Soviet agitation had to be altered so as to strengthen the Germans' will to oppose the advancing Red Army. In the occupied territories this was done by portraying the Bolshevist threat as a fundamentally European issue ("Europe will be victorious with Germany or sink into Bolshevist chaos") and repeatedly using the terrifying image of the "Asian hordes". German propaganda now credited its deadly enemy with something the Wehrmacht and SS had started but been unable to finish: a war of conquest and annihilation. Hitler had chosen a mythical name for this war, Operation Barbarossa, deliberately conjuring up an image of a secularized crusade and suggesting the return of a Golden Age. The whole undertaking resulted in a war of scorched earth that caused unimaginable destruction and human sacrifice. It ended in Europe's liberation from German fascism, the destruction of large parts of the European continent, 55 million dead, Hitler's demise, Germany's collapse, the defeat and dismantling of the Wehrmacht and the fall of the German generals.

That fall, however, was not exactly into a bottomless pit; there was soon further use for the generals, who even succeeded in salvaging the image of an "unsullied Wehrmacht". This was a decisive prerequisite for the survival of the myth of an army abused by Hitler and the SS that has continued to assert itself to this very day.[34] A number of circumstances coincided to support this. To begin with there was the *Denkschrift der Generäle* (generals' memorandum), presented to the International Military Court in Nuremberg in which some of the former commanders-in-chief tried to disguise the extent to which the Wehrmacht knew about, or was involved in, the ideological war and the anni-

hilation. The generals hoped to shirk responsibility by referring to the special function they had for the troops and by claiming to have taken a non-political, distanced, even oppositional stance towards Hitler. Then it became clear that due to Germany's new front position in the Cold War the old enemy images still had a certain currency. Finally, the Wehrmacht High Command's collective acquittal at the Nuremberg Military Tribunal also made a considerable contribution.

Both the generals and later generations succeeded in psychologically repressing something the judges wrote into their judgement, namely, that the General Staff and High Command "had participated actively or stood by in tacit agreement as before their very eyes crimes were being committed larger in scale and more outrageous than anything the world had ever had the misfortune to see". The lie about the "unsullied Wehrmacht" nurtured the legend of the misused "simple" duty-bound, ordinary soldier and the professionally authoritative and morally irreproachable German officer. In the 1950s, as the Bundeswehr was being built up, this image was effectively popularized in magazine series, war stories and war films (such as *Unternehmen Barbarossa, Verbrannte Erde, Der Arzt von Stalingrad,* and *08/15; Canaris,* to name just a few). Many of these were written by former Wehrmacht or SS members, and the books sold in their millions.

Also repressed was the fact that large numbers of Wehrmacht soldiers had become murderers, as was the possible role played in this by the kind of enemy images and orders communicated to those soldiers by the Army High Command. These, namely, repeatedly betrayed the same stereotypes: "inundation by Asians", "opposition to Jewish Bolshevism", the "iron will to totally and mercilessly annihilate the enemy". A so-called *Führerbefehl* (Führer command) passed on to the troops by Keitel, head of the Armed Forces High Command, refers to the soldier's right and duty in this battle "to use all the available means, without reservation and even against women and children, to succeed".

It was not difficult for the Wehrmacht to make a taboo of its participation in the destruction of the European Jews, as that involvement had been camouflaged in apparently harmless military jargon such as "retribution measures", "fighting partisans" and "prisoner-of-war matters". The established and potentially deadly code used internally by the Wehrmacht did not need to be deciphered; it was well-know that *Partisanen* were Jews, *Kriminelle* were gypsies, *Flintenweiber* were uniformed women, *Kundschafter* were children, to say nothing of the *Kommissarbefehl* of 6 June 1941 and the subsequent "special treatment" meted out to large numbers of Soviet prisoners-of-war by Wehrmacht, SS and security police.

This rather abstract and unrealistic self-image of the "unsullied Wehrmacht" is contradicted by an almost overwhelming amount of concrete evidence contained in innumerable military letters and photographs, or brought forward by people who were themselves involved.[35] These photographs include scenes of deportations, selections and mass executions. At the time of the so-called operational groups, mass killings were carried out in public, occasionally "as a

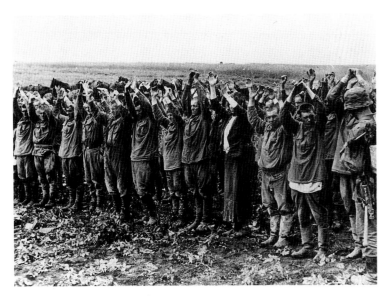

Red Army prisoners-of-war

resulting photographs was great. Prisoners in the camps took photographs secretly and smuggled them out to inform and alarm the world. The Nazis photographed and filmed their own embellished version of life in the ghettos and concentration camps to deceive and placate the world, as illustrated by the 1933 magazine reports on the Dachau concentration camp. They also took photographs in the ghettos and concentration camps for official use only, to document that orders had been fulfilled. A case in point is the infamous report, complete with copious photographs, by SS general Jürgen Stroop who was charged with liquidating the Warsaw ghetto: Es gibt keinen jüdischen Wohnbezirk mehr! (There is no longer a Jewish Quarter) The Nazis also took photographs unofficially, presumably to capture a particular image for themselves, their families and for posterity. When the Allies liberated the camps they also filmed and photographed the plight of the survivors and the mountains of dead bodies with the aim of confronting the Germans at least about the outcome of their war of annihilation against "Jewish Bolshevism" – a war they had wanted and accepted and for which they were being indicted. These photographs of the genocide were used as evidence at the Nuremberg Tribunal and later at numerous other NS trials, often serving to identify the perpetrators of the crimes and confirm witnesses' statements. The claims being made otherwise seemed implausible, in fact quite inconceivable, as did the graphic images they provided of an inferno which contemporaries exhibited a defiant and despairing unwillingness to accept. When Hannah Arendt spoke in the 1950s about the unreality of "the photographed events" in the camps, the photographs in question were being viewed from the perspective of a deeply perturbed morality. They were an outrage to human understanding because they went far beyond the nihilist statement that "all is allowed" and demonstrated that "all is possible".[37]

type of public entertainment" during which "soldiers sat on rooftops and rostrums to watch the spectacle". The respective evidence was found on dead or captured German soldiers and, needless to say, the Russians made no distinction between Wehrmacht and SS uniforms.

Despite the fact that taking photographs was generally prohibited during mass executions, a considerable number of photographs of Wehrmacht and SS crimes have survived. The ban obviously had to be reiterated constantly and could only be realistically monitored inside the concentration camps. Yet clearly a large number of cameras were focused from all angles on the persecuted, the dead, the spectators and the perpetrators of these atrocious acts,[36] and interest in the

The truth about Dachau, photoreportage in *Münchner Illustrierte Presse*, 16 July 1933

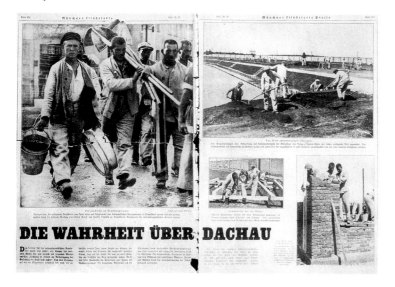

Taken out of the bunkers by force

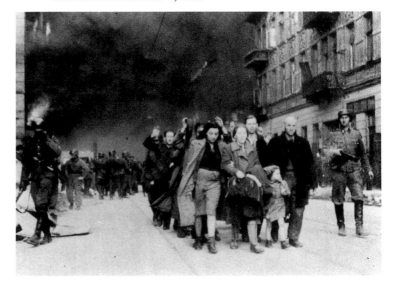

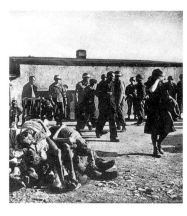

Margaret Bourke-White, The Mayor of Weimar and his wife went home and committed suicide. After the liberation of the concentration camp at Buchenwald by the US Army, citizens of Weimar were led through the camp, April 1945

The shocking impact of these photographs has not been dissipated. It has remained with us and altered our perception. With the passage of time, we see these images of deportations, selections, railway tracks, platforms, mountains of glasses, hair and suitcases, from a different angle. They still horrify us, but now it is because we see them in a wider context and realize that they confirm not so much the evil mentality of the perpetrators as the modernity of evil, the ambivalence of bureaucratic and socio-technological rationality, in other words, the two faces of the Third Reich, the simultaneity of an extraordinarily shaping and destructive power. The photographs stand apart from one another, refusing to be linked together or integrated into the continuum of time. This is one of the reasons why the modernization debates about the Third Reich's place in German history are so controversial and anyone relativizing the caesura of the years 1933 to 1945 is quickly suspected of playing down the NS era. Consequently, we are both disconcerted and bewildered when, almost as a matter of course, contemporaries of the events link such images or integrate them into the continuity of their life and times – as in the photo album owned by the last commander of the Treblinka camp and proudly entitled *Die schönsten Jahre meines Lebens* (The best years of my life).[38]

Notes

1 Harald Welzer, "Die Bilder der Macht und die Ohnmacht der Bilder" in Harald Welzer (ed.), *Das Gedächtnis der Bilder. Ästhetik und Nationalsozialismus*, Tübingen 1995, pp. 165 ff.

2 Berthold Hinz, "Disparität und Diffusion – Kriterien einer 'Ästhetik' des NS" in *kritische berichte* 17(1989)2, pp. 111 ff.

3 Whereas the modernization debate devotes a lot of attention to the link between social policy and annihilation policy in the NS State, little is given to that between cultural policy and annihilation policy. Cf. Cynthia Ozick, *Art and Ardour*, New York 1984, and the excellent film-essay by Peter Cohen, *Architektur des Untergangs* (1989).

4 Berthold Hinz, "Bild und Lichtbild im Medienverbund." in *Kunst Hochschule Faschismus. Hochschule der Künste Berlin* (ed.), Berlin 1984, pp. 17 ff. On NS-photography cf. Rolf Sachsse, *Photographie im NS-Staat. Die Erziehung zum Wegsehen*, Bonn 1995.

5 Reference is to my earlier work *Der Schöne Schein des Dritten Reiches, Faszination und Gewalt des Faschismus*. Frankfurt am Main, 1993, and to a more recent work by Herfried Münkler, "Die Visibilität der Macht und die Strategien der Machtvisualisierung" in *Macht der Öffentlichkeit – Öffentlichkeit der Macht* ed. by Gerhard Göhler, Baden-Baden 1995, pp. 213 ff.

6 Adolf Hitler, *Mein Kampf*, Munich 1940, pp. 116, 525 f. and 535 f.

7 Cf. Gerhard Paul, *Aufstand der Bilder. Die NS-Propaganda vor 1933*, Bonn 1990; On the SA cf. Peter H. Markl, *The Making of a Storm-trooper*, Princeton 1980; Peter Longerich, *Die braunen Bataillone. Geschichte der SA*, Munich 1989; Thomas Balistier, *Gewalt und Ordnung. Kalkül und Faszination der SA*, Münster 1989.

8 Quoted from Gerhard Paul, 1990; cf. note 7, p. 133.

9 Cf. Siegfried Zelnhefer, *Die Reichsparteitage der NSDAP. Geschichte, Struktur und Bedeutung der größten Propagandafeste im nationalsozialistischen Feierjahr*, Nürnberg 1991; Sabine Behrenbeck, *Der Kult um die toten Helden. Nationalsozialistische Mythen, Riten und Symbole*, Vierow b. Greifswald 1996.

10 Cf. Kurt Wehlau, *Das Lichtbild in der Werbung für Politik, Kultur und Wirtschaft*, Würzburg 1939; Willy Stiewe, *Das Pressephoto als publizistisches Mittel*, Phil. Diss., Leipzig 1936.

11 Peter Panter (pseudonym used by the writer Kurt Tucholsky), "Ein Bild sagt mehr als 1000 Worte" in *Uhu* 3 (1926)[2], pp. 76 ff.

12 Cf. various contributions in *Die Gleichschaltung der Bilder. Zur Geschichte der Pressefotografie 1930–1936*, ed. by Diethart Kerbs, Berlin 1983 (exhibition catalogue).

13 Cf. Thomas Friedrich, "Das Revolutionstrauma der Nationalsozialisten und der Umgang der NS-Bildpropaganda mit den Fotos der Novemberrevolution" in *Revolution und Fotografie. Berlin 1918/19*, Neue Gesellschaft für Bildende Kunst (ed.), Berlin 1989, pp. 227 ff. (exhibition catalogue).

14 Cf. Dietz Bering, *Kampf um Namen. Bernhard Weiß gegen Joseph Goebbels*, Stuttgart 1991.

15 Cf. Rudolf Herz, *Hoffmann & Hitler. Fotografie als Medium des Führer-Mythos*, Munich 1994. Also Brigitte Bruns, "Neuzeitliche Fotografie im Dienste der nationalsozialistischen Ideologie. Der Fotograf Heinrich Hoffmann und sein Unternehmen" in Diethart Kerbs, 1983; cf. note 12, pp. 172 ff.

16 *Simplicissimus* no. 9, 28.5.1923 and Konrad Heiden, *Adolf Hitler. Eine Biographie*. Vol. 1, Das Zeitalter der Verantwortungslosigkeit, Zurich 1936, pp. 117 ff.

17 Cf. Joseph Peter Stern, *Hitler. Der Führer und das Volk*, Munich 1981.

18 Konrad Heiden, 1936; cf. note 15, pp. 108 ff. and 336 ff.

19 Cf. Joachim Fest, *Hitler. Eine Biographie*, Frankfurt am Main, Berlin 1973, pp. 555 ff.

20 Cf. Ulrich Chaussy/Christoph Püschner, *Nachbar Hitler. Führerkult und Heimatzerstörung am Obersalzberg*, Berlin 1995.

21 Ian Kershaw, *Hitlers Macht. Das Profil der NS-Herrschaft*, Munich 1992, p. 141; Ian Kershaw, *Der Hitler-Mythos. Volksmeinung und Propaganda im Dritten Reich*, Stuttgart 1980.

22 Cf. in particular Hans-Ulrich Thamer, *Verführung und Gewalt. Deutschland 1933–1945*, Berlin 1986; Neue Gesellschaft für Bildende Kunst (ed.), *Inszenierung der Macht. Ästhetische Faszination im Faschismus*, Berlin 1987 (exhibition catalogue); Hans-Uwe Otto and Heinz Sünker (eds.), *Politische Formierung und soziale Erziehung im Nationalsozialismus*, Frankfurt am Main 1991; Peter Reichel, *Der schöne Schein des Dritten Reiches. Faszination und Gewalt des Faschismus*, Frankfurt am Main 1993; Ulrich Hermann/Ulrich Nassen (eds.), *Formative Ästhetik im Nationalsozialismus. Intentionen, Medien und Praxisformen totalitärer ästhetischer Herrschaft und Beherrschung*, Weinheim/ Basel 1993.

23 Cf. Eberhard Heuel, *Der umworbene Stand. Die ideologische Integration der Arbeiter im Nationalsozialismus* 1933–35, Frankfurt am Main 1989; Michael Ruck, "Vom Demonstrations- und Festtag der Arbeiterbewegung zum nationalen Feiertag des deutschen Volkes. Der 1. Mai im Dritten Reich und die Arbeiter" in *Hundert Jahre 1. Mai*, ed. by Inge Marßolek, Frankfurt am Main 1989.

24 Timothy W. Mason, "Die Bändigung der Arbeiterklasse im nationalsozialistischen Deutschland. Eine Einleitung" in *Angst, Belohnung, Zucht und Ordnung. Herrschaftsmechanismen im Nationalsozialismus*, ed. by Carola Sachse, i.a., Opladen 1982, pp. 11–54. Also Rüdiger Hachtmann, *Industriearbeit im 'Dritten Reich'. Untersuchungen zu den Lohn- und Arbeitsbedingungen in Deutschland 1933–45*, Göttingen 1989. Wolfgang Zollitsch, *Arbeiter zwischen Weltwirtschaftskrise und Nationalsozialismus. Ein Beitrag zur Sozialgeschichte der Jahre 1928–1936*, Göttingen 1990.

25 Ulrich Herbert, "Arbeiterschaft im 'Dritten Reich'. Zwischenbilanz und offene Fragen" in *Geschichte und Gesellschaft* 15 (1989)[3], pp. 320–360.

26 An indispensible work on this topic is Wolfhard Buchholz, *Die nationalsozialistische Gemeinschaft 'Kraft durch Freude'. Freizeitgestaltung und Arbeiterschaft im Dritten Reich*, Phil. Diss., Munich 1976; other references in Peter Reichel, 1993; cf. note 22, pp. 243 ff.

28 Cf. Karl-Heinz Ludwig, *Technik und Ingenieure im Dritten Reich*, Düsseldorf 1989, pp. 303 ff.; Rainer Stommer (ed.), *Reichsautobahn. Pyramiden des Dritten Reiches*, Marburg 1982; Hartmut Bitomsky, *Reichsautobahn* (documentary film by the German WDR television channel), Cologne 1986; Erhard Schütz/Eckhard Gruber, *Mythos Reichsautobahn. Bau und Inszenierung der 'Straßen des Führers' 1933–1941*, Berlin 1996.

29 Cf. special issue 'Krieg und Fotografie', *Fotogeschichte* 12 (1992) 43; Herfried Münkler, "Schlachtbeschreibung: der Krieg in Wahrnehmung und Erinnerung. Über 'Kriegsberichterstattung'" in *Fotogeschichte. Gewalt und Ordnung. Das Bild des Krieges im politischen Denken*, Frankfurt am Main 1992, pp. 176–207.

30 Cf. Wolfram Wette, "Ideologien, Propaganda und Innenpolitik als Voraussetzungen der Kriegspolitik des Dritten Reiches" in *Ursachen und Voraussetzungen des Zweiten Weltkrieges*, Wilhelm Deist/Manfred Messerschmidt/Hans-Erich Volkmann/Wolfram Wette, Frankfurt am Main 1989, pp. 25–208; Reinhard Rürup (ed.), *Der Krieg gegen die Sowjetunion. 1941–45. Eine Dokumentation*, Berlin 1991; Wolfgang Michalka (ed.), *Der Zweite Weltkrieg. Analysen, Grundzüge, Forschungsbilanz*, Munich 1989.

31 Marlis G. Steinert, *Hitlers Krieg und die Deutschen. Stimmung und Haltung der deutschen Bevölkerung im Zweiten Weltkrieg*, Düsseldorf/Vienna 1970. Gottfried Niedhart/Dieter Riesenberger (eds.), *Lernen aus dem Krieg? Deutsche Nachkriegszeiten 1918 und 1945*, Munich 1992.

32 Cf. among others, Wolfram Wette, "Das Rußlandbild in der NS-Propaganda. Ein Problemaufriß" in *Das Rußlandbild im Dritten Reich*, ed. by Hans-Erich Volkmann, Cologne 1993, pp. 55–78.

33 For an exemplary documentation by a war reporter cf. Winfried Ranke, *Deutsche Geschichte kurz belichtet. Photoreportagen von Gerhard Gronefeld 1937–1965*, Berlin 1991.

34 On the controversy surrounding the exhibition *Verbrechen der Wehrmacht* by the Hamburg Institut für Sozialforschung, see, for example, the positions taken by Karl-Heinz Janßen, "Als Soldaten Mörder wurden" in *Die Zeit*, 17.3.1995; Günther Gillessen: "Zeugnisse eines vagabundierenden Schuldempfindens" in *Frankfurter Allgemeine Zeitung*, 6. 2. 1996.

35 Cf. Hannes Heer/Klaus Naumann (eds.), *Vernichtungskrieg. Verbrechen der Wehrmacht 1941–44*, Hamburg 1995; Ernst Klee/Willi Dreßen (eds.), *'Gott mit uns'. Der deutsche Vernichtungskrieg in Osten 1939–1945*, Frankfurt am Main 1989; Ernst Klee/Willi Dreßen/Volker Rieß (eds.), *'Schöne Zeiten'. Judenmord aus der Sicht der Täter und Gaffer*. Frankfurt am Main 1988.

36 Cf. special issues "Lager, Gefängnis, Museum. Fotografie und industrieller Massenmord" in *Fotogeschichte* 14 (1994) 54 and 55.

37 Hannah Arendt, *Elemente und Ursprünge totaler Herrschaft*, Frankfurt am Main 1962, pp. 644 ff.

38 Adalbert Rückerl (ed.), *NS-Vernichtungslager im Spiegel deutscher Strafprozesse. Belzec, Sobibor, Treblinka, Chelmno*, Munich 1977, pp. 44 ff.

Rolf Sachsse

Photography as NS State Design
Power's abuse of a medium

A medium makes its mark and is instrumentalized by politics. As a result most people look the other way, turn a blind eye, as if it were no concern of theirs that millions of their fellow-citizens were being oppressed, humiliated, arrested, deported to camps, and murdered. What is it about the power of the media that can side-track people's everyday conscious perceptions so completely that they do not (want to) notice they are being manipulated? In the end, a world war was being waged around them with the help of those same media, and still nobody wanted to know why. What makes people so easily seduced? Just how far-reaching is the power of the media?

The term "state design" can really only be used retrospectively to describe photography's function for the NS regime and its citizens. Design in the sense commonly used today to designate an all-embracing shaping concept did not exist then. Neither Nazi party, government nor Wehrmacht propaganda strategists had a definitive concept of how to practically manipulate an entire population. On the contrary, their interventions into everyday life must be regarded as being part of a self-regulating, autopoietic system in which several minor causes provide the impetus for major effects. Design includes a broad realm of aesthetic action whose effects can only be controlled indirectly, usually by rendering the causes anonymous. The ruling political and military elites were at least partially aware of this; the Ministry of Propaganda did all in its power to keep abreast of advances in mass communications research, even at international level. A study of the pictorial medium of photography and its utilization by the NS state for propaganda, journalism and documentation purposes is only meaningful if such a system of aesthetic and media self-regulation is assumed. Within an ideologically coloured perception of the fine arts, it is admissible to use all forms and means available to achieve the greatest possible effect, even if they are otherwise reputed to be part of the much denigrated avant-garde; this explains why, of the Modernist artists, Herbert Bayer was not included at all in the exhibition *Entartete Kunst* (Degenerate Art), while László Moholy-Nagy's works were hung in a room inaccessible to the general public.

One fundamental problem that arises in any historical treatment of the NS state's visualization is the discrepancy between the enormous amount of pictorial propaganda material available and the insignificant amount of theoretically-backed instructions on press reporting or censorship; these in turn totally outbalance the tiny number of photographs betraying signs of opposition or sympathy. This disproportion gives rise to a quantum leap in the evaluation of these photographs. The individual propaganda photo signifies almost nothing, that is to say, it can scarcely be analyzed as a symbolic carrier,

whereas the few surviving photographic witnesses of resistance, the ghettos and the camps, necessarily take on the status of icons.

Along with the accompanying text, the photograph had the task of both facilitating and disguising the NS propagandists' utilization of the mass media for imparting their biased message. The media were not intended to be the message but rather an effective tool for communicating aesthetic ideas and programmes in which there was no room for people – especially not for people who were in any way outsiders. By definition, NS propaganda was a process of education that ran parallel to consumer advertising and counter to what was called smear campaigning. In this context, the educational theorist Ernst Krieck's claims take on a particular significance as they laid the foundations for a "persuasive" education, while also leaving room for racist conclusions. In principle, this process of "educating people to look the other way" was modern and could thus avail itself of modern means.[1] Part of this propagandistic amalgamation of advertising and education was to use images which, in terms of their composition, pulled all the persuasive stops, implied infinite reproducibility in finite reproductions, and attempted, by amassing all the forms available, to industrialize and thus instrumentalize people's perceptions.[2] Whether or not this was entirely successful is another matter.

To base an educational process on the manipulation of individual memory by maintaining full control of the motifs and the media must have been especially attractive for a politically reactionary regime such as the NS state (and indeed many other dictatorships). At first the state was vaguely interested in the production of positive memories in the interests of a long-term maintenance of power. Photography was regarded as the medium best suited to this, and on this assumption, the mode of organization was to proceed from the grass-roots up: not so much the great pictorial achievements of the professionals, artists and photojournalists, were of primary tactical significance to the state, as the simple snapshots taken by anyone capable of holding a camera. Accordingly, large numbers of photos of everyday life and family events, taken and processed anonymously, became more important to the NS regime than its own form of self-presentation in newspapers, magazines, and documentary films or newsreels *(Wochenschau)*. Like all the other political parties in the early 1930s, the National Socialists too availed themselves of contemporary means of public presentation, though fully aware that the journalists of any note, being more left-wing liberal in their views, wanted nothing to do with them. A clear indicator of how seriously they took the disadvantages they had in this respect, was the rigorous influence they exerted on the press and publishers during 1933 and 1934. There was

a serious shortage of new generation photojournalists, with the result that even mediocre photographers had great job opportunities. During the 1936 Olympic Games a large amount of the photo material had in fact to be bought from foreign news agencies and reporters. Yet the problem could not be solved simply by up-grading the profession. The military press units, or *Propagandakompanien,* set up shortly afterwards may have been well provided with equipment and staff, what they lacked in their ranks were good photographers. When the Ministry of Propaganda set up its *Referat Lichtbild* (photography department) in 1933, it made no distinction between amateurs and professionals. However, most of the attempts made to recruit a new generation of photojournalists from among the amateur photographers organized in upper middle-class photography societies failed. Were the overall notion of the production of positive memories to be salvaged, then there was little other option as of 1937 but to promote amateur photography on a very broad social scale. This aim was foiled by the outbreak of war.

The NS regime was forced to make a virtue of necessity, that is to say, to create the desired positive identification patterns for both citizens and state out of the poor quality photographs reproduced in newspapers and magazines in the early years of its existence. In doing this, the petty bourgeois taste of those in government coincided perfectly with the longing of the governed for a secure and cosy niche existence. The predominant motif was the idyll. This had already constituted the latent basis of art photography at the turn of the century, after which it had become a binding link for all amateur photographers. In the 1920s, the idyll also influenced the pictorial world of weekend newspaper supplements, travelogues and film stills. In the 1930s, it was ever-present in all illustrated publications, serving ideally to veil reality. As photojournalism lacked the capacity to present the regime with pathos and sensuality – herein lay a fundamental difference between it and sculpture, for example[3] – editors and their political patrons resorted to the already ubiquitous idyll: Not only were political leaders portrayed surrounded by flowers and people in national costume, the whole of Germany now consisted of picturesque sleepy little towns and rugged market traders with rosy-cheeked children. Worse still – and one of the appalling effects of NS propaganda – people were more than willing to accept this pictorial world as the truth.

There can be no doubt that photography was part of the propaganda machine.[4] The latter embraced not only the whole of NS cultural policy, but any sector that exerted an influence on the masses, be that the press, the media, or even individual events. The propaganda machine was to be installed as a smoothly running clockwork mechanism, kept in motion by occasional impulses from the political realm but otherwise working away unobtrusively. As early as the nineteenth century, it had been a specific feature of conservative media policy to negate the effect, even the existence of media communication – the idea being to be better able to manipulate it.[5] Consequently, all media activity in and around the Ministry of Propaganda was aimed at ensuring the machine functioned as smoothly and precisely as possible. This media activity consisted not simply of Minister Goebbels' speeches and personal memos, or of decrees issued by the Ministry, Hitler's adjutant general, or the chancellery, though these were decisive in the creation of communications guidelines. It consisted first and foremost of a self-propelling discourse made up of administrative procedures, anticipatory obedience, compliance and its acknowledgment, and threats of punishment for deliberate or negligent misconduct.

The Ministry of Propaganda's whole structure was implicitly aimed at creating quasi self-impelled procedures that could not be traced back to any individual source.[6] Such a process of depersonalization was particularly suited to ideological axioms and an administration designed to release individuals from responsibility, off-loading the latter onto the procedure as such. Hitler, Goebbels and Rosenberg had already committed the constituent guidelines for such a structure to paper. All that was required for them to quickly and effectively permeate the entire administration were minor initiatives. Both for internal purposes and in communications to the outside world, that is to say, the press and the people, any such initiative was referred to as an *Erlaß;* by combining this feudal term for a decree with the epithet used for the country's leader, one arrives at the designation *Führererlaß,* an ex cathedra construct beyond which no further inquiry was possible. As of autumn 1933, editors of publications with offices in Berlin were obliged to gather at midday every working day for the *Reichspressekonferenz* at which they received the latest news from the *Deutsche Nachrichten Büro,* the Reich's own news agency, announced personally by the *Reichspressechef* or one of his deputies.[7] This daily conference was the NS state's most important instrument for controlling the press; it had a complement in special weekly or irregularly convened conferences of which the so-called *kulturpolitische Pressekonferenz* was of some relevance for photography.

At these conferences photographs were generally treated in the same way as news items: if some person or event was not to be reported on then obviously no photographs were available. In all news items the primary focus was still on the power of the word.[8] Direct reference to photographs was usually made in two specific contexts: when they were to embellish verbally initiated campaigns, and when they were banned or censored. Instructions for the use of the photographs were given according to hierarchical function: the editors were addressed, not the reporters or photojournalists. Comments were rarely made to the actual work of the photographers, except perhaps in the form of a generally formulated criticism, for example, of how boring the photographs taken at some state event or other were. The photographers worked under a division of labour whose extent or importance they only partially understood – and with which they did not feel any particular need to concern themselves. On the other hand, their photographs provided the visual element in a conventionalized mode of communication to which the leaders only needed to react.

The cult of Adolf Hitler constitutes an example of National Socialist sales promotion; he was the piece of soap as which politics,

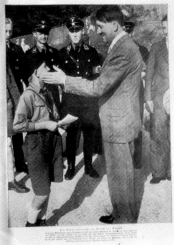

Heinrich Hoffmann, double page in *Der Illustrierte Beobachter,* 1936

Exhibition *Gebt mir vier Jahre Zeit!,* Berlin 1937

as he understood it, was to be sold to the general public. The figure of the *Führer des Deutschen Volkes* – a mixture of god, emperor and foreman – was to be omnipresent. Adolf Hitler's image, like that of former rulers, was both a symbol of protection and a demonstration of power.[9] Not only were the Führer's photos supposed to communicate an authentic impression – photography's very own speciality – they also had to transport symbolic values, transcend the regime – a task ideology assigned to art. The NS regime was at constant pains to make its personalized advertising logo appear as earnest as possible and as "popular" as was necessary. Almost all the efforts made to stage-manage Hitler's public appearances were marred by the irreconcilability of these diametrically opposed roles of statesman and popular hero. That the NS state viewed this particular propaganda sector as highly sensitive is demonstrated by the numerous regulations and prohibitions relating to the respective photographs.

At the fairs and exhibitions organized during the NS era – and often described as the last bastion of modernism under the swastika – photography had various functions to fulfil, apart from documenting the architectural design and decorative features of the stands. Its primary function was to create visual atmosphere, to evoke pre-linguistic moments. Standard elements in individual photographs, usually combined in huge formats like collages or photomontages, were expected to have an exact bearing on reality and avoid any impression of being an optical illusion. No effort was spared in mounting the individual photographs: from the huge but relatively boring pictorial friezes in the *Ehrenhalle* section of the *Kamera* exhibition in 1933, to the large montages in individual sections of the *Deutschland* exhibition in 1936 and the multi-media utilization of large-format photographs in the exhibition *Gebt mir vier Jahre Zeit* in 1937. In the latter case, Egon Eiermann's architectural design for the main concourse with its countless photomontages radiated an avant-garde modernity blighted only by Heinrich Hoffmann's "pictorially-lit" head of

Adolf Hitler[10]. Moreover, the entrance hall was at the forefront of modern developments: six large screens each measuring 45 square metres were covered with individual photographs changed hourly by a roller mechanism. The photographs used for the montages in the main concourse were almost all in the formal idiom of the New Vision, whereas the individual photographs on the large screens in the entrance hall gave a static impression, more in keeping with the style of contemporary photojournalism. There are conflicting claims about the success of these exhibitions and fairs. All in all, the *Deutschland* exhibition mounted for the 1936 Berlin Olympic Games was well attended, whereas the monumental propaganda effort *Gebt mir vier Jahre Zeit* is said to have attracted few visitors. The moment the NS regime felt it was at the zenith of its power, it revised its concept for exhibitions. The advertising agency *Deutsches Propaganda-Atelier (Pay Carstensen Institut),* founded in 1936 and owned by the Ministry of Propaganda, may have been set up in accordance with the most modern of princi-

ples, yet the exhibitions it mounted were all conventional and petty bourgeois in style – in fact, just what the people wanted to see.

The construction of the German *Autobahn* was a large-scale project to which the NS state accorded absolute priority. It constituted an important meeting point between industry and propaganda, ideally linking economic, propagandistic and military interests.[11] The Autobahn was not an idea originally conceived by a party or government official. It was adopted from private industry, and as the focal point of so much unparalleled energy, soon fused the identity of the German citizen with the concept of motorization on high-speed roads. However, as only very few people could actually afford this pleasure, it had first to be construed as a highly desirable ideal. It seemed advantageous, both economically and politically, to concentrate on motorization as an apparently individual, though thoroughly regulated mode of travel within the German Reich's clearly delineated borders. Here too, the history of the Autobahn contains a history of pictorial forms. During the first four years of its construction it was presented in the New Vision approach, with posters and brochures exhibiting a clear preference for photomontage; after 1937 however, a thoroughly retrograde pictorial policy was adopted, which became manifest in a competition

Erna Lendvai-Dircksen, The Reichsautobahn, reproduced in *Mensch und Werk*, 1939

Wolf Strache, *Auf allen Autobahnen, Ein Bildbuch vom neuen Reisen*, 1939

organized by the magazine *Die Straße,* and in two popular illustrated books on the Autobahn.[12] Visually, all that was left of the one-time fascination with the technical construction of the Autobahn was "the beautiful motorway under construction and traffic" consolidating all the racist-informed and ecologically-tinged *Heimat* clichés as it wound its way in sweeping curves through a hilly wooded landscape.[13] Yet this did not mean that more modern pictorial forms could not be utilized, as two books published around 1939 demonstrate: Erna Lendvai-Dircksen continued her series of racist portraits by photographing construction workers on the Autobahn, thus legitimating a form of socially class-conscious portraiture initiated by August Sander and continued in a perverted form during the era of the NS state. Wolf Strache was able to adapt contemporary pictorial forms for his detailed depiction of modern architecture. In so doing, however, he was content to confine himself to a context which he felt was appropriate and which he had already chosen for other book projects: war technology – the one modern thing about the NS state and one that called out to be presented by modern means.[14] A third book published in 1942 in memory of the co-ordinator of construction work on the Autobahn, Fritz Todt (who had been killed in an accident), attempted to extend the modernity of its design to include colour. Its other modern features were a moderately objective pictorial idiom from an axial viewpoint, close cropping, and documentary motifs. The attempt was not a success.[15]

No shortage of attempts were made to bring NS photography aesthetically in line with surrealist pictorial forms. Photography and painting in the 1930s frequently exhibit such features as compositional vagueness, highly detailed surfaces under "glamour lighting", or juxtapositions of otherwise incongruous items.[16] Elements of an international aesthetic are also to be found in the works of individual German photographers who remained in the country during the NS era or returned there around 1937, on being threatened with the loss of their citizenship. It would be audacious, however, to want to distill a specific aesthetic out of these features. The painter Heinrich Heidersberger, for example, had lived in Paris (and regarded himself as part of the circle around Giorgio de Chirico and the *pittura metafisica).* Yet after returning to his family in 1937 and settling in Braunschweig, his work radiated only the vaguest reflections of his time in Paris. His monumental *Festschrift* for the Heinkel plant in Oranienburg contained several views of apartment blocks and transformer stations taken against a pitch-black sky, and others of construction blocks under a setting sun. These are rare, however, compared with his numerous sober portrayals of industrial architecture, and certainly not enough on which to construct a surreal NS aesthetic.

The same applies to fashion photography in NS Germany. This export-orientated sector necessarily had to keep up with international standards, at least until 1938. Correspondingly, the works of Yva, Ewald Hoinkis and others followed trends which could be labelled "surrealist", but there their modernism ended: the settings were comparatively inelegant, the models less erotic, and above all, the couturiers were

Heinrich Heidersberger, Company housing estate Oranienburg, 1937

qualitatively inferior to those in France, Great Britain or the USA. Even before the National Socialists came to power fashion photography had already become the domain of exiles from Germany. By 1930 George Hoyningen-Huené had already left the German studios behind him, and Horst P. Horst, who had begun studying under Le Corbusier, quickly found his way behind the camera after a time as a photo model. Wilhelm Maywald and Erich Blumenfeld, on the other hand, were forced to take flight from the Nazis and start out on new and uncertain careers in France and the USA.

In 1933 the profession of photographer in Germany was in a sorry state. Three and a half years of economic crisis had stemmed the tide of commissions and swallowed up people's savings. Following an old German tradition, photographers took refuge in the apolitical niche of personal survival – politics was the responsibility of others, as was professional and vocational policy. A contribution made by the *Lichtbild Referent* to a Propaganda Ministry exhibition catalogue gives some impression of how politicians at the time viewed the profession of photographer. After an acknowledgment of photography as a "genuine people's art" we read their concrete expectations: "... Photography as a profession, as the professional representative of an essential people's art, is to receive new impetus ... It may even be necessary for German photographers to become involved in German advertising in a completely new way."[17] Exactly what this meant becomes clear in the following: "It will be up to the profession of photographer to promote photography in a racial sense." Photographers like Erna Lendvai-Dircksen and Erich Retzlaff had already put forward such ideas before 1933 and been met, justifiably, with widespread incomprehension; their success under the new regime was all the greater. This presentation of the profession's self-image culminates as follows: "Let us accustom ourselves, therefore, to speaking of photography as a craft, and to doing so with a traditional artisan's pride.... The values pursued by this craft include a vital inner link between the work

and national customs and traditions, an acknowledgment of responsibility for the work, and a highly developed technical perfection and cleanliness".[18] Apart from the last value mentioned, which has taken on a particular quality in view of the smooth-running machinery of destruction in Auschwitz and elsewhere, this conception of the profession of photographer has prevailed to this very day.

Most of the photographers who remained professionally active during the NS era later admitted to having had sympathies for the NSDAP even before 1933. There is a biographical reason for this. Most of these photographers were born between 1895 and 1910 and in various interviews they later mentioned their more or less strong links with the German Youth Movement – whatever the respective individual may have understood by that term. The majority of the Youth Movement associations and clubs pursued a common aim: a basically apolitical return to a harmony with nature – nature being regarded as given and immutable. For this the groups required binding links such as a nature mysticism, nutrition strategies, and a body culture. Depending on the group protagonists' particular leanings, these epistemes and guiding principles for action were variously weighted and sometimes expanded into something like a quasi-religious agenda. Even if the individual was not explicitly a messenger (of salvation), his or her links with such groups politically alienated them from reality. This alienation was wide open to abuse by propaganda programmes. For these young professional photographers, the National Socialists' accession to power meant the chance of a lifetime, that is, once the oppositional and Jewish photojournalists had left the country and the huge diversity of press publications prevalent in the 1920s had been reduced to just a few Nazi rags. The propaganda campaign being carried on in all walks of life required new and appropriate photographic material and there were far too few photographers to provide it. As they were not bound by traditional structures, all the young propagandists needed to do was fall back on their Youth Movement repertory of leisure and nature activities, body culture and community ideals. Not only was this timely, it also enabled them to regard themselves as heralds of future generations. A few compositional references to the quasi classical ideals gleaned from their vocational training quickly ensured a respectable living – with no necessity for anxious, sidelong glances at the really "high arts", and with no pressure to legitimate their work against reproaches of inferiority.[19]

In an era of state propaganda strategies, how a profession presented itself was of great significance. Both the NS regime and industry acknowledged amateur photographers in their capacity as real mass propagandists, however, the photographers themselves still had to justify their existence on a broad basis and against competition from the more intellectual press and cinema photographers. A negative self-image was not the right prerequisite for the positive world view the photographers were supposed to convey. These were some of the indirect reasons for the emergence of an unprecedented star cult in the realm of professional photography. Walter Hege was undoubtedly one of the first stars of German photography. By the

Walter Hege, The Ehrentempel in Munich, 1939

latest after his 1928 *Acropolis* series he was being hailed as the ingenious mediator of ancient beauty and greatness. In 1930, after the election of an NS government in the state of Thuringia, the Weimar *Baugewerbeschule* (school of architecture) was taken over by Paul Schultze-Naumburg, who immediately set about creating a new chair of photography for Walter Hege. In February 1930, shortly before his appointment, Hege had already commended himself for the post by publicly declaring his support for the NSDAP, which he joined the same year. His own pictorial inclinations were expressed in a heroic view of superhuman greatness – as manifest in antique sculpture and architecture, especially in a state of ruin. This went to the very heart of all the backward-looking tendencies of the late 1920s. With the most advanced technical means Hege portrayed immortality and monumentalism, while at the same time reducing these to a craftsmanship capable of demonstrating the *Triumph of the Will* in technical achievement. There is a striking similarity between Hege's work and Leni Riefenstahl's films. For many of her camera angles she adopted his photographic viewpoint, while he took over her editing technique in

his films. Hege's star status was acknowledged mainly among the NS state's leading political and cultural protagonists. Albert Renger-Patzsch and Paul Wolff on the other hand, exerted more influence on amateur photography and its propagandistic exploitation, and qualified as guarantors of a continuation of a modern form of commercial photography in the NS state. Whereas Renger's photos were used with maximum didactic effect in journalistic propaganda – without his active co-operation, though not expressly against his will – Wolff pursued his successful career in the NS state with deliberation and all the means available.

Albert Renger-Patzsch's photographs exhibited all the features of a skilled or even virtuoso mastery of technique, which is what made them the yardstick of (moderate) modernity as regards depicting objects in the form required by the NS state. Contemporaries were aware that this meant the photographer was to disappear behind his photos. Albert Renger-Patzsch's reputation as a "difficult" artist was compounded by the fact that he gave up his teaching post at the Folkwang School in Essen in 1934 after only one term. Whether he did so out of solidarity with the teacher and institute director Max Burchartz, who had been dismissed, or because of reproaches made against the director of the Folkwang Museum, Martin Grisebach, can no longer be ascertained. One way or the other, Renger kept his studio on the ground floor of the museum up until the bombing of the city of Essen. It is quite possible that for the photographer Albert Renger-Patzsch the old relationship between artist and society still applied in which the artist counted for nothing, the work for everything. The same can be said about the impact of his works in the context of NS propaganda. His photos tended to be reproduced as exemplary models suitable for motivating others to aspire to perfect craftsmanship and an objective rendering of the subject.

A photographer such as Paul Wolff did not disappear so easily behind his work. On the contrary. Although a number of other photographers also had the academic title of *Doktor,* Wolff was the only one to succeed in linking his so closely to his name – much like Propaganda Minister Goebbels – that even international historians of photography have not been able to prise them apart.[20] Wolff's speciality was to imbue his professional and complex photo production with an amateurish aura; his photos looked as if anyone with similar technical means could imitate them. This applied in particular to his numerous works on the theme of travel. Photography and travel have been inseparably linked since the advent of both the medium and the various means of transport.[21] The two activities are closely associated with leisure-time, that realm of individual freedom where energy is regained for work and where the prime mover is the illusion of freedom. Alongside sport, travel is surely the most important of all free-time activities, though unlike sport it bears the blemish of being a one-off experience. Since the 1880s, it had finally become possible to preserve travel experiences in photographs. A regime resolved to distort perception to the advantage of a privatized idyll must have seen this meeting point between photography and travel as an ideal moment at which to

Paul Wolff, *Groß-Bild oder Klein-Bild? Ergebnisse einer Fotofahrt durch Franken an die Donau,* 1938

intervene with propagandistic intent. However, the possibilities the Ministry of Propaganda and the *Deutsche Arbeitsfront* actually had for intervening were only indirect, usually taking the form of *Kraft durch Freude* (Strength through Joy) holiday programmes. These group holidays were organized on a strictly hierarchical basis and were available not only through the Strength through Joy association itself, but through most of the other NSDAP offshoots as well: The *Hitlerjugend* and the *Bund Deutscher Mädel* forcibly united all the former youth groups so as to ensure that their attractive leisure-time programmes – walking tours, camping holidays, sports festivals etc. – could be revived in paramilitary form. Here too, photography was integrated into the production of positive memories: the good life in the NS state was to find expression in pretty pictures of wonderful times together.

The 1936 Olympic Games, more especially, the Summer Games in Berlin, were doubtless a major festival of physical beauty. Hitler's VIP stand at the games was even shifted slightly off the central axis to accommodate Leni Riefenstahl's film cameras. There were also specially reserved, if spatially restricted, areas for the carefully selected

photojournalists, who were obliged to photograph the events dressed in outfits designed specifically for the occasion. In photography as in sport, however, anyone not suitable for the cadre had to join the amateurs. Among the photographers who failed to receive accreditation were passionate admirers of the NS leadership such as Paul Wolff and his photo agency, and the American James Abbe. Later, the two of them put this forward as proof of their having been hindered by the regime in the exercise of their profession. All in all, the 1936 Olympics constituted more a film than a photography event – film was that one decisive step ahead of the still image, well on the way to television.

After the 1936 Olympic Games, the NS regime felt it had its hands tightly enough on the reins of power to make a last attempt at integrating amateur photographers into their propaganda scheme. At great expense an exhibition entitled Gebt mir vier Jahre Zeit (Give me four years' time) was mounted in spring 1937 to mark the first four-year plan; this exhibition included a photography competition. Despite several calls to participate, and despite its extravagance and its modern design, the exhibition was poorly attended. Subsequently, amateur photography was more or less struck off the Propaganda Ministry's agenda. It had not succeeded in ideologically influencing that sector of free-time activities, nor in turning it into a wellspring of future photojournalists. However, the NS regime was still suffering from a lack of good and convinced propagandists, and would continue to do so up to its demise, so other ways and means had to be found to discover and promote new talent. There were two possibilities: vocational training in photography, and the integration of non-organized snapshot and amateur photographers into the regime's propagandistic strategies.

What the propaganda strategists understood by the term positive world view embraced foreign and local travel photography and school and youth photography. The negative effects of this were twofold. Millions of people in the NS state actually remembered their youth as a positive period in their lives thanks largely to the communicative achievements of amateur photography; what is more, the wide-scale promotion of the production of positive memories had so reinforced the notion of a privatized niche existence that the injustice being wrought on millions of other people could simply be ignored. People looked on, but no one saw what was happening. If a photo of deportations or torture happened to get captured on an amateur film it was quickly destroyed either by an "understanding" laboratory worker or by the anxious film owner. It is no wonder, therefore, that so little visual evidence of the everyday terror has come down to us, despite the existence of so many cameras; there are two sides to the idyllic coin.

The development, market launch, and utilization of colour photography highlight the close links that existed between the photography industry, political propaganda, state economics and aesthetic communication while the National Socialists held power. From the viewpoint of contemporary and economic history, colour film not only marked a new phase in the relationship between industry and politics, it also constituted a breakthrough in the effect industrial media had on aesthetic activity. Colour photography was fully in keeping with the interests of the German chemical industry, which was synonymous with the I.G. Farben company. These interests revolved around two goals: autonomy in the armaments industry, and the foreign currency income to finance this. Colour photography was more essentially linked with the second goal, but was not without relevance to arms production propaganda. With a view to the creation of positive memories, colour photography also played an important role in the regime's efforts to influence the psychology of the masses. Whether and to what extent the Ministry of Propaganda directly promoted colour film research cannot be proven one way or the other, but it is unlikely. What can be shown, however, is that the state had a lively interest in this research and its findings. Colour film perfectly suited the commercial strategy of I.G. Farben and Agfa, promising to become an export article that would guarantee foreign currency earnings. At the same time, it was a propaganda medium of relevance to the war effort. The realism of colour photography was considered more effective than the abstraction of black and white photography. An atmosphere of top secrecy marked the early stages in colour film's development between 1934 and early 1935. Official press conferences issued instructions that the film was not to be reported on.[22] This naturally increased the press' interest in the product, as was no doubt intended. The state's interest in the product on the other hand is illustrated in a pictorial reference whose message is more than obvious. The first successful photograph taken on colour film shows two female workers in front of the laboratory in Wolfen wrapped in colourful cloths; visible behind them is a colour chart for spectrometric analysis – and a swastika flag. No other industrial test photo displays such a large example of this emblem in such a compositionally significant position.

Both state and party were obviously interested in as many people as possible using the new film. This is reflected in the fact that its research and development were subsidized. There were two equally important reasons for this. Firstly, the largest possible number of consumers was to be introduced to the film so that they might use it not just for general purposes, but above all for propaganda purposes – when the time was right. 1937 was the year when state and party began their aggressive war preparations. Secondly, subsidized sales of the film offered a good opportunity to test its chemical and technical reliability. Yet things did not work out quite as planned. The film was neither produced nor sold in large quantities. There may have been technical reasons for this, but it was also an indicator of how slowly new consumer goods gained acceptance in the context of state propaganda and industrial advertising. The advent of colour film, like that of television, coincided with the outbreak of the Second World War.[23]

Since its invention, photography had been essentially linked with reproduction, which is also one of the reasons for its later success as a medium.[24] This meant not only the reproduction of individual photos but the option of producing large series of similar photos, which became common practice as of the middle of the nineteenth century.

Wilhelm Schneider, First Afga colour negative, 1935

Whether these series took the form of photo albums of famous contemporaries, police photograph archives of criminals and suspects, or comparative photos of the mentally ill, the very concept of the photo series always seemed to require some justification of this particular application and its high cost. Directly racist photo series turned up quite early in the context of colonial photography. These series, thinly disguised as ethnological studies, portray the people in question as different, even inferior. This kind of racism often reflected the arrogance of the white photographer, but was of no immediate existential threat to the people photographed. Their racist impact issued from their crudely emotive support of the texts they illustrated, though no specific argument was made either in the images or the captions. The popularization of racist ideology brought about amateur periodicals reproducing works by Arthur Gewehr, Erna Lendvai-Dircksen, Erich Retzlaff and Liselotte Strelow can be explained from a functional viewpoint: too many people had been repelled by Hans Günther's pseudo-scientific ranting,[25] consequently, amateur photos were to "gently"

awaken an interest in the positive racism of the National Socialist self-image. As everyone took family photos, these only needed to be suitably arranged to legitimize racist actions, or at least a feeling of racial superiority. Accordingly, the number of tips published on how to produce racially impeccable *Haus-* or *Generations-Alben* (private or family albums) increased greatly. By way of a technical enthusiasm for the photographic process, the respective photographs were to be deliberately integrated into the state's racist ideology – pure propaganda.

It is symptomatic of the NS state that apart from its arms production and administration policy, no other theme so accelerated the development and promotion of reproduction techniques as racism. Parish registers throughout the country were photocopied, mobile services installed to produce and copy name registers, and repeated recommendations made about how to use the resulting documents appropriately. Even the most dyed-in-the-wool National Socialists may not have recognized the immediate value of these services for racist purposes, yet they certainly had indirect effects. Thanks to a sim-

plistic evolution theory, they strengthened the identity of citizen and state; they also put pressure on people for whom proof of their Aryan descent seemed unimportant to legitimize themselves with the appropriate documents. Most of the documentation produced by this particular application of reproduction technology was concerned with as complete a compilation as possible of all parish and church registers. In view of its racist implications, this cultural inventory, though praiseworthy in itself, took on a strange aura – almost as if it laid the foundations for the atrocities committed later in the name of that racism.

The backdrop against which any review of the NS state, its history and its sub-histories, must be undertaken is the wide-scale persecution of people of different beliefs and convictions, of certain nationalities, of non-heterosexuals, and any kind of opponents of the regime. Against this backdrop, photos showing evidence or even hints of evidence of that persecution assume a particular significance.[26] Only a small number of such photos has survived. These in turn are very much in need of explanation because of the symbolic role each individual photo of an act of NS persecution takes on in the context of the overall policy of persecution,[27] and because of the sheer impossibility of describing the persecution and Holocaust perpetrated by sections of the German people on behalf of their state – and from which the rest were careful to look away. The earliest acts of persecution were the arrests of communists, socialists and other political activists in February and March 1933. At that time there were still some photojournalists, at least in Berlin, who openly criticized the NS regime. The photos, attributed to Georg Pahl,[28] of prisoners in Berlin-Plötzensee, or of the Munich lawyer Dr Siegel being pushed through the streets with a mocking notice hanging around his neck,[29] or of attacks against Jewish businesses in April and May 1933, represent the last vestiges of an honourable form of journalism, for which a genuine concern for people was more important than the anticipatory obedience which only six months later reigned supreme in editorial offices throughout the country. This concern is not immediately evident in the photos – except that they were obviously taken in a hurry, as was usually the case with photos of protest marches or other fleeting events. Here sympathetic involvement meant assessing a situation quickly and capturing it on film with no further ado.[30]

By contrast, a lot of photographs were taken of the countless attacks on Jewish shops at the beginning of April 1933 – the time of the so-called *Boykott-Aufruf* (call to boycott). There was no ban on taking such photographs. On the contrary, notices were sometimes stuck to Jewish shop windows warning people who continued to frequent them despite the SA guards and posters: *Jewish business! Anyone shopping here will be photographed.*[31] This is a classic example of how people's diffuse anxiety was played with – a game that was to form the basis of all future propaganda strategies on persecution and opposition. Although no mention was made of the use to which such photos would or could be put, the mere threat of having one's photograph taken was comparable to a police measure. Here the functional aspect of the myth of photographic objectivity, so often invoked in

Erich Retzlaff, Girl from the Lüneburger Heide, 1938

Goebbels' speeches, becomes clear: anything captured in a photograph could have official repercussions, become a matter for police investigation, be regarded as latently criminal. The SA hoards who put up such notices in March and April 1933 might have secretly hoped that people would draw this conclusion. That a democratic consensus did not prevent their dreams from coming true is one of the first components of the subsequent German tragedy.

What the photos of early acts of violence against Jews illustrate above all is the terrible normality of violence. The passers-by looked upon the activities of the SA or police guard in front of Jewish shops with the same indifference as they did upon the photographer. People looked away when individuals were attacked. The eye of the camera never caught sight of a single case of someone intervening on behalf of the victim. Often, the SA and police protagonists posed for the camera like big-game hunters with their quarry, taking an active part in

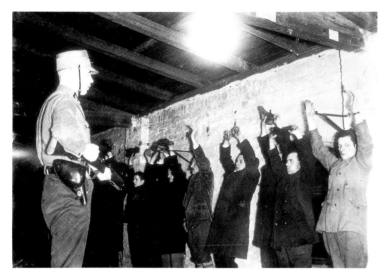

Georg Pahl (attribution), Arrests at Berlin-Plötzensee, March 1933

the mockery by having it photographed. Perhaps one of the best known examples of this is the photo of a Jewish man and a woman both with a scornful notice – it is so primitive that, as Frauke Dettmer writes, it reduces "the complex reality, almost to the point of exonerating it".[32] By comparison with the later atrocities, at least the early phases in the NS persecution have been relatively well documented in these distanced and objective photos.

In spring 1933 all oppositional press reporters and photojournalists were dismissed from their positions, imprisoned, deported to concentration camps, or forced into exile. The next step, namely the dismissal, persecution and expulsion of Jewish reporters and photo-

Cuxhaven, 27 July 1933

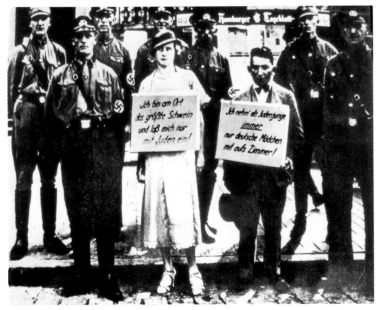

graphers who had not drawn attention to themselves as opponents of the NS regime, required a legalistic framework provided in the so-called Schriftleitergesetz (editorial act) of November 1933. The matter could thus be dealt with by a reverse procedure: the burden of proof for authorization to practise these professions now lay with the applicant and not the employer or the state. From spring 1934 onwards, the Deutsche Presse, a newsletter to which all editorial offices were obliged to subscribe, published lists of authorized and expelled members of the Reichsverband der Deutschen Presse[33]. In the course of the year, the list of expelled members became longer. As of 1935 it became shorter, only to disappear almost completely in 1936. Other photojournalists had already given up, sold off their archives to German agencies for next to nothing, and fled abroad. Just in case any of the émigrés attempted to continue working for the German newspaper market via their own or undercover agencies, the Deutsche Presse regularly issued so-called "warnings" against co-operation with such agencies.[34]

In the case of photographers, this exclusion process took longer, though its consequences were equally harsh. Cases of harassment against individual Jewish photo-shops and their proprietors in 1933 and 1934 have been reported but cannot be shown to constitute a specific strategy. What is certain is that no more state or party commissions were given to Jewish photographers. Other clients too became very reserved towards them. All this was compounded by disclosures and denunciations published in trade, amateur and illustrated magazines about supposed or actual ownership conditions or name changes. In January 1935 the Große Befähigungsnachweis (proof of qualification for setting up business) became law, providing a tool against Jewish business people in this sector.[35] As a result, a number of businesses had to be sold off, usually at a low price, to former employees and friends, who often proved not to be as friendly as had previously been assumed. This whole process, given the malicious and trivializing designation Aryanization, is the real reason why many German photographers had to emigrate.[36] Portraitist and photojournalist Lotte Jacobi, whose works appeared on the front page of numerous issues of the Berliner Illustrirte Zeitung, sold her studio and archives when her father died in 1935, by which time it was no longer possible to fetch a good price for them. Mario von Bucovich, portraitist of the upper classes, put his studio on the market as early as 1933. The equally prominent László Willinger fled to his brother Wilhelm's studio in Vienna in 1933, only to suffer the same fate there after the occupation of Austria in 1938. The Willinger press photo archive, Austria's largest, was expropriated and sold off at a ridiculously low price to Heinrich Hoffmann's agency. László Willinger succeeded in emigrating to the USA where he worked as a stills photographer in Hollywood; it is not known what happened to his brother. The list of studios and photo businesses sold off cheaply or expropriated is long and ends with surely the most spectacular case of all, that of the fashion photographer Else Neuländer-Simon, otherwise known as Yva, who was Germany's undisputed number one fashion photographer up until

spring 1935. Having lost her authorization as a photojournalist, she had to give her studio, at least in name, to her friend Charlotte Weidler. She finally closed the company down after the pogrom of November 1938. It is not know whether it was ever sold. She then worked as a radiographer at the Jewish community hospital in Berlin. From there she was deported to the concentration camp at Majdanek/Lublin where she was murdered in 1942.

With few exceptions, the photographs of NS persecution, expulsion and annihilation document a single viewpoint, that of the perpetrators and onlookers, or at least the hangers-on and indifferent spectators. As these photos vary so much in form and function, this is not always immediately evident.[37] Individual types of photo for specific uses can be specified, though they show no recognizable development, existing side by side uncommented and unchanged throughout the duration of the NS state. The most banal form of pictorial documentation is the straight shot of a specific object. In the context of NS persecution, this form was mainly used to illustrate the regime's architectural achievements. The refurbishment and extension of the concentration camp at Dachau near Munich was the subject of a comprehensive album; the photos were amateurish in appearance, providing a rather prosaic depiction of both the landscape and the building works.[38] Construction companies and subcontractors would often present this kind of album to their clients, or their clients' representatives, on completion of a building. Amateur photography periodicals even published practical tips on how to produce such documentation. The NS regime had countless prison, concentration and death camps built, and many of them have been documented in this manner.[39] The marked objectivity of these documentary photos corresponds to the function of the buildings depicted – with propaganda employing the same means as product advertising in photographing architectural achievements, sobriety was demanded in the presentation of the more ominous NS constructions.

These photographs have counterparts that are of much greater significance in the historical appraisal of the atrocities committed in the NS state. These counterparts depict acts of state-condoned violence against individuals or property, one of the most harmless being the large number of inflammatory postcards lampooning unpopular politicians. From the humiliation of individual Jewish citizens – forcing them to clean the streets with toothbrushes, cutting off their earlocks and beards, damaging traditional clothing, making them wear the yellow star – to organized attacks on their property such as the smashing of shop windows and looting that took place the morning after 10 November 1938 and which the media more or less ignored, the viewpoint adopted betrays that the photos were taken by sympathizers, or at least by people whose attitude to the actions was indifferent. It has seldom been possible to trace these photographs back to their authors, and very few of them were ever reproduced in contemporary publications. Yet most of them have clear similarities and can be grouped in two different categories. The first consists of photographs in which both perpetrator and victim were aware of the fact of being photographed. Here the very act of photographing has become a ritual act, the perpetrators posing with their victims like hunters with their quarry. Few of these victims have the self-confident and victorious expression on their face that the journalist Carl von Ossietzky has in photos taken of him in the Papenburg-Esterwegen concentration camp. Most of them were physically and mentally abused before the photos and their demeanour betray resignation and surrender. The perpetrators are all the more cheerful, pulling faces and behaving in a manner more suited to the tradition of private photos taken among friends.[40] In the first two years of the NS regime this kind of photo was found exclusively on marauding SA hoards and members of the police force.[41] In the run-up to the war, photographs of such scenes became less frequent, only to reappear in greater numbers in the context of Germany's occupation of foreign countries and the systematic killing of Jewish members of the local populations.[42]

The second group of photos of persecution and violence has wider implications in terms of the photographer's presence during the act. Behind this rather evanescent pictorial form – the photos are blurred and compositionally weak, possibly with a rear or cropped view of the protagonists – was photography's aspiration to objectivity, an aspiration very much in need of corroboration and often only achieved by the use of an appropriate caption at the time of publication. Whether in *Stürmer, Angriff,* or the *Illustrierte Beobachter,* the caption's concise and cynical interpretation provided the connotations of a doubly violent act: it not only exposed the location and the persons involved, it also specified how the photo should be read, obliterating any last vestiges of humanity. Years would often pass between the photographic take and its publication, and the real date of the event would then be veiled so as to support the caption's more general claims. This generalizing principle – concisely formulated as the *Kampf gegen das Weltjudentum* (the battle against global Jewry) or similar chimeras – grossly contradicted the individuality of the event as documented in the photo.

The pictorial composition has been standardized: a confined scene, often a row of houses on a narrow diagonal street that sealed off the background and restricted the event. The state provocateurs from SA, SS or police force are shown from the rear or the side, cropped so that personal identification would be difficult were the attack ever to be officially investigated. These figures also function as a further visual restriction of the already narrow pictorial space. The angle of vision – on an arrest, a coercive, humiliating measure, an act of physical violence – is through the crowd or over the shoulders of the provocateurs and almost always high, so that the victims are further degraded. These victims have almost always been specially "prepared" for the photo, that is to say, physically abused, mentally broken, and generally roughed up. This kind of mise-en-scène for photographic documentation was seldom undertaken at the photographer's instigation. On the contrary, the latter was only called in when the quasi-official attackers had completed their "preparations". Yet the photographer was still an accomplice; his presence was part of the stage-

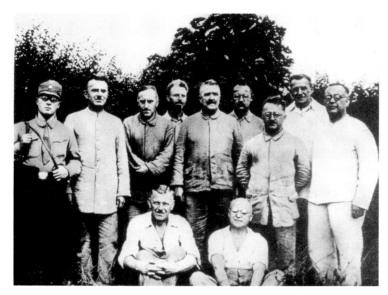

Carl von Ossietzky in the concentration camp at Papenburg-Esterwegen, c. 1936

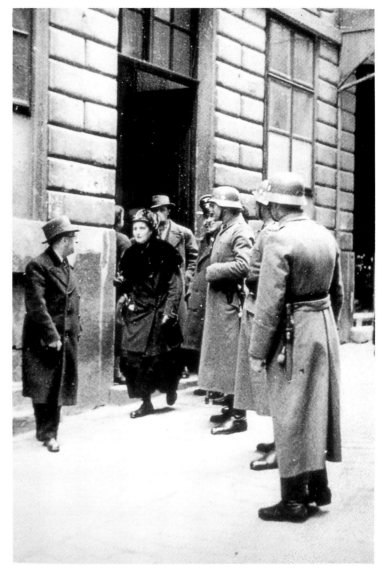

Attack on Jewish citizens

managed event, his gaze represented the attackers' viewpoint, his documentation legitimated the act as politically necessary or at least admissible. Only very few of the photographers who captured such events on film are known by name. The photos may have been taken by police photographers, officers using official cameras – and thus not needing to dirty their hands – or chance participants in the individual actions. Processing and distribution were carried out anonymously and enlargements plus negatives forwarded from the official laboratory to interested press photo agencies or directly to the editorial offices of the NS smear sheets.

Whenever opposition to the regime was prosecuted, its photographic depiction did not differ from that of other acts of persecution. Again the view is that of the perpetrator. The repertory is repetitive: scenes of baton-charging policemen, arrests staged with quasi big-game hunters, deportations, and concentration camps. It also included official documents; the obligatory police custody "triptych" consisting of profile, front face, and three-quarter frontal view from the left.[43] The profile shot from the right with the head fixed from behind by a metal rod speaks volumes. This type of photograph was, and still is, a type of torture, intentionally violating the photographed person's dignity. The central panel of such an Altar to Agony is in itself an inhuman view: A direct frontal view implies a narrowing of the field of vision and amounts to a type of advance condemnation. The three-quarter view from the left is always positioned to the right of the triptych thus leading back to the centre or to the profile and making an observation of the photographic ensemble recursive. Historically, opposition has often only been rendered personal, and thus visible, in this type of photo, and unfortunately the viewpoint almost always suggests illegality.

There is yet another photographic viewpoint taken by the state in its monopoly of force: that captured in photos of accused persons in court. When looked at historically, this viewpoint is less determining

and more documentary in its function. The courts began at an early stage to have photographs taken secretly during political trials. This was in breach of their own regulations which actually prohibited the practice. The epitome of such a documentation mechanism must surely have been the automatic cameras Roland Freisler had installed at various points in the wall panelling of the *Volksgerichtshof* (People's Court). Their pictorial evidence has literally made history: it shows exactly who appeared in court in connection with the assassination attempt of 20 July 1944, and in what physical state. The most strategically placed camera was installed in the wall directly above and behind Freisler's head and photographed the accused literally head on. Over the decades, this purely visual representation of a court obviously administering injustice has at least prevented the wound of the German judiciary from healing and thus ensured a partial critique of that injustice.

There can be no doubt that the Second World War instigated by the NS regime was well prepared with regard to industrial and armaments production, strategic policy, and propaganda campaigns. Just how perception became industrialized during the war is reflected in three different areas: propaganda's adoption of pictorial forms from the world of consumer advertising; technically the perfect documentation of all war damage, including the less desirable variation captured by the private snapshot; the deformation of the Germans' view of the Holocaust and the genocide perpetrated against other peoples. The strategy of pictorial censorship was unsuccessful, becoming bogged down in everyday matters and legitimization processes. The idyll of the pre-war years, the preferred mise-en-scène for politicians, was raised to the status of human happiness per se to be protected at all costs against enemies without and within. Practically speaking, this meant the revision and reinforcement of many former prohibitions. The organization of propaganda photography during the war can be quickly outlined: for every troop sector at the front there was a *Propagandakompanie* (propaganda company) producing material either for the media at home or for publicity activities in that particular combat zone; some of these companies were quickly deployed to high-risk combat sectors, others remained more or less permanently in one place. The so-called *PK* photoreporters were either professional photographers or photojournalists, some of whom had been forcibly recruited, but most of whom had volunteered to avoid front-line service. The personal files on *PK* photographers in the regional offices of the *Reichsverband der Deutschen Presse* (Reich Press Association) provide insight into the tragic biographies of creative people: the former Bauhaus photographer Umbo became a navy *PK* and his works were published frequently, which was an embarrassment to him later; by contrast, Herbert List would have been very happy to be a photojournalist, but despite a glowing reference from Heinrich Hoffmann he was not exempt from armed service.[44] The many claims these photographers later published in amateur periodicals that they had been glad, or would have been glad to become *PKs*, or at least unreservedly admired their work, were part and parcel of the standard rhetoric of the time and may, therefore, be of only marginal importance. However, such claims were unnecessary and certainly no proof that they had opposed the NS regime and the war it instigated.

Usually the *PK* photographers spent two to three months working at a front sector before returning to the central laboratory in Berlin to supervise the processing of their films. With a few tricks they were even able to smuggle their photos out of the laboratory – either to market them privately to newspapers and magazines, or to present them later as "documentary proof" of their opposition. Unlike the photojournalists, the local professional photographers were almost all employed taking portraits of soldiers, for which the men among them could be assigned to one of the much sought-after *UK* posts *(unabkömmlich*, meaning indispensable), at least until early 1944. Women photographers reported voluntarily for service in the *UK* posts because it exempted them from work in the armaments industry. Most of the professional photographers who had set up business after 1935 were too old for military service when the war broke out. They received commissions at home photographing Christmas festivities and the wartime activities of the charitable organization *Winterhilfswerk*. Later they were assigned to documenting the bombing damage. Finally, like other craftspeople and professionals, photographers too were deployed in the *Volkssturm*, the last reserves in the defence of the Vaterland.

Generally speaking, amateur photographers were meant to be involved in processing the Second World War for propaganda purposes. Consequently, ordinary soldiers capable of taking photographs were well provided with material and equipment in the hope they would assist the *PKs* wherever necessary. The *PKs* provided the models: cheerful group and landscape shots that portrayed the war as an adventurous journey, a logistically planned group outing imbued with a positive dynamism referred to as comradeship. By contrast, a leading article in the *Deutsche Presse* in 1943 provided a truly postmodern justification for *PK* photography: "We will rub our enemy's nose ... in our photographic proof, use it to punch him in the jaw and show the world just what reality is all about."[45] Yet not even the Second World War propaganda experts were quite sure what a reality destined to be thrown in the face of the enemy should look like. No sooner were these photos distributed than they began to turn on the rulers themselves. Press propaganda's main problem was the modernity of war itself: the speed with which news of victories or defeats could be transmitted increased so greatly thanks to radio and telegraphy that visual renderings seemed hopelessly outdated by comparison. The material the *PK* photographers and cameramen provided took an average of two weeks to reach the central laboratory in Berlin by courier. The subsequent technical and censorship evaluation meant it was another few days before a photo or a *Wochenschau* newsreel was released. This discrepancy grew as the war progressed and the fortunes of the military leaders waned.

From the very beginning, photography was given a dual function in the war: its propaganda material was to inform the population about military successes and thereby strengthen the will to continue the fight; it was also to provide documentary backup evidence of the bombing damage for the political settling of accounts in the post-war period. As soon as a city came under fire, local photographers received commissions and special permits to document the damage.[46] As the need for such documents increased, officers and troops involved in defending the respective town or anti aircraft position had to take up cameras.[47] This changed abruptly after the so-called *1000-Bomber-Angriff* (1000 bomber attack) on Cologne in May 1942; after the detailed reports on this huge bombardment, Goebbels ordered that future reports be short, non-illustrated news bulletins. Right up to the last months of the war, however, the commandants in all the large cities continued to have photos taken of damage to buildings.

One problem inherent in any propagandistically-controlled pictorial world, especially in the realm of personal memory, is that it can

have a reverse effect. The widespread availability of cameras and film among the Germans even in the early war years meant that the reality they recorded differed somewhat from the omnipresent propaganda view. The idyllic, racist and technoid motifs proffered in the photography magazines and illustrated newspapers could not prevent people from photographing undesirable motifs. In fact it even made these more enticing. This is particularly evident in that sector where the NS regime strove to be regarded as modern, that is to say, in its technically sophisticated military effort. The objective representation of the war in deliberately precise and clearly impartial scenes, for example, of the destruction of occupied cities, had unwelcome repercussions: amateurs began to register damage to their own surroundings in just as detailed a manner. When a fire broke out somewhere during the night, the amateurs grabbed their cameras and rushed up onto the roofs of their houses for a shot of the raging flames; when a grenade dropped on the other side of the street, curtains began to move and camera shutters click; when dawn broke after a bomb attack, women and men slunk through the streets with cameras hidden under their coats. Scenes of destruction and catastrophe exerted an irresistible power of attraction, and in keeping with the NS regime's propaganda slogans, these vivid experiences simply cried out to be captured on film.

This fascination with capturing scenes of destruction on film went hand in hand with a double-edged fear: that the next catastrophe could strike the photographer (in which case it is even conceivable that photography functioned as a magic ritual warding off the forces of evil) or that he or she could be caught taking photographs. No one was quite sure how the policeman or local warden would react if they caught someone in the act. As a result, in those who took the quasi illicit photographs this tension engendered a feeling that they were opponents or at least law-breakers, whether there was any legal justification for this or not. The fear-laden aspect of the photographic act became inseparably linked with the fascination exerted by fire, light rays, destruction and chaos, at which point the categories of legal or illegal ceased to apply. Consequently, police ordinances were almost irrelevant, that is, if ever they penetrated the awareness of the individual photographers at all. Irregular actions of any kind were suspicious, and everyone knew that the NS state was somewhat unscrupulous in its interpretation of the law.

Surely the most horrific outcome of the industrialization of perception is manifest in the souvenir photos kept by soldiers in private albums which came to light during various trials after the Second World War. Whether these photos served their owners as a form of psychological exoneration or as proof of their heroism is a moot question. The frequency with which they turn up is one of the most terrifying moments in the history of German photography. One thing that is certain is that all these photographs have the aura of the forbidden about them – not so much because of the immorality of their content, as because of the radical experience involved in actually taking them. The psychopathological element is all too evident here; this is a basic

component of bourgeois existence under exceptional wartime circumstances.[48] How else is it possible to explain the fact that these photos are repeatedly found in direct proximity to other completely harmless group, portrait or landscape shots – usually on one and the same page, seldom separate or in a special album. It is this abrupt proximity of idyll and evil that is so terrifying. Educating people to look the other way clearly nurtured abnormal capacities for psychological repression.

These photos of atrocities can be divided into three groups, whereby the sub-divisions refer more to the circumstances under which they were taken than to any thematic or compositional feature. The largest group consists of unfeeling registrations of shootings, hangings and other murders committed in the vicinity of combat areas. The frightening aspect here is the casualness with which the omnipresence of death is viewed: people stroll indifferently past partisans hanging in the streets. These executions were sometimes even photographed with a deliberate compositional effect in mind – against a picturesque backlight, for example. Interestingly enough, this kind of photo was usually taken by *PK* photographers. Photos of mass killings of Jewish citizens in the occupied territories form a special subcategory within this group. Among them is a series that particularly manifests the phenomenon of male voyeurism as a fascist eroticism of violence: photos of groups of naked women, usually taken from a distance immediately prior to their being shot. The amassed bodies exert an erotic power of attraction similar to that in Dominique Ingres' *Turkish Bath*. Rarely are women shown facing the camera directly, and if so then they are old women and children – this too in keeping with the tradition of the rapacious male gaze.[49] So far, the authors of such photos have been discovered to be exclusively SS and Wehrmacht members. It can be assumed that *PK* photographers had no access to the scenes of such atrocities.

This also applies to a group of photographs whose existence is only substantiated by verbal descriptions in court files. These photos depicted atrocities perpetrated against the civilian population in occupied countries. In the rare military, party, and SS court proceedings against the photographers who took photos of such scenes, the reference is almost always to individual cases, which often culminated in vicious attacks on infants, small children and pregnant women. To judge by the descriptions, these photos must have been primarily close-up and portrait shots, that is to say, taken with exactly the same kind of inner distance to the subject as has been the norm in child pornography. The indifference with which negatives of the worst possible atrocities were delivered for processing to the central laboratory may seem astonishing today; it is symptomatic of the arrogance of an elite who considered themselves physically superior and daringly heroic compared to those old men, women, and cripples who stayed at home. As for their impact, it is interesting to note that Libertas Schulze-Boysen was able to advertise successfully for her husband's opposition group by developing (in her capacity as laboratory assistant at the *PK* processing centre) private photos of this kind taken

both by rank and file and by officers, enlarging the most atrocious scenes and showing them to anyone interested in opposition.[50] The psychopathology evident in such photos represents a difficult area in the reception of the NS state, and one that has so far mainly been dealt with at the level of the fictional feature film.[51]

To draw conclusions about the general state of social relations on the basis of particular clinical cases is a dangerous undertaking. In judging the practice of photography in the NS state, as described above, it must not be forgotten that the medium was granted no autonomy or sovereignty of any kind as regards aesthetic form or social utilization. It is this that furnishes a serviceable definition of the term "state design": an imposed task embracing all possible forms of utilization, whether intended or unintended, and reflected both in the pictorial idiom of the resulting photos and in the modes of their distribution. It is high time historical research devoted to the Holocaust and the "fascination of violence" got round to recognizing and acknowledging this large complex of symbolic and documentary photos. This would greatly benefit well-founded source research on the NS state and its significance in German history.

Notes

1 Rolf Sachsse, *Photographie im NS-Staat, Die Erziehung zum Wegsehen*, unpublished.

2 Siegfried Kracauer, *Das Ornament der Masse*, Frankfurt am Main 1963.

3 Klaus Wolbert, *Die Nackten und die Toten des Dritten Reichs*, Giessen 1977 (doctoral thesis, Marburg University 1974).

4 Otto Thomae, *Die Propaganda-Maschinerie. Bildende Kunst und Öffentlichkeitsarbeit im Dritten Reich*, Berlin 1978.

5 Kurt Koszyk, *Deutsche Presse im 19. Jahrhundert*, Berlin 1966; Heinrich Hubert Houben, *Der gefesselte Biedermeier, Literatur, Kultur, Zensur in der guten, alten Zeit*, Leipzig 1924.

6 On the organization of the Propaganda Ministry see Willi A. Boelcke (ed.), *Kriegspropaganda 1939–41, Geheime Ministerkonferenz im Reichspropagandaministerium*, Stuttgart 1966.

7 Heinz Odermann, "Die vertraulichen Presseanweisungen aus den Konferenzen des Nazi-Propagandaministeriums" in *Zeitschrift für Geschichtswissenschaft*, Berlin 13 (1965), vol. 8, pp. 1365–72.

8 Willy Stiewe, "Das Bild als politische Waffe" in the official exhibition catalogue *Die Kamera. Ausstellung für Fotografie, Druck und Reproduktion*, Berlin 1933, p. 7 (annex 2).

9 Exhibition catalogue *Das Porträt. Vom Kaiserbild zum Wahlplakat*, Nuremberg 1977.

10 Rudolf Herz, *Hoffmann & Hitler*, Munich 1993, p. 131.

11 Claudia Windisch-Hojnacki, *Die Reichsautobahn* (doctoral thesis Bonn University 1977); Rainer Stommer (ed.), *Reichsautobahn, Pyramiden des Dritten Reiches*, Marburg 1982.

12 Erna Lendvai-Dircksen, *Reichsautobahn. Mensch und Werk*, Bayreuth (1939[1], 1942[2]) and Wolf Strache, *Auf allen Autobahnen. Ein Bildbuch vom neuen Reisen*, Darmstadt 1939.

13 Christina Uslular-Thiele, "Autobahnen" in the exhibition catalogue *Kunst im 3. Reich, Dokumente der Unterwerfung*, Frankfurt am Main 1974, reprint Frankfurt am Main 1979, pp. 148–82.

14 Wolf Strache, *Donnernde Motoren*, Stuttgart 1942.

15 Hermann Harz, *Das Erlebnis der Reichsautobahn*, Munich 1942.

16 Rosalind Krauss & Jane Livingston, *L'Amour fou – Photography and Surrealism*, Washington/New York 1985.

17 Heiner Kurzbein, "Die Fotografie im nationalen Deutschland" in the official exhibition catalogue of the exhibition *Die Kamera. Ausstellung für Fotografie, Druck und Reproduktion*, Berlin 1933, pp. 9–10.

18 Wilhelm Niemann, "Berufsfotografie", ibid., pp. 27–28.

19 Rudolf Arnheim, "Die Fotografie – Sein und Aussage" in *DuMont Foto I*, ed. by Hugo Schöttle, Cologne 1978.

20 Viktor Klemperer, *LTI, Die Sprache des Dritten Reiches*, Leipzig 1975, pp. 245–46.

21 Wolfgang Schivelbusch, *Geschichte der Eisenbahnreise*, Frankfurt am Main 1979.

22 Reichspressechef, Bestellungen aus der Pressekonferenz, Anweisung Nr. 669, Berlin 1936 (3.7.), Bundesarchiv Koblenz, Bestand Zsg. 101/8.

23 Siegfried Zielinski, *Audiovisionen, Kino und Fernsehen als Zwischenspiele in der Geschichte*, Reinbek 1989, pp. 170–71.

24 Rolf Sachsse, "Bild – Medium – Wirklichkeit" in exhibition catalogue *FOTOVISION, Projekt Fotografie nach 150 Jahren*, Sprengel Museum Hannover 1988, pp. 44–50.

25 H. F. K. Günter, *Rasse und Stil*, Munich 1926; by the same author *Kleine Rassenkunde des deutschen Volkes*, Berlin 1943.

26 Hannah Arendt, "The Image of Hell" in *Commentary* 2/3 (Sept. 1946), pp. 291–95.

27 Sybil Milton, "Argument oder Illustration. Die Bedeutung von Fotodokumenten als Quelle" in *Fotogeschichte* 8 (1988), issue 28, pp. 61–90.

28 Exhibition catalogue *Die Gleichschaltung der Bilder. Pressefotografie 1930–36*, Berlin 1983, pp. 127–28.

29 Heinrich Sanden, "Das Foto ist von mir …", ibid., pp. 122–26.

30 Paul Virilio, *Guerre et Cinéma I, Logistique de la perception*, Paris 1984.

31 Reinhard Rürup (ed.), *Topographie des Terrors, Gestapo, SS und Reichssicherheitshauptamt auf dem 'Prinz-Albrecht-Gelände', Eine Dokumentation*, Berlin 1987, plate 140, p. 113.

32 Frauke Dettmer, "Legende eines Bildes" in *Der Spiegel* 38 (1984), issue 13, pp. 10–12.

33 Reichsverband der Deutschen Presse, "Mitgliederbewegungen im Landesverband Berlin, Löschungen unter § 5, Ziff. 3 des Schr.L.Ges. (nicht-arische Abstammung)" in *Deutsche Presse*, Berlin, 24.1.1934.44.15–16 passim.

34 Dr. H. Henningsen, "Warnungen, Zur Beachtung" in *Deutsche Presse* 28.1.1939.399 passim.

35 "Dritte Verordnung über den vorläufigen Aufbau des Deutschen Handwerks (Grosse Befähigungsnachweis), Auszug aus dem Reichsgesetzblatt vom 18. 1. 1935" reproduced in *Der Photograph* 49 (1939), issue 5, pp. 18–19.

36 Helmut Genschel, *Die Verdrängung der Juden aus der Wirtschaft im Dritten Reich*, Göttingen 1966; Avraham Barkai, *Vom Boykott zur 'Entjudung'. Der wirtschaftliche Existenzkampf der Juden im Dritten Reich 1933–43*, Frankfurt am Main 1988.

37 Ulrich Keller (ed.), *The Warsaw Ghetto in Photographs*, New York 1984; Detlef Hoffmann, "Fotografierte Lager, Überlegungen zu einer Fotogeschichte deutscher Konzentrationslager" in *Fotogeschichte* 14 (1994), issue 54, pp. 3–20.

38 Reichsfinanzministerium (ed.), *Dachau, SS-Kaserne und Konzentrationslager* (bound album), Munich 1938 (1.3.), Bundesarchiv Koblenz, Bestand R 2 / 28350.

39 Katharina Blohm, "Konzentrations- und Zwangsarbeiterlager" in *Bauen im Nationalsozialismus. Bayern 1933–1945*, ed. by Winfried Nerdinger, Munich 1993, pp. 514–37.

40 Cornelia Zeul, "Zwischen 'weiblich und männlich', Narren-Freiheit auf privaten Fotos" in *Fotogeschichte* 11 (1991), issue 42, pp. 31–42.

41 Hanno Loewy, "Kein Utopia . . . " in Walter Zadek, *Kein Utopia . . ., Araber, Juden, Engländer in Palästina. Fotografien aus den Jahren 1935 bis 1941*, Berlin 1986, p. 7 (reprint from the *Illustrierten Beobachter*, no. 13, 31. 3. 1933).

42 Ernst Klee, Willi Dreßen, Volker Rieß (eds.), *"Schöne Zeiten". Judenmord aus der Sicht der Täter und Gaffer*, Frankfurt am Main 1988, pp. 122–29 and 151–53.

43 Regina Griebel, Marlies Coburger, Heinrich Scheel, *Erfasst? Das Gestapo-Album zur Roten Kapelle. Eine Foto-Dokumentation*, Halle/Saale 1992.

44 Reichsverband der Deutschen Presse, file on the photojournalist Herbert List, Berlin, Ingolstadt 1944–45, Bundesarchiv Koblenz, Bestand R 103 / 85.

45 E. Egon Schleinitz, "Das Bild als politische Waffe. Die schlagkräftige Arbeit der deutschen Bildberichter an den Fronten" in *Deutsche Presse*, Berlin 33.1943.71–72.

46 Rolf Sachsse, "Kölner Triptychen" in Hugo Schmölz et al., *Köln von Zeit zu Zeit*, Cologne 1992, pp. 7–16.

47 Martin Rüther, "Die Fotografen – Zur Entstehungsgeschichte ihrer Bilder" in *Fotografieren verboten! Heimliche Aufnahmen von der Zerstörung Kölns*, ed. by Thomas Deres and Martin Rüther, Cologne 1995, pp. 93–119.

48 Georges Bataille, *Die psychologische Struktur des Faschismus*, Munich 1978.

49 Susanne Kappeler, *Pornographie. Die Macht der Darstellung*, Munich 1988.

50 Diethart Kerbs, "Bilder, die es nicht mehr gibt" in the exhibition catalogue *Gleichschaltung*, 1983; see note 28, pp. 194–98; Griebel et al., 1992; see note 43.

51 Jutta Brückner, "Bilder des Bösen" in the exhibition catalogue *Inszenierung der Macht. Ästhetische Faszination im Faschismus*, Berlin 1987, pp. 345–52.

Hanno Loewy

"...without masks"
Jews through the lens of "German photography" 1933–1945

Never was so much effort invested in determining the "nature" or "essence" of "German photography" as in the period between 1933 and 1945. The image of Jews, or rather, the image of "the Jew" forged by "German photographers" had a number of functions. It was an integral part of the process of *Gleichschaltung* that took place in the public sphere, served by an ideologically standardized press, radio and photography. It was one of the fields in which National Socialist society gradually became increasingly radical, an arena in which power struggles, career rivalries and the battles for resources were fought out and frequently decided on the basis of ideological views. It fuelled the process of defining the "Other", and of stigmatizing "the Jew", and thus prepared the ground for the physical destruction of the Jews by making such action conceivable in the first place. The photographic imagery produced by German anti-Semitism was part and parcel of the attempt to create a counter-image to the "German character" by which the various definitions of what constituted "the German mission" and the "German character" could be reduced to the lowest common denominator – an image capable of single-handedly consolidating the centrifugal forces of the system and its different ideological elements. Photography, as something that people from all walks of life could actively pursue, was above all a popular component in this quest.[1]

Photographers were perfectly aware of the new status this granted them and of the responsibility it entailed, whether imposed or eagerly grasped. In July 1933, the magazine *Photofreund* carried the following text:

"We ought and want to create German photography ... The heart must speak in it, the German heart; the spirit must form it, the German spirit; sentiment must be tangible in it, German sentiment; and from this the new German photo will be born ... The German people have been rapidly united in the spirit of National Socialism ... All that seems in some way appropriate and good should and must be placed at the service of this tremendous idea, and thus photography too is called upon to help and contribute ... Photography should no longer distract from the struggle; no, it should lead into the midst of the fray and become a tool, a weapon in this struggle. The fact that it can be an explosive and powerful weapon is something the men of the new Germany have recognized clearly. Let the Führer determine the direction in which photography should develop. Proud, free and with a sense of responsibility, we are willing to stand by him and cooperate in honest struggle for the great idea. Let the Führer point the way; each of us must face the individual battle with an upright and affirming heart."[2]

The myths of the Führer-led state have been entrenched for too long in the popular picture that posterity has painted of National Socialism. Even today, the longing for exoneration is still too strong, the yearning for reassurance too deep in recalling personal involvement and enthusiasm or in remembering the driving force of interests and careers that pale into insignificance behind the monolithic image of total dictatorship.

Instead of this exonerating simplification, I propose that National Socialism be described as a society in which various elites, new and old, vied for influence, a society in which nepotism parasitically pervaded traditional bureaucracies, and in which the National Socialists were continually able to channel the rivalry for resources and power in the ideologically desired direction by creating ever more special departments with overlapping interests. In this form of totalitarian rule, hierarchy is reproduced time and time again in the struggle between different power groups. It is not the acquiescent executors of orders who are the backbone of such a society, but the people with initiative, who pursue their own interests by repeatedly placing themselves in the vanguard of the movement.

Photographers saw themselves very much as active participants in this process of social permeation and radicalization. Their photographs were intended both to promote and document the ideologization of society. Their work, like that of the press as a whole, was at the centre of National Socialist *Gleichschaltung* in the period 1933–1935.

Aryanization

Immediately after the new government headed by Adolf Hitler came to power, campaigns against the *Verjudung* ("Judâization") of the German press were successfully intensified, with all manner of publications by the various right-wing parties. For example, the nationalistmonarchist *Deutsche Nachrichten* ran a front-page article on *Reinigung der Bildpresse* (Cleansing the illustrated press) under the headline *Herunter mit der Maske* (Off with the mask). In it, an evidently well-informed author painstakingly tracked down anonymously published photographs and Jewish photographers in a number of periodicals. In April, the same newspaper had already launched a successful witchhunt against Jewish photojournalists that set "wrongly" denounced photographers scurrying to demand rectification.

Threats, boycotts, coercion and eager obedience were apparently only one side of the coin. As early as March 1933, a number of

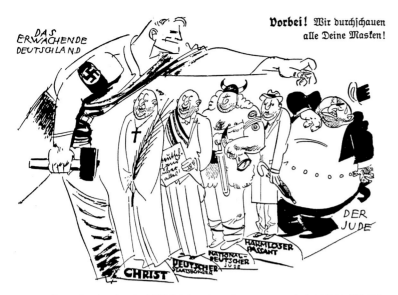

Copy of a drawing by Mjölnir taken from the propaganda brochure *Die verfluchten Hakenkreuzler. Etwas zum Nachdenken*, with a text by Josef Goebsch, Munich 1930

major publishing houses and German broadcasting corporations began dismissing their Jewish staff.[3]

The founding of the *Reichsministerium für Volksaufklärung und Propaganda* (RMVP) on 13 March 1933 went hand in hand with the "compulsory establishment of vocational organizations and the binding obligation to the state of persons employed in the press".[4] On 14 June 1933 the three professional associations of photojournalists merged to form a single organization, the *Reichsverband Deutscher Bildberichterstatter* (RDB). A law (the *Reichskulturkammergesetz*) passed on 22 September 1933 brought with it the formation of a national governing body for the press, the *Reichspressekammer*. From November 1933 until 30 June 1934 the RDB was integrated into the Reichsverband der Deutschen Presse. However, not all RDB members were admitted, for by this time, following the law on the "restitution of civil service status", the so-called *Schriftleitergesetz* of 4 October 1933 had been passed, regulating "involvement in the formation of the intellectual content of German newspapers . . . in word, news or image".

According to paragraph 5.3 of the *Schriftleitergesetz*, an editor had to be "of Aryan descent and not married to a person of non-Aryan descent". The law covered not only newsaper editorial staff, but also photo agencies and news services. Within a few months, the press had been "Aryanized". In June 1934, under enormous pressure, the Ullstein publishing house – and with it the Reich's largest illustrated periodical, *Berliner Illustrirte Zeitung* – was sold to a trustee company at a fraction of its value and officially transformed into the *Deutscher Verlag* in 1937. Max Ammann, president of the *Reichspressekammer* and publishing director of the National Socialist party press, took over the management. During this period, the "German press" lost most of its outstanding photojournalists, editors and photo agencies. Photo-

graphers such as Felix H. Man, Erich Salomon, Alfred Eisenstaedt, Nachum (Tim) Gidal, Martin Munkacsi, Walter Süßmann, Kurt Hübschmann, André Friedman (Robert·Capa), editors-in-chief such as Kurt Korff (*Berliner Illustrirte Zeitung*), Stefan Lorant (*Münchner Illustrierte Presse*), Gusti Hecht (*Der Weltspiegel*), picture agents such as Simon Guttman (Dephot), Rudolf Birnbach (*Weltrundschau*), Leon Daniel (*AP Bilderdienst*), Hans and Fritz Basch (*Deutsche Presse-Photo-Zentrale*), photographers such as André Kertesz, Lotte Jacobi, Elly Marcus, Nini and Carry Hess, Yva, d'Ora and many other photographers whose names were to be relegated to obscurity, forgotten and extinguished from memory.[5]

Jews were no longer active participants in the world of photography in Germany, but had become objects of "German photography". *Herunter mit der Maske (Off with the mask)* was the order of the day. But what was meant by "the Jew"?

Racial theory

Photographing Jews was not simply an act of photographic "image-making". Jews were not "picturesque". They were above all an enigma. National Socialist authors, first and foremost Hitler himself, and many anti-Semitic German intellectuals, had verbally formed an image of "the Jew" that provided a screen for the projection of all manner of fears and megalomanic fantasies. The "German character" as the epitome of all things "Aryan" was set against the figure of "the Jew" as the "world enemy" who does not seem to possess a "character" of his own at all. On the contrary, "the Jew" was defined primarily as a parasite capable of hiding behind any mask whatsoever. The Jew was behind democracy and liberalism, behind Marxism and capitalism, behind British "plutocracy" and Russian bolshevism, and even, if need be, behind the mask of German nationalism. Yet behind the masks, it was alleged, hid the immutable essence of the alien racial soul. History appears here as the ineluctable struggle between two utterly incompatible natures, a struggle for world domination between the Aryan-Germanic and the Jewish.

While the Jew appears on the one hand as a mask and as the very epitome of the sly weakling who seeks power through deceit, he constitutes, on the other hand, a figure of frightening constancy and strength. In a letter to Adolf Gemlich in 1919, Hitler wrote, "Through a thousand years of incest, often in the closest circles, the Jew has generally maintained his race and distinctive characteristics more clearly than many of the peoples amongst whom he lives."[6] Hitler warned of an emotive anti-Semitism directed against individual Jews, calling instead for a "reasoned anti-Semitism" that must first fight against the "privileges of the Jew". "Its ultimate and unalterable goal, however, must be the removal of the Jew as such."[7]

No struggle is possible without a clear distinction and definition of the Other. In 1930, Ernst Jünger also claimed that "the Jew" was a "master of all masks" and posited that "To the same degree in which

the German will gains sharpness and form, for the Jew, even the vaguest notion of being able to be a German in Germany becomes increasingly impracticable and he is faced with his final alternative, which is, in Germany, either to be a Jew or not to be."[8]

Six years later, Carl Schmitt categorically refused to understand the motives of a Jew, on grounds that "I cannot look into the soul of this Jew and that we have no access whatsoever to the innermost being of a Jew. We only know its lack of affinity to our own kind. Anyone who has grasped this truth knows what race is."[9]

And yet, as Alfred Rosenberg writes in his *Mythus des 20. Jahrhunderts*, "The racial soul is not physically tangible...". So how was it to be possible to look behind the mask into the abyss of the Jewish racial soul, and how was the photographer to be able to capture the nature of the Other in a photograph that is nothing but a superficial reflection? Seen from the point of view of this problem, photography is not so much a medium of portrayal as the expression of a form of relationship.

Photography is meant to reveal what remains hidden to the deluded eye. Photography is meant to capture what "the Jew" seeks to hide, in order to be able to rule and subvert. Photography is meant to confirm once and for all the transformation of the Jew from dangerously active subject to passive object. Photography is meant to break the secret power and destroy the dignity of its Opposite, the Jew. Photography is meant to anticipate the triumph of destruction.

In tackling the constitutive inner contradiction of their relativism – which deemed the Other inaccessible and therefore particularly dangerous – the National Socialist race theorists unleashed an almost manic drive to photograph in a frenzied attempt to find visual evidence for their allegations in the study of Jewish and other "alien racial" and "Aryan" physiognomies.

The photographers behind such "race studies" rarely left testimonies to their own reflections. In the books by Ludwig Ferdinand Clauss, author of various highly popular treatises on "race studies" there are at least some traces. Clauss published an illustrated travelogue in 1933, which was expanded and reprinted in 1937, documenting his search for the soul of the Ur-Semite in the desert. Beginning with an interpretation of the biblical tale of the struggle between David and Goliath, he seeks to analyze the core, the "racial principle" of the Semitic character. He defines his method as "researching the soul by living out the life", as a "working method ... that involves playing other roles in life".[10]

He describes his own technique of role-acting in the service of research as "taking Nordic possibilities to the extreme" and as acting "at the furthest possible remove from one's own self", contrasting this with the Semitic masquerade as a vessel "for the transience of the type of soul"[11] that is unable to do otherwise than present itself, to the photographer in particular, as sly and bent on deceit.

The Semite appears here as a preying "creature of the moment" that "withdraws into the deepest recesses of its innermost being with its booty".[12] To Clauss, "the Jew", on the other hand, is the utterly dan-

"Jew from Bukhara with the characteristic traits of the Near Eastern race. Butcher (shochet). A craft based on subtle knowledge." In Ludwig Ferdinand Clauss, *Semiten der Wüste unter sich*, Berlin 1937, after p. 136

gerous degeneration of the Semitic "Ur-type", whose threat is all the greater because his masquerade calls upon divine authority and has penetrated into "Nordic" culture through the book and the letter of the law. "We need only consider the history of Western faith ... it is a part of our own fate with which we are confronted and with which we struggle when we succeed in recognising the Semitic character."[13]

With these closing words, the interpretation of the struggle between David and Goliath comes full circle. Goliath, expecting "honest battle by the same standard and custom"[14], finds himself facing a sly opponent who calls upon God and has no idea "that an individual can be rooted in himself, in the unconditional awareness of his own strength."[15] Goliath, the conqueror, "Nordic man has a right to go out into the world and make it his own, creating it in his own image."[16] For David, for the others, the "Nordic battle custom ... can only be a mask that they wear, perhaps without noticing it."[17] The deceit by which

David slays the Nordic Goliath is the moment of truth. "The struggle between people of different race can never be honest, noble, knightly, any more than a struggle between men and monsters. In such a struggle, once it has flared up, the only honest solution is the destruction of the opponent. Goliath's forebears failed to wreak this destruction when they set foot in that land." [18]

Long before the National Socialists were able to conceive of actually putting into practice a policy of destruction, the logic of their relationship towards the Jews had already been anticipated.

Exhibitions

How could the "Jew without a mask" – the "soul" of the Jew, so difficult to portray – be presented to a mass public in a way that differed from the caricatures published in the *Stürmer* and corresponded more closely to everyday experience?

On 8 November 1937 the exhibition *Der ewige Jude* (The eternal Jew) opened at the Deutsches Museum in Munich. The exhibition was one of a series of propaganda shows, the first of which, *Die Kamera* (The camera), in 1933, had been aimed at mobilising photography (both professional and amateur) for its new tasks in National Socialism. Even then, speakers and publications pointed out the "enormous significance of photography for race research". Heiner Kurzbein, head of the press illustrations department in the Ministry of Propaganda, who was to become a key figure in National Socialist pictorial propaganda, had publicly stressed the purely Aryan character of the new *Reichsverband der deutschen Presse*.

Further major exhibitions followed, on the Olympics in 1936, the *Grosse antibolschewistische Ausstellung* (Great anti-bolshevic exhibition) in 1937, and the *Gebt mir vier Jahre Zeit* (Give me four years' time) exhibition that ran from 30 April to 13 Juli 1937 in Berlin.

Der ewige Jude was to be the most successful of all the exhibition projects. It opened in Munich and toured all the major cities in the Reich. The history of Jews in German cinema played a major role in the posters and photographs and above all in the footage produced specially for the exhibition and screened hourly. *Juden ohne Maske* ("Jews without a mask") was the name of the compilation film produced in 1938, of which only a fragment is still extant in the federal archives.[19] *Juden ohne Maske* comprised scenes from well-known German films in which Jews were portrayed as murderers or as "despisers" of the "German cultural heritage", including such aspects as "Alpinism". Peter Lorre's confession in the film *M* was "exposed" as the admission of "the Jew" unable to do otherwise than murder. The press carried reviews claiming that "in the film, the Jew dropped his mask" and the commentary accompanying the compilation film transformed all too familiar cinematic scenes into the discovery of a Jewish conspiracy: "Jewish speculation destroyed the German natural character" or "the Jew conducted his campaign of destruction with the poison of crime" and "to fight the Jew is to fight the devil".

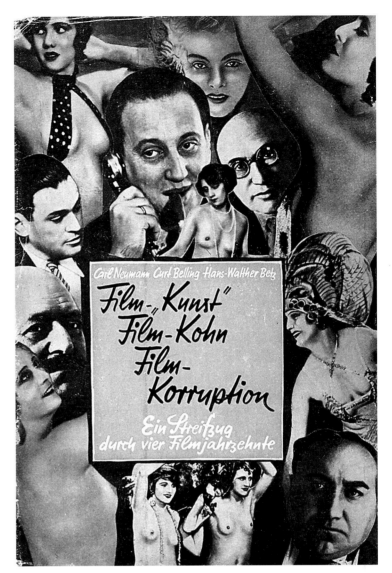

Cover of the book *Film-"Kunst", Film-Kohn, Film-Korruption*, 1937

The Ministry of Propaganda jealously guarded its monopoly on such interpretations in the face of independent initiatives and attempts to excel at propagandistic effects when dealing with "the Jewish question". One example of this can be reconstructed from the correspondence between the official departments involved. In 1941, the German ghetto administration in Lodz (by then renamed Litzmannstadt) began to consider how to publicize its successful and, in this case economically effective, Jewish policy in the form of an exhibition. One idea was to present ghetto production works (which supplied such companies as Neckermann and the Hamburg department store Alsterhaus, not to mention the Wehrmacht) and document "Jewish unculture". The contrast between the two was apparently intended to show the achievements of the German ghetto administration in a particularly favourable light. Ghetto administrator Hans Biebow, a former coffee trader from Bremen, evidently hoped to be entrusted with

the administration of all the ghettos in occupied Eastern Europe.[20] It was therefore particularly convenient to have an eager amateur photographer on hand. The head of the accountancy department, one Walter Genewein from Salzburg, had been busily photographing "life" in the ghetto since the summer of 1940 and had also been taking official photographs of the production works and the many and varied activities of the Council of Jewish Elders. Genewein photographed "Jewish life" with an empowered eye. He had joined the NSDAP in Austria in 1933, and from 1940 onwards his photographic interests lay in proudly documenting the German ghetto administration's success at eking out something useful – to wit, labour, saleable goods and, finally, the remains of the murdered – from the human garbage "found" in the ghetto. These photographs showing the sorting of the meagre possessions of those who had been gassed conclude Genewein's private slide series, which he produced at the end of the war, perhaps even compiling it after his return home, and which he kept until he died. Yet Genewein did not just take photographs for his own personal satisfaction.

In January 1942, Genewein was entrusted with the task of establishing a museum. Within the ghetto, Hans Biebow called upon Professor Emanuel Hirschberg to set up a "scientific department" and to begin collecting liturgical objects and producing paintings and dolls on the theme of "Customs of Eastern European Jewry". In the weeks that followed, Biebow submitted an initial exhibition plan to the Litzmannstadt branch of the Wartheland *Reichspropagandaamt*. The concept was turned down. In June, the ghetto administration received the following notice: "On no account can I agree to the plan to set up an additional cultural exhibition [i.e. in addition to the ghetto production; HL]. There are a number of arguments weighing against it, which there is no need to list in detail at a time when the Jewish question is being treated extensively in a series of major exhibitions, and given on the other hand that life in the ghetto is intended to separate the Jews from the national community and should not serve to make them and their life appear in any way interesting to outsiders or satisfying the curiosity of those who ought to be content that with the establishment of the ghetto the Jew has disappeared from their walk of life."[21]

Not only had Biebow's protector Reinhard Heydrich been assassinated by the Czech underground, but "the Jew" had also begun to "disappear" in recent months, even from the ghetto. Between January and May 1942, more than 50,000 people were deported from the ghetto and murdered in the gas vans at Chelmno. The ghetto administration and its economic independence had been intended to be temporary. A museum hardly fitted in with such a concept. Biebow's attempts to allay the doubts of the *Propagandaamt* were to no avail. "This exhibition is intended to comprise only a few torah scrolls, caftans, prayer books, a few pictures of Jewish types and illustrations of the Jewish community, such as their primitive means of disposing of faeces, their uncultivated lifestyle etc. Such an exhibition is not intended to seem interesting to the visitor, but merely repulsive ... What is more, the ghetto administration and their management pro-

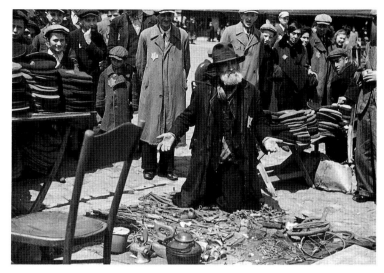

Walter Genewein, Getto L'Stadt der "Handel"

vide a guarantee that the Jews and contemporary Jewish life are presented in a such way as to arouse a sense of disgust in anyone who comes in contact with it."[22]

The impassioned amateur Walter Genewein, however, continued to produce his colour slides. In September, the ghetto administration ordered a slide projector in order to at least show the photographs to small groups, probably to customers from the clothing industry and Wehrmacht. In 1944, instead of a museum, they mounted an exhibition showing products from the ghetto, just a few weeks before the last Jews living in a Polish ghetto were deported to Auschwitz-Birkenau.

Amateur photographers

The major propaganda exhibitions had, admittedly, always been a source of inspiration for the rapidly growing numbers of amateur photographers in the 1930s. Five thousand entries for a Reich photographic competition were shown at the *Gebt mir vier Jahre Zeit* exhibition in Berlin. Personal reminiscences were to be merged "organically" to create a metaphor of the "German character" (according to *Photofreund*). As early as 1933, Heiner Kurzbein wrote in *Photofreund* on the founding of a national association of amateur photographers, *Reichsverband deutscher Amateurphotographen*: "Above and beyond its significance as a memento, the family photo can have an educational and affirmative effect with regard to race policy and can sharpen the eye of every comrade for the endeavours of race research."[23] This topic was to be addressed frequently by photographic periodicals in the period that followed.

Innumerable amateur photographs exist showing signposts proudly declaring a town or village to be *judenfrei*, photographs of anti-Semitic carnival floats, of shops that have been ransacked or of peo-

ple being publicly humiliated in the street. Countless photographs and amateur films will surface in the future because their owners no longer have any reason to hide them. Amateurs photographed everything that could be photographed, all the way to the very threshold of the gas chamber. At the right-hand edge of a picture by the Jewish photographer Abraham Pisarek, who managed to record a deportation of Berlin Jews on 10 November 1938, an amateur filmmaker can be seen shooting a film. It would be interesting to know what became of it.

Since the publication of Joe Heydecker's photographs of the Warsaw ghetto in the early 1980s[24] a number of books have been published with photographs by former Wehrmacht soldiers whose pictures were not taken in an official capacity and who did not belong to a propaganda company.[25] Joe Heydecker's claim that his photos were taken at great personal risk remained undisputed for a long time. Yet his photographs are clearly far less unusual than he would have us believe. In 1993, photographs of the Warsaw ghetto by Willy Georg were published, and the Deutsches Historisches Museum in Berlin has an extensive collection of colour slides of southern Polish ghettos taken by a member of a signal unit, awaiting publication. In 1988, photographs by former Wehrmacht sergeant Heinrich Jöst appeared in Israel, all of them apparently taken on his birthday on 19 September 1941 in the Warsaw ghetto. Jöst, who died in 1983, had given the photographs to Günter Schwarberg in 1982 for publication in the German periodical *Stern*. He said he had encountered no problems in entering the ghetto with his camera and taking photographs. "I wanted to know what was going on behind the ghetto walls. Until then, I had known nothing of all this, even though I was a grown man,"[26] claimed Jöst, who said he had not shown the photos to his family or to his comrades. This, at least, if not the entire story, is clearly a fabrication. In the Yad Vashem archives there are now more than a dozen photographs by Heinrich Jöst found in the possession of two different fallen German soldiers at the end of the war and passed on to Yad Vashem independently of each other.

Jöst did pass on his pictures. And he was not the only one. Heinrich Jöst's comrades were not shocked by them, but proudly presented them in their albums. The Yad Vashem Centre not only has photographs by Jöst, but dozens of photo albums and thousands of photographs by German soldiers and SS men showing a wide variety of ghettos and execution sites at various times. What is more, most of these albums bear handwritten commentaries and captions that leave no doubt as to just how well their owners were informed and how fully they condoned what their pictures show.

"The Warsaw Ghetto. A Cultural Document for Adolf Hitler" is the title given by one soldier, clearly a member of the Luftwaffe, to his album containing photographs of the ghetto alongside postcards of Warsaw and pictures of himself in the company of his comrades. Another soldier created his album of Przemysl as early as 1939 and has painstakingly penned the words "The 'Chosen People'" under two of the photographs. Another album shows the Jews of Siedlice and their

Albums of unknown German soldiers

"removal". The laconic commentary on two photographs of corpses reads "The end!" Such examples could be cited ad infinitum.[27]

"The act of photographing," wrote Dieter Reifarth and Viktoria Schmidt-Linsenhoff in 1983 in one of the first studies to address this topic, "is a further and more sophisticated mockery of the victims. For the perpetrators it is a comic interlude. By whatever means they will kill the men of Lukow and Lublin – by transporting them to an extermination camp, by shooting them in a mass execution or simply by burning them in the barns on the photographs – they interrupt this work for a private interlude in front of a comrade's camera."[28] The photographs are often of groups, showing the victims with their laughing murderers. Time and time again, corpses are photographed. Scenes of humiliation are particularly popular, such as the cutting of beards (as symbols of Jewish power) and other forms of humiliation. All this happens thou-

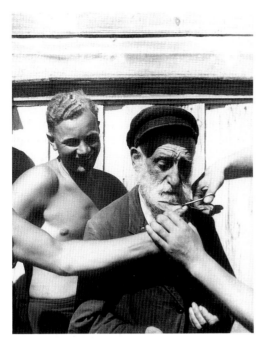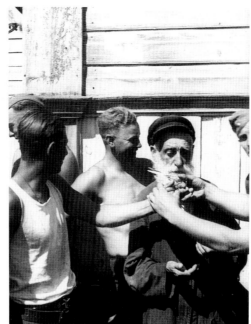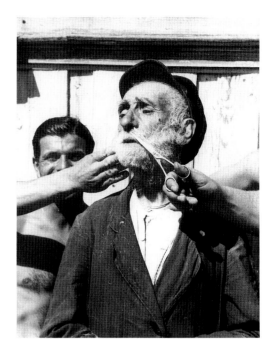

Alois Gehrmann, Western Ukraine, July 1941

sands of times over with no attempt at concealment from their own superiors, and in spite of the fact that the Wehrmacht supreme command and the SS leadership issued repeated circulars and decrees prohibiting photos being taken of executions and maltreatment, or of ghettos at all. These prohibitions are so numerous that their effectiveness appears doubtful.[29] The point, it would seem, was not whether photographs were taken or not, but the awareness of the photographers that, in taking these pictures, they became conspirators, accomplices, perpetrators, and thereby fully subscribed to the regime and its aims. Letters from members of the Wehrmacht clearly indicate how widely (and how soon) knowledge of the killings became commonplace. "While I was having my evening meal," writes Private W.H. on 28 May 1941, "the conversation also turned to the Jewish question in the *Generalgouvernement* and the world at large; it is very interesting for me to listen to such discussions. I was astonished to hear that, in the end, they were all agreed that the Jews must disappear completely from the face of the earth."[30] Photographs are also repeatedly mentioned. "Well, the comrades certainly made short work of them," writes a soldier on 26 July 1941 from Romania. "I have seen pictures of it, I can tell you what it looked like ... The Romanians will also have to learn how to deal with these scourges of humanity. Yes, I am experiencing all sorts and much that is new."[31] Lance-corporal W.F. wrote home on 9 May 1943: "Papa recently wrote that he thinks this is a war between Jews and Catholics. I think this is a war of Jewry against the Aryan people..."[32] On 21 August 1941, Major C.H.B. wrote of the Warsaw ghetto:"Here, the Jews trade amongst themselves, shouting loudly...That morning ... I saw several corpses, including some children, partly covered with paper weighted with stones. The other Jews pass by

without taking any notice until the primitive hearse cart comes along and picks up the 'remains' with which no trade is possible."[33] With regard to Auschwitz, we learn from soldier S.M. in his letter home dated 7 December 1942: "Jews come here, to Auschwitz that is, at the rate of 7000 or 8000 a week and die a hero's death soon afterwards. What a fine thing it is to see a bit of the world..."[34]

The soldiers brought home thousands of pictures in their albums. When he was arrested in Hanover in 1959, the Commandant of Treblinka still had an album with pictures of his former workplace labelled *Die schönste Zeit meines Lebens* (The best years of my life). Indeed, the only photographs of the selections at Auschwitz-Birkenau are from an album that obviously belonged to an SS man. At the liberation of Dora-Mittelbau, the album fell into the hands of a female prisoner, Lilly Jacob Meier, who had been in Birkenau herself and who recognized members of her family amongst them.

"Photography," according to one amateur magazine in 1940, "in its widespread popularity, has become one of the means of forging links and creating personal contact immediately... On the one hand, it records the experiences, landscapes and war effort on the front, while on the other hand creating a unique link between the front and home."[35]

Illustrated press

The motifs and subject matter – even the things the soldiers and SS men themselves believed they actually saw in the ghettos and camps – were shaped primarily by the medium of the illustrated perio-

dicals. After 1933, under the auspices of Heiner Kurzbein, head of the illustrated press department of the Ministry of Propaganda, the production of photojournalistic features was rapidly coordinated and controlled. At press conferences, in press releases and directives, themes were allocated and photographs supplied. There obviously seems to have been keen competition for coveted themes and photographs, fuelled by motivation rather than by acting on orders. Various periodicals were more or less adroit at currying favour by handling the sensitive issues that were bound to draw the attention of the illustrated press department chief. All the major periodicals ran reports and brief illustrated articles on "The global problem: the Jews", portraying the subversive influence of Jewish wire-pullers amongst American, British and French politicians, on Jewish-Bolshevist crimes in the Soviet Union, on the racial miscegenation expressly and systematically promoted by the Jews, on the secret conspiracies of Jews and Freemasons, on the German "war of defence" against world Jewry, Polish and Czech terror, *Vernegerung* ("Negroization") and Jewish *Schacher* ("hagglers"). The most sweeping anti-Semitic reports were published, needless to say, in the *Berliner Illustrirte Zeitung*. Its reporters, especially Wolfgang Weber, Hanns Hubmann and Leopold Fiedler, reported on the Jewish world conspiracy from Palestine and Lisbon, from Rumania and Shanghai. Harald Lechenperg, editor-in-chief of the *BIZ* was not dependent on the allocations by the illustrated press department or the favours of Heiner Kurzbein. But he was not one to turn down a good story either.

Such was the climate in which Hilmar Pabel, one of Germany's most famous postwar photographers, created his cover-story photo feature on the ghetto of Lublin for the *BIZ* in December 1940. It is of particular interest for the fact that it triggered the only noteworthy discussion to date on the extent to which "German photographers" also bore responsibility for the crimes committed. Today, this photo report is widely regarded by most photography historians in Germany as an example of manipulation running counter to the intention of the images used and therefore of the photographer.

After the war, Pabel was accoladed as the "photographer of humanity" and repeatedly lauded for his anti-war stance. Rarely questioned about his ghetto "report", Pabel obstinately described these photographs as a one-off and, above all, unwilling exception. He claimed that, as a freelancer, he was supposed to photograph an army hospital in Lublin for the magazine *Erika,* but that a military police unit had forced him to take part in a raid against smugglers in the ghetto. The photographs had been passed on to the editorial offices of the *BIZ* in Berlin without his knowledge. He had had nothing to do with the captions and, on learning of the report, had been utterly appalled.

All this was believed. In 1992, he was even nominated for the David Octavius Hill Medal of the *Gesellschaft Deutscher Lichtbildner.* Time and time again, it is pointed out that, if only they had been accompanied by a different text, Pabel's photographs would speak of pity for the victims they portray.

In fact, Pabel's photographs cannot have been the idea of a military police unit. After all, the Wehrmacht had its own propaganda companies. There was no impromptu "requisitioning" of photographers from the Reich. Pabel's photo series contains shots that have obviously been taken over a period of several hours (as the changing light conditions indicate). Pabel was obviously in the ghetto without an armed escort, as the lack of reaction amongst the people on the streets clearly shows. There is much to suggest that the "underground" raid showing smugglers being "tracked down" is staged. The soldiers are shown entering the cellar without their weapons drawn.

Nothing in this story rings true. Nor does anything ring true in Pabel's claim that the photographs show pity for the people in them. Though Pabel is otherwise proud to point out that he always aimed for cover photos, little attention is paid to his cover photo in this case.[36] It shows a German soldier striding heroically, followed by a Jewish smuggler with a sly expression carrying a sack. It is an unambiguous metaphor of an unequal struggle. It is David against Goliath. Only this time Goliath is prepared. From this photograph, the path leads through the alleys of the ghetto ("everyone trading with everyone else") down into the underground where bearded old men (not exactly typical smugglers, and possibly forced to participate in this photo session) "await" the photographer.[37] He looks over the soldiers' shoulders, confirming their view and their willingness to use violence against the defenceless (and evidently harmless) victims. Pabel's photographs, at least in the order that the series presumably had when it was submitted, are a veritable educational introduction to the stance of the perpetrator. From the menacing vision of a Jew attacking from behind, to the portrayal of the face of self-imposed misery ("greasy hands grope the meat" is the caption accompanying a photo of a street hawker) the observer is brought to the point of willingness to shoot at a defenceless person who is merely an "example" of his dangerous kind.

Pabel's report was anything but an "unwilling exception". It was the single most important step in his career. Not only was it his first report for the biggest and most prestigious periodical of the day, but it was also a cover story. Before that, Pabel had not only photographed for *Erika* and other relatively innocuous magazines. Nor had he worked only for the *Neue Illustrierte Zeitung*, which had been headed since 1931 by his one time fellow student Willy Stiewe. They had taken a course in printed media studies under Emil Dovifat in Berlin in 1932 and Willy Stiewe had since gone on to become one of the leading NS newspaper theorists. "That which is portrayed is in itself enough to guarantee that the image captivates the newspaper reader because it addresses the reader's innermost self, and because these things he is shown are matters that concern him. All the captions, too, are geared towards this message: it is your business!"[38] Willy Stiewe's words formed what was to all intents and purposes the canon of National Socialist photographers' self-styling. To him, realism was not a form of photography, but its ability to present "the thing itself in the image"[39] as "the true reflection of a piece of reality".[40] Heinrich Hoffmann, Hitler's personal photographer, styled himself as the mere custodian

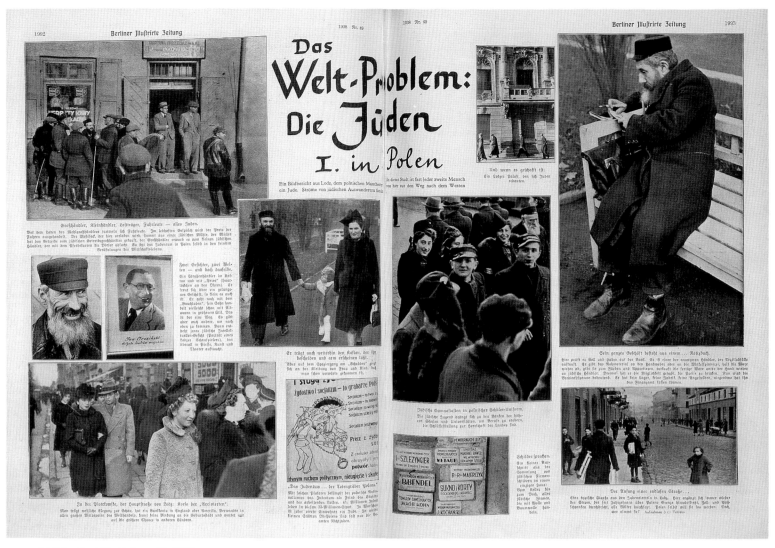

Berliner Illustrirte Zeitung 49, 1938

of facts, claiming that "the photographer reproduces an image, captures something, and that is all." In this way, like so many others, he denied all responsiblity for his own work. "Objectivity" now meant asserting that the results of one's own action were no more than a mere consummation of "facts", and otherwise citing the will of the Führer. This ideological construct was rationalised to the point of irrefutable inevitability: "reasoned anti-Semitism" as opposed to "emotive anti-Semitism". It was this negation, this "liberation" from all personal responsibility, that made any conceivable (and indeed any inconceivable) action possible in the first place, going far beyond the pale of civilization. At the same time, this collective "freedom from responsibility" was also the key to the sense of freedom from guilt that was to become widespread after 1945.

Willy Stiewe's patronage in the publishing world brought Pabel other clients apart from the *BIZ*. Since the late 1920s, Stiewe had been picture editor of the *Illustrierter Beobachter*, the illustrated periodical of

Franz Eher Nachf., the NSDAP party publishing house. From 1935 at the latest, it carried Pabel's reports prominently. Pabel had no need to join the party. His reports were adequate.

In its 48th issue in 1935, the periodical carried a full-page report (with seven photographs) under the heading *Juden... demonstrieren im Hyde-Park* (Jews ... demonstrate in Hyde Park). Under a photograph of two speakers is the caption: "These are our opponents abroad – a symbolic image of *Weltverjudung.*" It is not known who wrote the texts. The motif of a Jewish assembly, at any rate, must have been one that Pabel himself found during a visit to London.

On another rare occasion, however, he has put his name to the copy as well (even under the National Socialists copyright was taken seriously). *Bromberg. Elf Monate nach dem Blutsonntag* (Bromberg. Eleven months after Bloody Sunday) is a two-page report in the *Illustrierter Beobachter* of 25 July 1940. In it, Pabel writes of "hate-filled and megalomanic Polish scum" and of the German soldier "binding fast his helmet for the final reckoning, without succumbing to the

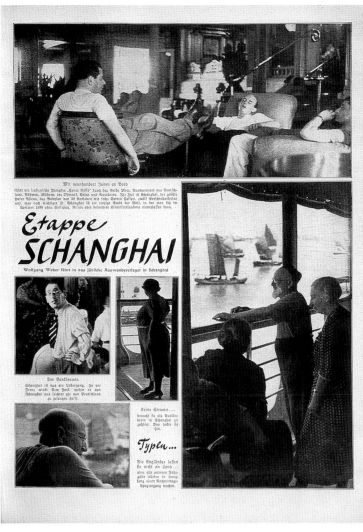

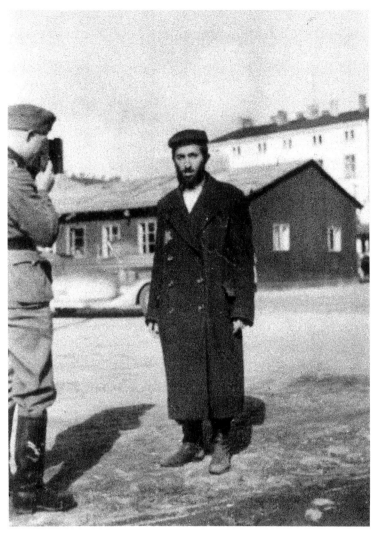

Berliner Illustrirte Zeitung 10, 1940

SS-PK Schilf, Lodz, April 1940

intoxication of conquest". Just three weeks later, Pabel filed another two-page report from "liberated" Bromberg with comparative photos of Polish and German children. It states that Polish attempts to destroy Germanic culture had failed because "our people and comrades, from a purely biological point of view, did not allow themselves to be absorbed by the inferior Polish race" (*IB* of 15 August 1940). Pabel also filed an intelligently composed report several pages long on Neubistritz in Sudentenland, "liberated from Czech rule", the text of which could hardly have been written without drafts by Pabel (IB of 22 May 1940). What is more, his reports occasionally ran as cover stories, such as his *Schulunterricht zum deutschen Vormarsch* (School lessons on the German advance) published in 11 July 1940 under the headline *Von 8–9 Uhr: Frontstunde* (From 8–9 o'clock: front lesson), which Pabel recalled with special pride a year later in the periodical *Gebrauchsfotografie*.

Fifty years later, Hilmar Pabel's amnesia went so far that he had lost all recollection of his five years of work for the *Illustrierte Beobach-*

ter. Given such memory gaps, we are obliged to rely on our own assumptions, for example that Pabel was not in Lublin on behalf of *Erika* alone, but also on behalf of *NIZ* and *IB* and that his work there may well have been rather less impromptu than he cares to remember, and that the quality of his reporting destined him for higher things – such as the *Berliner Illustrirte*.

Propaganda companies

In 1941, Pabel was conscripted into a *Propagandakompanie (PK)*. His employer was the same Harald Lechenperg who, as editor-in-chief of the *Berliner Illustrirte Zeitung*, was now also in charge of editing the Reich's most lavish colour (!) illustrated periodical, *Signal*, which was published in twenty different languages with a total circulation of over 2.5 million for distribution throughout occupied Europe to consolidate the new world order.

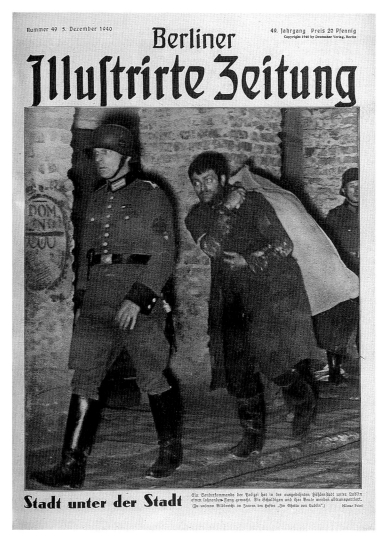

Nummer 49 5. Dezember 1940 49. Jahrgang Preis 20 Pfennig
Copyright 1940 by Deutscher Verlag, Berlin

Berliner Illuſtrirte Zeitung

Stadt unter der Stadt

Ein Sonderkommando der Polizei hat in der ausgedehnten Höhlenstadt unter Lublin einen lohnenden Fang gemacht. Die Schuldigen und ihre Beute werden abtransportiert.
(Zu unserem Bildbericht im Innern des Heftes „Im Ghetto von Lublin".) Hilmar Pabel

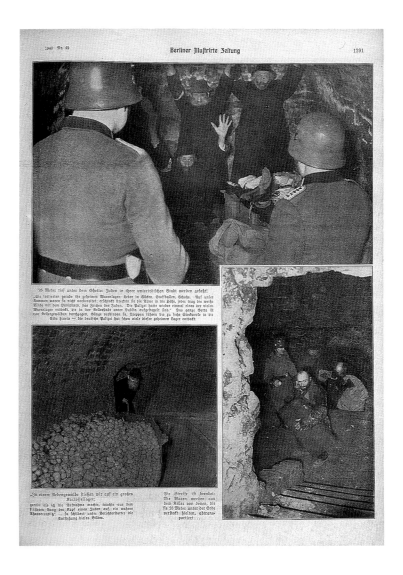

1940 Nr. 49 Berliner Illuſtrirte Zeitung 1291

25 Meter tief unter dem Ghetto: Juden in ihrer unterirdischen Stadt werden gefaßt!

Berliner Illustrirte Zeitung 49, 1940

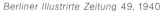

Working for *Signal* was the highest accolade any photographer could hope to achieve. Yet the *BIZ* also continued to print the reports by *PK* (propaganda company photographer) Pabel, including a report on Goebbels in the *Befehlszentrale der Reichshauptstadt* (Command HQ of the Reich capital) on 2 March 1944, for which many are likely to have envied him. Such envy would have been all the more justified given the fact that the use of photographs and texts supplied by the propaganda companies was centrally administered. All exposed films were passed on to the illustrated press department after clearance by the military censors and distributed from there to the various editorial offices. Set up in 1938, the propaganda companies comprised most of the active photographers still working in the Reich. For many of them, the propaganda companies were the last chance of avoiding front line service.

Wilfried Ranke estimates the overall production of the propaganda companies at more than two million photographs and 80,000 texts.[41] The federal archives even put the figure at a possible 3.5 mil-lion propaganda company photographs. The photographers themselves were responsible for the captions.

The fact that Pabel (and other photographers) continued to work for the *Berliner Illustrirte* on a regular basis was clearly a privilege. Other propaganda company photographers were left to do the groundwork, though they too might occasionally be published in the *BIZ* – a case in point being the members of propaganda company PK-689 which covered the dying of the Warsaw ghetto over an extended period of time, photographing and filming there for months. Some 720 photographs remain and are now part of the vast collection of propaganda company photos in the federal archives.

It was these photographers, most notably Albert Cusian and Erhard Josef Knobloch, who were responsible for the most cynical report ever published in the entire National Socialist illustrated press. On 24 July 1941, under the headline *Juden unter sich* (Jews among their own kind) the *Berliner Illustrirte Zeitung* ran a report on the ghetto as a "home of disease", claiming that "the Jews themselves have

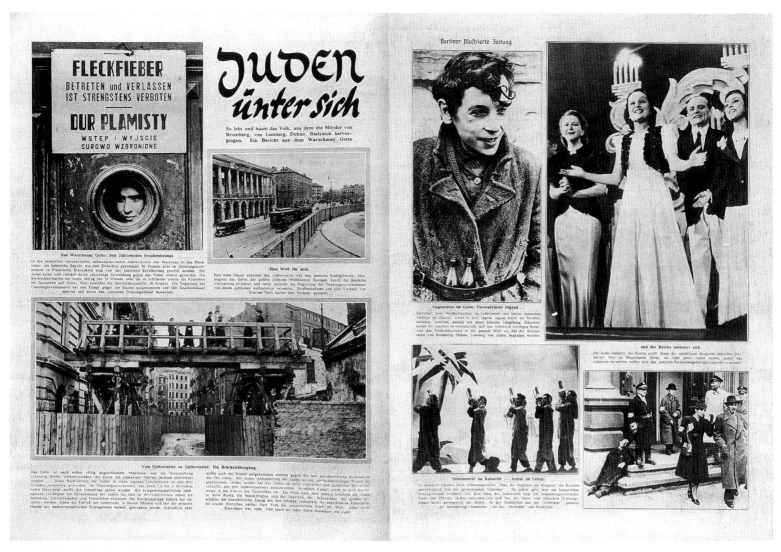

Berliner Illustrirte Zeitung 30, 24 July 1941

become immune to typhus through years of being accustomed to it," and that this made them a health hazard for the rest of the world. Photographs of poverty and cabaret, starving people and a casino in the ghetto are contrasted, and one of the photos shows a beggar beside the entrance to the office of the Jewish Council, suggesting that the "rich" in the ghetto are letting the poor starve. Photographs of wretched funerals at the cemetery are "proof" of Jewish impiety towards the dead. Other photos show the "most remarkable market in the world: Jews trading with Jews ... here the archetypal Jewish instinct rages: trade is undertaken here for its own sake."

In 1984 Ulrich Keller published a selection of the photographs taken by PK-689 in Warsaw and Lodz.[42] Many of the unpublished photos show the various tasks of the Jewish Council, including the Jewish Police. Ulrich Keller points out that the photographers themselves, who certainly did not write the captions that later accompanied their photographs in the *Berliner Illustrirte,* selected some of their motifs specifically with their subsequent purpose in mind or even staged

them accordingly. Time and time again, a key role was played by a photographic angle that indicated Jewish indifference towards the misery of the ghetto, even suggesting that Jews themselves were mainly responsible for the situation. In one botched scene (which therefore remained unpublished), Albert Cusian has a well-dressed mother and her child pass by a starving man indifferently, while all the other passers-by seem mesmerised by the presence of the photographer. Cusian and Knobloch knew the type of reports for which they produced their photographs. They knew which "facts" were expected of them.

Walther Kiaulehn, one of the propaganda company reporters who was to shape German journalism and literature after the war,[43] wrote "objectively" in his report in *Signal*[44] after the deportation of Jews from Marseilles, also documented by PK photographers, that "all this has nothing to do with literature, but only with hygiene."[45]

Epilogue

The PK photographers and their colleagues from the illustrated press formed the core of "German photography" after 1945. Hilmar Pabel, Max Ehlert and Wolfgang Weber, Harald Lechenperg and Hanns Hubmann, Leopold Fiedler and Wolf Strache, Gerhard Gronefeld, Bernd Lohse and Fritz Kempe built up the editorial offices, associations and institutions of German postwar photography, and worked together again for such periodicals as *Quick* and *Stern*. The lies and denials that had shaped their lives now formed the basis for that strangely forgetful morality that was to culminate in Pabel's *Bilder der Menschlichkeit* (Images of humanity). Did the maxim "never again!" really mean they had learned from their own crimes or was it the lesson of the catastrophe of defeat? In 1954, Pabel made his photographic summary of that experience. His book *Jahre unseres Lebens*[46] (Years of our life) is widely regarded as documenting a break with the National Socialist past. Yet readers will search in vain for the victims of National Socialism. Instead, it is the Germans themselves (first the soldiers and then the refugees) who are portrayed as the victims of a catastrophe visited upon them as though from without. "The dialogue between the great peoples had broken off, the second world war had begun," claims one of the captions known beyond doubt to have been penned by Pabel himself. And "a poor Russian peasant … did not see the German lad as an 'enemy', but as a human being on whom the war had been inflicted just as it had been on him". Pabel's words do not reflect a differentiated viewpoint. The image of the Germans as victims replaces any memory of his own actions and even continues to consolidate, albeit in a different form, the images of National Socialism and the fantasies of self-defence forced upon the German people. "We were all refugees." Only one of the photographs seems to breach this hermetic continuity. It shows an old woman pensively contemplating a work of art. The caption appears to provide information: "The last of an extended family. Husband, children and all her relatives are dead. She was standing in front of Rodin's *Citizens of Calais* at the Kunstmuseum Basel. 'Here, I find consolation and peace,' she says. 'I am free of hate and have no desire for retribution. In spite of everything that has happened, I believe that we Jews should not be self-righteous. God has passed judgment on us all…'"[47] Viktoria Schmidt-Linsenhoff has described the structure of this self-exoneration as an arrangement from which "the consensus of forgetting is presented as humanitarianism".[48] "A judgment passed on us all." In 1954, Hilmar Pabel still saw the Jews as ultimately responsible for their own fate, or at least as responsible as their murderers. Pabel is interested in the person of the survivor only insofar as her presence allows him to alter the angle from which the reality of destruction is viewed. "The photograph of the Jewish woman visiting the museum does not point to the millions of murdered Jews, but is a substitute for them."[49] Such was the measure of "humanitarianism" with which postwar German society was willing to live.

I wish to thank Timm Starl and Rolf Sachsse, without whom this essay would not have been possible.

Notes

1 To date, there has been no research of any note on this subject. Contributions to the debate have, however, been published regularly since the 1980s in the magazine *Fotogeschichte*. An initial overview is provided by Sibil Milton's 1988 essay "Argument oder Illustration. Die Bedeutung von Fotodokumenten als Quelle" in *Fotogeschichte* no. 28, year 8, pp. 61–90. However, Milton does not closely examine the specific anti-Semitic iconography and function of National Socialist imagery.

2 C. A. Kanitzberg, "Der neue Weg" in *Photofreund*, Berlin 1933, issue 13, 20 July 1933, pp. 259–60.

3 Mosse-Verlag alone, the publishers of *Berliner Tageblatt*, dismissed 118 Jewish staff in March 1933 (*Jüdische Rundschau*, no. 28/29, 7 April 1933). Gusti

Hilmar Pabel, Jewish emigrant contemplating Auguste Rodin's *Citizens of Calais* at Kunstmuseum Basel, before 1956.

Hecht, Jewish editor-in-chief of the illustrated periodical *Der Weltspiegel* was kept on until 1 October 1933 before her name disappeared from the masthead.

4 Bernd Weise, "Pressefotografie als Medium der Propaganda" in: *Die Gleichschaltung der Bilder. Pressefotografie 1930–36.* Diethart Kerbs, Walter Uka and Brigitte Walz-Richter (eds.), Berlin 1983, p. 144.

5 Reichskulturwart Hans Hinkel railed in 1935: "We know that here and there Jews are working incognito . . . We want a clean break at last. Just as anonyms are undesirable, so too are goinonyms. Anyone who compromises intellectually or otherwise with Jewry has no place in the cultural lebensraum of the German people." "Schluss mit Tarnung und Verfilzung" in *DNB, Strohmänner des Judentums,* Berlin and Munich 1935 (27 July).

6 Letter from Adolf Hitler to Adolf Gemlich dated 16 September 1919. Cited in Eberhard Jäckel (ed.) with Axel Kuhn, *Hitler – Sämtliche Aufzeichnungen 1905– 1924.* Stuttgart 1980, pp. 88–90. A detailed study of this letter can be found in: Claussen, Detlef, *Vom Judenhaß zum Antisemitismus,* Darmstadt and Neuwied 1987.

7 Ibid.

8 Ernst Jünger in the debate on "the Jewish question" in *Süddeutsche Monatshefte,* September 1930, p. 845.

9 Carl Schmitt, "Die deutsche Rechtswissenschaft im Kampf gegen den jüdischen Geist" in *Deutsche Juristen-Zeitung,* 41 (1936), issue no. 20, p. 1194.

10 Clauss, Ludwig Ferdinand, *Semiten der Wüste unter sich,* Berlin 1937, p. 26.

11 Ibid., p. 145.

12 Ibid., p. 147.

13 Ibid., p. 154.

14 Ibid., p. 10.

15 Ibid., p. 13.

16 Ibid., p. 15.

17 Ibid.

18 Ibid., p. 17.

19 It is possible to discuss this film here thanks to the painstakingly detailed analysis carried out by Evelyn Hampicke, who also reconstructed the reception and use of film in various National Socialist events.

20 The Gestapo, for whom the economic self-interests of the ghetto administration were a thorn in the side, tapped the telephones of the ghetto administration. The reports of the telephone conversations they tapped deal repeatedly with Biebow's career ambitions. On 3 March 1942, for example, one such report states: "Moreover, government vice president Moser and RR Weygant are of the opinion that Biebow hopes, through a closer connection with Heydrich, to become Germany's 'expert on Jews' in order to take over management of all the ghettos." (Cited in *Unser einziger Weg ist Arbeit. Das Ghetto in Lodz 1940–1944,* compiled and edited by Hanno Loewy and Gerhard Schoeberner, published by the Jüdisches Museum Frankfurt. Vienna 1990, p. 104.

21 In a letter from the director general of exhibitions and trade fairs, Maiwald, to the Reichspropagandaamt Wartheland, Litzmannstadt branch, on 24 June 1942 (ibid., p. 55).

22 Letter from the ghetto administration to the Reichspropagandaamt dated 27 August 1942 (ibid.).

23 Heiner Kurzbein, "Reichsverband deutscher Amateurfotografen" in *Photofreund,* 13 (1933), pp. 367 f.

24 The first edition was published in Sao Paolo in 1981. The German edition followed in 1983, Joe J. Heydecker, *Das Warschauer Getto,* Munich 1983.

25 Joe Heydecker, on the other hand, was employed in a photographic laboratory of propaganda company PK-689, whose pictures will be dealt with below.

26 Cited in: Günter Schwarberg, *Das Getto. Ein Spaziergang in die Hölle,* Frankfurt am Main 1991, p. 78.

27 My attention was drawn to these albums by Judith Levin of the Yad Vashem Archives.

28 Dieter Reifarth and Viktoria Schmidt-Linsenhoff, "Die Kamera der Henker" in *Fotogeschichte* 3 (1983), issue no. 7, p. 57.

29 The relevant prohibitions, orders, circulars and decrees are too numerous to list here.

30 Cited by Walter Manoschek (ed.), *Es gibt nur eines für das Judentum: Vernichtung,* Hamburg 1995, p. 25.

31 Ibid., p. 38.

32 Ibid., p. 67.

33 Ibid., p. 42. One month previously, the *Berliner Illustrirte Zeitung* had run a report on the Warsaw ghetto, the tone of which seems to have been adopted for the "observations" of the soldier cited here.

34 Ibid., p. 63.

35 Editorial, "Soldaten-Weihnacht 1945" in *Die Fotografie mit Spiegelreflex-Kameras,* 7 (1940), issue no. 42, p. 2.

36 According to Hilmar Pabel in 1941 in the magazine *Gebrauchsfotografie.*

37 Deliberate manipulations of this kind in the Warsaw ghetto are documented. For example, Adam Czerniakw noted in his diary that "twenty orthodox Jews with peot and twenty upper class women" were forced into a mikveh for a German film team.

38 Willy Stiewe, *Das Pressephoto als publizistisches Mittel,* doctoral thesis, Leipzig 1936, p. 124.

39 Ibid., p. 35.

40 Ibid.

41 Winfried Ranke (ed.), *Deutsche Geschichte kurz belichtet. Photoreportagen von Gerhard Gronefeld 1937–1965),* Berlin 1991, p. 38. Both the editor and the author of the foreword add to the myth of a photographic statement open to interpretation (depending on the captions), possibly with the exoneration of the photographer in mind. "Photography in itself is silent and patient . . . The photograph gains its meaning only through its caption," writes Dieter Vorsteher on p. 8 for the Deutsches Historisches Museum. ". . .but photographs are known to be silent and patient. The caption is intended to lend them a voice," writes Wilfried Ranke himself on p. 38. Does this mean that pictures themselves express nothing at all, or is such apparent source research aimed at the old myth that pictures, without distortion by the interpretative text, would show nothing but the "truth"? (As though no interpretations or interactions were possible in the visual worlds of photography.) This, however, would mean that the "critical assessment" of National Socialist photographers was more or less subscribing to their own self-styled image as incorruptible guardians of facticity, expressed in ever new variations from Heiner Kurzbein to Willy Stiewe and Heinrich Hoffmann.

42 *The Warsaw Ghetto in Photographs,* edited by Ulrich Keller, New York 1984.

43 These include Peter von Zahn, Henri Nannen, Werner Höfer, Ernst von Khuon, C.W. Ceram, Herbert Reinecker and Jürgen Roland, to name but a few.

44 *Signal,* first April issue 1943.

45 Cited by Ahlrich Meyer in "Die Razzien in Marseille 1943 und die Propagandaphotographen der Deutschen Wehrmacht" in *Francia. Forschungen zur Westeuropäischen Geschichte,* issued by the Deutsches Historisches Institut, Paris, vol. 22/3 (1995).

46 Hilmar Pabel, *Jahre unseres Lebens.* Stuttgart 1954. The book was such a success that it was reprinted two years later by the Bertelsmann-Lesering book club.

47 Ibid., p. 54.

48 Viktoria Schmitt-Linsenhoff, "Die Verschlußzeit des Herzens" in *Fotogeschichte,* 12 (1992), issue no. 44, p. 63.

49 Ibid.

Hermann Glaser

Images of Two German Post-War States
The Federal Republic of Germany – Examples from the History of Everyday Life

There are many different reasons why photography is an import-ant medium for the history of everyday life. Anyone who wants to know (and read) about what constituted the reality of past times – "the naked truth without ornamentation, a thorough examination of detail" (Leopold von Ranke) – usually also wants to see that reality. Since the 19th century, the technical reproduction of images (photography, film, television) has undergone a constant process of improvement and perfection. In the days when virtual reality could not be produced, as it can today by digital technology, people believed that photographs captured reality in an "inimitably faithful" and unique way. In 1839, when Alexander von Humboldt reported from Paris to Duchess Friede-rike von Anhalt-Dessau about a new revolutionary invention – L. J. M. Daguerre's photographic process – he was particularly fascinated by the fact that "in just a few minutes, light, forced by chemical artistry" produced "lasting traces" and in so doing clearly outlined the contours of even the most subtle details.[1] Roland Barthes' "that has been" first became conceivable on the day "when a scientific circumstance (the discovery that silver halogens were sensitive to light) made it possible to recover and print directly the luminous rays emitted by a variously lighted object".[2]

The invention of the hand-held camera made it possible for peo-ple to inform themselves in detail about current events by means of photographs, almost as if they had witnessed these events person-ally; the photograph's authentic character always seemed to present a correct image of reality. "The photographic image conquered every-day life and became an indispensable witness of extraordinary events. It opened up new possibilities of 'seeing' with a precision and clarity that neither words nor drawings could achieve. Photography now became the mirror of the world. Although at first it was only used for portraits and sights of historical interest, it soon became part of every-day life, documenting almost everything that happened in the world."[3] Roland Barthes sees the essence of the photograph as having two specific features, a *studium* and a *punctum*, both of which have a bear-ing on the observer: "It is by *studium* that I am interested in so many photographs, whether I receive them as political testimony or enjoy them as good historical scenes: for it is culturally (this connotation is present in *studium*) that I participate in the figures, the faces, the fea-tures, the settings, the actions. The second element will break (or punctuate) the *studium*. This time it is not I who seek it out (as I invest the field of the *studium* with my sovereign consciousness), it is this element which rises from the scene, shoots out of it like an arrow, and pierces me. A Latin word exists to designate this wound, this prick, this mark made by a pointed instrument: the word suits me all the better in

that it also refers to the notion of punctuation, and because the photo-graphs I am speaking of are in effect punctuated, sometimes even speckled with these sensitive points; precisely, these marks, these wounds are so many points. This second element which will disturb the *studium* I shall therefore call *punctum*; for *punctum* is also: sting, speck, cut, little hole – and also a cast of the dice. A photograph's *punctum* is that accident which pricks me (but also bruises me, is poignant to me)."[4] The *studium* requires a code, is aimed at interpreta-tion; the *punctum* is the detail (what pricks me). "It is not possible to posit a rule of connection between the *studium* and the *punctum* (when it happens to be there). It is a matter of a co-presence, that is all one can say."[5]

If one approaches photography at the end of the war in 1945 with such philosophical considerations in mind, then the individual and collective "devotion" to photographs "shot" during that period would seem to be particularly intense. For people who witnessed "those times" the respective photographs still evoke moments of parti-cular biographical importance. The succeeding generations on the other hand – usually sensitized to the post-war period by parents and grandparents – see in these photographs compelling historical emblems of everyday life which offer access to past exotic spiritual and emotional spaces, be that the ambience of a bombed house or a kidney-shaped table. Both groups fully understand the code of these images, readily available to them from either their own personal expe-rience or from what has been handed down. The aphoristic interpreta-tion imposed on selected photographs at a later date – incited by the irritation of the *punctum* and transposed from the affective to the cog-nitive level – is an "addition": "It is what I add to the photograph and *what is nonetheless already there*."[6]

In search of lost time, a snapshot can produce an effect similar to that triggered by Marcel Proust's madeleine dipped in hot tea. Such effects constitute "resurrections of the past": "In the split second for which they endure, these resurrections of the past are so complete that they not only oblige our eyes to ignore the room close at hand in order to look at the pathway lined with trees or the rising tide; they also force our nostrils to breathe the air of far-distant places, our will to choose between the different possibilities they offer, our whole person to believe itself surrounded by them, or at least tottering between them and the present places in a state of bewilderment caused by an uncertainty similar to the one we occasionally experience when an ineffable vision appears just as we are about to fall asleep."[7]

The initial impression left by a photograph of everyday life in the past is that of a fixed surface: "The photograph's bewildering state-

ment is made by its light, its clarity, its flat surface – with neither reverse side nor depth, it is a spell-binding exposure of a past that it shows in full but does not restore." [8] Developed in a dark room ('chambre noire') it is like a bright room ('chambre claire') – and has an aura of unambiguity: the ruin is a ruin is a ruin … What is seen in such a clarity, however, sets a deliberate interpretative process in motion: What does the picture "mean"? What transcendence informs its immanence? The photographer makes the "significance" of the image transparent by means of small pointers. The "bright room" of the photographic image corresponds to the "dark room" of its content, which can be explored with the aid of empathy and "infra-knowledge".

The "dark room" can also be interpreted in such a way that the people and things appearing in photographs are in fact only shadows of what they were in reality. Plato's *Politeia* contains the parable of the cave, a dark underground chamber where people are shackled from childhood, a dwelling with an opening to the daylight to which the inhabitants, however, cannot direct their gaze; they are imprisoned, caught in the co-ordinate grid of their situation, and "so fastened that they can only look straight ahead of them and cannot turn their heads. Beside them and above them a fire is burning, and between the fire and the prisoners runs a road, in front of which a curtain-wall has been built, like the screen at puppet shows between the operators and their audience, above which they show their puppets." Paul Valéry refers to Plato's famous cave as a "dark room" – "in my opinion, the largest ever conceived." [9]

It is in this chiaroscuro that the particular quality of a successful photograph of everyday life can be found: in the combination of bright surface and still dark meaning; the Abbild, or image, rises up to the Inbild or ideal. What is illuminated, however, remains ambiguously shaded: the light source of truth lies "outside".

II

A selection of 16 photographs, typical for the period between 1945 and 1970, illustrates the interrelation between momentary Abbild and multi-dimensional Inbild. The intention is to "bring out" what is "hidden" in the image and what (historical) studium – that exploration of the Zeitgeist – can add to it. The individual photograph proves to be a probe, encountering and "addressing" various different levels of consciousness. The photograph is not understood as an illustration of a time pattern that has already been "deciphered" and "read", but as a sign that puts us on the track (or as a catalyst that renders meaning tangible). The photographer – who in his capacity as a "reporter on the world of everyday life" may not wish to be an artist but is one nevertheless, whether he proceed intuitively or deliberately, naively or strategically – maps out the socio-cultural time-scape "truthfully" (which does not necessarily mean "correctly") and from important surveying points. The chance aspect involved in taking photographs constitutes a coincidence; the photograph functions as a synapse or junction, a point of intersection and interaction between the perception of surface detail and insight into deeper structures.

Photograph 1

Bathers enjoy themselves on the bank of the river Havel near Berlin – in the immediate proximity of military graves. The remains of the soldiers, buried hastily in the chaos of the collapse, have not yet been transferred to another graveyard and already flowers and grass have begun to grow on their resting place. This photograph may have been taken in the summer of 1945, perhaps even a year later. Its perspective (that coexistence of *studium* and *punctum*) is indicative of the existential mood of the post-war period: the fear of death has succumbed to the joy of life; those who survived want to enjoy themselves. In the words of Ingeborg Bachmann, written later in her life:

Soldiers' graves along the river Havel, c. 1946

"There is nothing more beautiful under the sun than to be under the sun."[10]

May 1945 was so gloriously sunny and warm that it felt like summer. Arnulf Baring recalls the most beautiful gift it brought, serenity. When reflecting on early May 1945 the first thing that comes to his mind is that silence, that stillness, day after day, sitting under a bright sky in the warm sun and not being the slightest bit afraid anymore.[11] A snapshot – "why choose (why photograph) this particular moment rather than some other?"[12] – taken at noon, when the Great Pan sleeps and for a brief moment human beings are spared his lunacy. Panic might still break out again when he wakes, but this carefree spirit might prevail too. The indifference of death and life, or indifference to death in the midst of a new life. The photograph is imbued with the atmosphere of a "panic idyll". What had begun in the cold winter of 1944/45 (the finale of a terrifying downfall) ended in the warmth of spring. For the Germans that spring was the herald of the occupation zones. In the words of Hans Werner Richter: "Life was most carefee in the English zone, most luxurious in the American zone, and most hazardous in the Russian zone."[13]

Photograph 2

The characteristic interior design prevalent in the Third Reich – that "nordicized", rustic, "blood and soil" or "Brauhaus" style – was a perversion of a state of mind which itself had perverted the cosy simplicity of the Biedermeier style, manifesting itself in the so-called *brauner Plüsch* (brown plush). The garden gnome, representative of a world in which knick-knacks filled a horror vacui, is not just an ornamental but above all an ideological feature of that style, suggesting loyalty and honour, stability and homely cheer. Life during the war-time bombing had been reduced to satisfying the most elementary needs. Gaping holes in house-fronts provide unimpeded views of intimate spaces in which a modicum of *Heimat* ("the territory that reassures us of our existence") has been created with what was left of the furniture; part of the "panic idyll" is setting up home again despite the shortages.

This photograph by L. Winkler (of makeshift living-quarters in Berlin) shows life re-establishing itself among the ruins. It also documents two phenomena: destruction (statistically, the rubble to which many German cities had been reduced amounted to more than 400 million cubic metres, corresponding to about 10 million filled railway cars), and the will to reconstruct. On the top floor we see people taking a short break from work to reflect on what comes next; on the floor below is a couple relaxing with a cup of afternoon coffee. The prevailing mood resembles that described by Willy Brandt (arriving in Bremen in 1945 from exile in Norway and Sweden) – although the people he met were in tatters and undernourished, they did not seem as if their will to live and build a future had been broken: "In those September days I experienced how close human misery and human greatness lie, and how forgetting is both a curse and a blessing."[14]

L. Winkler, Emergency housing among the ruins, rear house, Oranienstrasse 187, c. 1946

Photograph 3

It is not all that important, and not immediately apparent, that this photograph by Hans Schürer is a view of the audience attending the first concert given by the Munich Philharmonic Orchestra after the war (a performance of Ludwig van Beethoven's 9th Symphony in the Great Hall of Munich University, 1945). Typical for the spirit of the time is the emotional need expressed on the people's faces: music experienced as a means of survival. The photograph captures a moment of transport, of abandonment to another world that – as an ideal vision – distracts from hardship: an appreciation of art without pretense or affectation, an immersion in art without coquettish inwardness, an artistic celebration without pathos. According to Ernst Bloch, music, because of its immediate power of expression, has more than any other of the arts the capacity to "assimilate" suffering and hope.[15]

The people's clothing alone indicates that this is a "bourgeois" audience. This social class in particular was representative of a culture

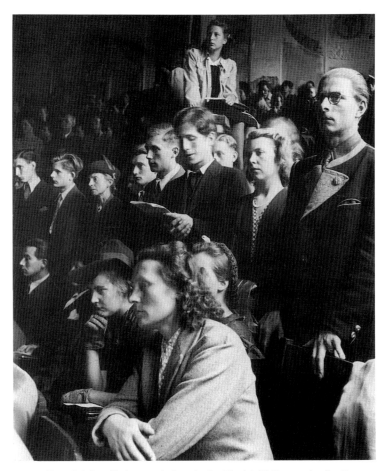

Hans Schürer, First concert given by the Munich Philharmonic after the war in the Great Hall of Munich University, 1945

An (ambivalent) caption for this photograph by Friedrich Seidenstücker (1947) might be "Tolle et lege, tolle et lege – Take up and read, take up and read" (Saint Augustine, The Confessions, Book VIII). A makeshift window separates the books from the people; a hint of resigned astonishment can be perceived in the eyes of the window-shoppers, suggesting that they are unlikely to cross the threshold. Their neat and well-kept clothing (saved from the war's destruction) might lead one to expect a certain purchasing power, but obviously not for the kind of thick folios on display here. Cheap Rowohlt rotary press novels (rororo) are probably not available in this particular shop.

The attentive respect for books, which constitutes the *punctum* of this photograph, could be interpreted as compensation for years of deprivation. After 12 years of dictatorship the mind can wander freely again. What free culture means is illustrated in the range of books available. At the time of this photograph the number of books on sale was still restricted by paper shortages and translation rights. The age groups particularly "affected" by that free culture were those old enough at the so-called "zero hour" to recognize spiritual values but also young and agile enough to be able to withdraw quickly from National Socialist indoctrination. According to Ernst Rowohlt, who in 1946 began using newspaper and rotary presses to print modern novels, Germany was faced with an entire generation with no appreciation of what his generation regarded as literature: "Sinclair Lewis, Joseph Conrad, André Gide – they have hardly ever heard these names. Already in 1938, English or American authors could no longer be published, and with the outbreak of war all foreign literature disappeared from the libraries. Today's thirty-year-olds were seventeen then. All that interests me at the moment is the spiritual vacuum in the generation now faced with the task of sorting out this mess. This is where I see my task." [18]

From a methodological point of view, it may seem somewhat paradoxical to associate Seidenstücker's photograph with the literary culture so essentially influenced by Ernst Rowohlt, a culture which grew out of the scarcity of the so-called *Trümmerzeit* or rubble period. After all, this photograph does not show that particular book culture. On the contrary, the tomes on display seem more likely to belong to the "mummified" German library book category. In fact, what we see here is an antiquarian bookshop run by Gerd Rosen on Berlin's Kurfürstendamm, one of the first bookshops to open in Berlin after the war.

But "correctness" is not essential here; it is the "atmosphere" that must be authentic in a historical photograph. At the time, idealistic pathos – "the struggle for inner awareness and transformation" – marked the efforts being made to re-educate the German people. Essentially, the content of the photograph could be summed up in the cultural rhetoric of the time as a "belief in the eternity of the spiritual world". Germany's great moment could be its return to humanity, despite its greatest humiliation. Thus on 10 May 1945 (in a BBC radio series that

that Herbert Marcuse called "affirmative": a culture in which the intellectual, spiritual world is separated from and raised above civilization as an independent realm of values. Its determining feature is an insistence on an infinitely better and more valuable world, universally binding and demanding of affirmation; a world that is essentially different from the world of the everyday struggle for survival, but one which individuals are capable of grasping from "within", without altering those inevitable facts of life. It was in this realm that cultural activities and objects could assume the dignity that raised them high above everyday life: their reception became an act of celebration, of exaltation. "It responds to the misery of the isolated individual with general compassion, to physical suffering with the beauty of the soul, to outward enslavement with inner freedom, to brutal egoism with the virtuous realm of duty." [16]

The photographer negates the questionability and ambivalence (or ambiguity) of the "Good, Beautiful and True". In contrast, Günter Eich's poem "Latrine" presents a counter-image to lofty idealism: . . . *Irr mir im Ohre schallen / Verse von Hölderlin. / In schneeiger Reinheit spiegeln / Wolken sich im Urin* . . . (Demented, resounding in my ears / Verses by Hölderlin / As pure as snow / Clouds reflected in urine).[17]

Friedrich Seidenstücker, Books on display again in Rosen's Antiquarian Bookshop, Kurfürstendamm, 1947

had enabled the novelist to broadcast his views since October 1940) Thomas Mann addressed his German listeners from exile in America. That great moment would be a difficult and sad one, because Germany no longer had the strength to bring it about on its own. Horrendous, almost irreparable damage had been done to the country's good name. Its power had been squandered. "But power is not everything, it is not even the main thing, and German dignity was never just a matter of power. Being German once meant, and may one day again mean, gaining respect, admiration, from power, through our human contribution, our free spirit." [19]

was one filled with anxious excitement. Soon, however, the anxiety was dispelled and excitement predominated. On 28 April 1945 Ursula von Kardorff notes in her diary that the American soldiers are friendly: "Sometimes a few of them look over our garden fence. We enjoy chatting with them ... They bring chocolate and we talk as objectively as possible – in indescribably bad English – about politics." [20]

This kind of statement is typical of the time. The Germans were fortunate to have the Western Allies in their country. Klaus-Dietmar Henke, whom we have to thank for a comprehensive study of the American occupation of Germany, comes to the justifiable conclusion that the enemy in the west was indeed a very friendly one. In view of the human catastrophe caused by the Germans, and despite the victors' determination to eliminate National Socialism, the American (and English) occupation of Germany was embarrassingly fair and undeservedly constructive, a triumph of political judgement, humanity and foresight. [21]

The horror of the war had not destroyed the standards of fair play, culture and morality so deeply-rooted in Western democracies. The Germans, who for twelve years had scorned any kind of humanity, scarcely acknowledged the humanitarian behaviour of the Western occupiers at first; they simply took it for granted. Some even considered themselves victims. The reaction of young people was different. In the literal sense of the term, and partly out of boredom, they very quickly "got together" with the "enemy" who now held sway in their country. Of course, the population in general was impressed by the outward appearance of the Americans. The efficiency of their equipment, their worldly flair (chewing gum, Lucky Strike cigarettes, aftershave, Life magazine), furthered their reputation. Such accessories conjured up a distant world of cultivated consumerism, something that had been suppressed in the stiflingly provincial world of the Third

Photograph 5

The photograph of American soldiers taking a break by the roadside is to be understood as depicting not the calm before, but the tranquillity after the storm. Their weapons have probably been left in jeeps and transporters parked opposite them but not visible; most of the soldiers have removed their helmets. Their faces look tired but in no way exhibit the tense exhaustion of battle. The faces of the children and young people who have joined the soldiers, while remaining at a certain distance, are serious. Despite the prohibition against "fraternization" first tentative "approaches" are being made: an advance from a distance. This photograph was taken by the Munich photographer Hans Schürer in a rural area in the south shortly after German capitulation – the American occupation of Bavaria was more or less complete. "Contacts and friendships were made quickly." The photographer's annotation is not yet visibly verified. Instead, what the photograph has captured is the moment, still tinged with scepticism, when first contact was being made. Initially, the cry "The Americans (Amis) are coming!"

Hans Schürer, American occupation of Bavaria, 1945

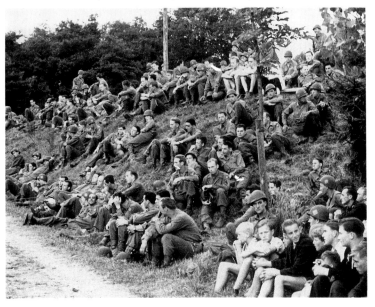

Reich. The myth of the "brave new world" soon received further confirmation not just in the content but also in the impressive outward appearance of the Care packets. At a time of total shortage, those packets stood for an earthly paradise in miniature form. With a "click" of visual empathy, Hans Schürer captured the emotional state of the Germans in the early phase of their "Westernization".

Photographs 6, 7 and 8

The scenes of destruction and devastation at the end of the war held a particular fascination for German photographers, who portrayed the total collapse – the result of total war – as an agglomeration of ruins and rubble. In the West at least, it was now possible to photograph those picturesquely macabre scenes in their symbolically transparent configurations, freely and without political restrictions.

Given that so many photographs were taken of the ruined landscape of the immediate post-war period (sufficient film material of the Third Reich had also survived), it is possible to compensate at least on "paper" (in photograph collections, exhibitions, illustrated books) for a huge deficit in the preservation of the national heritage. This deficit represents a disregard both for history and for the history of everyday life, a repression of the worst intervention in history into Germany's urban fabric – the far-reaching destruction of its cities. There are scarcely any warning memorials to be found in German cities today, and those that exist do so as a mere quotation (though carefully preserved). The Gedächtniskirche in Berlin is a case in point. The following are some outstanding examples of "ruin photography":

– Fritz Eschen worked in Berlin; he survived persecution by the Gestapo thanks to his *Mischehe* (mixed marriage). "The ruined landscapes suggest good weather. They are genuine, as can be seen from the fact that there are people in them, though very few and mainly pedestrians. Their paths seem adventurous. They pick their way precariously across the Landwehr canal or, if they are lucky, find a boat to row them across. In some places groups of people gather; refugees from the east arrive at the Lehrter railway station. Two soldiers sit against the wall of a house, their young faces visible from beneath their caps. By contrast, the boots on their feet are only fit to be thrown away. Children run around barefoot playing among the ruins. It is summer."[22]

– Friedrich Seidenstücker also took photographs of the clearance left behind in Berlin by the war. In the 1920s he had captured everyday life in the city with humour and empathy, though without achieving any particular renown. On his return to Berlin from a refuge in the countryside, the subject he chose to photograph no longer appealed very much to the Germans once they had been seized by a "giddy reconstruction drive": the ruins of Berlin, "... bullet-riddled monuments, the ruin of the Royal Castle in all its bloody detail. Seidenstücker, who had never before been interested in buildings, produced an uncompromising pictorial chronicle of the sooty, crumbling

remains of the lost city ..." In his later photographs we seldom find those beautiful women he had once "shot" secretly and mischievously but without covert voyeurism, "their long legs, their seductively rounded bottoms, the fine curves in their bathing costumes", though occasionally he portrayed beauty queens, those idols of the post-war era.[23]

– Herbert List, who is regarded as a representative of *fotografia metafisica,* also took aesthetically appealing photographs of ruins in Munich: "Among the ruins lies the beauty of the calm after the storm, the beauty of pure form without content. The columns of the Propyläen have been sanctified by their destruction. The remains of the Hofreitschule reach up into the void like an aqueduct. The plaster cast of Michelangelo's Slave is contorted in even greater agony than the original in the Louvre, a huge gaping hole in his left arm. In the ruins of the Akademie, covered in snow, the casts wait in endless silence."[24]

– Germany's most famous portrait photographer, August Sander, turned his attentions to the destroyed city of Cologne. In the 1920s Sander had been the representative of the objective "New Vision". What he captures in Cologne is above all the absence of people (it was 1946 before he returned to the city from his refuge in the Westerwald region): a few streetcars, and in the background, several passers-by and cars – his photographs seem not to want to perceive more life than that. "Sander climbed up to the top of the cathedral towers and panned his camera like a surveyor doing topographic studies for a new city plan."[25]

– What Sander in his "severity" left out, Hermann Claasen made the focal point of his ruin photography. Claasen had photographed Cologne secretly during the air-raids; after 1945 he concentrated primarily on iconic details, the human, all-too-human stirrings of a reticent new beginning: "The first smile in a new life, the early stages of reconstruction, the picturesque improvisation, the touching detail, that art of survival so typical of the Rhineland which at the time made thieves and 'occupying renovators' out of many Cologne citizens."[26]

The "emotional perspectives" of the *Trümmerzeit* photographers, their particular inclinations and intentions, are well documented in three specific photographs:

– The view of a devastated street in Hamburg in 1945 expresses a mood of hopeless despair, despite the fact that the rubble has been cleared. This scene conjures up in "visual" form what the writer Wolfgang Borchert later conjured up in "literary" form in his radio play *Draußen vor der Tür* (Man Outside). Outside the front door stands an amputee, returned from the war, his stomach empty, his feet cold. "A man returns to Germany ... One of those who come home and yet are not at home, because their home no longer exists. Their home is, therefore, outside the door. Their Germany is outdoors, under the night sky in the rain, on the street. That is their Germany."[27]

– Ritterstrasse in Cologne (around 1947) as seen by Hermann Claasen, with its meandering tracks laid for the cars to carry away the rubble, signals the initial stages in the post-war reconstruction. The neatly dressed old woman in black, carefully picking her step, is the personification of survival; she is "on her way".

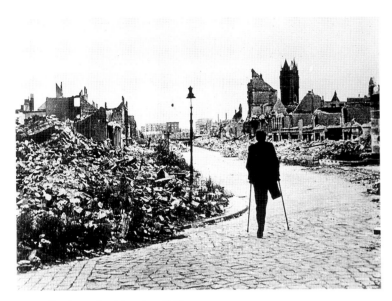

Hamburg street in ruins, 1945

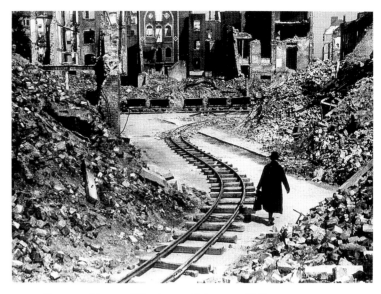

Hermann Claasen, Ritterstrasse, Cologne, c. 1947

Hanns Hubmann, Ruins in Munich

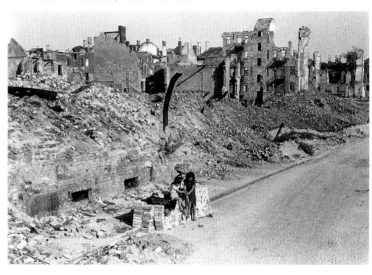

– The third photograph (by Hilmar Pabel) in this small comparative study illustrates how the ruined city of Munich could also embody hope: "The old order is collapsing, the times are changing, and new life flourishes in the ruins." Friedrich Schiller certainly did not anticipate "how far the old order can fall, how radically times change, and how wonderful it is that, despite it all, new life flourishes in the most devastated fields of history." [28]

There is one significant flaw in German ruin photography: In its preoccupation with the "miracle" of re-emerging life, it neglects the difficult task of coming to terms with the reasons for the devastated landscape, namely, the National Socialist terror regime and its mass murderers. The radicalism that characterized the photographs of Allied reporters[29], for example, who also sought out and photographed concentration camps, has been deferred; in its preference for "genre painting" ruin photography evaded true mourning.

Photographs 9 and 10

Jetzt kommt das Wirtschaftswunder/ Jetzt kommt das Wirtschaftswunder / Jetzt gibt's im Laden Karbonaden schon und Räucherflunder / Der deutsche Bauch erholt sich auch und ist schon sehr viel runder / Jetzt schmeckt das Eisbein wieder in Aspik/ Ist ja kein Wunder – nach dem verlorenen Krieg. (Here comes the Wirtschaftswunder / Here comes the Wirtschaftswunder / The shops are full of cutlets again and even some smoked flounder / The German belly is feeling much better and is already much rounder / Jellied pork delights once more / Which is little wonder – after losing the war.)

This cabaret song praises what Ludwig Erhard personified – and he was repeatedly photographed in such or similar poses. A life of deprivation was followed by the sweet life; the gloom of the *Trümmer-*

zeit was transformed into sparkling new wealth. The chorus in Friedrich Dürrenmatt's play *Der Besuch der alten Dame* (The Visit) critically mirrors the colourful facade of the prevailing materialism ("Wealth rises up!"): *Ziemende Kleidung umschließt den zierlichen Leib nun / Es steuert der Bursch den sportlichen Wagen / Die Limousine der Kaufmann / Das Mädchen jagt nach dem Ball auf roter Fläche / Im neuen, grüngekachelten Operationssaal operiert freudig der Arzt / Das Abendessen dampft im Haus. Zufrieden wohlbeschuht schmaucht ein jeglicher besseres Kraut / Lernbegierig lernen die Lernbegierigen. / Schätze auf Schätze türmt der emsige Industrielle / Rembrandt auf Rubens / Die Kunst ernähret den Künstler vollauf. / Es berstet an Weihnachten, Ostern und Pfingsten vom Andrang der Christen das Münster / Und die Züge, die blitzenden hehren / eilend auf eisernen Gleisen von Nachbarstadt zu Nachbarstadt, völkerver-*

Ingrid von Kruse, Hartmut von Hentig, 1985

L. Kindermann, Ludwig Erhard at a cabaret performance in the "Prälaten" in Berlin, 1958

bindend, halten wieder. (Seemly atire enfolds the delicate body / The young man steers a sports car / The merchant a limousine / The girl chases a ball on a red surface / With delight the doctor operates in the new green-tiled operating theatre / Steam rises from the evening meal at home. Satisfied and well-shod, everyone is smoking better weeds / In their thirst for knowledge those thirsty for knowledge learn. / The diligent industrialist piles up treasure upon treasure / Rembrandt upon Rubens / Art nourishes the artist fully. / At Christmas, Easter and Pentecost the cathedral is bursting with Christians / And those trains, sparkling and majestic, rushing on iron tracks from neighbouring town to neighbouring town bringing people together, stop again.) [30]

Although taken at a much later date, the portrait study of Hartmut von Hentig (by Ingrid von Kruse) could be seen as a contrast to the Ludwig Erhard study: sensitive intellectuality, the discrete charm of a democratized aristocracy, reflective, committed to anticipatory reason, unconventional but stylish. Hentig, who as a young officer "emigrated to the army", survived the Third Reich, then put it all behind him ("1945: one of the most delightful years of my life") [31], became one of the Federal Republic's most prominent and imaginative educators. Politely aloof, he proved to be an innovative seeker of evidence, a

"keeper" of the philosophical tradition and the history of ideas (by preserving, overcoming and advancing them).

It was the in-group of the intellectual aristocratic dynasties who pitted their strength against the trivial materialism of the Wirtschaftswunder, supposedly symbolized in the portrait of Ludwig Erhard. Most of the members of those dynasties had been part of Germany's inner emigration during the Third Reich, still managing (with the help of their far-reaching connections, for example with Marion Gräfin Dönhoff, the central figure in a liberal network of relationships) to preserve their inner resources after the loss of their material substratum. Players in a critical glass bead game, they worked together in sovereign solidarity (which provided them with great influence as the "left-wing intelligentsia"), adding high polish to the era of the feuilleton. In their critique of culture these intellectuals may indeed have abhorred the economic upswing, but they certainly did not despise the blessings of the bountiful life: "Write left, eat right" was the motto.

Ludwig Erhard's portrait stands for the dubiousness of a photography that presents people in a pose, losing sight of their psychological complexity and thus stereotyping them. There is no visual indication of the fact that Erhard was a subtle and revolutionary, daring and

dedicated theoretician and practitioner of a "third path" between capitalism and state socialism – social market economy. To quote Ralf Dahrendorf: "What I associate with the name Erhard is the most radical change in German society this century, more radical than anything that went before it – assuming that one takes the whole of society into account and not just its political structures."[32] The "good man from Tegernsee", as the magazine *Der Spiegel* called him because he liked to head south to Bavaria to escape the "greenhouse" atmosphere of Bonn, promoted ethical utilitarianism in the Federal Republic: the greatest degree of happiness for the greatest number of people. This found expression notably in the 1952 Equalization of Burdens Act. Despite all remaining reactionary, even neo-fascist tendencies, Germany in the 1950s and early 1960s also experienced a decisive thrust of modernisation that helped in a "playful" way to overcome the German tendency towards fatal regression – offering a "life design" of western provenance.[33] "Curves everywhere, rounded, sweeping, almost as if the evil angularity of the swastika, Hitler-salute, and SS-rune was to be forgiven and forgotten by the grace of the beetle, the shell, the kidney-shape. We found reconciliation in these forms."[34]

On an analytical level this "verbal image" by Karl Markus Michel corresponds to a statement by the (conservative) political scientist Hans Maier, pointing out that in the 1950s a new society did not simply emerge out of an old one, as many had resentfully claimed, but that "finally and irrevocably, the Germans under Adenauer became acquainted with the formal principles of modern society – once the convulsive anti-modernism of the Third Reich had come to an end."[35]

The "Westernization" of Germany had entered its decisive phase. The cultural critique of the time, predominantly left-wing in orientation, failed to grasp the complexity of the 1950s. It was not until several decades later, when above all young people rediscovered the nostalgic value of its accessories, that more justice was done to the period.[36]

Photograph 11

The photographs of the *Wirtschaftswunder* era operate to a large extent at the level of immanence, are fixated on the facticity of the surface with little interest in transparency – history as photographic news (Bildzeitung). Apart from a few striking exceptions, it was a time of photographic "equivalence" (German: *Gleich-gültigkeit*, also meaning indifference) – though on a high, artificial level, as the magazines of the time, *Twen* and *Das Schönste*, illustrate.

The magazine *Das Schönste*, which first appeared in October 1955, had a characteristic high-class, mail order catalogue quality about it. This "monthly magazine for lovers of the fine arts" (theatre, cinema, television, dance, music, poetry, painting, sculpture, architecture, home design) appealed to those "many lovers of the fine arts in search of authentic values". The aim of the magazine was to track down all that was creative and enduring, to report in words and pic-

tures on events and personalities in the world of the arts, that is to say, to offer a cultural chronicle of the time – which even included the advertising sections where "companies declare their commitment to the idea of quality through their products". The target group was an exuberant elite that not only dressed, lived, ate and travelled well, but also wanted to explore the beauties of culture and was therefore "impatient for each new monthly issue". The articles and photographs were informative, inspiring and motivating; open-mindedness was the order of the day, as far, that is, as decency allowed. The magazine reconnoitred the territory of the spirit; its scouts were educated, liberal writers who were knowledgeable, trustworthy and stimulating.

With its particular "philosophy" and its wealth of photographs of "cultivated everyday life", *Das Schönste* successfully fulfilled the kind of task the illustrated weekly newspaper *Gartenlaube* had taken upon itself around the middle of the nineteenth century, namely, that of promoting cultural liberalism to the benefit of a republican society.

Photograph 12

A few striking exceptions have already been mentioned. This photograph shows a 1950s newsstand. The cover pages on display mainly embody sexual dream worlds. The stance of the observer – the image's counterpoint – refers to social reality. The wealth of the middle class was the result of much hard work and self-denial. The glossy magazine pictures are aimed to arouse and activate drives; the physiognomy of the supposed purchaser betrays tiredness and resignation: whatever dreams he may have, they do not seem to be coming true. For synaesthetic purposes the following poem by Ingeborg Bachmann could be assigned to this photograph (as the correspondence between the image and the word is not one of illustration but of synaptic deflection):

Newspaper stand in the 1950s

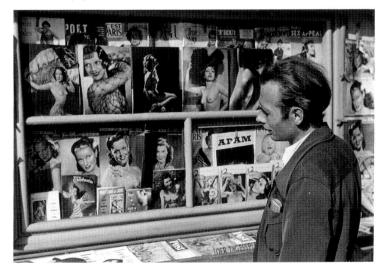

"Wohin aber gehen wir | But where will we go
ohne sorge sei ohne sorge | *Don't worry, don't worry*
wenn es dunkel und wenn es kalt wird | When it is dark and cold
sei ohne sorge | *Don't worry*
aber | But
mit musik | *With music*
was sollen wir tun | What should we do
heiter und mit musik | *Be cheerful, and with music*
und denken | And think
heiter | *Cheerful*
angesichts eines Endes | In view of an end
mit musik | *With music*
und wohin tragen wir | And where will we carry
am besten | *Preferably*
unsre Fragen und den Schauer aller Jahre | Our questions and the horror of all the years
in die Traumwäscherei ohne sorge | *To the dream laundry, don't worry,*
sei ohne sorge | *don't worry*
was aber geschieht | But what will happen
am besten | *Preferably*
wenn Totenstille | When deathly silence
eintritt"[37] | enters[37]

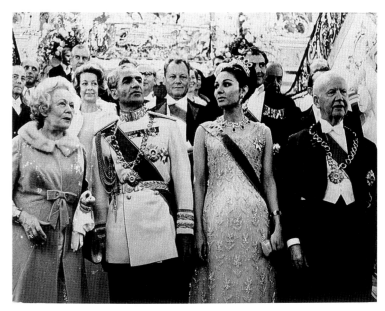

Reception in Schloss Augustusburg, 1967

Photographs 13, 14, 15 and 16

Photography, in the hands of a capable photographer of course, can constitute an objective corrective to subjective human perception, influenced as the latter is, for example, by sympathy or antipathy. The frenzied social critique of the 1960s, which culminated in the student protest movement, had its counterpart in a style of documentary pho-

"Märkisches Viertel", West Berlin 1971

tography whose harsh objectivity forced reality to unmask itself: Unyielding stances were undermined by having a mirror held up to them, by being confronted with their "direct frigidity"; fortuitous, spontaneous, creative forces were cemented over and niches levelled; the geometrized satellite town is the inhuman reverse side of modernization. The photograph entitled *Märkisches Viertel 1971* ("a city for 60,000 people designed at the drawing board, a huge dormitory town without a past, conjured up out of nowhere") proves to be a symbol of Alexander Mitscherlich's "inhospitable city", where it is impossible for people to take root. The photograph of the "splendid reception" given to the Shah of Persia Reza Pahlevi and his wife Fara Dibah by the Federal German President Heinrich Lübke (28 May 1967) in Schloß Augustusburg is structurally comparable, from a feudal standpoint, to the *Märkische Viertel*: the establishment has become bogged down in inhuman rituals. Some of the faces, for example that of the president's wife (Wilhelmine Lübke) and of the wife of Germany's foreign minister (Rut Brandt) betray a certain irritation; even Willy Brandt, who as federal chancellor would later dare to bring about more democracy, may well have experienced the ritual exercise as embarrassing. Superimposed on this decorated and bejewelled demonstration of power is the arrogant gaze of the Shah, seconded, so to speak, by that of the simple to naive Federal German president in all its "aimless candour". Just as the exact location of those concrete apartment fortresses is of no great significance, so too the photographer here has condensed his communicative intention to its very essence, producing a visual emblem that renders the 1968 rebellion by a section of Germany's students and school pupils, and its alternative artistic movements, quite understandable

The photographs of a sit-in (in Dahlem) – in protest against students being expelled from college in 1968 – and of a Euro-Pop con-

cert in Munich in 1979 symbolize both the cautiously-determined oppositional attitude of the emerging *APO* (extra-parliamentary opposition) and the state of mind of a young generation liberating itself through creative ecstasy.

The overall scenario conjured up by these four photographs clearly shows how a minority's single breach of the rules had a relatively major catalytic effect at the time – the Federal Republic had reached a highpoint in its process of ossification, holding back or blocking the process of emancipation at work in all sectors of everyday life thanks to the thrust of modernisation. The function of the acts of provocation was to shatter the "mindlessness" of the established orders, the norms, regulations, attitudes, taboos, and stereotypes – in other words, to break down repressive structures. Influenced by the "happening", first developed in the realm of art, a broad repertoire of disruptive forms (go-ins, teach-ins, sit-ins, love-ins) was created, expressive of an "aesthetics of opposition" that was in fact only possible because the democratic institutions proved unusually tolerant, mainly due to insecurity. The shock inflicted on the establishment by "disorderly" clothing, chanting choruses, scatological jargon ("shit" being the password to the left-wing underground) was often experienced by those effected as psychological terror. They could no longer rely on "authority" alone but had to prove their competence. According to Jürgen Habermas, the new techniques of limited rule-breaking breached the bureaucratic power apparatus and had a proportionally large effect with relatively little effort because they aimed at highly sensitive parts of a complex, and therefore susceptible communications system. The pop culture "trick" of exaggerating size, colour and contour, of duplicating or multiplying half forgotten images from everyday life and thus bringing them back to consciousness, also characterised the protest techniques used to expose status symbols to ridicule.[38]

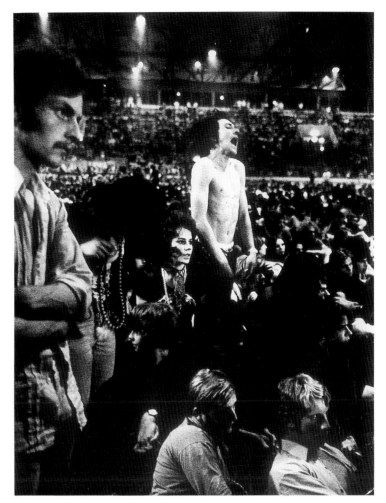

Audience at the Euro-Pop concert in Munich, 1970

III

Sit-in protest against university expulsions in 1968, Free University, Berlin-Dahlem

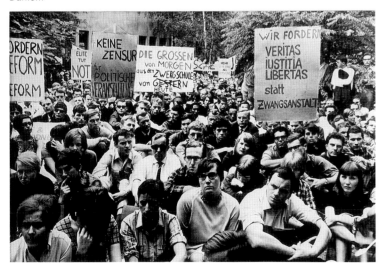

History and everyday life – these 16 photographs of everyday life between 1945 and 1970 can only undertake isolated probes, can only deal with moments, snapshots, or "clicks". The art of the photographer "expands" visual images into visual aphorisms, captures the "final links" in long chains of events. In other words, a successful photograph is an intersection where the most varied of threads are not only pulled together but also unravelled and spun again. The plurality of historical photographs can help to structure the fabric of a specific period in time. To fully appreciate the value of photographs of everyday life one must not allow oneself to be impressed by them emotionally, but rather decipher their content with the help of the elaborate and "erudite" code of cultural history *(studium)*. On the other hand, a "successful" photograph can awaken the desire to know more. In the darkroom of our existence, photographically fixed moments from everyday life undoubtedly represent bright spots capable of throwing light on our main concerns: what we are, what we are like, where we come from and where we are going.

Notes

1 Quoted in *In unnachahmlicher Treue. Photographien im 19. Jahrhundert – ihre Geschichte in den deutschsprachigen Ländern*, Museen der Stadt Köln, Cologne 1979, p. 28.

2 Roland Barthes, *Camera Lucida*, London 1993, transl. Richard Howard, p. 80.

3 André Barret, *Die ersten Photoreporter. 1848–1914*, Frankfurt/M. 1978, p. 8.

4 Roland Barthes, 1993; cf. note 2, p. 26. Cf. Walter van Rossum, "Nichts sagen, die Augen schließen. Roland Barthes' Bemerkungen zur Photographie" in *Merkur. Deutsche Zeitschrift für europäisches Denken* 3 (1986), p. 154.

5 Roland Barthes, 1993; cf. note 2, pp. 42 ff.

6 Ibid., p. 55.

7 Marcel Proust, *Le temps retrouvé*, Bibliothèque de la Pléiade, 1954, Vol. III, p. 875: "... car ces résurrections du passé, dans la seconde qu'elles durent, sont si totales qu'elles n'obligent pas seulement nos yeux à cesser de voir la chambre qui est près d'eux pour regarder la voie bordée d'arbres ou la marée montante; elles forcent nos narines à respirer l'air de lieux pourtant lointains, notre volonté à choisir entre les divers projets qu'ils nous proposent, notre personne toute entière à se croire entourée par eux, ou du moins à trébucher entre eux et les lieux présents, dans l'étourdissement d'une incertitude pareille à celle qu'on éprouve parfois devant une vision ineffable, au moment de s'endormir."

8 Walter van Rossum, "Roland Barthes' Bemerkungen zur Photographie"; cf. note 4, p. 155.

9 Quoted in Bernd Busch, *Belichtete Welt. Eine Wahrnehmungsgeschichte der Fotografie*, Frankfurt/M. 1995, p. 18, 13. (The Plato translation here is by H. D. P. Lee, from Plato's *Politeia*, Penguin Books Ltd., 1955, repr. 1965, pp. 278–79).

10 Ingeborg Bachmann, "An die Sonne" in *Merkur* 6 (1956), p. 534.

11 Arnulf Baring, "8. Mai 1945" in *Merkur* 5 (1975), p. 449.

12 Roland Barthes, 1993; cf. note 2, p. 6.

13 From Dieter Franck, *Jahre unseres Lebens 1945–1949*, Munich/Zurich 1980, p. 66.

14 Willy Brandt, *Erinnerungen*, Frankfurt/M. 1989, p. 142.

15 Ernst Bloch, *Das Prinzip Hoffnung*, Vol. III, Frankfurt/M. 1973, pp. 1249, 1258.

16 Herbert Marcuse, "Über den affirmativen Charakter der Kultur" in *Kultur und Gesellschaft I*, Frankfurt/M. 1965, p. 63.

17 In *Gesammelte Werke*, Vol. I, Frankfurt/M. 1973, p. 36.

18 "Gespräch mit einem Verleger. Ernst Rowohlt über seinen Ro-Ro-Ro-Plan", in *Neue Zeitung* 9. 12. 1946.

19 Thomas Mann, "Deutsche Hörer! Fünfundfünfzig Radiosendungen nach Deutschland" in *Werke. Das essayistische Werk*, Vol. VIII, ed. by Hans Bürgin; Vol. III, *Politische Schriften und Reden*, Frankfurt am Main/Hamburg 1968, p. 290.

20 Ursula von Kardorff, *Berliner Aufzeichnungen 1942 bis 1945*, Munich 1994, p. 317.

21 Klaus-Dietmar Henke, *Die amerikanische Besetzung Deutschlands*, Munich 1995.

22 S.W.: "Fritz Eschens Nachkriegsberlin" in *Frankfurter Allgemeine Zeitung* 17. 7. 1989. Cf. Klaus Eschen/Janos Frecot, *Fritz Eschen: Berlin 1945–1950*, Berlin 1989.

23 Isolde von Mersi, "Augenblick mal. Der Fotograf Friedrich Seidenstücker" in *Zeitmagazin* 1987.

Cf. Museumspädagogischer Dienst Berlin, *Alltagskultur/Industriekultur*, Protokoll einer Tagung vom 15. 1. bis 17. 1. 1982 Berlin (West). Photographs: Friedrich Seidenstücker. Berlin 1945–1950, Berlin 1982.

24 Sabine Scheltwort, "Erste Ruhe nach dem Sturm. München in Trümmern: Herbert Lists Fofografien von 1945" in *Frankfurter Allgemeine Zeitung* 6. 6. 1995.

Cf. Stadtmuseum München, *Memento 1945. Münchner Ruinen*, Munich 1995.

Cf. Herbert List, *Photographien 1930–1970*, text by Günter Metken, Munich 1976.

25 Mathias Schreiber, "Kulturruine. August Sander fotografierte im zerstörten Köln" in *Frankfurter Allgemeine Zeitung* 8. 6. 1985.

Cf. Winfried Ranke, *August Sander. Die Zerstörung Kölns. Photographien 1945–46*, text by Heinrich Böll, Munich 1985.

26 Mathias Schreiber, "Kulturruine"; cf. note 25.

Cf. Hermann Claasen, *Das Ende. Kriegszerstörungen im Rheinland*, two texts by Heinrich Böll, Cologne 1983.

Cf. Hermann Claasen, *Trümmer*. Rolf Sachsse Werkverzeichnis, Vol. II (ed.) Klaus Honnef, Cologne 1996.

27 Wolfgang Borchert, *Draußen vor der Tür*, Hamburg 1956, p. 8.

28 Thilo Koch/Hanns Hubmann/Hilmar Pabel, *So fing es an. Erinnerungen und Bilder aus den Jahren 1945–49*, Braunschweig 1988, p. 14.

29 Cf. Margaret Bourke-White, *Deutschland. April 1945*, Munich 1979.
Lee Miller, *Der Krieg ist aus. Deutschland 1945*, Berlin 1995.
Jewgeni Chaldej, *Von Moskau nach Berlin*, Berlin 1995.
Klaus Honnef/Ursula Breymayer (eds.), *Ende und Anfang. Photographien in Deutschland 1945*, exhibition catalogue, Deutsches Historisches Museum, Berlin 1995.

30 Friedrich Dürrenmatt, "Der Besuch der alten Dame" in *Komödien I*, Zurich 1957, p. 356.

31 Hartmut von Hentig, *Aufgeräumte Erfahrung. Texte zur eigenen Person*, Munich/Vienna 1983, p. 39.

32 Hans-Christian Huf (ed.), *Das Land der großen Mitte. Gespräche über die Kultur der Bundesrepublik*, Düsseldorf/Vienna/New York 1989, p. 67.

33 Cf. Axel Schildt, *Moderne Zeiten. Freizeit, Massenmedien und "Zeitgeist" in der Bundesrepublik der 50er Jahre*, Hamburg 1995.

34 Karl Markus Michel, "Abschied von der Moderne? Eine Komödie" in *Kursbuch 89* (1987), pp. 126 ff.

35 Hans Maier, *Die Deutschen und die Freiheit. Perspektiven der Nachkriegszeit*, Stuttgart 1985, p. 19.

36 Cf. Research project subsidised by the Volkswagen Foundation "'Modernisierung' and 'Modernität' in der Bundesrepublik Deutschland der 1950er Jahre", directed by Prof. Dr. Arnold Sysottek, 1987–1991, University of Hamburg, Arts and Humanities.

37 Ingeborg Bachmann, "Reklame", quoted in Karl Otto Conrady (ed.), *Das große deutsche Gedichtbuch*, Kronberg/Ts. 1977, p. 1002.

38 Jürgen Habermas, *Protestbewegung und Hochschulreform*, Frankfurt/M. 1969, pp. 34 ff.

Stefan Wolle

The Smiling Face of Dictatorship.
On the political iconography of the GDR

The birth of totalitarianism from the spirit of love

Old photos of the GDR era have a magic all their own. Leafing through the daily papers and the few magazines that existed at all or thumbing through the more highbrow periodicals with a claim to aesthetic and artistic discernment, the visual message is invariably the same: Socialist society as a haven of beauty, harmony, purity, order and security.

Visualizing these key concepts of the single-party state involved creating a pictorial programme with the severe beauty and undeviating regularity of an Orthodox iconostasis. Each and every thing, each and every person, had as firm a place in Socialist society as in any iconography. The images that remain seem to illustrate the phrases, slogans and catchwords which, for forty years, permeated and shaped the country as a whole.

The overall-clad worker grasping the handle of some machine or tool in his strong fist, the cooperative farmer smiling merrily at the wheel of her potato harvester, the white-coated scientist scrutinizing the contents of the test tube, the dark-suited academic gazing pensively into a bright future, the border guard with earnest mien defending the achievements of Socialism, people spending their free time reading a good book or in an art group, Young Pioneers busily studying, collecting waste or happily indulging in sports and team games. Variations on each theme were, of course, possible, albeit no more than two

Hochneder/Krisch, 2nd Workers' Festival of the FDGB (Free German Trade Union Federation), June 1960

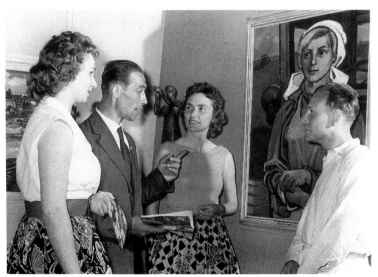

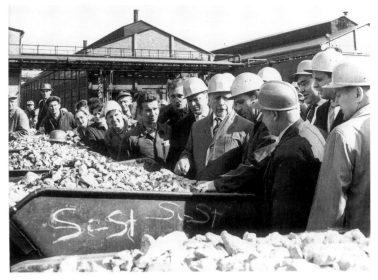

Gahlbeck, Walter Ulbricht visiting the Freital stainless steel works, September 1962

or three dozen for each basic motif. Occasionally, a worker might be wearing a checked shirt with the sleeves rolled up, or might be standing, shovel in hand, in an open-cast coalmine or wielding a pneumatic drill in a mine shaft. He might be depicted with or without the proletarian cap. What counted, after all, was the basic symbolic gesture and the facial expression. The worker was invariably strong and sturdy, the member of the working intelligentsia astute and erudite, the student thirsty for knowledge, the party official composed and responsible. Whenever a leading figure of party and state gave important instructions to the workers, those present would be seen listening with an inimitable expression of blissful devotion. In fact, it is precisely this mindless, blissful smile that is the single constant factor throughout the visual imagery of the GDR. Photography was the medium that documented this typically East German expression while at the same time creating a firm role model worth emulating. After all, the ability to sustain a look of inner enlightenment throughout interminable addresses and stultifyingly boring speeches was a major success factor for anyone bent on a career in the SED (Socialist Unity Party) state.

The photographs document the birth of totalitarianism from the spirit of sentimental kitsch. Kitsch, in this context, may be defined as a false, insincere and misused sentiment. The very life blood of Socialism was the lyrical phrase. "The wall behind which people were imprisoned was made of verse," wrote Milan Kundera. "There was dancing

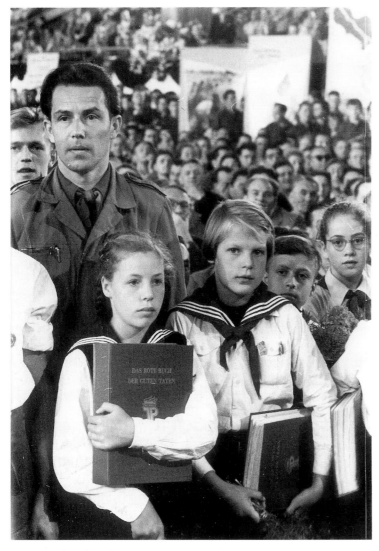

5th SED Party Rally at the Werner Seelenbinder Hall in Berlin, July 1958

6th SED Party Rally at the Werner Seelenbinder Hall in Berlin, January 1963

addressed those present, by force of habit, as "comrades". Immediately, and for the very first time in that parliament, he was interrupted by a heckler: "Not all those present in this chamber are comrades," jeered one of the members. At which the hitherto all-powerful chief of the *Staatssicherheit* secret service, taken aback, stuttered, "Sorry, it's just a natural, human thing. It's just a question of formalities. But I do

Reiche, Thälmann Pioneers at the inauguration of a monument to the Soviet soldiers who fell in a 1945 tank battle, 6th Pioneers' meeting at Cottbus, August 1970

in front of it. No, not a danse macabre! A dance of innocence. Innocence with a bloody smile … The novelist who wrote about this period with the blind eyes of a conformist, produced mendacious, stillborn works. But the poet, who merged with his epoch just as blindly, often left behind beautiful verse. … through the magic of poetry all statements become the truth, provided they are backed by the power of emotion. And the poets certainly felt so deeply that their emotions smoldered and blazed. The smoke of their fiery feelings spread like a rainbow over the sky, a beautiful rainbow spanning prison walls…"[1]

It was not by coincidence that the language of propaganda teemed with metaphors of love. Speeches and laudatios invoked party loyalty, love of the Soviet Union, devotion to the ideals of socialism. Around the camp fires, declarations of collective love were made with pious solemnity.

When Erich Mielke delivered his memorable valedictory speech to the *Volkskammer* (People's Chamber) on 13 November 1989, he

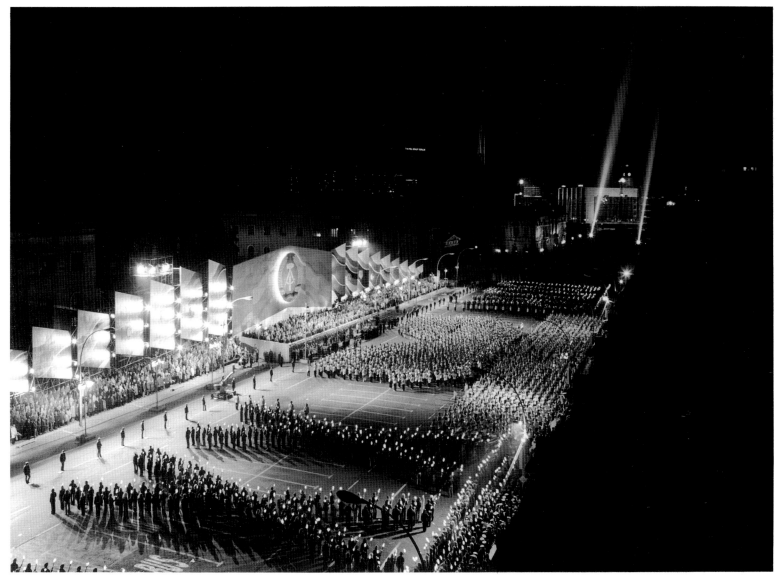

Szepan, 25th anniversary torchlight procession, 21 November 1974

love all, all people!"[2] Abbreviated to the soundbite "But I love you all!" the words of the Stasi chief quickly became a household catchphrase. He had inadvertently touched the secret heart of the matter. The GDR was ruled by the dictatorship of love, with the authorities playing the role of the strict yet loving father and their subjects reduced to dependent children.

Power calls for theatricality. Totalitarian power loves political stagecraft and the ritual subjugation of the masses by means of parades, processions, pomp and circumstance. In the age of technical reproduction, these rituals are documented. As a master of ceremonies, Hitler was peerless, surpassing every other dictator of the twentieth century, including Walter Ulbricht and Erich Honecker. The rituals, void of meaning, continued as a lifeless mechanism that no longer made any real impression. In the GDR, on the evening of 6 October

1989, the blue-shirted cohorts marched past their leaders in the flickering torchlight for the last time. For the last time, too, the Monday papers rolled off the GDR presses on 9 October 1989 – the day of the peaceful autumn revolution – carrying the full-blown visual programme of the SED.

Painting – or to be precise, the pseudo-neoclassical oil painting of the Stalin era – was the aesthetic cradle of GDR iconography. The photographic modernism created in the twenties by the Soviet avant-garde had vanished without trace, replaced by a photography whose outmoded aesthetic was full of stiffly heroic poses, static in both form and content, mirroring the intellectual barrenness of the prevailing dictatorship. Iconographically, a system of symbols had become firmly established. Even the emblems of the modern age – the smoking chimneys of the power stations, the red-hot molten steel of the fur-

naces – seemed archaic. These were images that evoked the immuta-bility and permanence of power.

The power of images

Pictures are ideal transmitters of totalitarian ideology. In the GDR, basic patterns of feeling and thinking were just as irrational – or rather, anti-rational – as they are anywhere else, and, needless to say, propaganda was easier to convey in images than in words. Texts, after all, create distance. They can be set aside, mulled over, re-read, reflected on. Visual images, on the other hand, are almost like music, creating a sense of harmony, spiritual concord and political consen-sus. They are inaccessible to the distanced observer.

The message of these visual images was simple and unambigu-ous. They promised strength, beauty, youth, health and security. In the shamelessness with which they appealed to people's secret longings and fears, they bore a similarity to western advertising, though they lacked its technical sophistication. The symbolism of the imagery was aimed at the emotions. After all, propagandists and advertising execu-tives alike know full well that the individual's emotional response is more intense, more immediate and more lasting than his or her intel-lectual response. An image triggers a flood of associations and emo-tions and has made its mark long before the wheels and cogs of our critical faculties have creaked reluctantly into motion.

Yet the system of telling people what to think was as flawed in the field of photography as it was in the field of art, literature, science or scholarship. What is more, the regime was constantly caught in a clinch between its call for superb craftsmanship and its exertion of

6th SED Party Rally at the Werner Seelenbinder Hall in Berlin, January 1963

intellectual control. The photos had to be of a high technical quality if they were to have any impact. Socialist cultural and scientific policy, in other words, was based on the maxim of having cake and eating it too. This, however, has little bearing on the stringent specifications and conditions of selection that applied to published photos. As a rule, the photo reporters of the news service *Allgemeine Deutsche Nachrich-tendienst* (ADN) and the press submitted their exposed films to the editorial staff, who developed them, selected the photos and cropped them as they saw fit. Smaller newspapers obtained their photos from ADN. The photos supplied by ADN were strictly censored and their function, in terms of aesthetics and contents alike, was that of setting a norm – with varying degrees of success depending on the subject in question. The main emphasis lay on publishing photographs of key events in the daily papers. This included Party rallies, conferen-ces, official visits, inaugurations etc. The photographers admitted to such events were expected to turn up wearing dark suit and tie – and their photos were correspondingly formal. Anything that did not fit in with the strict rules of protocol was simply cropped or discarded.

The photographer was thus constantly caught between the wish to create interesting, lively images, and the obligation merely to record the tedious rituals of power. Attempts were admittedly made to breathe some life into the dreary official routine. Photographers would produce studies of what was happening on the fringes of such events, capturing everyday life and seeking in this way to add a touch of origi-nality to the unchanging and oft repeated liturgy. It was not unusual for the documentation of official events to take on an element of satire or even become an inadvertent disavowal of the system. Even after the photographs had been screened, plenty material of this kind ended up in the archives.

As the East German regime did not actually prohibit anyone from taking pictures, a wealth of unofficial photographic material accrued. These photographs, however, were mainly in the private and personal sphere. The photographic portfolios of collectives, institu-tions and companies forged a link between these two fields that other-wise had very little to do with one another.

The image of the leader

In the beginning was Stalin. The opening words of the Gospel according to Saint John could just as easily be paraphrased to de-scribe the nascence of the GDR. The East German state may well have been Stalin's "unloved child", as it was termed by Wilfried Loth, but his child it undoubtedly was.[3] Loth is right in pointing out that, for the Soviet Union, an East German satellite state was always the second-best solution to the German problem. A neutral Germany without milit-ary or political ties to the west, beyond the power blocs, would have ousted American military power from Europe, allowing the Soviet Union to prevail all the way to Gibraltar. Whatever his hidden intentions

Busch, Spring Fair, Leipzig, March 1985

may have been with regard to Germany, the GDR was Stalin's own personal creation.

The benevolent smile of the mass murderer was the central icon in the early years of the GDR. The new leadership cadre was moulded to his requirements and the social system shaped by Stalin remained more or less structurally intact after his death – and even after his *damnatio memoriae*. Stalin's evil spirit haunted his disciples to the bitter end and beyond. The image of the moustached Georgian brought with it redemption from the guilt their generation had taken upon itself under the rule of the moustached Austrian.

Iconographically, there are both similarities and differences in the way the cult of leadership was staged under Hitler and under Stalin.[4] The image of Stalin was static and composed like an icon, as central to Communist iconology as the image of Christus Pantocrator is to the Russian Orthodox church. It conveyed a message of eternal and sacred power, and of the immutability of the "law of historical development" that had taken the place of the divine scheme of redemption. The image of Hitler, on the other hand, was dynamic and full of movement. The *Wochenschau* newsreels showed the Führer on the move, in planes, fast cars and trains, rushing along roads lined by exultantly cheering crowds, inspecting guards of honour with his entourage, visiting company premises, exhibitions etc. Until he took refuge in his East Prussian *Wolfsschanze* headquarters in 1941, Hitler was also visibly present at the scene of war: giving a speech on the Heldenplatz in Vienna, striding through the grounds of Hradany castle in Prague, focusing his binoculars on the fighting in Poland, dancing in front of the private train carriage in Compiègne, driving in an automobile through Paris.

The image of Stalin changed little over the years. The simple Red Army uniform of the thirties replaced the white dress uniform jacket of the general with its golden medals and oversized epaulettes. Hitler changed his pose and costume like a comedian, appearing in trenchcoat or SA uniform, in tuxedo or lederhosen, in a tailored suit or in leather cap and goggles, playing the automobilist or the aviator, and from 1939 onwards giving preference to a simple and specially designed uniform without epaulettes.

Stalin was a lonely man. The paintings of the later years show him as an increasingly isolated figure. He lived behind the vast walls of the Kremlin, where his light burned well into the night. Hitler was constantly surrounded by his henchmen, by official guests and enthusiastic followers. What Hitler and Stalin had in common was their love of the common man, the worker, the peasant and, above all children. Little blonde girls are a favourite iconographic attribute in the imagery of modern tyranny.

Having lost the war, the Germans in the Soviet zone had the chance of being on the winning side simply by replacing the pictures of their leader. It was not a question of a Soviet victory over Germany, but of the working class victory over the imperialists, whose lackey Hitler had been, and who were now preparing new wars in West Germany.

The cult of personality that developed around Stalin surpassed anything modern history had witnessed in that respect. It was a cult willingly accepted by the SED leaders and by the intellectuals and artists who supported them.

Stalin's death on 5 March 1953 did little to change that in the short term. With the funeral ceremony, the cult was heightened to the point of apotheosis. The directorate of the German Association of Authors sent a telegram to the Soviet Association of Authors that read "... How much we miss his dear heartbeat, his kind smile, his structuring hand. Yet the great teacher has left his house in order. His pupils have long since become masters. The Central Committee of the Communist Party, forged by his hand, the working class, the peasants, the intelligentsia, nurtured by his love, are proof that, beyond death, his wisdom lives on through them." The religious aspect of the Stalin cult is expressed even more clearly in an article by Stephan Hermlin. In a special issue of *Sinn und Form* published to mark the death of Stalin, he wrote: "I saw him only once – standing upright at the balustrade of the Lenin Mausoleum one First of May, surrounded by millions of faces like a sea of blossoms. Yet for more than twenty years, in good times as in the most difficult hours, I was able to turn to Stalin, the living Stalin. Silently, within my heart, he replied, condoning, reproaching, consoling."[5]

In February 1956, Khrushchev delivered his famous secret speech, attacking Stalin's excesses and, in toppling him from his feet of clay, plunging Communists throughout the world into a crisis of faith. Stalin's lackeys in the SED leadership scurried to put a safe distance between themselves and the abyss into which their idol had plummeted. A half-hearted and inconsistent "break with the past" began, but it was only skin deep. Images of Stalin disappeared. The erasure of visual memory is an integral part of the history of Socialist imagery.

Stalin, it was hoped, would moulder in his grave, and his name never be mentioned again. No attempt was made at any critical reflec-

tion on Stalin or Stalinism. Indeed, it was hardly possible to do so given that the structures and rituals of power, the economic system, even the prevailing mentality, were all products of Stalinism. His was a skeleton that simply would not stay in the cupboard, rattling its bones in internal Soviet conflicts and causing unrest even in the GDR. The metaphorical references in the film by Georgian director Abuladze, distributed in Germany under the title *Die Reue* ("Regret") spelled the writing on the wall for the SED leaders, and the guardians of ideological virtue were astute enough to ban the film in East Germany. It was no coincidence that it should have been an article on Stalin that resulted in a ban being imposed on the critical magazine *Sputnik* in 1988, catapulting the SED leaders into open conflict with their Big Brother. Not even in 1989 were the SED's successors able to exorcise the ghost of Stalin. In its early days, the PDS was quick to damn Stalinism, though the term was never clearly defined. Did they mean the Real Existing Socialism that had prevailed until 1989, or did they mean the regime of terror in the thirties? A reply to this question would require a profound analysis of socialism. Above all, the question of similarities and differences between the two "enemy brothers" Stalin and Hitler would have to be addressed. Such a debate would jeopardize the "antifascist legitimation" of the GDR and with it the historical selfawareness of the SED's former followers. The attitude to Stalin and Stalinism that has prevailed since 1953 fits into Germany's repression of its past history and can only be addressed in this context.

Ulbricht and Honecker were merely miniature models of their teacher Joseph Vissarionovich Dzhugashvili (Stalin). The cult that surrounded them was relatively modest. Pictures of Ulbricht from the early sixties indicated a relaxation of the aesthetic rigidity of the image of leadership. In this, Ulbricht left nothing to chance. In the Secretariat of the State Council he had his own collection of photos alongside the pictorial archives of the news agency ADN/Zentralbild and the Institute for Marxism-Leninism (IML). Society was geared for modernization, and Ulbricht catered to the spirit of the age by conveying a modern image. Photos showed him in casual wear pursuing team sports such as volleyball, or playing table tennis with his wife Lotte. A "sport for all, once a week" campaign launched under the catchy slogan *"Jeder Mann an jedem Ort – einmal in der Woche Sport"* was promoted by the good example of the State Council Chairman. Ulbricht was keen to be photographed visiting art exhibitions, conversing with writers, or in his box at the opera. On official occasions, however, the photographers could not or would not relinquish the aesthetics of the Slavonic iconostasis. Then, the politbureaucrats would take up their positions according to the rules of protocol, with their First Secretary in the middle, looking for all the world like the saints displayed on the iconostasis. After each new election, the newspapers were full of portraits of Central Committee members. Dressed in suit and tie, they resembled each other like peas in a pod, right down to the uniform facial expression. The size of the photograph stood in direct relation to the individual's position in the political hierarchy, giving western observ-

Lotti Ortner, Walter Ulbricht, Erich Honecker, P. Verner (?) and A. Neumann playing volleyball, early 60s

vers a reliable yardstick by which to chart the rise and fall of East Germany's politicians.

After 1971, Ulbricht as a visual motif disappeared into the black hole of party history and was replaced by the po-faced countenance of Erich Honecker. Even in the heavily retouched and coloured portraits that graced every East German office, he appeared strained and inhibited. In fact, his narcissism knew no bounds. In the media, he staged an unparalleled "court circular". Amongst journalists, the word was that Honecker personally chose the photos of himself for publication in *Neues Deutschland*. In 1988, there was something of a rumpus about the official photo on the inside of the brochure containing Erich Honecker's Report to the 7th Assembly of the Central Committee of the SED.[6] Honecker had a new photo taken and sent to the publishers, Dietz-Verlag. The brochure, however, had already gone into print with the old photo. Günter Hennig, head of Dietz-Verlag, sent an embarrassed letter to Hager, the Central Committee official in charge, offering to scrap one million printed copies.[7] In the end, readers had to

make do with the usual photo of the Secretary General.[8] Every year, on the occasion of the Leipzig Spring Fair, the Chairman of the State Council spent several hours visiting the various trade fair halls. The next day's paper consisted almost entirely of photos showing Honecker in conversation with various diplomats and representatives of foreign companies. On 17 March 1986, no fewer than 35 photos of Erich Honecker appeared in the party newspaper. Yet even as the country sniggered at its leader's vanity, *Neues Deutschland* went on to print even more photos of Honecker the following year. The issue of 16 March 1987 contained a record 43 photos of him. In 1988, there were only 33 and in 1989, the year the Wall came down, there were 38. Even the Monday edition of *Neues Deutschland* that appeared on 10 October 1989, reporting on the celebrations marking the 40th anniversary of the GDR, carried 26 photos of Honecker. It was the last issue of *Neues Deutschland* in the familiar style of the good old GDR. One day later, the newspaper led with a report headed *"Provokationen von Rowdys am Nationalfeiertag"* ("Provocation by rowdies on national holiday") and, for the first time, there is talk of "dialogue" and a "willingness to discuss the situation". For Erich Honecker, the age of the multiple exposure was coming to an end.

Images of Heimat

"Die Heimat hat sich schön gemacht, und Tau blitzt ihr im Haar ... die Wiese blüht, die Tanne rauscht, sie tun geheimnisvoll. Frisch das Geheimnis abgelauscht, das uns beglücken soll." ("The homeland has preened herself and dew glitters in her hair ... the meadow in bloom, the rustling pine, have a mysterious air. They know of the mystery that is to bring us happiness.")[9] Such were the songs of the Young Pioneers as they strapped their knapsacks on their backs and headed for the woodlands and meadows. Apart from the songs of the International Workers' movement and Soviet partisan songs, the German folksong and a number of new *"Lieder der Heimat"* were the stock of the East German youth organizations. Love of the homeland was an important ingredient in Socialist topology and iconology. In the fifties, Socialist variations on the Nazi "blood and soil" metaphors evoked a united Germany and railed against all things American, Western and modern. The traditional vernacular of German architecture was contrasted with rootless cosmopolitanism and the Americanization of urban planning. The German forest, a major symbol of romantic nationalism since the early nineteenth century, played an important role in the founding years of the GDR. German oak leaves wreathed the black, red and gold cockade on the caps of the *Nationale Volksarmee*, founded on 1 March 1956. Allegedly derived from the coat of the *Freikorps* of 1813, the uniforms are nevertheless remarkably reminiscent of the Nazi *Wehrmacht* uniforms. The roofs of German homes had to be pitched, just as Hitler had liked them, rather than flat, in the modern tradition of the Bauhaus. Images were full of rustling forests, babbling brooks, squirrels leaping from tree to tree. German castles, mountains

Wlocka, German singers' meeting at Eisenach, October 1953

and forests, the peasant working the soil, girls in dirndles – all were presented in a light as favourable as any to be found in the coffee-table books published in the West by the nationalistic and expansionist *Vertriebenenvereine* (associations of ethnic Germans expelled from various regions of Eastern Europe), though images of the Eastern European regions to which Nazi Germany had laid claim were, of

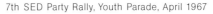

7th SED Party Rally, Youth Parade, April 1967

course, an almost inviolable taboo. The anti-modern, pseudo-romantic symbolism was part of the iconography of a perfect world.

The symbols of progress and modern technology fitted smoothly into the traditionalist portrayal of the world of the peasant or artisan. Belching smokestacks, modern industrial plant, tractors and agricultural machinery, oil pipelines, electricity pylons and new buildings were key motifs.

They did not destroy the fairytale world. On the contrary, they enhanced it. In the visual portrayal of society, there was no environmental damage, no landscape was scarred, no cultural heritage lost, no city centre defaced and no traditional values lost. It was an image that stood in stark contrast to reality. The GDR pursued a virtually unfettered exploitation of natural resources and neglected buildings of architectural and historic importance in favour of a few prestige projects.

From the early eighties onwards, the focus was consciously shifted to motifs of modernity. At ever shorter intervals, waves of new and incomprehensible slogans swept across the country. Cybernetics, mensuration technology, operational research, networks and rationalisation were invoked as means of streamlining the Socialist economy. Iconographically, there were no new ideas. The most frequent motif at the time was a generally young audience concentrating on some object or other that was the focal point of the picture. That focal point might be a formula or atomic model chalked on a blackboard, with a lecturer explaining, but mostly it was a machine or a control panel. Students and scientists had been accorded more and more importance over manual workers since the sixties, albeit without ousting them entirely. The worker, his brow smeared with oil and sweat, remained an important icon of Socialism right up to the end.

The beauty of humankind

A humanist view of society prevailed in the GDR. Official definitions of humanism tend to be longwinded, theoretically highbrow and vague. In the jargon of the SED's cultural studies, Socialist humanism was a "historically entirely new quality in the overall development of humanism and the humanist movement as such. It expresses the objectively real emancipatory role of the revolutionary struggle of the working class and the building of socialist and communist society." [10] In everyday life, the humanist view of society consisted of naive optimism, a one-dimensional faith in progress, a shallow concept of truth and beauty, and the reduction of art to a provincial, petty bourgeois realism. "Our people don't understand that" was a frequently voiced and dangerous verdict in the world of art, literature and music. Aesthetic taste was based primarily on classical antiquity and the neo-Neoclassicism of the nineteenth century. The parallels with certain aspects of National Socialism are obvious, and by no means coincidental.

Wittig, Crop rotation near Erfurt, August 1954

The humanist view of society embraced by Socialism was subject to direct political instrumentalization. Optimism and love of life were meant to motivate people to fulfil the economic plan; collectivism and folkloristic sentimentality served as a check on behaviour and thought.

The positive categories of the Socialist view of humankind also had their negative counterpart. Pessimism was an expression of ideological weakness, while scepticism or even nihilism were the dangerous poison of the enemy, intended to sow the seeds of doubt regarding party leadership. Intellectualism or individualism were a kind of sickness to be eliminated by any means.

The humanist view was as vague as it was menacingly specific. It defied analysis and eschewed legal definition. After all, the analytical approach was in itself an expression of intellectual arrogance and lack of class consciousness. Such vagueness made it all the easier to apply prohibitions and laws arbitrarily. In this respect, the visual portrayal of the new individual was an important element of the system of oppression and disciplinary measures. The image was intended to be emulated. It set a standard, and to deviate from that standard was hardly conducive to furthering one's academic or professional career.

Athletes were an important motif, and nowhere was the GDR as outstandingly successful as it was in the field of sport. The triumph of the sporting will was a symbol of the allegedly superior social order. The dynamic athlete, the Olympic medallist on the rostrum, the victor adulated – such images occurred frequently in the visual programme of the GDR. Shallow optimism merged with a message of struggle, victory and success.

In iconography as in life, it was but a small step from athlete to soldier. There was a very real reason for the GDR to place such emphasis on physical health and the body beautiful. Apart from the prestige that the sporting achievements brought, it was important to have physically fit soldiers and healthy mothers of future soldiers. The beauty of

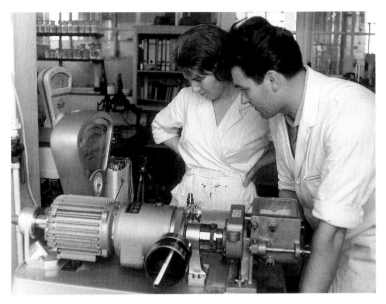

Krieger, Genthin washing powder works develops a low-dust powder, 1964

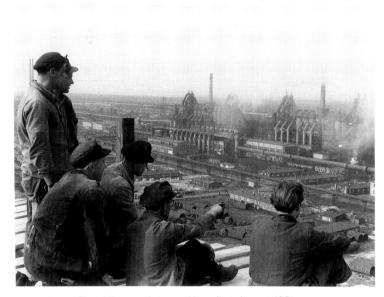

Sturm, Eisenhüttenstadt ironmaking plant, August 1954

the military life was another important pictorial motif. The army had its own periodical, *Armee-Rundschau,* consisting primarily of pictures of soldiers and weaponry. School books and children's magazines also propagated the beauty of the military life.

Of course, the Socialist photographic aesthetic also adopted woman as a key motif of every cultural era. Needless to say, the focus was on the professional woman as colleague, epitomizing the beauty of self-fulfilment through work and career. On the other hand, there was the motif of the mother and housewife. Women were happy to put their children in creches and kindergartens, and hurried with their offspring to the routine medical check-ups.

In 1954, the periodical *Das Magazin* was launched, offering a motley mix of light reading. Following the events of 17 June 1953, the party had come to the conclusion that people should have some fun and relaxation after a hard day's work. Based on this premise, apart from the short stories and recipes, there was also a nude photo each month. The dearth of eroticism in Real Existing Socialism meant that this alone was enough to make the periodical a highly coveted under-the-counter item. A subscription was a valuable asset indeed. In public libraries, the magazines with the nude photos were available only at the supervisor's desk on presentation of the reader's ID as a necessary security measure against theft.

One of Socialism's major positive values was the sense of community. The wisdom of the collective was pitted against the scepticism and doubts of the individual. Work in the factory, the field or the laboratory was generally portrayed as a community experience. Favourite motifs were discussions and meetings – and these were indeed a major part of working life under the Socialist system. The focal point is often an elderly worker or a party official or government representative indicating some goal. It might be a real object, a plan, a model or text.

The gesture is often one that points towards the future, towards a new dam or a planned dairy farm. At the same time, such a gesture could also be read as pointing towards the bright future of Communism, in a photographic adaptation of the gesture used in statues of Lenin and revolutionary paintings.

Images of evil

A deep dichotomy informed the world of Socialist imagery. The harmony, order, purity and security of the *Heimat* stood in stark con-

Military manoeuvres of "brothers in arms", 1970

Eckleben, The brigade during a presentation of the KPSU programme, 1961

Eberhard Giebel, "Red Meeting" in the transport department of Farbenfabrik Wolfen, 1960

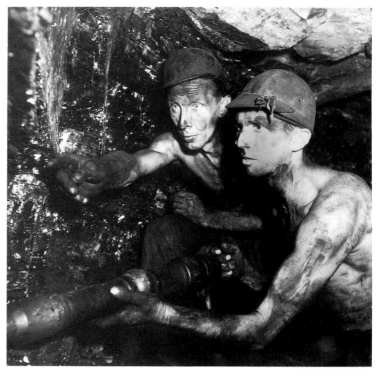

National prizewinner Franz Franik, 1952

trast to the enemy principle that represented unrest, impurity and insecurity. Such images, however, were more dynamic and more interesting. One of the main problems of portraying this contrast was the sheer fascination of evil. Set against pictures of the imperialist world, Socialist images seemed all the more staid and uniform. Capitalism, rotten to the core, was aesthetically far more interesting than all the endless images of happiness, harmony and security. Not that the Socialist periodicals failed to show pictures of the homeless, the beggars and the starving unemployed in the capitalist world. Yet as far as their powers of political persuasion were concerned, the equally popular photos illustrating the moral decay of bourgeois society possessed a certain ambivalence, to say the least. Just before the Berlin Wall was built in 1961, a series of illustrated reports was published about young East German girls working in striptease joints and brothels, pandering to the American forces. Yet the glittering world of the West, as those in the upper echelons of the SED were well aware, was not without appeal to the people of the GDR and anti-imperialist propaganda pictures were therefore subject to strict regulation. The foreign policy periodical *Horizont,* launched in 1963, carried not only articles on international politics and current affairs, but also photos from all over the world, showing people demonstrating against oppression and for liberty, workers on strike, police wielding truncheons and batons, clouds of tear gas hanging over the Quartier Latin in Paris – in short, images of a generation in revolt. Perhaps it was not so much imitation that the party feared as the vague yearning for the big, wide world. News pictures conveyed the message that life was always elsewhere

Pictures showing direct confrontation with the class enemy were rare. In the historiography of the GDR, the uprising of 17 June 1953 was reduced to a few stereotypes. According to the official version, world imperialism had attempted to destroy Socialism in the GDR on this "Day X". An "attempted fascist coup" had taken place, manipulated by the Western secret services, and thwarted by the majority of the workers with the aid of the Soviet army. No further details were to be found in the history books prior to 1989. Illustrations would merely have been an added complication. The only photo frequently published was the shot of the burning Columbia building on Potsdamer Platz, torched by "fascist provocateurs". Another similar photo of a burning stand at the Brandenburg Gate was printed in the *Geschichte der Arbeiterbewegung*.[11] Any other photos disseminated in the GDR addressed fringe events. There are, for example, some press photos of young people under arrest, dressed in "cowboy shirts" – proof that the provocateurs came from the western sectors of Berlin. Other photos show people thanking friendly, smiling Soviet soldiers or expressing their confidence in the party.

The act of "securing the state border of the German Democratic Republic" on 13 August was reduced to a single image. A workers' militia is standing in front of the Brandenburg Gate, with two water cannons stationed in the background. There is nothing particularly threatening about the scene. Indeed, the men with the machine guns look for all the world like family men who have just changed out of their fireside slippers and donned the ill-fitting uniform of the militia.[12] This is precisely the political intention of the photo. In fact, it proved so popular that in 1987 it was staged as a "living tableau" and driven through the streets in the procession marking the 750th anniversary of Berlin. Other photos addressing the subject of the "anti-fascist defence wall" merely illustrated the political context: the people of Berlin thanking the members of the workers' militia, members of the FDJ presenting flowers, workers voicing their approval of the steps taken by the GDR government etc.

In its visual portrayal of itself, the GDR was remarkably ahistoric. The repression of history is not a product of the period since the Wall came down.

Dictatorship's family album

Since 1989, two very different ways of remembering the GDR have prevailed. For some, it was the land of social stability, job security, kindergartens and cheap bread. Even allowing for certain material shortages, the sense of community is emphasized. For others, the GDR was the land of the Wall, the Stasi and repression. The two sides are difficult to reconcile, and there are visual symbols for both. For

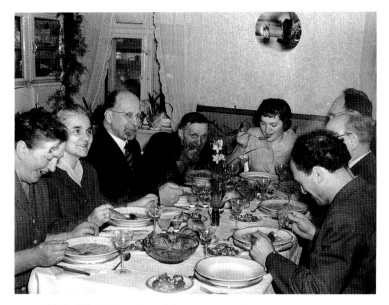

Walter Ulbricht lunching with the workers of Forst district, February 1961

many people, the images of happiness have the nostalgic charm of an old family album, which does not document problems, but presents life as a never-ending series of birthday parties, day-trips and holidays. Contented faces smile into the camera, people gather in groups, giving their hair a quick comb beforehand. Years later, thumbing through the old photo albums over a cup of coffee on a Sunday afternoon, all's well with the world. Nobody wants to be the spoilsport, and everybody patiently accepts the endless parade of children, spic and span and washed behind the ears for their first day at school, confirmation or weekend outing.

It is the comfortable satisfaction of old family albums that confronts us when we regard the visual heritage of the GDR. Walter Ulbricht and his wife Lotte taking lunch with an ordinary family might sum up the ambivalent cosiness of the SED dictatorship. A smiling grandfather amongst his nearest and dearest springs to mind. Yet the picture looks like a photomontage, like a lie. After the last spoonful of soup, at the latest, the State Council Chairman will stand up and hurry to his black limousine with the pink curtains in a flurry of armed bodyguards, to get on with the business of governing his heavily armed little country. But that is not the problem. The idyllic images of the cosiness and security of the dictatorship are not simply staged or faked. Those happy people, those exultant flag-waving crowds, the faith in the children's eyes, the ignorantly blissful faces – all this really did exist. Such depths of devotion can neither be invented nor coerced. The beauty of the photos and the ugliness of dictatorship are not a real contrast. That idyll really existed – and it was terrible.

Notes

1 Milan Kundera, *Life is Elsewhere* (transl. Peter Kussi), London 1986, pp. 270–271.

2 This is the version of Mielke's unclear statement cited in the official records; cf. Helmut Herles and Rose Ewald (eds.), *Parlaments-Szenen einer deutschen Revolution. Bundestag und Volkskammer im November 1989*, Bonn 1990, p. 193.

3 Wilfried Loth, *Stalins ungeliebtes Kind. Warum Moskau die DDR nicht wollte*, Berlin 1994.

4 Alan Bullock, *Hitler and Stalin. Parallel Lives* (London 1991); Martin Loiperdinger, Rudolf Herz, Ulrich Pohlmann (eds.), *Führerbilder. Hitler, Mussolini, Roosevelt, Stalin in Fotografie und Film*, Munich/Zurich 1995.

5 *Sinn und Form, Beiträge zur Literatur* 5 (1953), p. 11.

6 Erich Honecker, *Mit dem Blick auf den XII. Parteitag die Aufgaben der Gegenwart lösen*, 7. Tagung des ZK der SED, 1/2 December 1988.

7 Letter from Günter Hennig to Hager, BArch-SAPMO, ZPA, DY 30/42326, Büro Hager.

8 Letter from Hager to Honecker, ibid.

9 "Die Heimat hat sich schön gemacht", song of the Young Natural Scientists (lyrics by Manfred Streubel, music by Gerd Natschinski) in *Seid bereit! Liederbuch der Thälmann-Pioniere*, Leipzig 1973, p. 126 f.

10 *Kulturpolitisches Wörterbuch*, Berlin 1978, p. 274.

11 *Geschichte der deutschen Arbeiterbewegung*, vol. 7, p. 192f.

12 Heinz Heitzer, Günther Schmerbach, in *Illustrierte Geschichte der DDR*, Berlin 1985.

Klaus Honnef

From Reality to Art
Photography between profession and abstraction

Perhaps Marx was right in one respect at least. Paraphrasing a remark by Hegel, he once maintained that all great events and personalities in world history reappear in one fashion or another ... the first time as history, the second time as farce.[1] Photography is undoubtedly just such an event, and one whose comparatively brief history would certainly seem to prove his point.

The invention of photography responded to a profound social need that reached its apogee in the first half of the nineteenth century. Society's shaping force, the bourgeoisie, longed to see itself fittingly represented in pictorial form with an authenticity that corresponded to its empirical world view. Though the individual components of the photographic process as such had been known for a long time, it was only within the context of the western world's advancing industrialization that they were successfully amalgamated. The resulting capacity to produce images of richly detailed precision, described by Alexander von Humboldt as "true to nature", was at the same time the product of an anonymous technical process suited – albeit within limits at first – to use on an industrial scale. This new technique of reproduction threatened the livelihood of artists unwilling to change to photography. In pragmatic terms, at least, photography fuelled the autonomous tendency in art expressly proclaimed by an idealistic aesthetic. In spite of this, or perhaps because of it, many major artists dismissed out of hand any claim to art that photography may have had. Nevertheless, many of them were prepared to adopt photographs as a short-cut in the painstaking process of creating a painting. Others, including Edgar Degas and Hendrik Breitner, became keen photographers.

Barely a hundred years later, photographers were to find themselves facing a situation similar to that of the painters before them. With the electronic media threatening to undermine photography's hitherto undisputed position as a widespread, mass-impact pictorial technique, the influence of photographic images on the collective consciousness was gradually eroded and television rapidly accelerated the flow of information. Instead of second-hand documentation, it promised immediacy, and instead of showing, in the words of Roland Barthes, "what has been", it granted the observer virtual presence as events unfurled. Most of the illustrated periodicals disappeared from the information market, yet the sum of illustrated publications remained unchanged. Admittedly, their character was fundamentally altered. Photographers reacted to the loss with an increasingly aestheticized view. The growing use of colour supported this trend. At the same time, the notion that photography was also a pictorial process of some artistic value began to gain currency. Nevertheless, what Wolfgang Kemp has described as the "pressure of legitimation" exerted on photo-

graphy in relation to art, was exacerbated. The artistic endeavours of the photographers continued to be denigrated in the realms of the fine arts, where they were regarded as upstart artisans. On the other hand, artists began, albeit hesitantly at first, to discover photography as an artistic technique in the realization of their aesthetic ideas. In the *Idee* section of the 1972 *documenta 5* in Kassel, photographs were presented for the first time on an equal footing with paintings and sculptures at a major exhibition of contemporary art. Though this fundamentally liberated photography from the pressure of legitimation,[2] artists using photographic images within the scope of their artistic concept tended to regard them as little more than vehicles for conveying an artistic idea that could be substituted by drawings or by recited texts – prototypes with no particular artistic value, as it were. In the end, photography was to survive nevertheless as a medium of art, no less artificial and separate from the concrete world than the artisanal art techniques.

War had brought with it the sweeping triumph of professional photography, whose proponents, by their own admission (or suggestion) felt committed to documenting what was going on around them. After all, its weapons were not only aircraft, tanks and artillery, and an unimaginable mass of human labour, but also cameras in the hands of eager photographers, some bolder than others. In other words, the war was also being waged in the field of propaganda. Both qualitatively and quantitatively,[3] however, the Allied Forces were the victors in that field as well, first over National Socialist Germany and, shortly afterwards, over imperial Japan. Soviet photographers often had to swap their cameras for guns. It was hardly by coincidence that the German leaders united their reporters in *Propagandakompanie* units, whose true function was euphemistically referred to by the abbreviation *PK*.[4] Finally, in the chill wind of the Cold War, journalistic photography blossomed even on the ravaged soil of postwar Europe. No-one cared much about artistic criteria. It was a case of one voice for all: Rudolf Augstein, editor of the German weekly news magazine *Der Spiegel*, claimed that his magazine "... does not want to make a study of a living face. It does not want art, it wants craftsmanship."[5] Yet he, too, was fully aware that photography had a wider potential. In fact, only a few sentences before he had conceded that "If someone with a name like Yousuf Karsh or Cecil Beaton creates a portrait, it is a social event. These people see themselves as artists; they illuminate their subjects, correct an expression, scatter garlands, and are incensed if their model breaks into an unscheduled grin. They want a composition, a beautiful picture, even one devoid of content."[6] The astute young man from Hanover had no truck with art. What he wanted was the truth, the

whole truth and nothing but the truth, which was hardly surprising considering the barrage of lies Augstein and his comrades had endured day after day on the front line, where their mendacity had been so drastically obvious.

The photographer Max Ehlert clearly met Augstein's criteria of the honest and upright photographer with no particular artistic ambitions. It was in praise of Ehlert's work that Augstein had addressed the "Dear Spiegel Reader" in the article from which the above sentences are quoted. Ehlert had produced a number of cover portraits for the political weekly *Der Spiegel* – no fewer than twenty-three of them by the first half of 1953. Ironically, none other than Ehlert himself had been a master of staging National Socialist pomp and pageantry and had celebrated the demonstration of their obscene power play with evocative images.[7] His heroization of the SA and SS (Berlin 1938) and the march-past of the gymnasts at the 1938 Party Rally in Nuremberg[8] are more than just uncritical – they are clearly sympathetic. In terms of aesthetic quality, they are far better than the efforts of Hitler's personal photographer Heinrich Hoffmann. Indeed, they bear comparison with the photographs by Alexander Rodchenko of the march-past on the Red Square in Moscow in 1936. Like many other Germans, Ehlert too had carefully revised his biography after the Third Reich. All that remained was the "*PK* man" (as Augstein put it) who had nearly gone down with the warship *Blücher* and, as he later told the *Berliner Illustrirte,* had raised his arm and sung – nota bene – *Deutschland, Deutschland über alles* in the euphoria of being saved.[9]

Needless to say, Max Ehlert was not the only photographer who had been quick to discard his political views with his uniform. When the British set up a new, democratic press, was it through sheer carelessness or because of their proverbial sense of fair play that they took over almost the entire guild of photographers who had worked for *Signal,* the National Socialist propaganda flagship abroad? The team was headed by the Austrian Harald Lechenperg, one of the great names among legendary German photojournalists, most of whom had emigrated. Under the Nazi regime, Lechenperg had been editor-in-chief of the *Berliner Illustrirte* as well as of the illustrated magazine *Signal,* whose overall concept he had developed. From editor-in-chief of the *Berliner Illustrirte* to editor-in-chief of the illustrated magazine *Quick* in 1948 was, it seems, but a small step.

Hilmar Pabel and Hanns Hubmann – both of whom had fortune smile upon them in the Nazi years[10] – followed in Lechenperg's footsteps. Together, through the influential magazine *Quick,* they shaped the widely circulated public image of the three western zones of occupation (referred to in a witty Cologne carnival song as "Trizonia") and of the newly-founded republic whose capital was Bonn. Wolfgang Weber, according to Augstein the most important figure alongside Lechenperg in German journalistic photography before Hitler became Chancellor, became chief reporter for the *Neue Illustrierte* in Cologne two years after the German defeat. Although he spent much of his time abroad during the Nazi regime, his hands were not quite as clean as they might have seemed.[11] It is hardly likely that he neither knew nor

approved of the malicious photo feature published by the *Berliner Illustrirte* in 1938 on the situation of the emigrant Jews in Shanghai, which conveyed the unambiguous message that the appalling local conditions in which they existed were appropriate surroundings for people of their ilk. His photographs positively savour the misery of their situation, and even without the unequivocal captions, the reporter's message of "racial superiority" is loud and clear. Hilmar Pabel was not the only one who had seen what was really going on and had recorded it on film[12], for example in the ghetto of Lublin. Weber had too. These features and other similar reports with double-page photo spreads relativize Rolf Sachsse's persuasive thesis of "looking the other way"[13] under the National Socialist regime.

Does this mean that photography had no "zero hour"? Did photographers fly the flag of continuity over the desert of a ruined Germany? In terms of the people involved, nothing had changed. The appetite for supposedly authentic images was immense – people wanted to see detailed pictures of the universal suffering in the wake of the lost war that created a sense of community, as though shared suffering were somehow easier to bear. They also wanted more outward-looking images, pictures that reached beyond the barbed wire boundaries of the hermetically closed Third Reich. Initially, there was no shortage of educational photo series in the surprisingly numerous illustrated periodicals. Most reporters with a camera pursued a veristic style inspired not so much by the neorealism of Italian cinema as by the harsh reality of the immediate surroundings. Italian neorealism, after all, manifested itself in the open break with the bombastic rhetoric of Italian Fascism, and a number of its protagonists had been members of the Resistance. Most German photographers, by contrast, could be described in the words of Rolf Sachsse in his monography on the architecture photographer Hugo Schmölz: "Politically, he was neither committed to nor against National Socialism, and was never a member of the Nazi Party. The situation of a well established artisan was unlikely to prompt him to adopt either stance, for both would have meant a loss of custom."[14] Only (West) German cinema – with the exception of Helmut Käutner's artistically unsuccessful experiment – proved as resistant to change as German photography, whose protagonists preferred to make a virtue of opportunism. They cultivated an aesthetic mediocrity, ruled by sentimental realism in all its valueless detachment. At the time, such an approach was read – in the social sciences and historiography at least – as one that signalized detachment from National Socialist ideology. Nowhere in sight was there an innovator of the calibre of the architect Schneider-Essleben who, in a debate in 1985, expressed his regret at the failure to grasp the opportunity for a radical new start at the time by demolishing Cologne Cathedral as well.[15]

The illustrated press picked up where its forerunners prior to the National Socialist *Gleichschaltung* had left off. Images of the everyday dominated the illustrated press, showing interminable queues, people waiting anxiously for the return of prisoners-of-war, economic misery, the black market, defusing bombs, life amongst the ruins, with political

events featuring only on the fringes. Politics bore the taint of dirty business. Instead of visiting Jewish emigrants in Shanghai as he had done before, Wolfgang Weber now paid a visit to German prisoners-of-war in a British camp. His photographs convey a comparatively reassuring and pleasant image. They show the former soldiers doing their Christmas shopping, working on a farm, going about the open camp, lunching with their British overseers, or a young German squaddie taking his leave of an English girl to catch the last bus at 9 in the evening. The photographer's detached gaze focuses on what is generally termed the "human interest" aspect of events. The overall mood is one of conscious objectivity.[16]

This was more or less how illustrated features by other reporters in other periodicals also looked. Although the "human interest" factor tended to set the tone in the reports, the photographs were positively saturated with the stuff of tangible reality, especially when seen through eyes that have been overwhelmed by the evocative imagery of the media world fifty years later. Even so, the distinct lack of aesthetic wit, formal boldness, emotional intensity, compelling force and daring inspiration make the work of Geman photographers seem rather pedestrian and even narrow-minded, and none of the illustrated magazines, be it *Quick,* or *Neue Illustrierte* or *Kristall,* or even, in its early days, *Stern,* came anywhere near the professional standards of their American counterparts such as *Life* or *Look.* One need not look far to find the reasons why. German photography was slow to recover from the emigration and genocide of the Jews under the racist excesses of National Socialism, and in the field of photographic journalism it never recovered at all. German photography in the immediate postwar years could not have produced anything better than it did. It was only gradually, as the Federal Republic of Germany found its feet and was basking in the early days of its economic miracle, the *Wirtschaftswunder,* that its horizons were broadened by young photographers such as Rolf Gillhausen, who was to become art director for *Stern,* Max Scheler, Robert Lebeck, Stefan Moses, the American Will McBride, Thomas Höpker, Wolfgang Haut, F. C. Gundlach and, finally, before photographic journalism lost its significance entirely, Michael Ruetz, Barbara Klemm, and Angela Neuke. Was it by pure coincidence that the Germans spearheaded mass tourism at the same time, taking a look themselves at the territories hitherto explored for them by photographers? The metaphor of "expanding horizons" thus gained its material basis.[17]

Nor would it be entirely unfounded to see German mass travel as an expression of a subconscious wish to flee. On the surface of things, the idea of recuperation after overcoming material shortages may have been the decisive factor, yet it is obvious that the memory of the disastrous National Socialist regime had been retained in a strangely fragmented form. Photographs of the war were very much in demand during the fifties, and the magazine *Kristall* had no qualms about boosting its circulation with questionable tales of German soldiers' heroic deeds. Rose-tinted memoirs of such shady war heroes as the National Socialist Luftwaffe General Adolf Galland met with considerable interest. The myth of the honourable German Wehrmacht was born and the army of the new federal republic, the Bundeswehr, which firmly bound Germany within the western alliance, even named its barracks after Nazi generals. The magazines were silent about the atrocities in the death camps, and the mechanisms of repression fostered a selective image of the immediate past. Not even a film as harrowing as Alain Resnais' *Nuit et Brouillard* (Night and Fog – 1955) was able to shake the country out of its collective amnesia – in contrast to such films as *Beiderseits der Rollbahn* (1952–53), a simplistic quasi-documentary patched together out of motley newsreel footage in a rousing celebration of German soldiery, underlined by a commentator's voice that vibrated with all the pomp and pathos of Nazi propaganda and brightened the world of mindless bar-room politics. Perhaps it was this blinkered view of historic events that nurtured the longstanding and now discredited assumption that the darker side of history had simply not been recorded to any great extent in photographs.[18] To apply the yardstick of aesthetic judgement would be scandalous, given the unimaginable and undepictable atrocities in the concentration camps and death camps of the Third Reich that were the inevitable and gruesome consequence of its racist friend-and-foe ideology.

On the other hand, this dilemma touches upon photographic practice as well as on any attempt to develop an aesthetic theory of the medium. The old question of the morality of artistic activity is almost inevitable, and for some critics photographers are nothing more than perpetrators who are satisfied with substitute activities. The image of the hunter-with-camera is still popular. Yet it shifts the focus of discussion onto the level of morality, which is problematic in a discussion of aesthetics, and one might be tempted in a sophist manner to conclude that looking the other way is by far the better path. Many Germans adopted this stance and trained their already incomplete memories to that end. A more fruitful approach to a theory of photography was supplied by the communications researcher and early editor of the *Frankfurter Zeitung,* Siegfried Kracauer, with his *Theory of Film,* published in New York in 1960. Although the German edition of this seminal work was published four years later than the American edition, Kracauer was not unknown in postwar Germany. Rowohlt publishers had already issued a translation of his earlier, pioneering work on pre-war German cinema, *From Caligari to Hitler* (1947), albeit in abridged form, in 1958. In Kracauer's view, the photographer appears as the "empathetic" interpreter of historical events. "This means that the photographer's selectivity is of a kind which is closer to empathy than to disengaged spontaneity. He resembles perhaps most of all the imaginative reader intent on studying and deciphering an elusive text. Like a reader, the photographer is steeped in the book of nature."[19] Kracauer expressly distinguishes between the photographer and the artist who is intent on making his mark on things.[20] At the same time, while by no means denying the photographer a subjective attitude to the objects he photographs, he specifies a "disciplined subjectivity" comparable to the approach of a historian who takes into account the social, psychological, cultural and historical context of the material he

is studying. The iconological method adopted by the art historian Erwin Panofsky, which merges expressly and tacitly time and time again in a continuous correspondence between Kracauer and Panofsky,[21] and the intensive exchange with younger members of the Warburg Institute in London influenced Kracauer's analyses to an extent that cannot be overestimated. The notion that a work of art is not created solely by the imagination of its author is a substratum of iconological interpretation that evidently forged a link to his studies on the phenomenon of the mass media of photography and film. According to the iconological method, the significance of each work of art is perceived by taking into account all the factors – historical, social, economic and cultural – with which it is imbued and which have been adopted by an artistic personality and condensed in the individual work.

As early as the twenties, Kracauer had already made an impact with an important essay on photography (*Die Photographie* – 1927).[22] However, he had yet to present every aspect of his concept of the photographer's "disciplined subjectivity" when the physician and photographer Otto Steinert, in the Saarland, then under French administration, announced the trend towards "subjective photography". Neither Steinert nor the authors, Franz Roh and J. A. Schmoll gen. Eisenwerth, who collaborated with him in writing the texts for the catalogues and illustrated anthologies accompanying a total of three exhibitions on the theme, seem to have been familiar with Kracauer's research in the USA on Fascist and National Socialist propaganda. Nor is there any indication that they were familiar with Kracauer's earlier published writings. Even the theories of Walter Benjamin, who, like Kracauer, addressed the topics of photography and film, have left no obvious traces in their essays. The Nazis robbed German scholarship, like German photography, of its finest minds. Benjamin's writings on photography were not to gain currency until much later, when, in the wake of the student revolts of the seventies, they were plundered as a source of social theory, while Kracauer's ideas were adopted by the most committed film theorists and critics of the sixties and seventies, only to be all but ignored in the discourse on photography.[23] A third important witness from the days of the Weimar Republic, Rudolf Arnheim, who, like Walter Benjamin and Siegfried Kracauer, had been forced to emigrate, can be found in the texts of Roh and Schmoll gen. Eisenwerth. However, it is not his ideas on the "photographic" basis of film under the flag of "film as art" (1928?) that are represented, but only his views on the psychology of art. Nevertheless, Steinert's view of the subjectivity of the photographic process is rather more roughshod than Kracauer's subtle argumentation, and his definition of "subjective photography" was based mainly on the personal "composition" of the photographer, which he considered to be dependent on an "individualized photography".[24]

Roh (only in the catalogue of the first exhibition) and Schmoll gen. Eisenwerth concentrated particularly on consolidating a theoretical basis for photography within the context of art. The fact that, in doing so, they looked to the rich sources of the psychology of perception, gestalt theory and existentialism, is hardly surprising, given the dearth of innovative ideas in the field of social sciences under National Socialism. What is remarkable, on the other hand, is their total disregard for media-specific issues, especially considering the fact that the *Neues Sehen* and *Neue Sachlichkeit* of the twenties had been a point of discussion and controversy in a discourse to which Franz Roh had contributed substantially.

Irrespective of his credo of "experimentation and new solutions", Otto Steinert kept an open option on the position of photography between documentation and art without wishing to deny the medium's realistic traits.[25] Yet he and – still more emphatically – Schmoll gen. Eisenwerth guided photography towards the realms of art. Thilo Koenig,[26] however, in his exhaustive study of the concept of "subjective photography", emphasizes quite rightly that the photographer's approach did not follow some specifically German path, but responded to relevant international currents in the development of the medium in the USA, France and the Netherlands. In particular, the direction taken by contemporary art in casting off the strictures of figurative and constructivistically geometrical composition to cultivate instead what seemed to be a formally unfettered rendering of spontaneous ideas and subjective impressions, captivated the imagination of younger, more experimentally minded photographers such as Chargesheimer and – no doubt inspired by the contact with his artist friends – of the more artisanal Hermann Claasen.[27] Yet Steinert took very few radically abstract pictures into account in the selection of the three versions of the exhibition and the slogan "subjective photography". In fact, realistic camera images and abstract pictures predominated, and even examples of artistically experimental laboratory techniques or photograms played a secondary role. Portraits were few and far between, while landscapes and pictures of technical appliances or industrial architecture were more numerous. Yet the emotional detachment from technology cannot be overlooked. As a rule, the technical objects are used as an excuse for an original formal approach and, in contrast to the photography of *Neues Sehen* or *Neue Sachlichkeit*, "subjective photography" had no interest whatsoever in their functionality.

Steinert's texts have an undeniably anti-technical undertone. The euphoric faith in technology that had prevailed in the twenties had faded with the advent of yet another world war. "In the great crisis that has arisen out of the problematic relationship between man and technology in every field of modern life during the decades of catastrophe in the twentieth century, the call for a technology consciously guided by man, and for a better controlled, that is to say, creatively guided technology, has grown ever more vociferous. It is within this broad context that the most recent photographic movement, too, is to be understood, which seeks to give the individual a compositional right, not against technology, but with all the technical possibilities available," was how the praxis-oriented Steinert described his concept of a "subjective photography".[28] Feeling that a more "humane" technology should be mirrored in the photographic images, he placed particular

emphasis on the aspect of individual composition. Otto Steinert probably underestimated the danger of the formal elements of the photographic image being absolute, involving a fundamental change in its original character. Its outstanding success, particularly with regard to international feedback, exacerbated this danger so that the offshoots of "subjective photography" became fossilized in formalistic craftsmanship.

The main shortfall of this undoubtedly promising concept of subjective photography was its lack of a sound theoretical basis. It had broken any links with the media theories in the writings of Kracauer, Benjamin, Balázs, Hauser, Arnheim and Moholy-Nagy. The philistine spirit of National Socialism had taken its toll. Whereas the avant-garde photography of the Weimar Republic had openly and confidently projected its sense of self-awareness, the "photographic approach" (Kracauer) adopted by Steinert was distinctly "defensive".[29] "Such a reticent, sceptical attitude to its own pictorial means would suggest that it was not possible after 1945 to develop as optimistic an understanding of the media or as direct an approach as the photographers of the twenties had done. In this one may see symptoms of an international crisis in the visual-photographic appropriation of reality".[30]

Because of a certain "class-struggle" factor encouraged by those in power and also present in the personal disposition of many photographers themselves, photography in East Germany proved less susceptible to crisis than in West Germany. Worker photography, ideologically ennobled by the oppositional stance of many of its protagonists under National Socialism, enjoyed a renaissance. The photographs of Herbert Hensky, Gerhard Kiesling and Jochen Schott are works of superb technical craftsmanship that reflect the photographers' social commitment and betray a one-sided bias to which they nevertheless owe their distinctiveness. Hensky and Schott contributed towards the image of the worker hero as a role model, crystallized out of the "mass ornament" (Kracauer) and given individual traits. At the same time, in the metallic sheen of the bodies in the worker portraits so brilliantly staged by Kiesling, one finds a later variation on the "cold persona" described by Ernst Jünger in his literary vision of the "worker soldier". Compared to the heroic worker figures of East German photography, the Ruhr miners photographed by Carl Andreas Abel certainly appear to be the more civilized of the species. And yet, the journalistic photography of Socialist origin, though lacking the material possibilities open to their counterparts in the West, is aesthetically more persuasive – perhaps precisely because of its one-sidedness – than the photo features by the likes of Pabel or Weber. In spite of the heated debate on formalism that raged against the background of Socialist Realism, artistic experiments in East Germany were not necessarily condemned. Fritz Kühn, a close acquaintance of Albert Renger-Patzsch (who continued, as he had done in the Third Reich, to photograph trees, grasses and stones), was able to publish his books with photographs in the style of Neue Sachlichkeit and Neues Sehen without hindrance, and a surrealistic self-portrait of Edmund Kesting was printed on the cover of an exhibition catalogue from the photo-

graphic collections of the Dresden Kupferstichkabinett. Admittedly, these were exceptions to the rule and, as in West Germany, albeit for other reasons, symptoms of an aesthetic decline in photography increased in East Germany during the fifties.

Alongside journalistic photography, there was a renaissance of the bourgeois portrait in the West. In Düsseldorf, Liselotte Strelow photographed the representatives of industry and commerce and, at their own request, personalities from the world of politics and culture. Stylistically, she adhered to the expressive photography of the Jewish studio photographers who had operated on Berlin's Kurfürstendamm during the Weimar Republic and who also inspired the work of Helmut Newton. Strelow, who had trained under Suse Buyk and taken over her studio, vied with Rosemarie Clausen in the field of theatre photography.

A number of factors aggravated the crisis in photography – a crisis which, in the end, was to introduce a complete turnaround in its self-appraisal. The increasingly indivualized view of the respective photographer towards a definite subjectivism provided an opportunity for more open-minded individuals to escape the uncertainty of a medium already losing its monopoly on information to television and ripe for aesthetic renewal. On the threshold of the millenium, computer technology has shown that photography will not, after all, follow contemporary art down the road towards abstraction, but will pursue instead the decidedly artificial and subjective photographic imagery adopted by the only independent photographic genre, namely, fashion photography. In this respect, the claim that the protagonists of "subjective photography" deliberately adopted an escapist stance[31] and actively assisted the collective repression of National Socialist crimes, misses the mark of historical truth. Although the content of the images may permit no other conclusion, the determined effort to claim autonomy for the arts – in which Steinert and Schmoll gen. Eisenwerth certainly included photography – also has a political dimension. This is reflected in the vehement rejection of all strategies aimed at instrumentalizing art for political propaganda purposes, following the experience of the recent past. Predominantly left-wing patterns of interpretation, which are unwilling to see art's claim for autonomy as anything but fiction, tend to ignore this political implication.

The most important photographic images of a Federal Republic gradually gaining economic power and political influence, whose inner contradictions erupted time and time again and increasingly dominated the collective consciousness towards the mid-sixties, were produced by photographers with a talent for seeing things with a "stranger's eye". The former American GI Will McBride was a stranger in the still grey wastelands of Germany in the fifties and sixties. His photographs broach the fragile inconsistencies of the Wirtschaftswunderland. The photojournalists Rolf Gillhausen, Robert Lebeck and Max Scheler also contributed towards a counterpoint view. On extensive travels abroad, some of them had acquired, perhaps without even knowing it, the mind-set of the stranger even in looking at their own country. At almost the same time, in distant New York, Siegfried Kra-

cauer defined photography as a medium of alienation and described the photographer as a "witness", an "observer", a "stranger", from which he deduced that only "emotional detachment" could enable the photographer to identify with people and objects, allowing him to capture his image without violence and interpret his material sensitively.[32] Recognizing the familiar in the unfamiliar and being aware of the historical determination of a subjective attitude are, in Kracauer's opinion, prerequisites for a "photographic approach" appropriate to the medium and one which he also demands of the historian in his reflections upon history. Angela Neuke and Michael Ruetz were witnesses of events that suddenly made the entire country seem strange and unfamiliar when, in 1968, the conflict that had been smouldering for so long between the generations of father and son erupted suddenly and publicly with massive force. Suddenly, the Federal Republic with its grand coalition government had become a police state in which protests against the existing order of things were brutally and ruthlessly smashed – Neuke, Ruetz and the committed journalists on the fringes of the student protests of the late sixties had made it their business not to look the other way. Yet it was the television images that had the greatest impact on public opinion. They fanned the flames of the emergent generation conflict and the climate of social change ensured that images of protest and the state's response to the occasionally militant revolt had profound and far-reaching social consequences. Ten years previously, images of the movements against German rearmament, against the atomic bomb, demonstrations against meetings of the Waffen-SS, had gone almost unnoticed.

When the students took to the streets to protest against the sclerotic structures of their university system, the Deutsche Gesellschaft für Photographie honoured Dr Bruno Uhl, the influential representative of the photographic industry, with their cultural award and also accoladed the photographers Chargesheimer, Charlotte March and Thomas Höpker. Uhl was not unknown in the sphere of photography. As an industrial promoter of "amateur photography" he had already made a name for himself under the National Socialist regime. After the war, he engineered the amalgamation of the West German photographic industry and was also the spiritus rector of *Photokina*, the major trade fair in the photographic sector. The *Photokina* exhibition initiated by L. Fritz Gruber continued in the tradition of large-scale photographic exhibitions such as *Film und Foto* in Stuttgart (1929) and the prestige-enhancing photography shows under the National Socialists, but in spirit and mise-en-scène it leaned more heavily towards Edward Steichen's successfully staged photographic exhibition *The Family of Man* (1955). Hermann Claasen's picture of a war invalid photographed in rear view possessed an irresistible rhetoric that invited identification and, as the central work, set the tone for this ambitious project.

In fact, the *Photokina* exhibitions with their pluralistic concept addressing photography's many and varied interactions with art and industry, at the same time relativizing photographic experiments by integrating them into the scintillating spectrum of photographic possibilities, had a deeper and more lasting influence on the image of photography in West Germany than the artistic exercises and even the illustrated periodicals, until art finally appropriated the medium. The dominant aesthetic of the photographic exhibitions ornamented the technical developments and mercantile turnover. Instead of aesthetic considerations, photographic design was in the foreground. Small wonder, therefore, that the decisive artistic impulses of German photography, unleashed by the artist and photographer team Hilla and Bernd Becher, or by Klaus Rinke, Johannes Brus and Sigmar Polke were completely ignored by the photographic industry. The history of photography did indeed repeat the history of art since its painful valediction from academic historiography – as farce.

Notes

1 Karl Marx, Der achtzehnte Brumaire des Louis Bonaparte, *Marx-Engels-Studienausgabe*, vol. IV, Frankfurt am Main 1966, p. 34.

2 *documenta*. Photography's actual breakthrough into the domain of art did not come until *documenta 6* five years later, at which photography – along with film and video art – was granted its own separate department irrespective of the divergent aims of photographic practice.

3 Cf. Klaus Honnef and Ursula Breymayer (eds.), cat. Berlin 1995.

4 Cf. Rudolf Augstein, "Lieber Spiegelleser" in *Der Spiegel*, 29 July 1953.

5 Ibid.

6 Ibid.

7 The attribute "obscene" is used here in the sense employed by Susan Sontag in her essay "Under the Sign of Saturn" in *A Susan Sontag Reader*, London 1983, pp. 385 ff.

8 Cat. *Das Deutsche Auge*, Hamburg and Munich 1996.

9 Rudolf Augstein, 1953 (see note 7).

10 Cf. the essay by Hanno Loewy in this publication.

11 The photographer presented himself to the author as a cosmopolitan traveller, which in a certain sense he was, as he had spent the Nazi years almost entirely abroad and had not come into contact at all with the National Socialist crimes.

12 For details, see Hanno Loewy's essay in this publication.

13 Cf. the essay by Rolf Sachsse in this publication.

14 Rolf Sachsse in K. H. Schmölz and Rolf Sachsse (eds.), *Hugo Schmölz*, Munich 1982.

15 At a panel discussion in the Rheinisches Landesmuseum in Bonn on the occasion of the exhibition *Aus den Trümmern – Kunst und Kultur in Nordrhein-Westfalen – Neubeginn und Kontinuität*.

16 For details, see Klaus Honnef, "Zwischen Reportage und Kunstfotografie" in the cat. *Aus den Trümmern*, Cologne and Bonn 1985.

17 Cf. Klaus Honnef, "Vom Traum zur Wirklichkeit" in F. C. Gundlach, *Mode-welten,* ed. by Klaus Honnef, Berlin 1985, pp. 256 ff.

18 See Peter Reichel and Hanno Loewy in this publication.

19 Siegfried Kracauer, *Theory of Film,* New York 1960, p. 16.

20 Cited by Volker Breidecker, "Ferne Nähe. Kracauer, Panofsky und 'the Warburg tradition'" in *Siegfried Kracauer – Erwin Panofsky, Briefwechsel,* Berlin 1996, p. 172.

21 Ibid.

22 Siegfried Kracauer, *Schriften,* vol. 5, Frankfurt am Main (publication pending).

23 The author is one of the few who used Kracauer's "Introduction" to his *Theory of Film* as a source for his texts. Cf. cat. *Hilla und Bernd Becher,* Bonn and Cologne 1975 and cat. *documenta 6,* Kassel 1977.

24 Cited by Thilo Koenig, *Otto Steinerts Konzept Subjektive Fotografie (1951–1958),* Munich 1988, p. 5. Koenig's highly informative treatise is the most thorough and authoritative treatment of the subject to date and dispenses with many myths, prejudices and misinterpretations.

25 Otto Steinert, cited in the cat. *Subjektive Fotografie – Bilder der 50er Jahre,* Essen 1984, p. 6 as motto.

26 Thilo Koenig, 1988, pp. 20 ff. (see note 24).

27 Cf. Rolf Sachsse, *Hermann Claasen, Werkverzeichnis,* vol. 3, ed. by Klaus Honnef, Cologne–Pulheim 1997.

28 Otto Steinert, cited in Thilo Koenig, 1988, p. 8 (see note 24).

29 Ibid., p. 201.

30 Ibid.

31 Ibid., pp. 21 ff., here too the most important source references.

32 Volker Breidecker, 1996, pp. 171 f. (see note 20).

Volker Albus

UP AND RUNNING
Industrial products and advertising

German advertising was probably never so innocent and unsullied as it was in 1949, when it was enough merely to announce the availability of a product. *"Es gibt wieder Sunlicht Seife"* ("Sunlicht soap is back again") claimed the full-page ad printed in issue 15 of *Stern* magazine. Framed by a burst of sunbeams, a radiantly smiling young man presents an enormous bar of Sunlicht soap. Triumphantly holding it aloft like some salvaged treasure, he seems to be reassuring the deprived consumer that "It's all over now, the good old days are here again . . .". To confirm that things really are back on track again, and that the dark days of deprivation are finally over, the graphic designer has portrayed the figure straddling a miniature industrial skyline complete with smoking factory chimney. There is no subtle associative ploy here, nor any profound brand message. The very words *"Es gibt wieder"* ("back again") and the assurance that a bar costs only 50 pfennigs was enough to ensure sales. It was as easy as that – in those days.

The graphic design, too, is straightforward. The advertisement takes the form of a simple black and white linocut or woodcut, with a headline in block capitals and the word *WIEDER* ("again") stressed in black, the full brand name as a subtitle and the "soapman" in the centre, bathed in a well-deserved nimbus – a familiar image.

So much modesty by default was not to last. As Germany's economic miracle, the *Wirtschaftswunder* of the fifties, took hold, the shortages that had plagued the early postwar years soon became a thing of the past. It was not long before there was enough to go round again. Soon, there would even be plenty of everything, then more and more. Today, there is sometimes more than enough. The sigh of relief and even humility echoed in the message that the product is "back again" gave way to a modestly self-confident sense of "here and now" availability. A golden age was dawning – not just for the world of advertising. The simple ads for basic necessities such as detergents were soon followed by a general trend towards the proud presentation of technical, fashionable or cosmetic innovations.

The buoyancy of the car industry and the burgeoning household appliances and electrical goods industries, in particular, reflected the rapid rise in living standards during this period. Yet for some time, many ads continued to invoke the martial aesthetics and belligerent language of the Third Reich. In 1951, ads for the SABA-FREIBURG W10 radio (with hardwood casing) were still claiming to offer "powerful sound and crystal clear purity" *("gewaltige Klangfülle und kristallklare Reinheit des Tonbilds")*, while "Germany's most finely-tuned radio set" *("Das trennschärfste deutsche Radiogerät")* was advertised in issue 9/51 of *Stern* magazine against a background of organ pipes mildly

reminiscent of the Iron Cross and illuminated by sweeping beams of light that would hardly have been out of place at a Party rally. In 1954, the Graetz company ran an ad in *Stern* issue no. 7, tersely claiming: "Expertly shot. Expertly intercepted. Expertly broadcast by Graetz radio and TV sets" *("Meisterhaft geschossen. Meisterhaft abgefangen. Meisterhaft übertragen mit Graetz Radio- und Fernsehgeräten")*.

These ads run by the market leaders SABA, GRUNDIG and Graetz were all based on the same recurring structure: a free-standing photograph of the appliance in question combined either with a sketch of some activity such as football, car racing or horse racing, or with an image of a happily smiling housewife. In contrast to these tentatively simulated references to real life and experience, another category of advertisements sought to pick up where the legendary artwork of the twenties had left off. Yet for all their avant-garde collage techniques, linear perspective and dynamic typography, they differed fundamentally from their forerunners in two major respects. First, the geometrically stylised ads presented the product itself in a conventional overall view, generally at a slight angle. Second, these otherwise completely neutral product photographs were retouched to look like drawings. Lighting, wood veneer, switches and buttons, mouldings and recesses were all highlighted to create an impression of sculptural plasticity and glossy class. These highly polished images reflected the solemn grandeur of the product names – "Musica", "Melodia", "Sinfonia", "Opus", "Rondo" etc. – and the practice of enhancement came to be known as *Betonretusche* (roughly: "concreting over"). Such cosmetically altered images of perfection had nothing to do with photography, let alone with the kind of subtle photographic objectivity that reveals the "essence" of a product. At best, they embodied a "this is how it looks" approach to product presentation.[1]

As foreign companies began to gain a foothold on the market, as new magazines were launched and, above all, with the advent of television, the content and style of advertising changed. The gravity and the collective modesty of humble contentment that had prevailed in the postwar years were swept aside by a wave of optimistic, forward-looking, modern social idealism. It was impossible to ignore the "realism" of film and television, whose popular images of a perfect world peopled with wholesome families, cooing lovers and sophisticated couples stood in stark contrast to another, more intellectualised, graphic approach that corresponded clearly with the latest trends in art, film and photography, and presented the product primarily as a real industrial product suitable for everyday use.

Just as these contrasting worlds of advertising differed widely, so too did the projected aesthetic appeal which David Ogilvy would

Rowenta advertisement in Magnum no. 11, 1956

Anton Stankowski: advertisement for IBM, 1953

later discuss in terms of "brand image".[2] What both basic approaches had in common, however, was their increasing use of photography and photographic techniques. In 1953, Anton Stankowski, who had trained at the Folkwangschule in Essen, created a series of ads for IBM consisting of a photo-graphic image with a block of copy set beneath the "picture". Stankowski's work was clearly motivated by an endeavour "to find the clearest, most concise and evocative form for every kind of legible and visible message".[3] For example, he would mount a precisely balanced frontal or side view of an office workplace – desk, chair, typewriter, once with secretary, twice without – into the photogram of a rose, a male profile or a baby. The text, which begins on the black background of the photogram, elucidates and complements the visual message. In fact, these first words, together with the picture and the brand logo, were actually enough to achieve what Moholy-Nagy described in his *Typographische Mitteilungen* of 1925 as a "visually-associative-conceptually-synthetic unit".[4]

Whereas the stringency of Stankowski's motifs evokes a certain precision, order and clarity, triggering associations of rational office organisation, the advertisements created from around 1956 by the McCann agency for the Opel car company clearly seek to cultivate an image of "comfort", "taste" and "elegance". Here, too, a more or less square photograph or photographic composition is combined with a block of copy in relatively small print to create a "visually associative unit". The difference in this case, however, is the fact that, at the time, the limousines in question were hardly everyday appliances, but relatively prestigious status symbols. Photographer Gert Pfannkuch and art director Julius Stahlberg rose to the challenge of conveying this exclusive image for the Opel brand. Ladies seated at the steering wheel or swathed in the perfect drapery of some haute couture creation, were gloved, coiffed and powdered to grace a *Vogue* cover, and everything about the scene exuded an air of genteel sophistication. Opel was synonymous with high society.

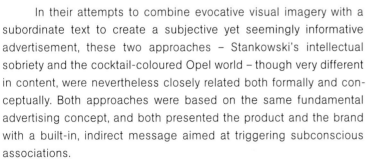

Gert Pfannkuch (photographer): advertisement for *Opel*, 1956

ZEISS IKON advertisement in *Magnum* no. 12, 1957

In their attempts to combine evocative visual imagery with a subordinate text to create a subjective yet seemingly informative advertisement, these two approaches – Stankowski's intellectual sobriety and the cocktail-coloured Opel world – though very different in content, were nevertheless closely related both formally and conceptually. Both approaches were based on the same fundamental advertising concept, and both presented the product and the brand with a built-in, indirect message aimed at triggering subconscious associations.

Faith in the image, especially in the power of the photographic image, was briefly adopted by camera manufacturers ZEISS IKON in the mid-fifties as the motto of their advertising campaign. One-liners bearing such messages as *"Ein Bild sagt mehr as 1000 Worte"* ("A picture says more than a thousand words") and *"Für Photos, die etwas sagen sollen"* ("For photos with something to say")[5] were mounted in a full-page collage. As in a picture puzzle, these "truisms"

were represented by typographic elements, freestanding photographs of objects or visually striking scenes. This was by no means new, and *Magnum* magazine, in which the ZEISS IKON ads appeared, appropriately devoted its issue no. 22 to the subject of *Dadaismus in unserer Zeit* (Dadaism Today). "It is the material, the surface itself, its structure, that is suddenly gaining a fascinating significance for the photographers in the spirit of Dada, and it is the object exhibited, solitary in space (or in nothingness), wrenched out of any context, derobed of its function, raised to a new level and seen from a new angle, that is becoming the darling of the photographer," wrote Karl Pawek.[6] One such "new level". was undoubtedly advertising and the messages it conveyed, and Hans Richter, one of the fathers of Dadaism, confirmed in the same issue that "no advertising agency anywhere in the world can do without photomontage."[7]

Photomontage, a more or less Dadaist-inspired collage of text and image, and the composed image rather than the simply struc-

tured advertisement of a few years previously, became standard practice. In retrospect, however, most of these advertisements seem to us to be somehow inhibited, cautious, at times mildly elated, sometimes just plain orderly and disciplined. They simply lacked the proclamatory force, the sheer devotion and the cutting edge of the work created in the twenties and thirties. But could we have expected anything other than a coy confession, a hopeful and optimistic acceptance of the new economic and political situation? I doubt it. The trauma was simply too deep to permit the kind of emphatic commitment to a new beginning that had prevailed in the interwar period. Bearing this in mind, it seems in retrospect that the renaissance of montage was often merely the result of a general stylistic insecurity. Adopting surrealistic, abstract or simply symbolic motifs was clearly a means of compensating for the era's lack of its own artistic self-awareness.

There were, however, also examples that consciously addressed this mood of general insecurity and uncertain future. The 1959 Siemens ad, for example, shows nothing but a barely discernible row

SIEMENS advertisement in *Magnum* no. 25, 1959

Advertisement for *Deutsche Zeitung* in "Woher Wohin – Bilanz der Bundesrepublik", *Magnum* Sonderheft (special issue), 1961

of lamps shot at an angle. The actual form of the seven square lamps and one round lamp can just be made out against the deep black of the nocturnal background. In the 1961 ad run in the *Deutsche Zeitung*, the actual scenario is also identifiable only as a conversation between two men and a woman, suggesting a typical office situation.

Both these ads are full-page black-and-white photographs. The respective logo is either presented freestanding as a geometrical counterpoint (Siemens) or as a title integrated into the scene. Both ads bore some relation to an "experimental" or "subjective" photography which, according to its exponents, could "convey all the technical and formal possibilities that lend themselves to shaping the visual experiences of our time..." [9] and, as such, to shaping the authentic advertising photography of the period as well.

An advertising photo by Chargesheimer formulated this "visual experience" in an almost metaphorical vein. "I want to show the

world as it is, our world in all its harshness, its strangeness, its serenity and its beauty, yes its beauty," he once wrote.[10] And indeed, all the "harshness", "strangeness" and "beauty" of "the world as it is" are expressed in this photograph. This black and white shot could hardly be further from the Hollywood atmosphere of the Opel ad. It has been raining, the street is wet, there is no tree, no bush, no sense of scintillating luxury, no holiday atmosphere; it is a weekday, a workday, anyday. But even such days and such everyday occurrences as a wet street have their own appeal, their own "beauty". We simply have to see them. Chargesheimer sees them and he shows them to us in a fleeting and utterly realistic beauty that is rarely captured in this way.

This principle of realistic yet subjectively associative imagery contrasted sharply with the stringency of a more factual, statement-like presentation. Such advertisements, including, for example, those designed for the Braun company at the Ulm Hochschule für Gestaltung under Otl Aicher, eliminated all references to function or aesthetics beyond that of the appliance itself. The appliances, most of them freestanding or photographed against a white background, were aligned or listed like "signs".[11] "True photographic design begins with the use of a photo as a typographic element," wrote lecturer Ernst Scheidegger in 1959.[12] Photographs of the respective appliances were arranged accordingly. Radios, household appliances and projectors were photographed frontally, almost at eye level and with virtually no shadow. The presentation in the advertisement itself gave no idea of actual dimensions. Standard types were shown, brand and model named, and the function was indicated by the photographic image or by the designation "Projector P A 2", "Transistor T 520", "Toaster HT 1". Photography was a technical means to an end: the reproduction of an image.

It is this photographic production of images entirely devoid of "aura" that distinguishes them from the work of such photographers as Willi Moegle. "For Moegle, the product or object he photographs becomes a personality he observes, whose phenomenology he scrutinises intensely, and which he studies closely," wrote Otto Steinert in a 1967 essay marking Moegle's 70th birthday.[13] As J. A. Schmoll gen. Eisenwerth noted, "It is the special form and significance of the respective objects to which a photographer like Willi Moegle devotes his attention."[14] Moegle sought to trace and portray the essence of things, their materiality, corporeality, functional characteristics and even their grace, by photographic means alone – by lighting, arrangement, choice of background and choice of position. This was anathema to the exponents of the Ulm school. They extrapolated the essence. They sought to achieve a timeless, impersonally objective reproduction that precluded any form of individual or emotional reference, in keeping with a design approach based as far as possible on a scientifically and empirically founded timelessness of the material world. (Even today, the ERCO lighting company still takes the same approach. Their advertisements, featuring rather more highly perfected photographs, possess the deliberately informative tone of a news cable's factual vocabulary.)

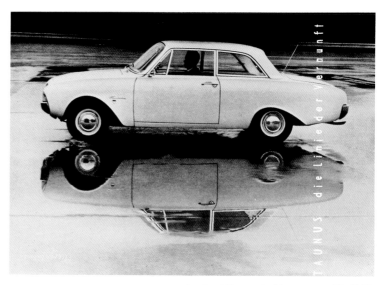

Chargesheimer: advertisement for *Ford Taunus* in *Magnum* no. 33, 1960

Otl Aicher: advertisement for *Braun*, 1958

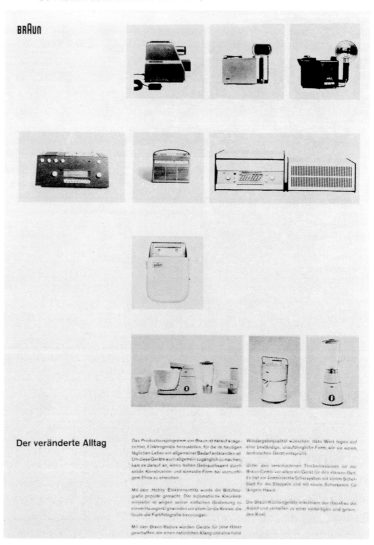

Willi Moegle: *Jenaer Glass*, Schott company, 1959

Warum werden so viele Volkswagen gekauft?
(Bis heute über 7 Millionen. 3,5 Millionen in Deutschland. 1,2 Millionen in Amerika. 2,5 Millionen in der übrigen Welt.)
Dafür gibt es viele Gründe. Das ist der wichtigste:

Der VW läuft und läuft und läuft und läuft
und läuft und läuft und läuft und läuft
und läuft und läuft und läuft und läuft
und läuft und läuft und läuft und läuft.

Charles Wilp (photographer): advertisement for *Volkswagen* in *Stern* no. 2, 1963

It was Moegle's approach, however, that came closer to the requirements and expectations of industry. From the beginning of the fifties until the early seventies, when he handed over his studio to Hansi Müller-Schorp, his colleague of many years, Willi Moegle worked for such companies as Arzberg (porcelain), Schott (glass), Schönwaldt (porcelain) and Schnaidt (furniture).

"Der VW läuft... und läuft... und läuft... und läuft..." (VW keeps on running ... and running ... and running ...) was surely the most successful German advertising slogan of all time. Not only do we grasp the meaning immediately, but we can actually see in our mind's eye Charles Wilp's sequence of photographs showing an ever smaller VW Beetle purring away into the distance.[11] In this advertisement, created in 1963 by the Düsseldorf agency DDB, image and text merge to form an independent medium with a cohesion rarely achieved before (or since). Although it employs the simplest of linguistic and photographic means, this advertisement was not only a resounding success, but actually became something of an icon. It touched on the

pulse of the sixties as few other cultural achievements could, with a text and imagery reflecting West Germany's newfound self-confidence as no other advertisement had done before. It smacked neither of nouveau riche vulgarity nor of selfish mediocrity, and it not only meant that the past was forgotten, but stated simply and laconically that things were up and running – and would keep on running, from now on, non-stop. (Right up to the present day.)

Notes

1 See the advertisement for ROBERT BOSCH GMBH STUTTGART in *Stern* no. 25, 1951, and the advertisement for Graetz in *Stern* no. 49, 1954.

2 David Ogilvy, *Ogilvy über Werbung*, Düsseldorf und Wien 1984, p. 14. Cited by Manfred Schmalriede in "Deutsche Werbefotografie 1925–1988" in *Deut-*

sche *Werbefotografie 1925–1988*, published by Institut für Auslandsbeziehungen, Stuttgart 1989, p. 12.

3 Käthe Klein, *Aus der Geschichte der Folkwangschule für Gestaltung. Schrift 26 der Folkwangschule*, Essen 1965, p. 35. Cited by Anton Stankowski in *Kunst und Design. Fotografie*, published by Institut für Auslandsbeziehungen, Stuttgart 1989, p. 8.

4 Laszlo Moholy-Nagy, "Typo-Photo" in *Typographische Mitteilungen*, Leipzig, October 1925, p. 202. Cited by Manfred Schmalriede in "Werbefotografie und Werbung von 1925–1988" in *Fotografie und Werbung*, published by Museum Folkwang, Essen 1989, p. 18.

5 See the advertisement for ZEISS IKON in *Magnum* no. 13, 1957.

6 Karl Pawek, "Die Photographen sind die Dadaisten von heute" in *Magnum* no. 22, 1959, p. 22.

7 Hans Richter, "Dada ist tot, es lebe Dada!" in *Magnum* no. 22, 1959, p. 11.

8 This advertisement appeared, inter alia, in "Woher Wohin – Bilanz der Bundesrepublik", *Magnum* Sonderheft (special issue), 1961.

9 Otto Steinert, 1951. Cited by Ute Eskildsen: " 'subjektive fotografie' das Programm einer zweckfreien Fotografie im Nachkriegsdeutschland" in *Subjektive Fotografie*, published by Museum Folkwang, Essen 1985, p. 6.

10 Cited by D.D., "Helles Brot in kohlenschwarzer Hand" in *Frankfurter Allgemeine Zeitung*, 23. 08. 1996, p. 6.

11 Thilo Koenig, "Information statt Persuasion. Werbung und Plakatgestaltung mit fotografischen Mitteln" in *Objekt + Objektiv = Objektivität? Fotografie an der HfG Ulm 1953–1968*, published by HfG Archiv Ulm, Ulm 1991, p. 93.

12 Ernst Scheidegger, "Fotografie und Werbegrafik" in *Neue Grafik* no. 4, 1959, p. 30. Cited by Thilo Koenig, op. cit., p. 95.

13 Otto Steinert, 1967, "Für Willi Moegle" in *Die Sachaufnahme. Willi Moegle*, published by Museum Folkwang, Essen 1985, p. 7.

14 A. Schmoll gen. Eisenwerth, "Für Willi Moegle", ibid., Essen 1985, p. 7.

Plates

1 August Kotzsch, Melon, c. 1870 (cat. no. 20)

2 Heinrich Wilhelm Müller, Elegy, 1902 (cat. no. 30)

3 Erwin Quedenfeldt, Head outlined in light, 1914 (cat. no. 36)

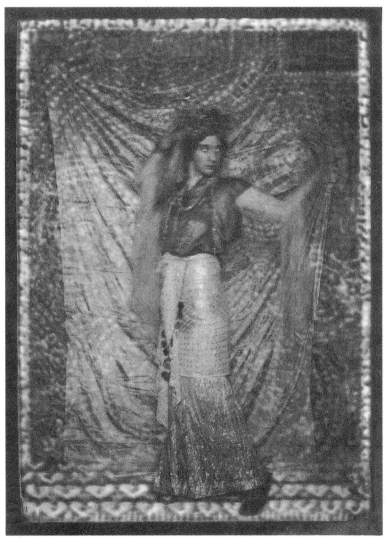

4 Frank Eugene, Fritzi von Derra as Salomé, c. 1907 (cat. no. 10)

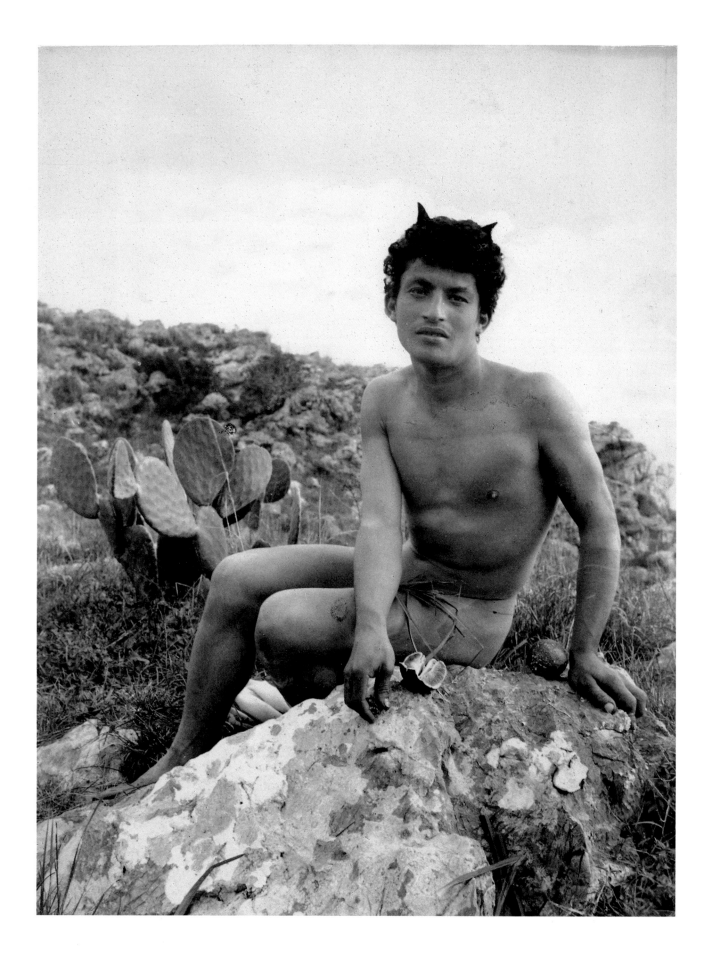

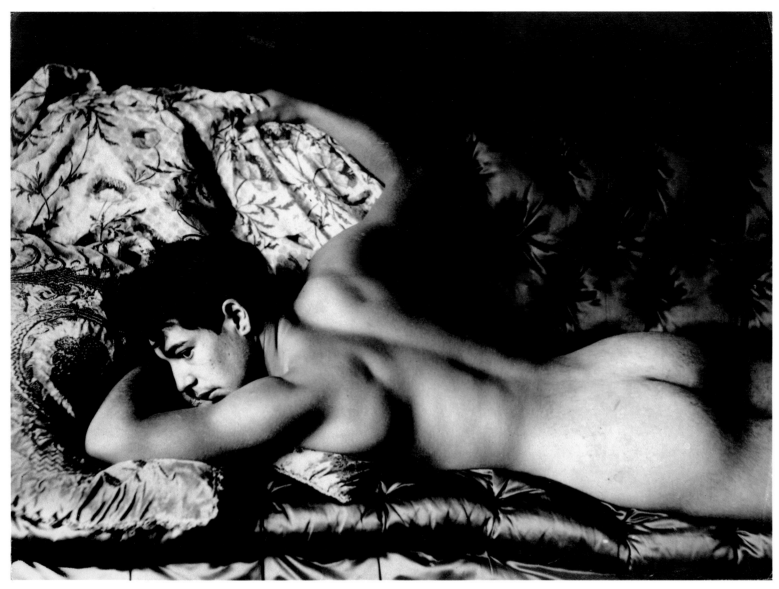

6 Wilhelm Plüschow, Male nude, c. 1900 (cat. no. 34)

5 Wilhelm von Gloeden, The young faun, 1899 (cat. no. 12)

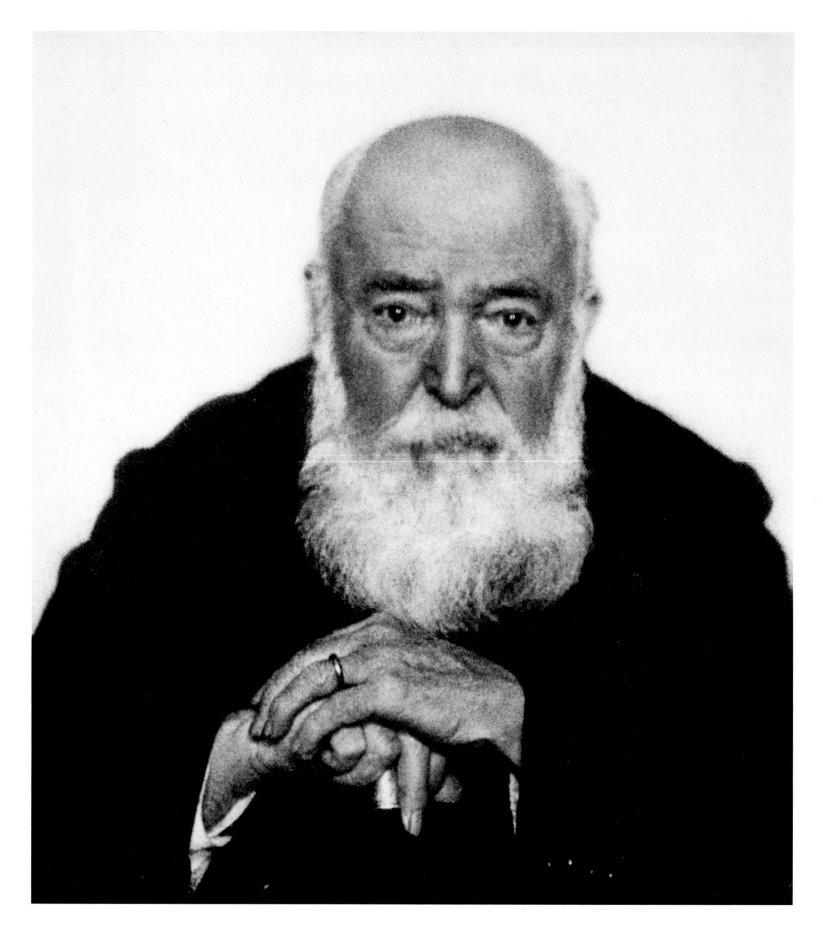

8 Theodor and Oscar Hofmeister, Night walk (the witch), 1900 (cat. no. 17)

7 Hugo Erfurth, Hans Thoma, c. 1920 (cat. no. 62)

9 Hermann Rückwardt, Weidendammer Bridge (detail), Berlin, 1897 (cat. no. 38)

10 Anselm Schmitz, Cologne cathedral as seen from beyond the garden of the Archbishop's Palace, summer 1882 (cat. no. 43)

11 Franz Schensky, Large wave, c. 1925 (cat. no. 119)

12 Nicola Perscheid, Hans Poelzig, architect (1869–1936), after 1925 (cat. no. 105)

14 Heinrich Zille, Untitled, c. 1900 (cat. no. 45)

13 Rudolf Dührkoop, Anna Muthesius in the conservatory, 1910 (cat. no. 8)

15 August Sander, Abitur candidate, Cologne, 1926 (cat. no. 115)

16 Karl Blossfeldt, Fern, c. 1921 (cat. no. 57)

18 Erich Comeriner, The keys of my typewriter, 1929 (cat. no. 60)

19 Georg Trump, Feldmühle, c. 1929 (cat. no. 127)

17 Hannes-Maria Flach, Hohenzollern Bridge, Cologne, c. 1927 (cat. no. 73)

20 Werner Mantz, Electrola display window on Hohe Strasse, Cologne, 1928 (cat. no. 89)

21 August Sander, Cologne "Court Musicians", 1928 (cat. no. 116)

22 Friedrich Seidenstücker, Bearing the load, 1928 (cat. no. 121)

23 T. Lux Feininger, The leap over the Bauhaus, Dessau, c. 1928 (cat. no. 66) 175

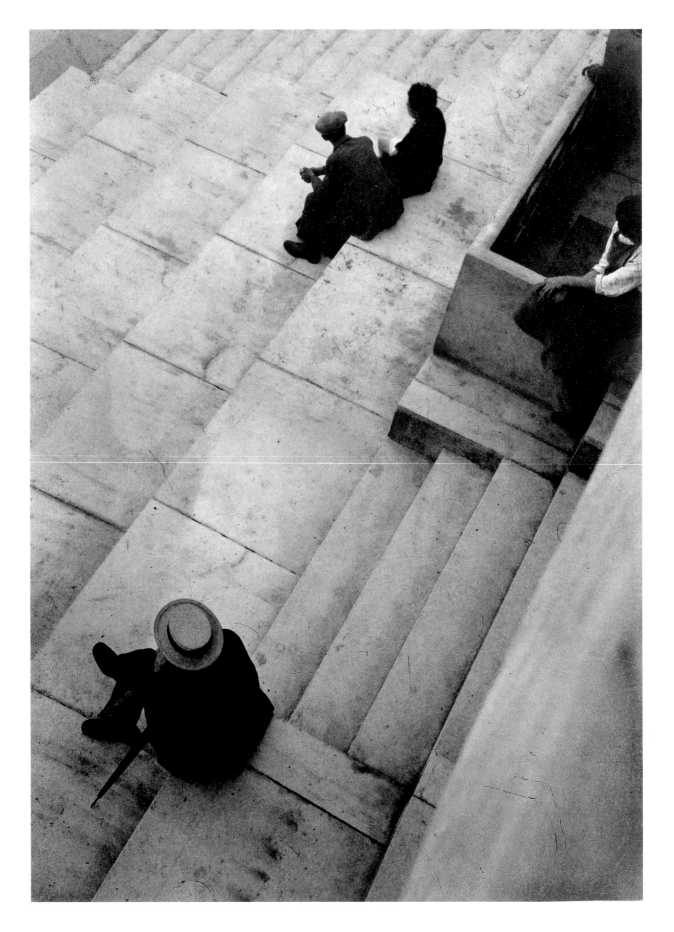

24 László Moholy-Nagy, In Lyon's stadium, c. 1929 (cat. no. 98)

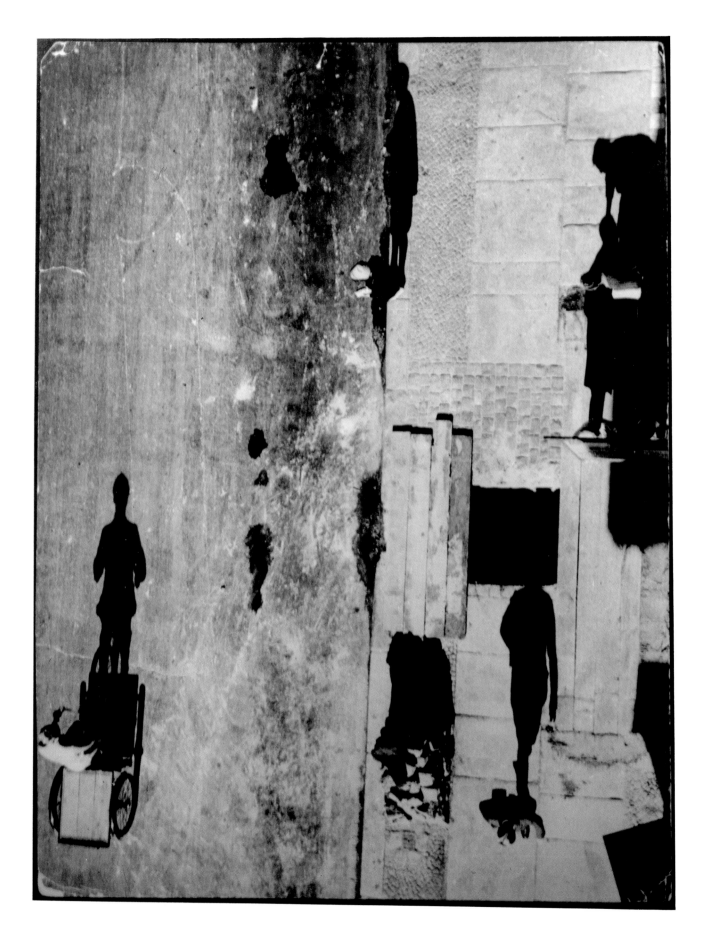

25 Umbo, Uncanny street, 1928 (cat. no. 128)

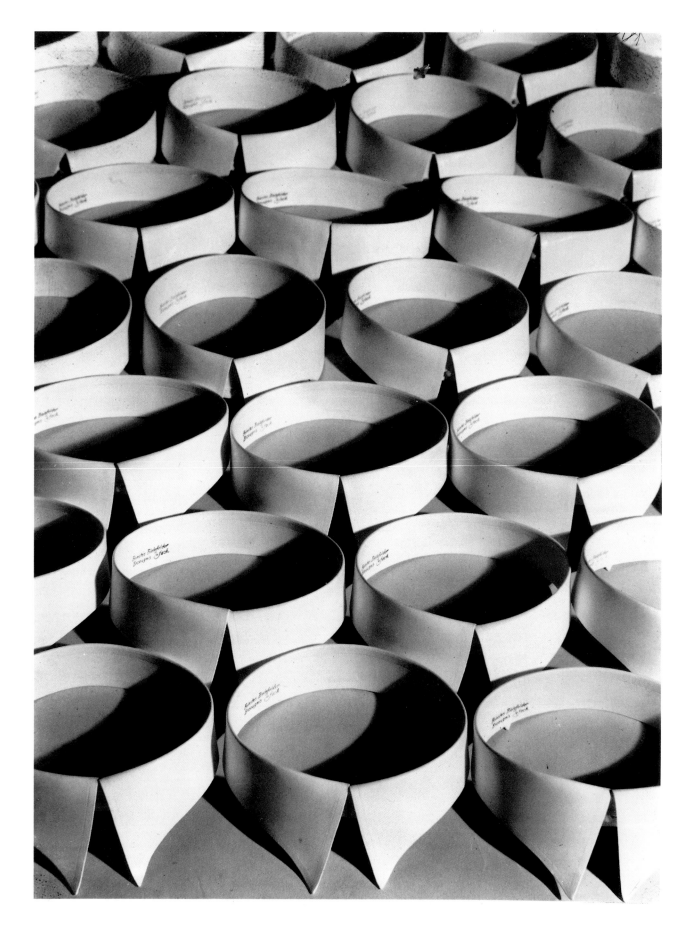

26 Hein Gorny, Untitled, 1928 (cat. no. 76)

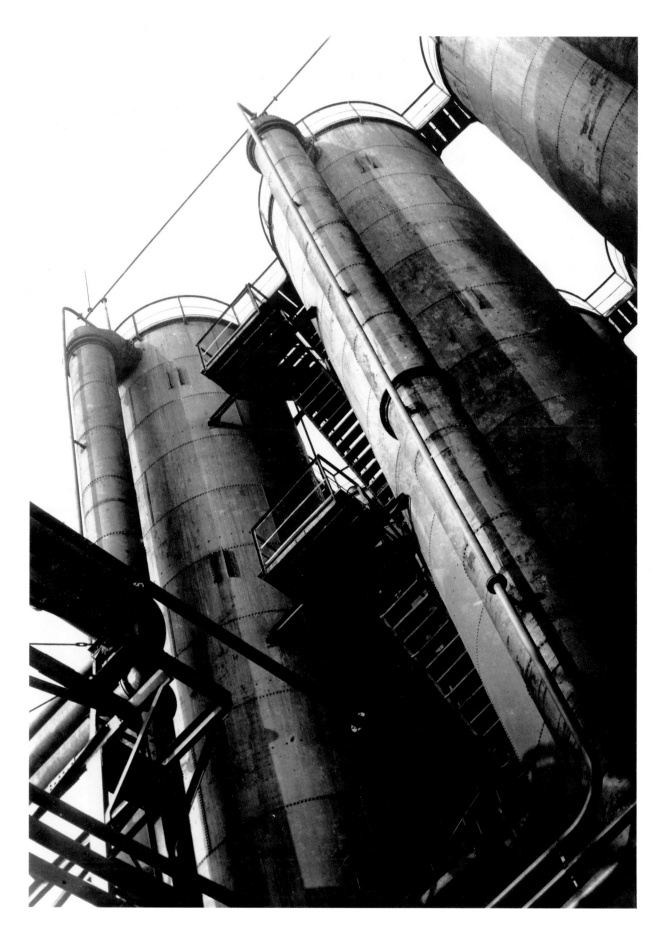

27 Max Burchartz, Benzol and ammonia processing tank, c. 1928 (cat. no. 58)

29 László Moholy-Nagy, Photogram No. 1 – The mirror, 1923 (cat. no. 94)

28 Christian Schad, Untitled, 1918 (cat. no. 118)

30 Walter Ballhause, The unemployed in advertising, 1930/33 (cat. no. 132)

31 Errell (Richard Levy), The advertisement, 1930 (cat. no. 155)

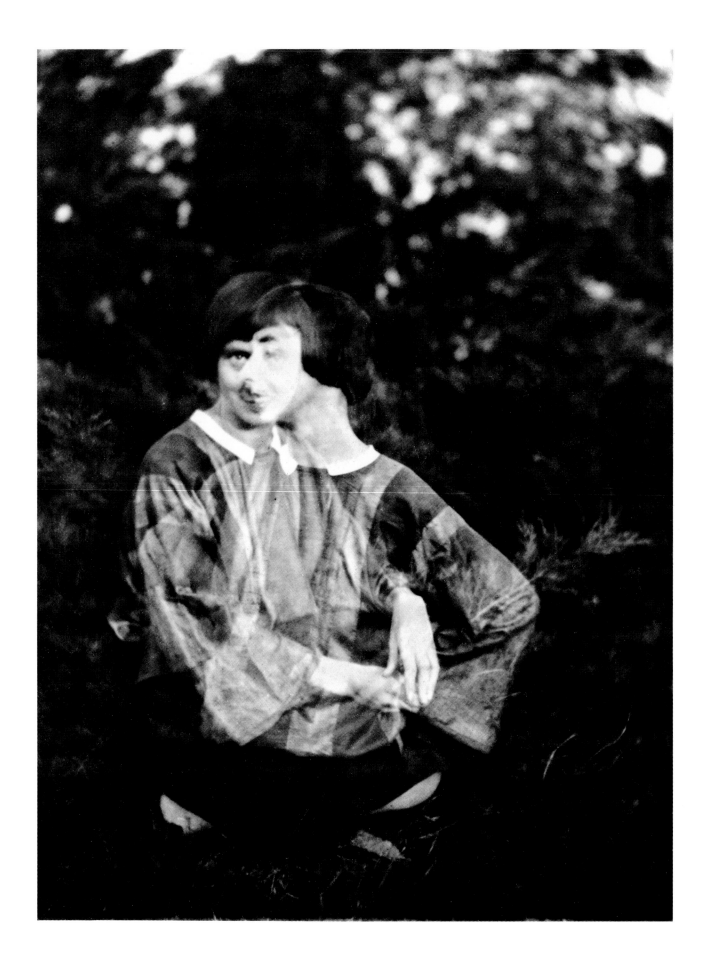

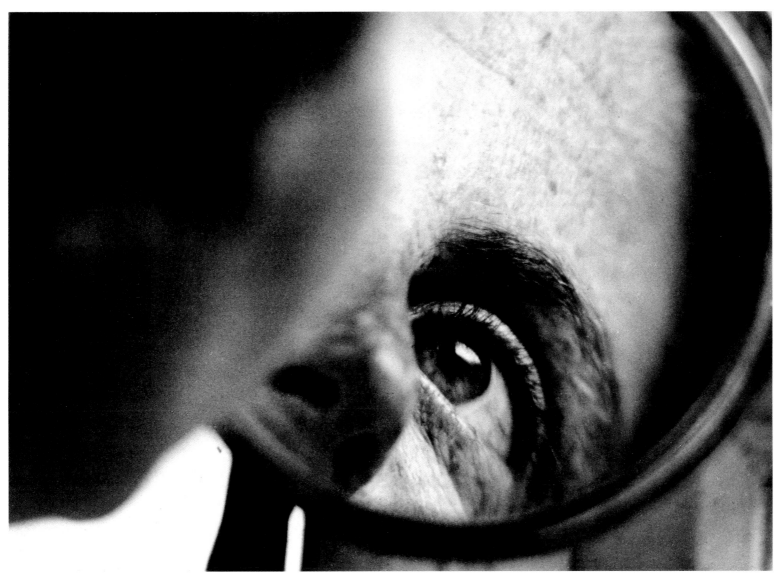

33 Raoul Hausmann, A glance in the shaving mirror, 1930/31 (cat. no. 167)

32 Hannah Höch, Self portrait (double exposure), 1924 (cat. no. 81)

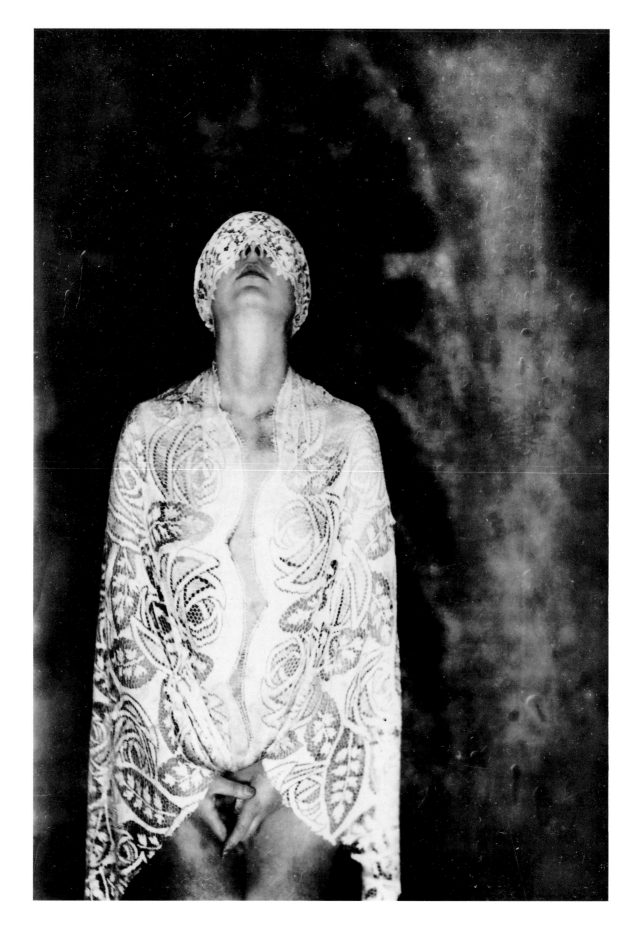

186 34 Marta Astfalck-Vietz, Untitled, c. 1927 (cat. no. 49)

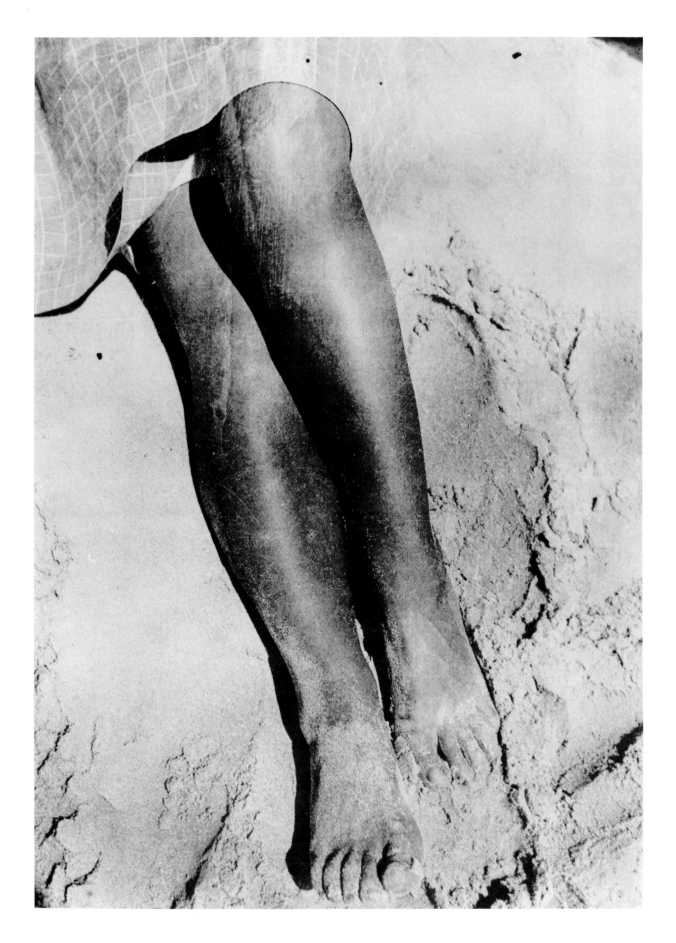

35 Herbert Bayer, Legs, c. 1928 (cat. no. 50) 187

37 Walter Peterhans, Portrait of his beloved, 1929 (cat. no. 107)

36 Willy Zielke, Still life – Colours in chemistry, 1934 (cat. no. 265)

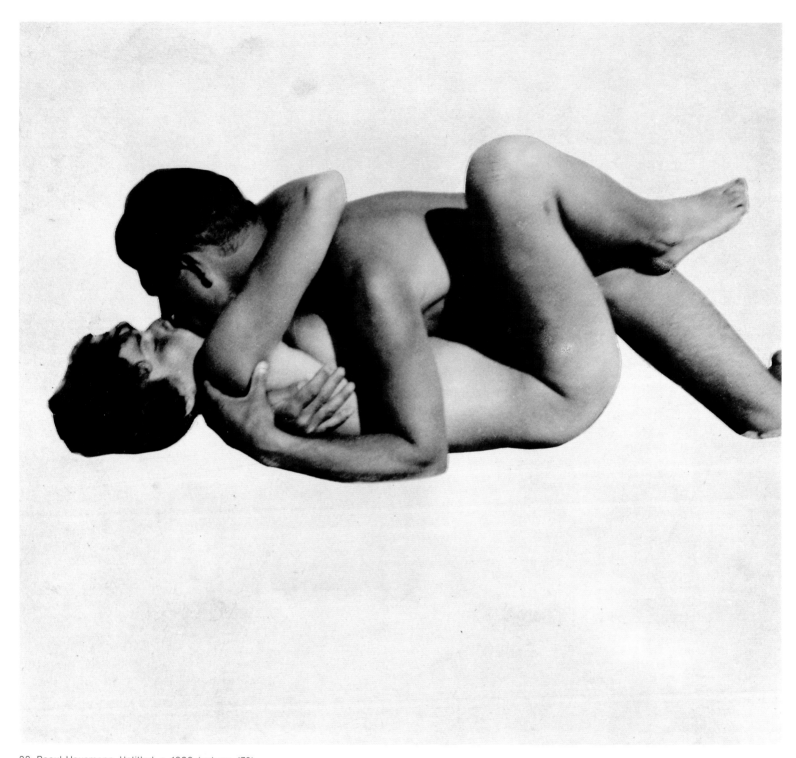

38 Raoul Hausmann, Untitled, c. 1930 (cat. no. 170)

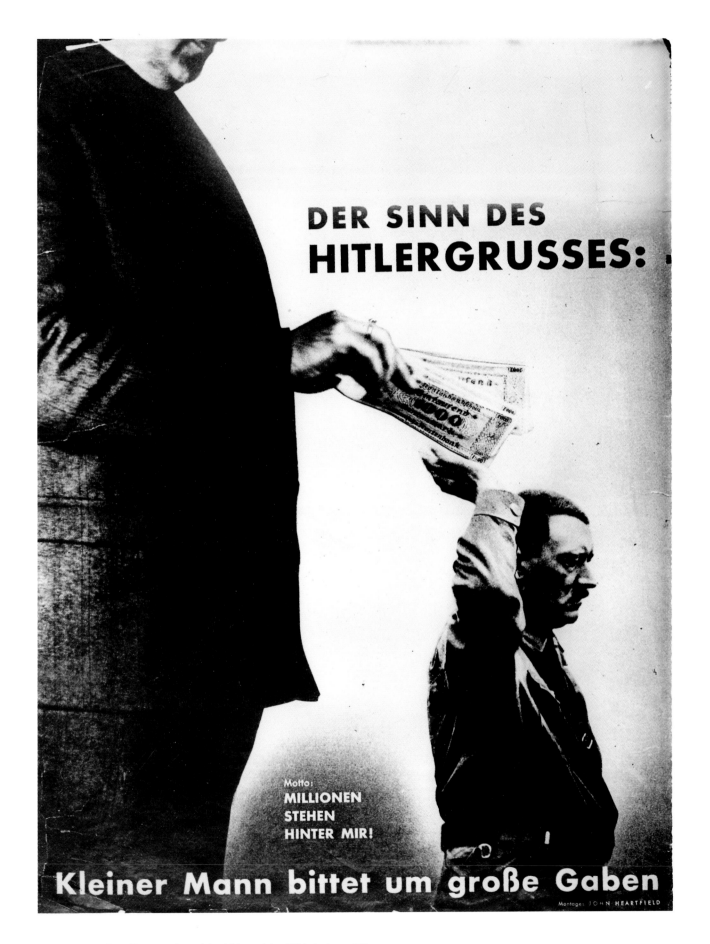

DER SINN DES
HITLERGRUSSES:

Motto:
MILLIONEN
STEHEN
HINTER MIR!

Kleiner Mann bittet um große Gaben

Montage: JOHN HEARTFIELD

39 John Heartfield, The meaning of the Hitler salute, 1932 (cat. no. 173)

40 Heinz Hajek-Halke, Defamation, 1926/27 (cat. no. 77)

41 Heinz Hajek-Halke, Eva Chanson, c. 1929 (cat. no. 78)

43 Lotte Jacobi, Karl Radek, 1932 (cat. no. 185)

42 Lucia Moholy, Franz Roh, 1926 (cat. no. 95)

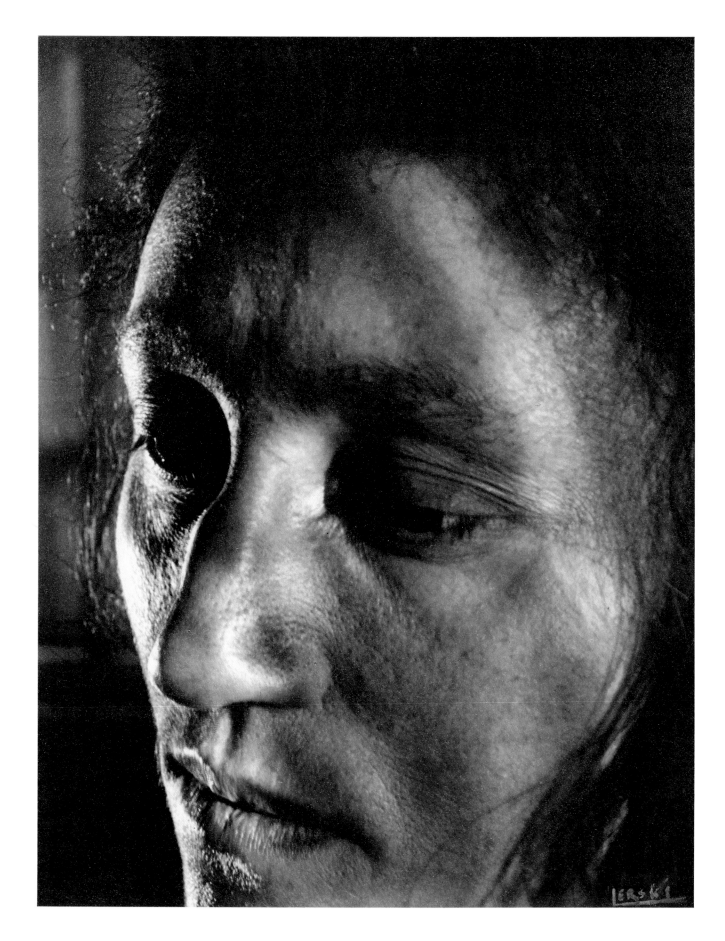

196 44 Helmar Lerski, Cleaning woman, c. 1928 (cat. no. 86)

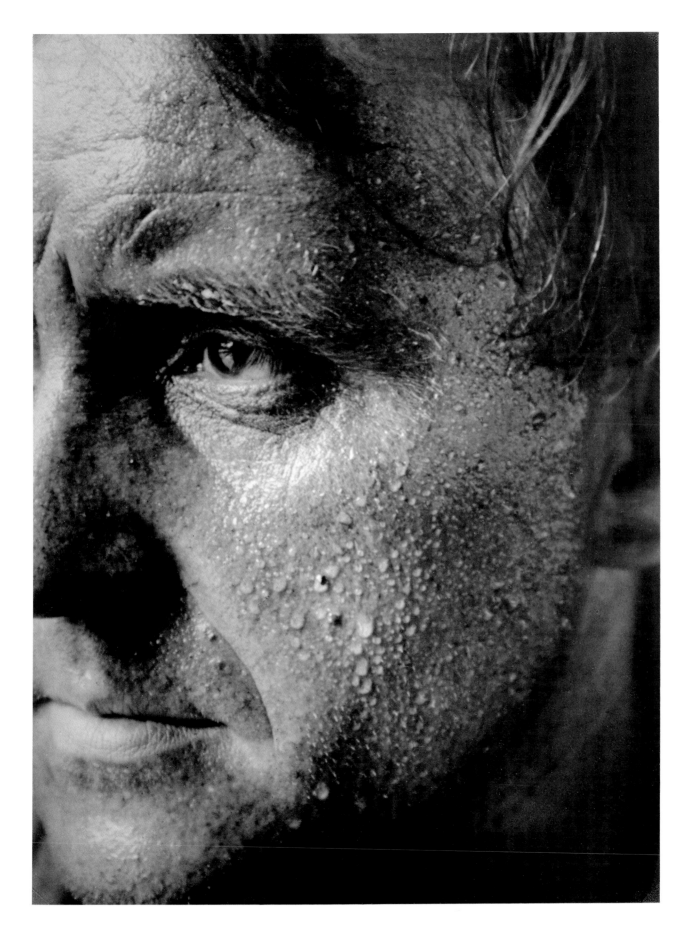

45 Erich Retzlaff, Blast furnace worker, before 1931 (cat. no. 218)

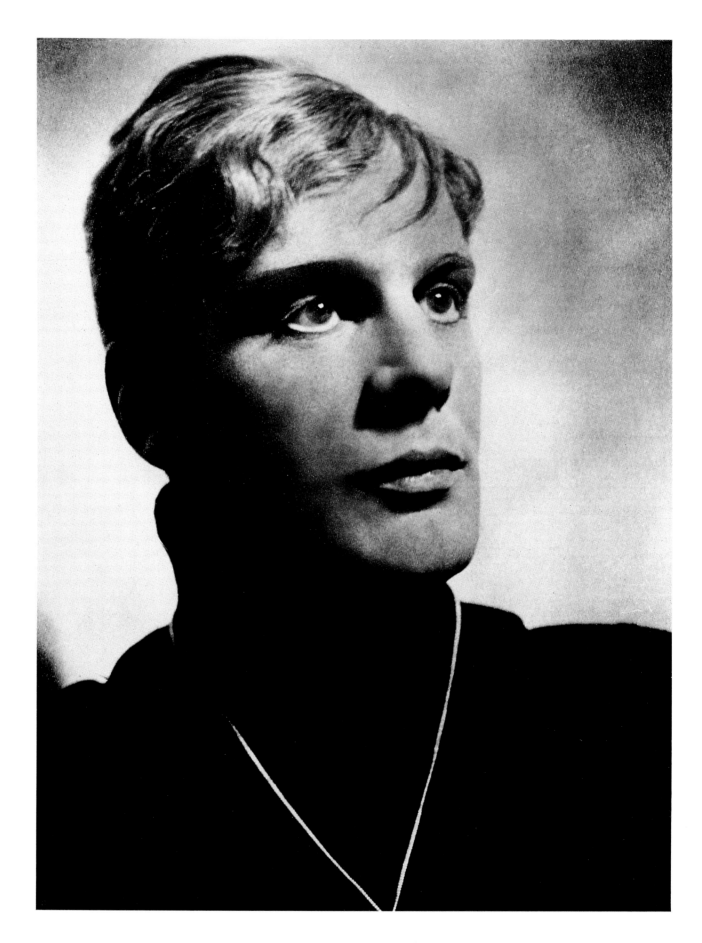

46 Rosemarie Clausen, Gustaf Gründgens as Hamlet, Berlin, 1936 (cat. no. 142)

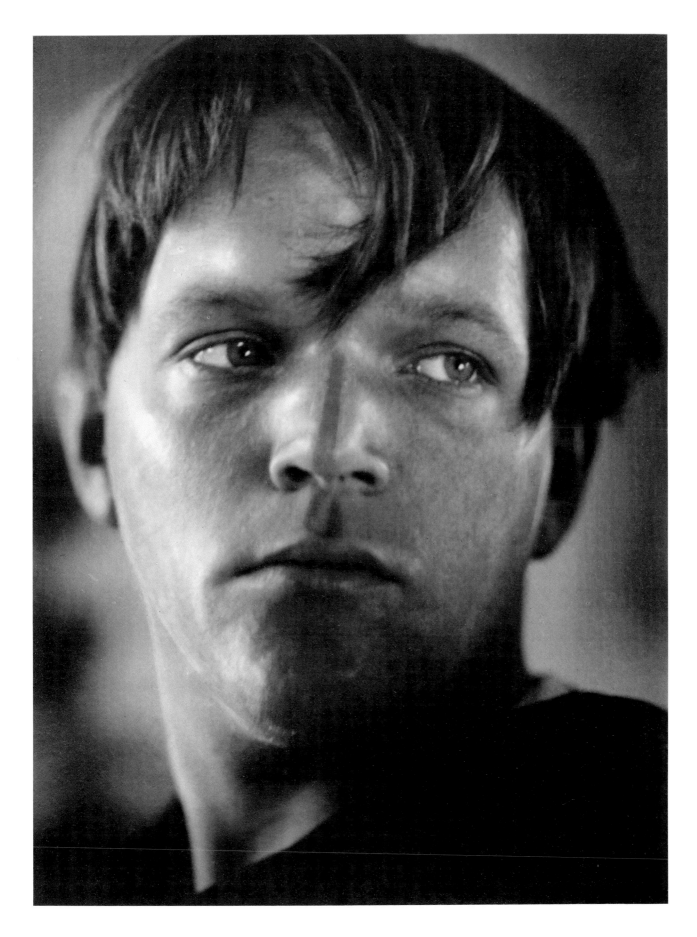

47 Helmar Lerski, Veit Harlan, actor, c. 1927 (cat. no. 85)

48 Albert Renger-Patzsch, Small tree, 1929 (cat. no. 112)

49 Albert Renger-Patzsch, Towers and east facade, Murbach Abbey, Alsace, 1936 (cat. no. 217)

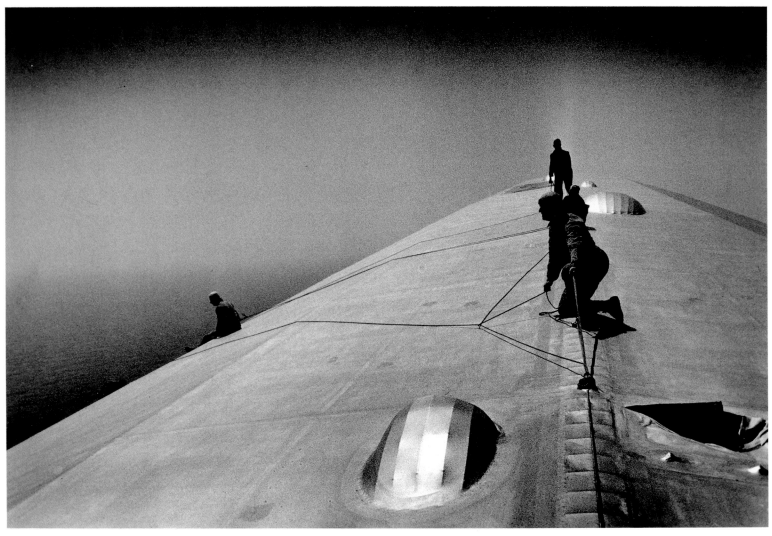

50 Alfred Eisenstaedt, Graf Zeppelin, 1934 (cat. no. 149)

51 Martin Munkàcsi, Motorcyclist, Budapest, c. 1923 (cat. no. 99)

52 Aenne Biermann, Pantheon, 1928 (cat. no. 53)

53 Walter Hege, Acropolis – Evening view of the Parthenon and Erechtheion, 1928/29 (cat. no. 79)

54 Alfred Eisenstaedt, Hindenburg's funeral, 1934 (cat. no. 151)

55 Herbert List, Torso of a statue, Corinth, 1937 (cat. no. 196)

56 Erna Lendvai-Dircksen, Bückeburg, before 1935 (cat. no. 191)

57 Fritz Henle, Drummer at the Palio in Siena, 1933 (cat. no. 180)

58 Sasha Stone, Lights of Berlin, c. 1930 (cat. no. 246)

59 John Gutmann, Class. Olympic High Diving Champion Marjorie Gestring, 1936 (cat. no. 163)

60 Werner Rohde, Mannequins, c. 1930 (cat. no. 221)

61 Tim Gidal, Florence, c. 1934 (cat. no. 161)

62 Martin Munkàcsi, Berlin-Wilmersdorf (spectators), c. 1930 (cat. no. 205)

63 Martin Munkàsci, Montage with the actress Eva Sylt, 1932 (cat. no. 206)

64 Imre von Santho, Couple, Picnic in the woods (blue beachwear with red belt), c. 1935 (cat. no. 233)

65 YVA, Rear view of two seated women, c. 1933 (cat. no. 259)

66 Erich Salomon, State visit to Berlin by King Fuad, June 1929 (cat. no. 113)

67 Erich Salomon, German and French ministers in late night session at the Hague reparation conference, January 1930 (cat. no. 225)

68 Felix H. Man, Mussolini in his office, 1931 (cat. no. 199)

69 Alfred Eisenstaedt, Goebbels in Geneva, September 1933 (cat. no. 150)

71 Willy Pritsche, After the assumption of power, 1933 (cat. no. 211)

70 Wolfgang Weber, Women's prison in Aichach, c. 1931 (cat. no. 250)

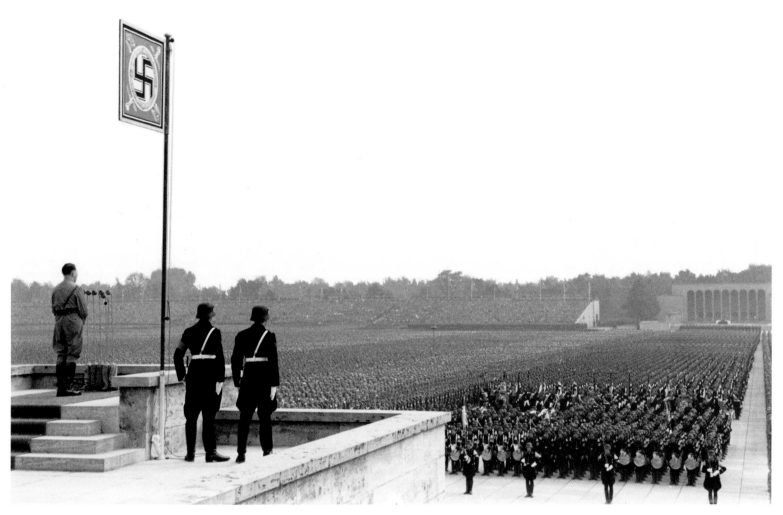

72 Max Ehlert, NSDAP party rally, Nuremberg, 1937 (cat. no. 146)

73 Max Ehlert, Closing ceremony at the Olympic Games, Berlin, 1936 (cat. no. 145)

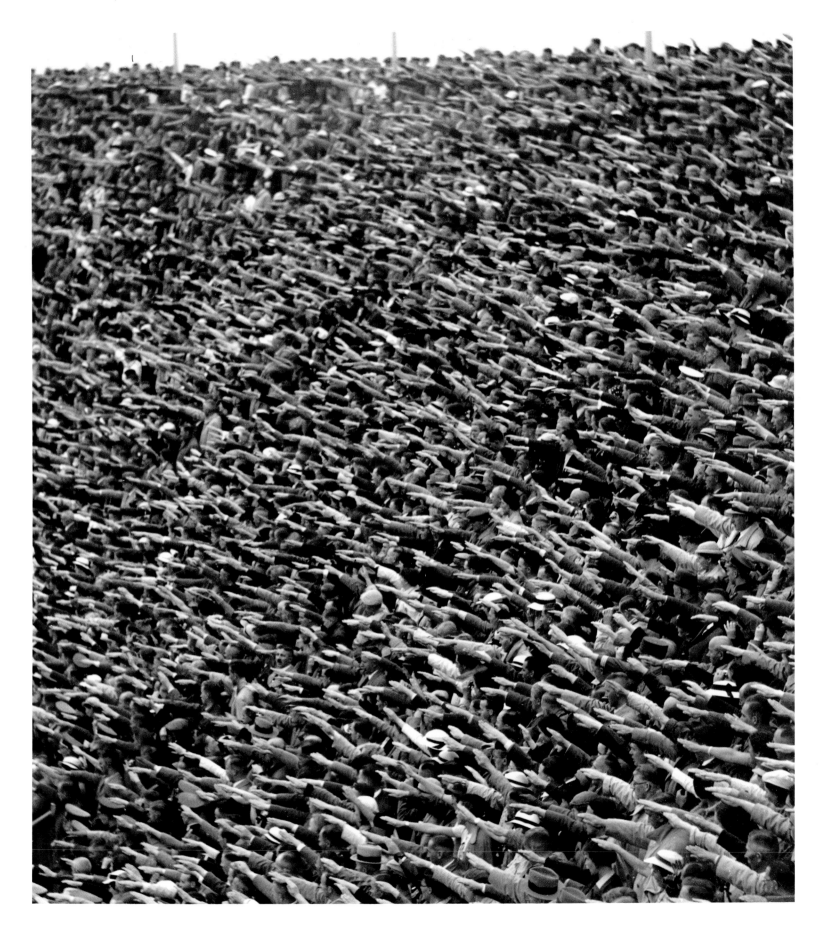

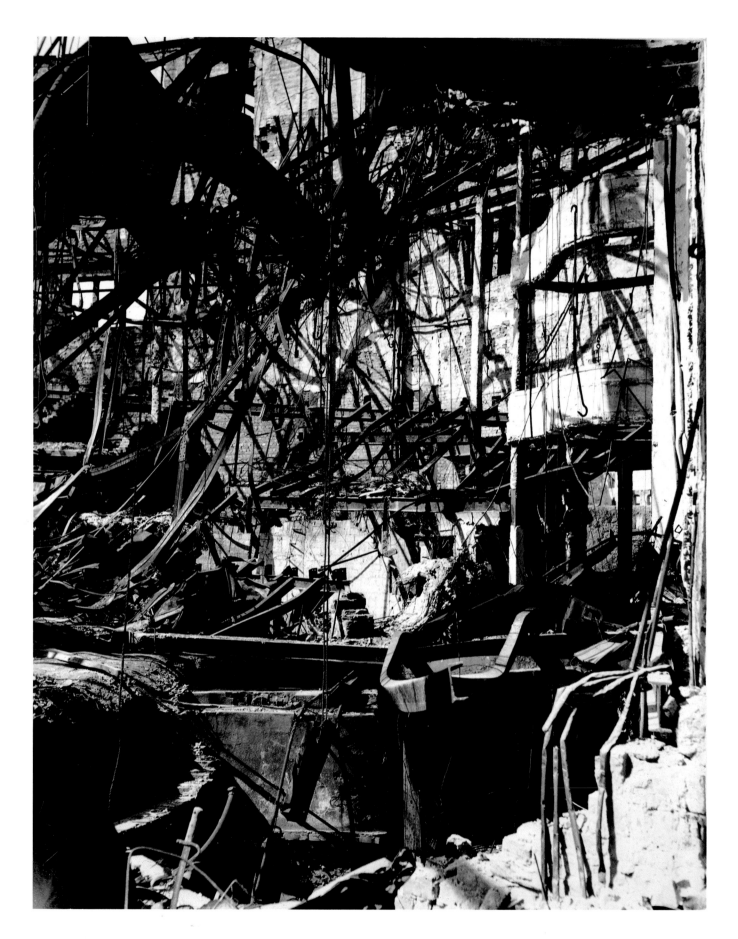

226 74 Richard Peter, sen., Dresden, Interior of the Semper Opera House, 1945 (cat. no. 374)

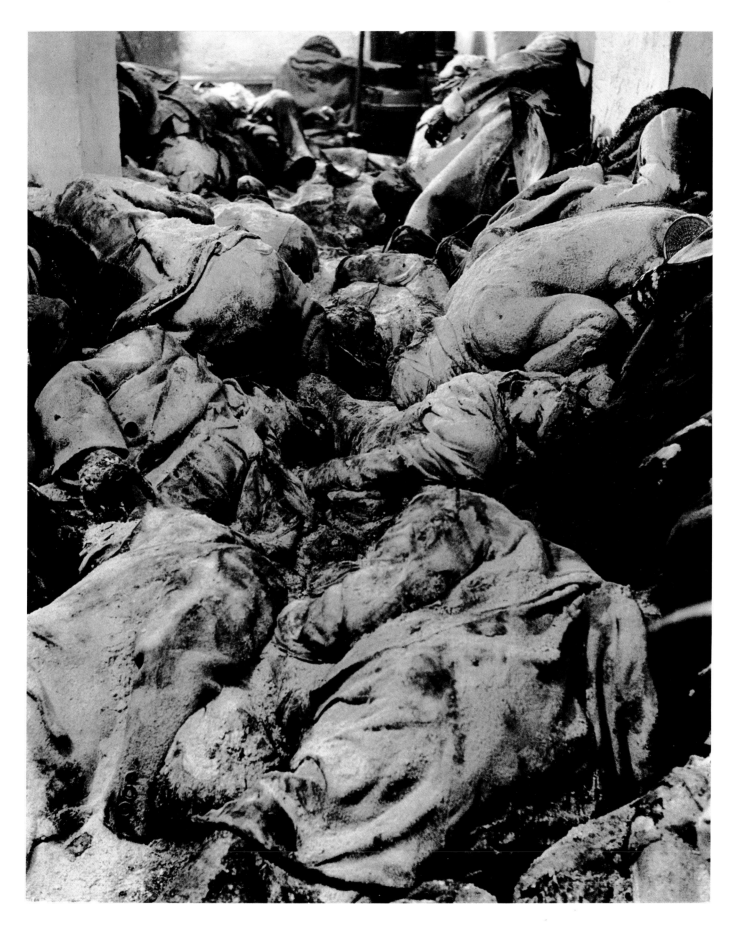

75 Richard Peter, sen., Dresden, Mass grave in an air raid shelter, 1946 (cat. no. 373)

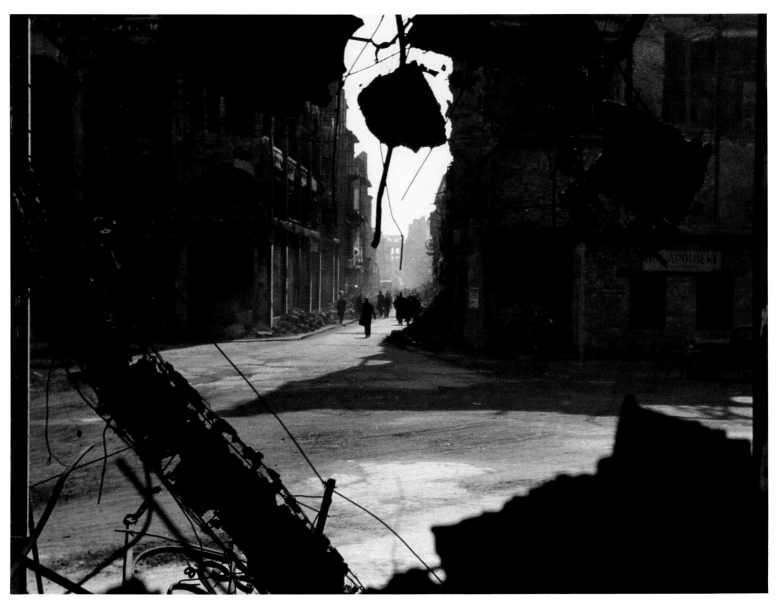

76 Hermann Claasen, Wallrafplatz (Hohe Strasse seen through the window of the Fuss flower shop), Cologne, autumn 1945 (cat. no. 284)

77 Edmund Kesting, Self portrait, c. 1955 (cat. no. 325)

78 Karl Heinz Mai, "Trümmerfrau" (II), Leipzig, 1949 (cat. no. 341)

79 Karl Heinz Mai, Identity card photograph, Gerda, Leipzig, 1948 (cat. no. 337)

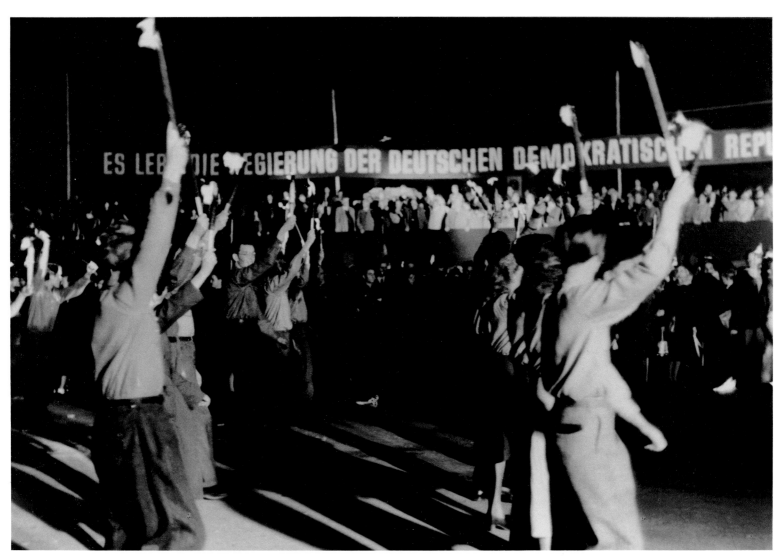

80 Herbert Hensky, Greeting the government, Berlin, 11 October 1949 (cat. no. 310)

81 Herbert Hensky, Adolf Hennecke in the coal mine in Oelsnitz, Erzgebirge, 20 October 1948 (cat. no. 309)

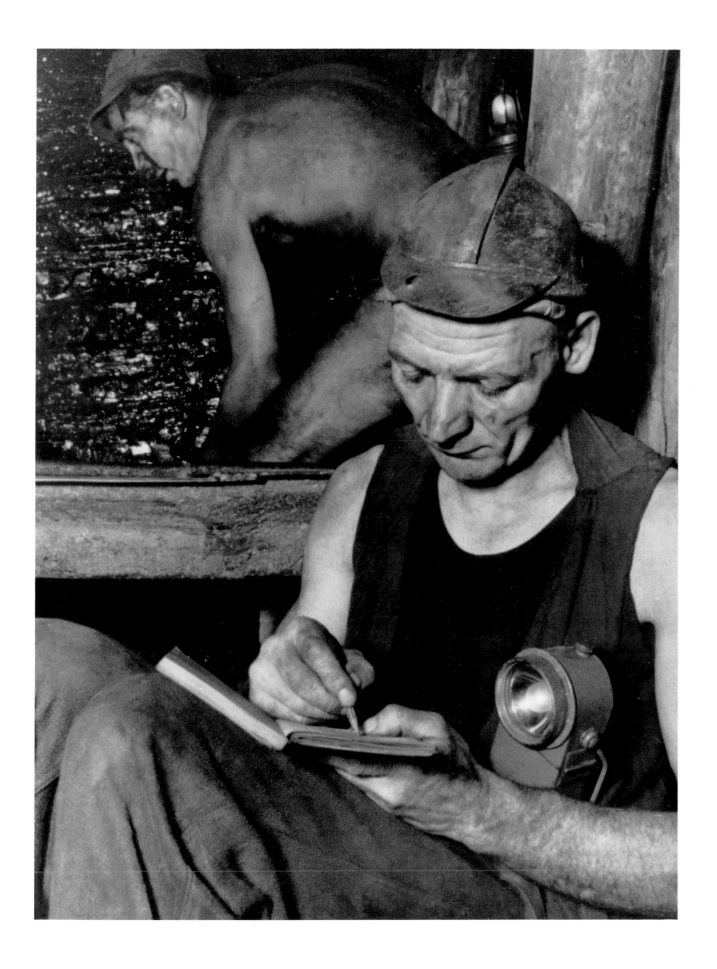

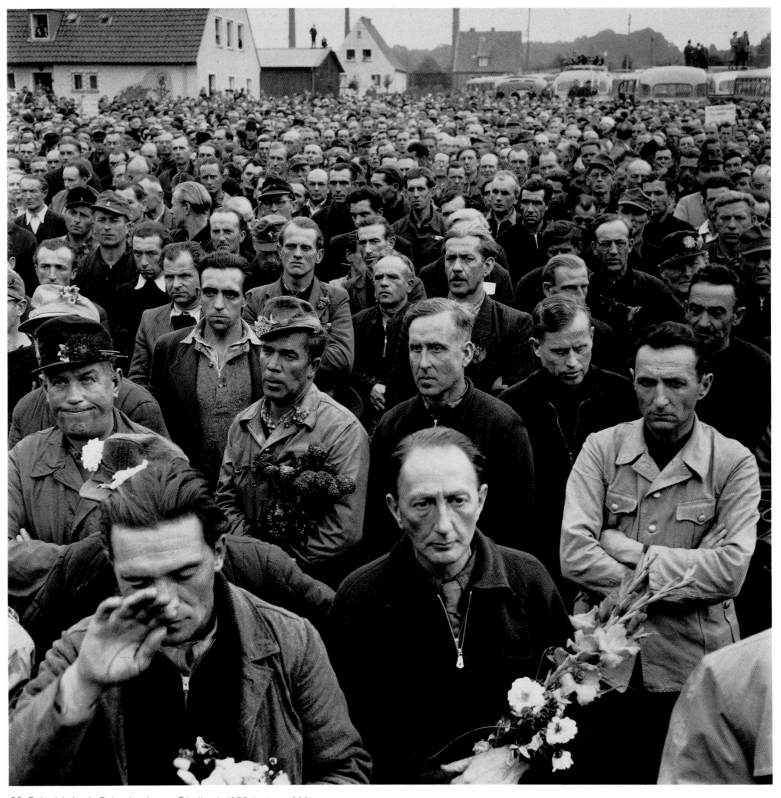

82 Robert Lebeck, Returning home, Friedland, 1955 (cat. no. 336)

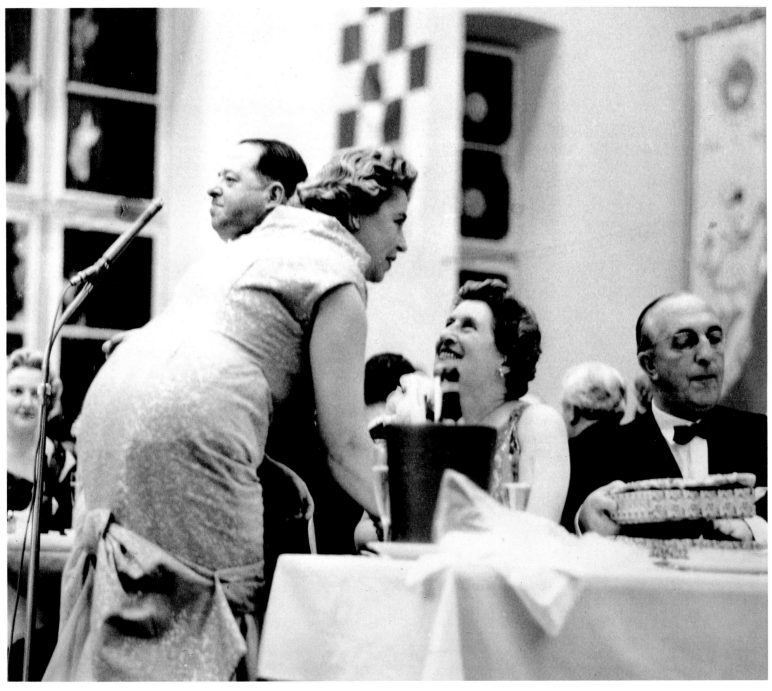

83 Chargesheimer, Thomas Liessem, New Year's Eve 1955 (cat. no. 280)

85 Will McBride, Wall with a white line, Berlin, 1957 (cat. no. 347)

84 Hugo Schmölz, Village church in Frielingsdorf by Dominikus Böhm, north aisle, 1928 (cat. no. 120)

86 Otto Steinert, One-legged pedestrian, 1950 (cat. no. 399)

87 Chargesheimer, Child at a street corner, 1958 (cat. no. 278)

88 Fritz Kühn, Untitled (supporting wall), 1955 (cat. no. 329)

89 Fritz Kühn, Untitled (sunlight in the forest), c. 1955 (cat. no. 331)

90 Willi Moegle, Chemist's bottles, Gral Glassworks, 1954 (cat. no. 349)

91 Carl Andreas Abel, Crankshaft, 1964 (cat. no. 268)

92 Peter Keetman, Drops of oil, 1956 (cat. no. 322)

93 Fritz Brill, Ink in roller printer – Hostmann & Steinberg, 1951 (cat. no. 275)

94 Arno Fischer, Marlene Dietrich in Moscow, 1964 (cat. no. 293)

95 Hubs Flöter, Hildegard Knef, 1950 (cat. no. 296)

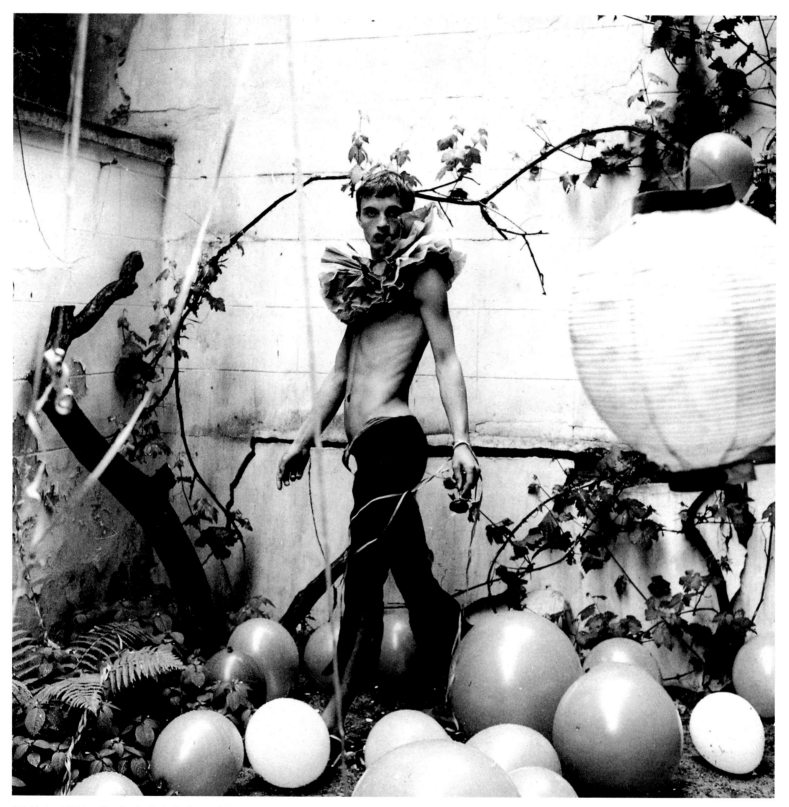

96 Herbert Tobias, The Berlin Party is Over, 1960 (cat. no. 409)

97 Adolf Lazi, Portrait of Willi Baumeister, 1947 (cat. no. 335)

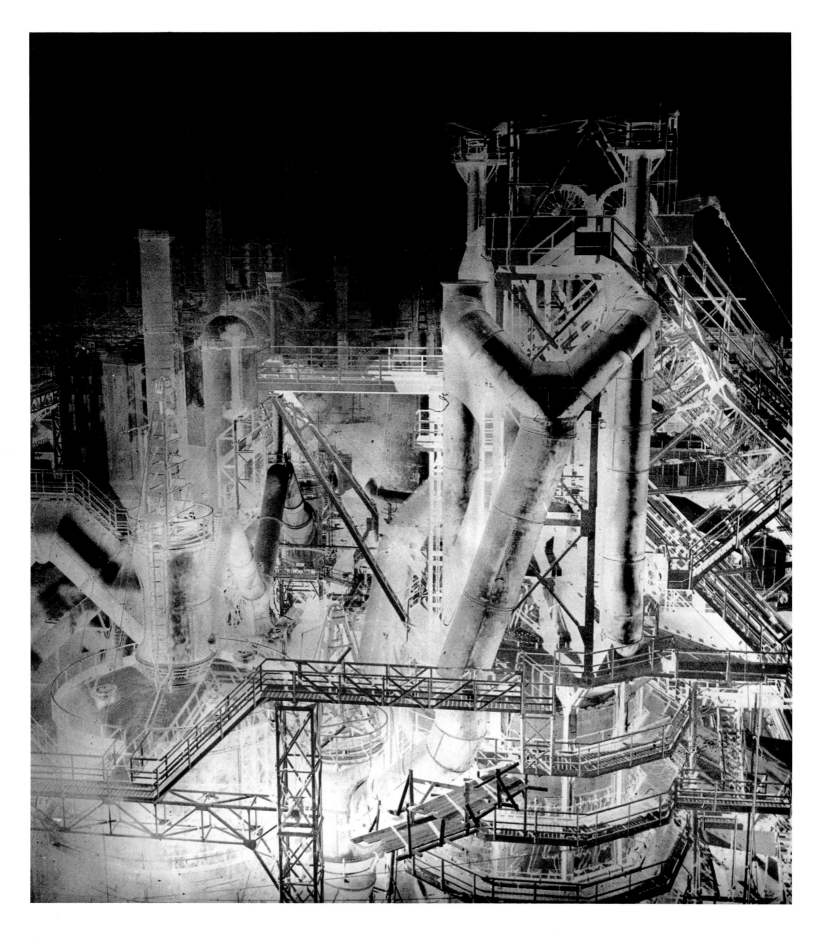

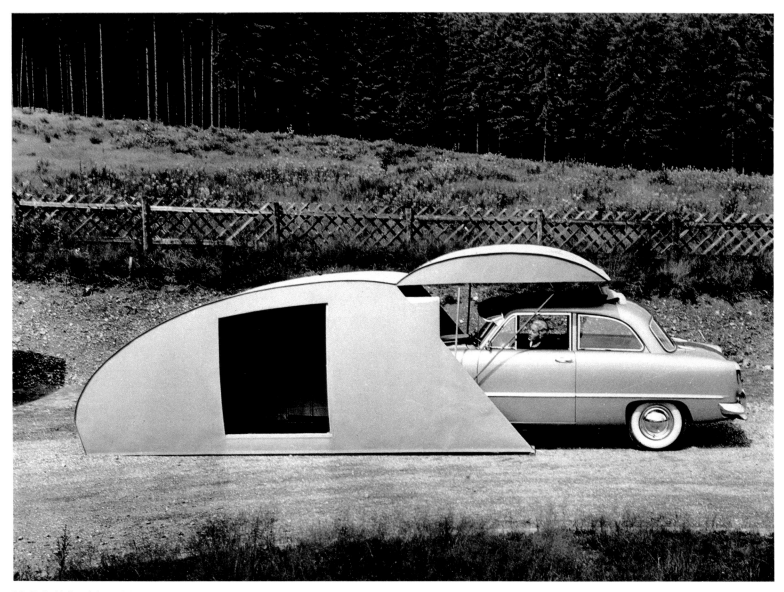

99 Ruth Hallensleben, Advertisement for garages, c. 1958 (cat. no. 303)

98 Ludwig Windstosser, Blast furnace, c. 1951 (cat. no. 417)

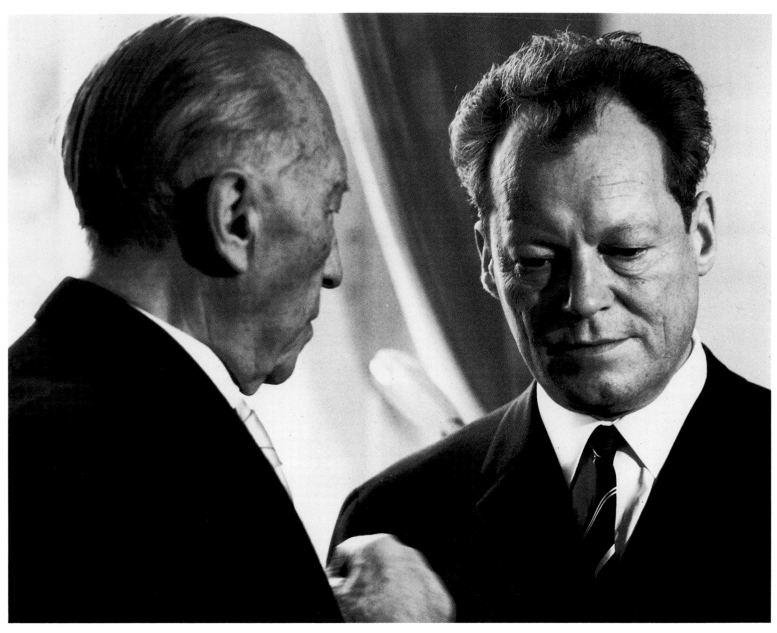

100 Jupp Darchinger, Foreign Minister Willy Brandt and former Federal Chancellor Konrad Adenauer, 1966 (cat. no. 287)

101 Rolf Gillhausen, from the series Images of Postwar Germany, 1957 Election Campaign: Federal Chancellor Konrad Adenauer leaving his special train car, 1957 (cat. no. 298)

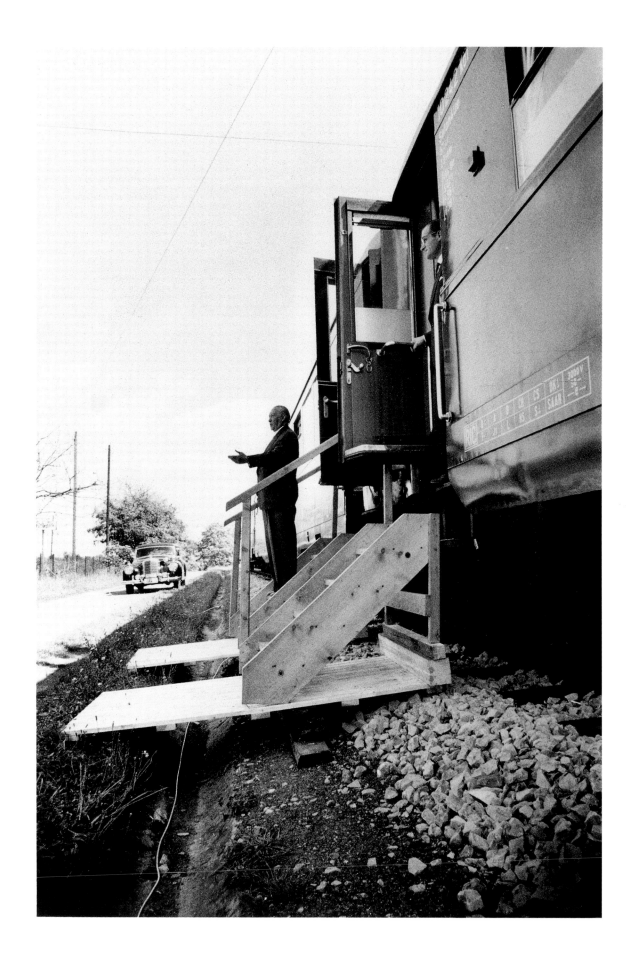

253

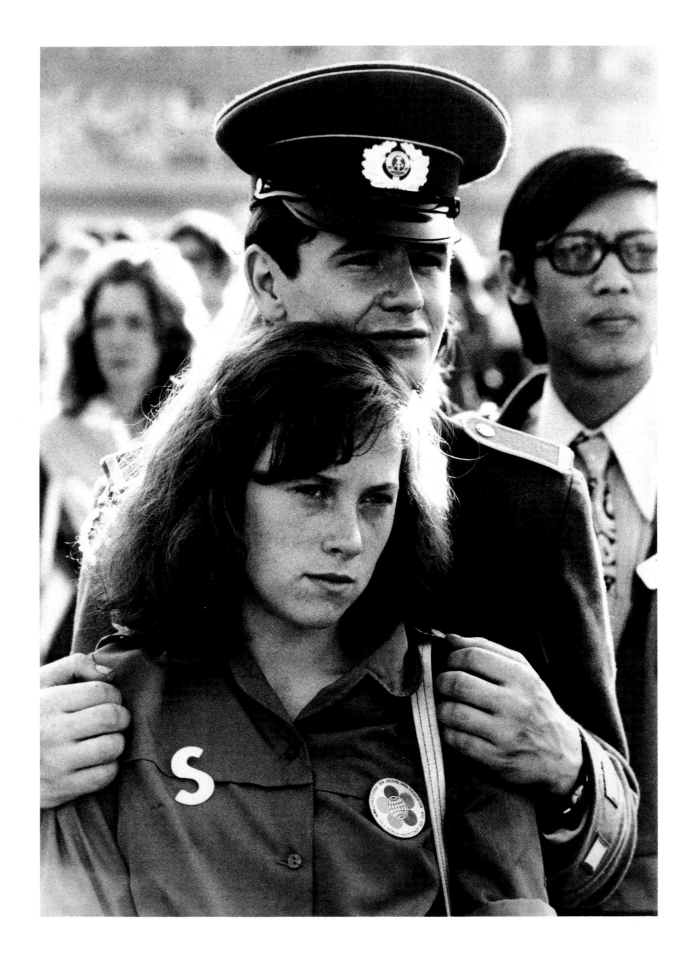

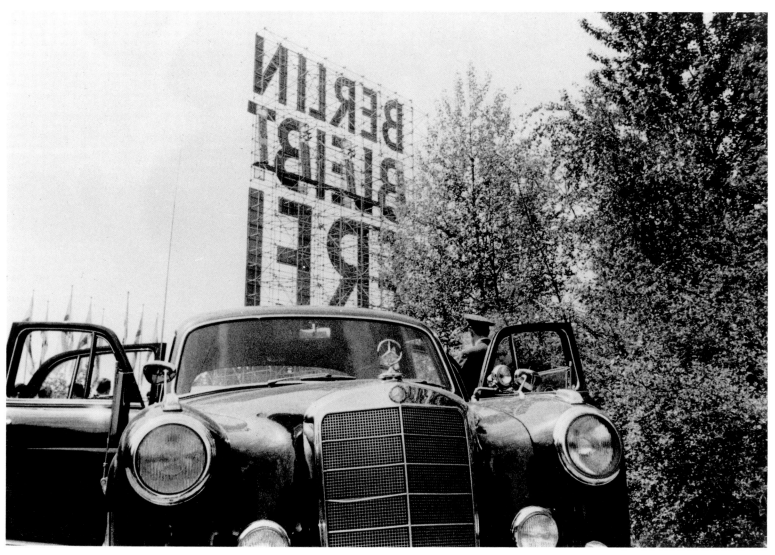

103 Arno Fischer, West Berlin, 1959 (cat. no. 295)

102 Thomas Höpker, from the GDR series, 4/31 (soldier), c. 1966 (cat. no. 313)

104 Evelyn Richter, Mstislav Rostropovich, 1968 (cat. no. 387)

105 Stefan Moses, Elly Ney, 1964 (cat. no. 355)

106 F. C. Gundlach, Rankestrasse, Biggi, Berlin 1963 (cat. no. 301)

107 Charlotte March, Model with two dogs, c. 1962 (cat. no. 344)

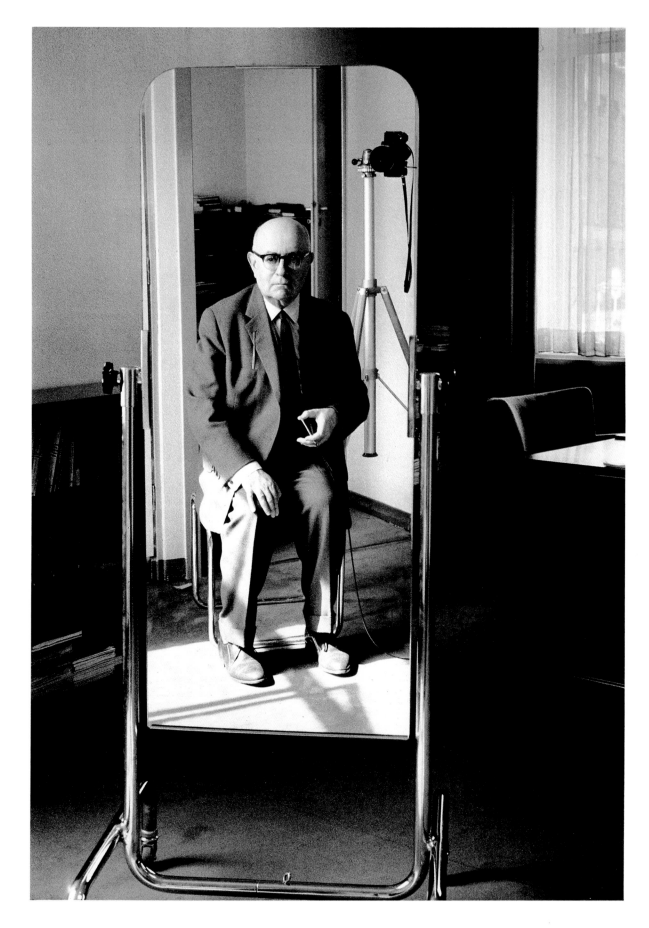

108 Stefan Moses, Theodor W. Adorno, 1964 (cat. no. 356)

109 Liselotte Strelow, Lea Steinwasser, 1964 (cat. no. 404)

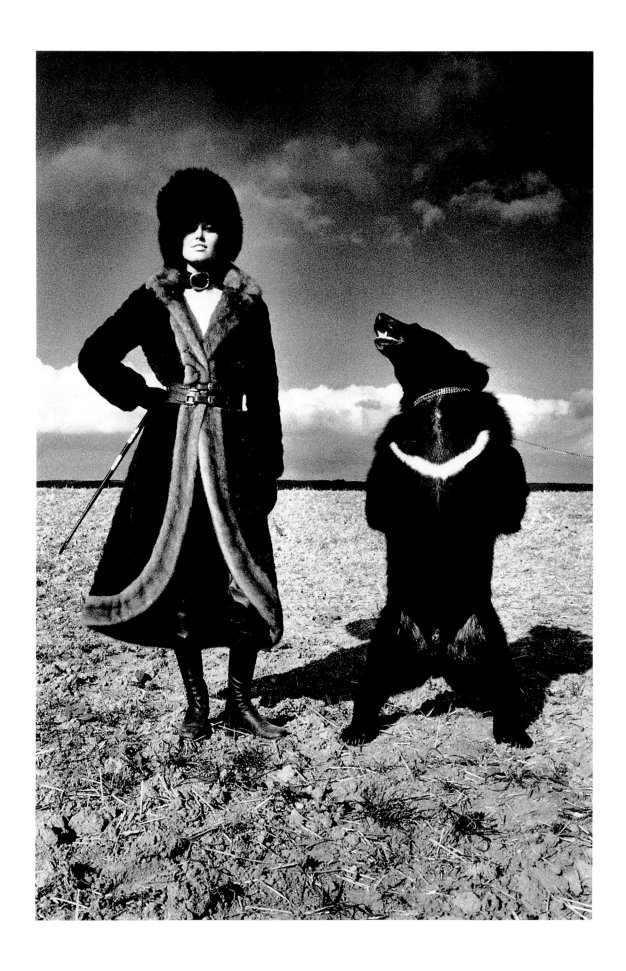

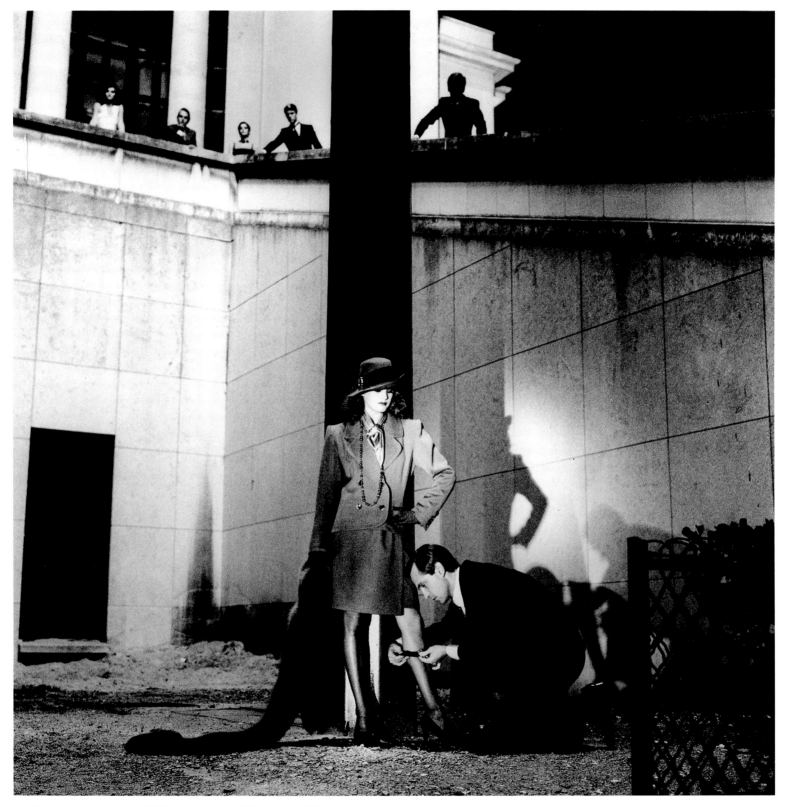

111 Helmut Newton, Saga, VOGUE France, Paris, 1969 (cat. no. 365)

110 Helmut Newton, Tigre Royal, VOGUE France, Paris, 1969 (cat. no. 364)

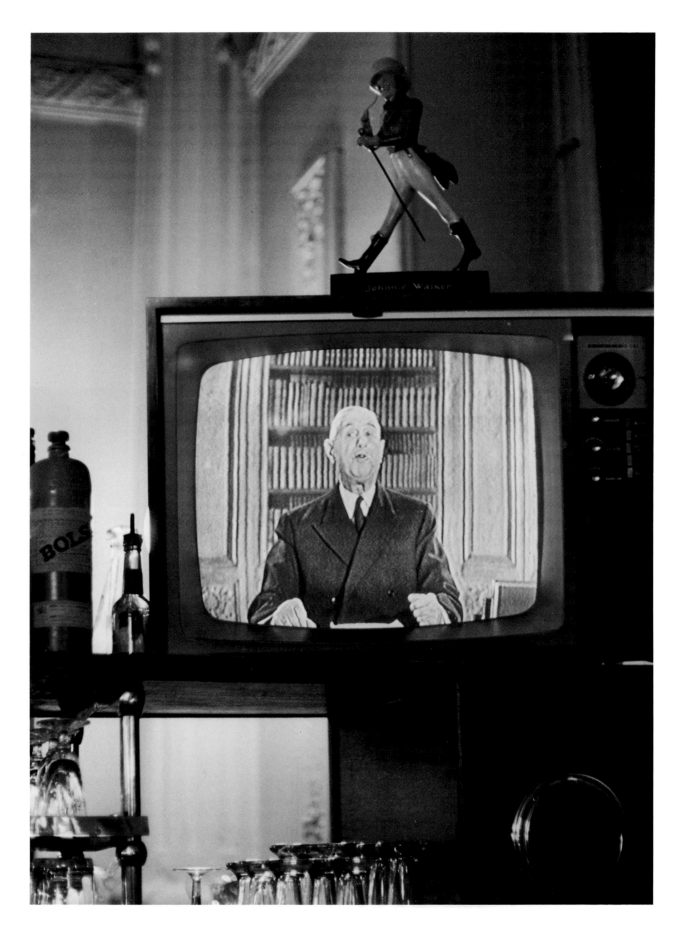

112 Max Scheler, De Gaulle in a bar in Châtillon (Lyonnais), 1965 (cat. no. 395)

113 Charles Wilp, Charles Wilp taken against an abstract horizon in Düsseldorf and merged with the geographic horizon at the Indian Ocean, 1957 (cat. no. 414)

114 Robert Häusser, Nescafé, 1954 (cat. no. 304)

115 Floris M. Neusüss, Untitled, Body photogram, Berlin, 1963 (cat. no. 359)

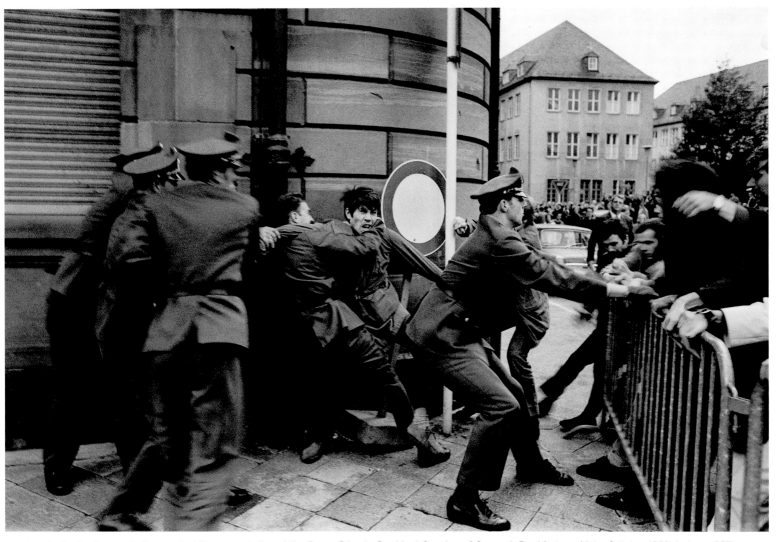

116 Angela Neuke, Demonstration against the presentation of the Peace Prize to President Senghor of Senegal, Frankfurt am Main, October 1968 (cat. no. 357)

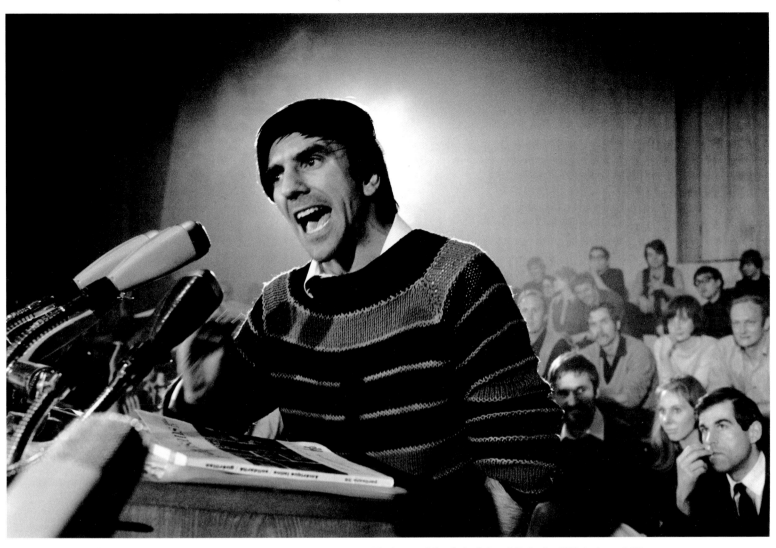

117 Michael Ruetz, German Characters, No. 3, Rudi Dutschke in the Auditorium Maximum of the Freie Universität, Berlin, 1967 (cat. no. 389)

118 Kilian Breier, Luminogram, c. 1964 (cat. no. 273)

119 Detlef Orlopp, Untitled, 1970 (cat. no. 372)

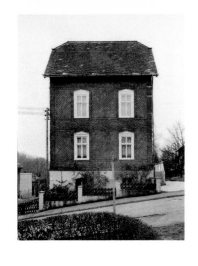 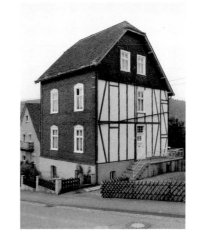 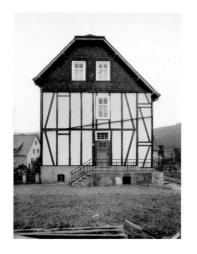 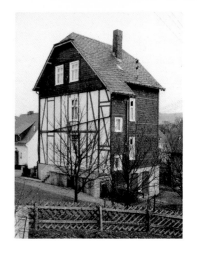

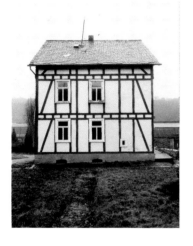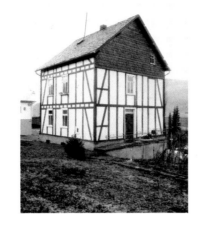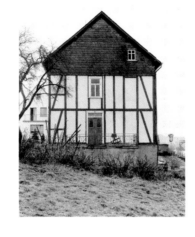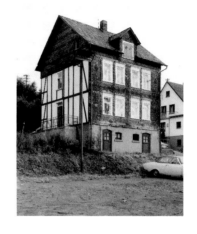

121 Johannes Brus, Flying cucumbers (Cucumber party), 1970 (cat. no. 276)

◁ 120 Bernd and Hilla Becher, Half-timbered houses in Siegerland, 1971 (cat. no. 272)

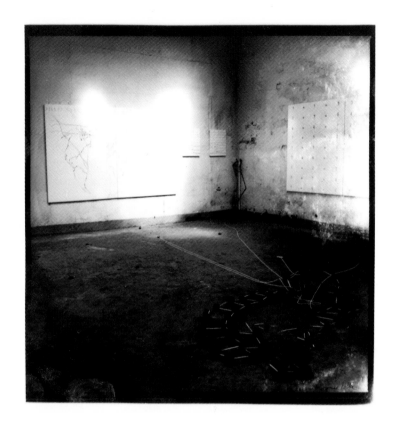
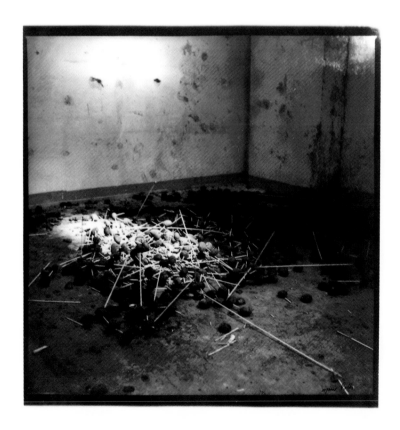
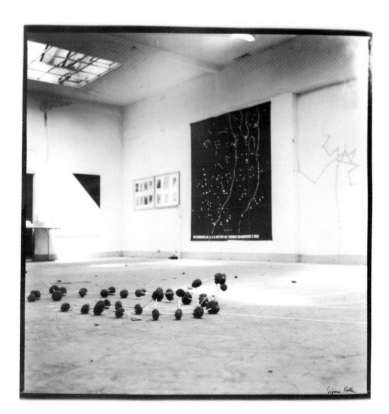

122 Sigmar Polke, 4 untitled photographs, 1969 (cat. no. 378)

Photographs in the exhibition

1870–1918

1

Anschütz, Ottomar
Storks, 1884, near Berlin
Celloidin paper prints
each 9.5 x 13.9 cm
Agfa Foto-Historama, Cologne

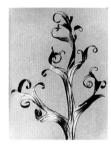

2

Blossfeldt, Karl
Silphium laciniatum, 1915–1923
Gelatin silver print
30 x 24 cm
Manfred Heiting Collection

3

Blossfeldt, Karl
Equisetum hyemale, undated,
later print
Gelatin silver print
19.3 x 25.4 cm
Private collection, Bonn

4

Blossfeldt, Karl
Impatiens glandulifera, undated
Gelatin silver print
25 x 19.2 cm
Private collection, Bonn

5

Diez-Dührkoop, Minya
Julie Wolf-Thorn (double portrait),
1907
Celloidin paper print
16.3 x 21.9 cm
Museum für Kunst und Gewerbe
Hamburg, Juhl Collection

6

Diez-Dührkoop, Minya
Lotte Buchler, 1908
Platinum print, 21.8 x 16.6 cm

Museum für Kunst und Gewerbe
Hamburg, Juhl Collection

7

Dührkoop, Rudolf
Anna Muthesius at the pianoforte,
1909
Platinum print, 21.9 x 16.8 cm
Berlinische Galerie, Landes-
museum für Moderne Kunst,
Photographie und Architektur,
Photography Collection

8

Dührkoop, Rudolf
Anna Muthesius in the conservatory,
1910, Platinum print, 21.8 x 16.7 cm
Berlinische Galerie, Landes-
museum für Moderne Kunst,
Photographie und Architektur,
Photography Collection
Plate 13

9

Dührkoop, Rudolf
Dr. Richard Dehmel, Blankenese
(Hamburg poetry circle), Hamburg,
1905
From the portfolio "Hamburg Men
and Women at the beginning of the
XX century"
Heliogravure print, 26.5 x 20 cm
Museum für Kunst und Gewerbe
Hamburg

10

Eugene, Frank
Fritzi von Derra as Salomé
c. 1907
Platinum print, 18.8 x 13.9 cm
Fotomuseum im Münchner
Stadtmuseum
Plate 4

11
Eugene, Frank
Self portrait, c. 1907
Platinum print
19 x 12.5 cm
Fotomuseum im Münchner
Stadtmuseum

12
Gloeden, Wilhelm von
The young faun, 1899
Albumen print
22.5 x 17 cm
Fotomuseum im Münchner
Stadtmuseum
Plate 5

13
Gloeden, Wilhelm von
Three young men, c. 1900
Albumen print
15.3 x 21.6 cm
Fotomuseum im Münchner
Stadtmuseum

14
Hilsdorf, Jacob (?)
Anna Muthesius, c. 1911
Gum print
23.7 x 17.8 cm
Berlinische Galerie,
Landesmuseum
für Moderne Kunst,
Photographie und Architektur,
Photography Collection

15
Hilsdorf, Jacob
Anna Muthesius, 1911
Albumen print
22.5 x 16.3 cm
Berlinische Galerie,
Landesmuseum
für Moderne Kunst,
Photographie und Architektur,
Photography Collection

16
Hofmeister, Theodor and Oscar
Fritz Mackensen, 1898
Reddish-brown gum print
54 x 45.5 cm
Museum für Kunst und Gewerbe
Hamburg

17
Hofmeister, Theodor and Oscar
Night walk (the witch), 1900
Blue gum print
64.5 x 92.5 cm
Museum für Kunst und Gewerbe
Hamburg; Plate 8

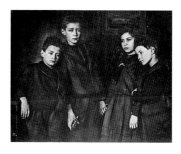

18
Hofmeister, Theodor and Oscar
Siblings, 1901
Brown gum print
62.5 x 80 cm
Museum für Kunst und Gewerbe
Hamburg

19
Hofmeister, Theodor and Oscar
Marsh flowers, 1897
Brown-black gum print
56 x 33 cm
Museum für Kunst und Gewerbe
Hamburg, Juhl Collection

20
Kotzsch, August
Melon, c. 1870
Albumen print
14.9 x 19.2 cm
Kupferstich-Kabinett Dresden
Plate 1

21
Kotzsch, August
Quinces, c. 1870
Albumen print
11 x 19.6 cm
Kupferstich-Kabinett Dresden

22
Krone, Hermann
The Frauenkirche in Dresden,
c. 1865
Albumen print
32.5 x 28 cm
Agfa Foto-Historama, Cologne

23–28
Krone, Hermann
From the King's Album.
Cities of
the Kingdom of Saxony
Albumen prints
each 16 x 25 cm
Agfa Foto-Historama,
Cologne

23
Dresden
seen from the
Marienbrücke, c. 1872

24
Zwickau seen from the north,
c. 1872

25
Meissen, view from the south-east,
c. 1872

26
Zschoppau seen from the south,
c. 1872

27
Königstein, from the slope of the
Herrenwäldchen, c. 1872

28
Dippoldiswalde seen from the
Birkenleite Nord, c. 1872

29
Müller, Heinrich Wilhelm
Homewards, 1901
Brown gum print
64 x 91.5 cm
Museum für Kunst und Gewerbe
Hamburg

30
Müller, Heinrich Wilhelm
Elegy, 1902
Colour gum print, 15 x 80 cm
Museum für Kunst und Gewerbe
Hamburg
Plate 2

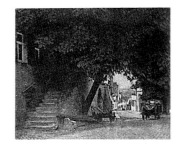

31
Müller, Heinrich Wilhelm
Judengasse, Rothenburg
ob der Tauber, 1908
Colour gum print
46 x 56.6 cm
Museum für Kunst und Gewerbe
Hamburg

32
Perscheid, Nicola
Anna Muthesius, c. 1910
Albumen print
19.5 x 14 cm
Berlinische Galerie, Landes-
museum für Moderne Kunst,
Photographie und Architektur,
Photography Collection

33
Perscheid, Nicola
Fräulein Sakur, c. 1905
Carbon print, 22.4 x 16.4 cm
Museum für Kunst und Gewerbe
Hamburg

34
Plüschow, Wilhelm
Male nude, c. 1900
Albumen print
16.6 x 22.8 cm
Fotomuseum im Münchner
Stadtmuseum
Plate 6

35
Plüschow, Wilhelm
Male portrait, c. 1900
Albumen print
23 x 17 cm
Fotomuseum im Münchner
Stadtmuseum

36
Quedenfeldt, Erwin
Head outlined in light, 1914
Platinum print, 26.5 x 20.5 cm
Museum für Kunst und Gewerbe
Hamburg
Plate 3

41
Sander, August
Portrait of a peasant woman,
1913
Gelatin silver print
23 x 17 cm
Private collection,
Bonn

37
Quedenfeldt, Erwin
Turkish woman, 1916
Colour gum print
39.7 x 28.5 cm
Museum für Kunst und Gewerbe
Hamburg

42
Sander, August
Soldierly differences in size, 1915
Gelatin silver print
79.7 x 60.3 cm
Courtesy of Galerie Kicken,
Cologne

38
Rückwardt, Hermann
Weidendammer Bridge (detail),
Berlin, 1897
Collotype, 28 x 38.5 cm
Berlinische Galerie, Landes-
museum für Moderne Kunst,
Photographie und Architektur,
Photography Collection
Plate 9

43
Schmitz, Anselm
Cologne cathedral as seen from
beyond the garden of the
archbishop's palace, summer 1882
Collotype, 17.5 x 27 cm
Rheinisches Amt für Denkmal-
pflege, Abtei Brauweiler
Plate 10

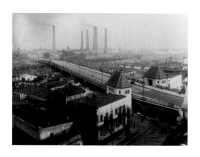
39
Rückwardt, Hermann
Putlitz Bridge with the Moabit
power station, 1912
Collotype, 30.3 x 40.3 cm
Berlinische Galerie, Landes-
museum für Moderne Kunst,
Photographie und Architektur,
Photography Collection

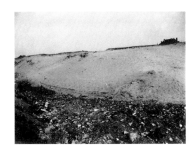
44
Zille, Heinrich
Untitled, c. 1900
Albumen print, two-part, 8 x 11 cm
and 8.7 x 11 cm
Berlinische Galerie, Landes-
museum für Moderne Kunst,
Photographie und Architektur,
Photography Collection

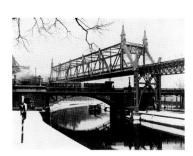
40
Rückwardt, Hermann
Elevated railway bridge over the
Landwehr canal, near the track
junction, after 1903
Collotype, 30 x 41 cm
Berlinische Galerie, Landes-
museum für Moderne Kunst,
Photographie und Architektur,
Photography Collection

45
Zille, Heinrich
Untitled, c. 1900
Albumen print
8.5 x 10.9 cm
Berlinische Galerie, Landes-
museum für Moderne Kunst,
Photographie und Architektur,
Photography Collection
Plate 14

1918–1929 (1933)

46
Albers, Josef
Portrait of Paul Klee, Guetary,
Biarritz, 1929
Gelatin silver print
25.3 x 20.4 cm
Bauhaus-Archiv Berlin

47
Astfalck-Vietz, Marta
Untitled, 1925/26
Gelatin silver print
16.2 x 12.3 cm
Berlinische Galerie, Landes-
museum für Moderne Kunst,
Photographie und Architektur,
Photography Collection

48
Astfalck-Vietz, Marta
Untitled, 1925/26
Gelatin silver print
16.4 x 12.3 cm
Berlinische Galerie, Landes-
museum für Moderne Kunst,
Photographie und Architektur,
Photography Collection

49
Astfalck-Vietz, Marta
Untitled, c. 1927
Gelatin silver print
16.4 x 11.3 xm
Berlinische Galerie, Landes-
museum für Moderne Kunst,
Photographie und Architektur,
Photography Collection
Plate 34

50
Bayer, Herbert
Legs, c. 1928, 1987 print
Gelatin silver print
29.6 x 21.7 cm
Bauhaus-Archiv Berlin
Plate 35

51
Bayer, Herbert
Bicycle, 1928
Gelatin silver print
22.4 x 29.1 cm
Bauhaus-Archiv Berlin

52
Bergmann-Michel, Ella
Laying tracks at the Eschenheimer
Turm, 1927
Gelatin silver print, 17.8 x 12.5 cm
Courtesy of Galerie Kicken,
Cologne

53
Biermann, Aenne
Pantheon, 1928
Gelatin silver print, 17.7 x 23 cm
Museum Folkwang Essen
Plate 52

54
Biermann, Aenne
Observation (Daughter Helga),
c. 1929
Gelatin silver print
23.5 x 18 cm
Manfred Heiting Collection

55
Biermann, Aenne
A couple sleeping on the sand,
before 1930
Gelatin silver print, 12 x 16.8 cm
Museum Folkwang Essen

56
Blossfeldt, Karl
Dipsacus laciniatus,
c. 1921
Gelatin silver print
29.6 x 11.9 cm
Manfred Heiting Collection

57
Blossfeldt, Karl
Fern, c. 1921
Gelatin silver print
29.8 x 11.9 cm
Manfred Heiting Collection
Plate 16

58
Burchartz, Max
Benzol and ammonia processing
tank, c. 1928
Gelatin silver print
23.8 x 17 cm
Museum Folkwang Essen
Plate 27

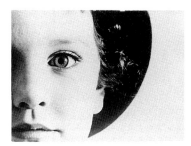

59
Burchartz, Max
Lotte's eye, c. 1928
Gelatin silver print
29.8 x 39 cm
Museum Folkwang Essen

60
Comeriner, Erich
The keys of my typewriter,
1929
Gelatin silver print
23.7 x 17.4 cm
Manfred Heiting Collection
Plate 18

61
Errell (Richard Levy)
Coty perfume, c. 1927
Gelatin silver print
29.5 x 23.4 cm
Museum Folkwang Essen

62
Erfurth, Hugo
Hans Thoma, c. 1920
Oil print, 36.7 x 33.8 cm
Rheinisches Landesmuseum Bonn
Plate 7

63
Erfurth, Hugo
Else Muche-Franke, 1927

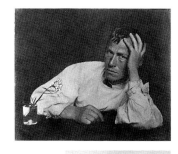

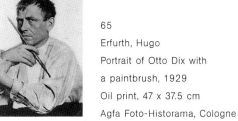

Oil print
32 x 22.1 cm
Manfred Heiting Collection

64
Erfurth, Hugo
Portrait of Otto Dix
with a carnation,
1929, print after 1934
Oil print, 24.5 x 31 cm
Agfa Foto-Historama, Cologne

65
Erfurth, Hugo
Portrait of Otto Dix with
a paintbrush, 1929
Oil print, 47 x 37.5 cm
Agfa Foto-Historama, Cologne

66
Feininger, T. Lux
The leap over the Bauhaus, Dessau,
c. 1928
Gelatin silver print, 21.4 x 17.8 cm
Museum Folkwang Essen
Plate 23

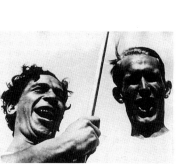

67
Feininger, T. Lux
Delight in sport, c. 1928
Gelatin silver print
17.5 x 23.8 cm
Museum Folkwang Essen

68
Feist, Werner David
Man with pipe, 1928
Gelatin silver print
20.1 x 14.4 cm
Museum Folkwang Essen

69
Finsler, Hans
Rolled fabric, mirrored,
before 1930
Gelatin silver print
23.6 x 17.5 cm
Staatliche Galerie Moritzburg,
Halle, Archive Fotokinoverlag

70
Finsler, Hans
Advertisement,
after July 1929
Gelatin silver print
16 x 23.4 cm
Staatliche Galerie Moritzburg,
Halle, Archive Fotokinoverlag

71
Finsler, Hans
Shear wave 2,
before December 1928
Gelatin silver print, 22.6 x 15.5 cm
Staatliche Galerie Moritzburg,
Halle, Archive Fotokinoverlag

72
Flach, Hannes-Maria
Nude, Hannes Flach, c. 1922
Bromoil print, 39.6 x 27 cm
Museum Ludwig, Cologne,
Gruber Collection

73
Flach, Hannes-Maria
Hohenzollern Bridge, Cologne,
c. 1926
Bromoil print, 32 x 22.1 cm
Manfred Heiting Collection
Plate 17

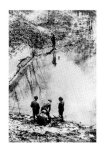

74
Gidal, Georg
At the pond, Tim Gidal,
1927
Gelatin silver print
11.2 x 7.6 cm
Museum Folkwang Essen

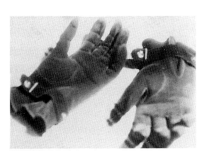

75
Gidal, Georg
My gloves, c. 1929
Gelatin silver print
9.1 x 13.8 cm
Manfred Heiting Collection

76
Gorny, Hein
Untitled, 1928
Gelatin silver print
26.9 x 20 cm
Museum Folkwang Essen; plate 26

77
Hajek-Halke, Heinz
Defamation, 1926/27,
Gelatin silver print (c. 1950)
40 x 30 cm
Michael Ruetz, Berlin; plate 40

78
Hajek-Halke, Heinz
Eva Chanson, c. 1929
Gelatin silver print, 24 x 18 cm
Michael Ruetz, Berlin; plate 41

79
Hege, Walter
Acropolis – Evening view of the
Parthenon and Erechtheion, 1928/29
Gelatin silver print
20.2 x 26.9 cm
Museum für Kunst und Gewerbe
Hamburg; plate 53

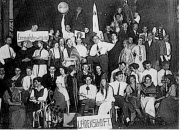

80
Held, Louis
Bauhaus festival at Ilm Castle in
Weimar, 1924
Gelatin silver print, 14.7 x 21 cm
Courtesy of Galerie Kicken,
Cologne

81
Höch, Hannah
Self portrait (double exposure),
1924
Gelatin silver print (1987)
31.7 x 24.3 cm
Berlinische Galerie,
Landesmuseum
für Moderne Kunst,
Photographie und Architektur,
Photography Collection
Plate 32

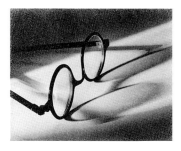

82
Hoinkis, Ewald
Spectacles, 1929
Gelatin silver print
16.5 x 21 cm
Museum Folkwang Essen

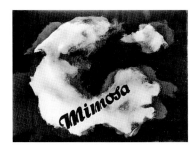

83
Kesting, Edmund
Mimosa, Berlin, 1928
Gelatin silver print
29.7 x 39.5 cm
Manfred Heiting Collection

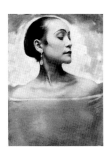

84
Lendvai-Dircksen, Erna
Portrait of a dancer,
c. 1920
Tinted gelatin silver print
23 x 17.3 cm
Manfred Heiting Collection

85
Lerski, Helmar
Veit Harlan, actor,
c. 1927
Gelatin silver print, 22.8 x 17.1 cm
Museum Folkwang Essen
Plate 47

86
Lerski, Helmar
Cleaning woman, c. 1928
Gelatin silver print
23.6 x 17.9 cm
Museum Folkwang Essen
Plate 44

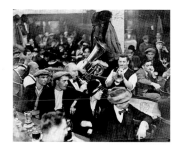

87
Man, Felix H.
Metzger brewery, Munich,
1929
Gelatin silver print
24.8 x 28.5 cm
Manfred Heiting Collection

88
Man, Felix H.
Entrance to the wave pool,
Lunapark, Berlin, 1929
Gelatin silver print (1982)
22.3 x 16.6 cm
Berlinische Galerie, Landes-
museum für Moderne Kunst,
Photographie und Architektur,
Photography Collection

89
Mantz, Werner
Electrola display window on Hohe
Strasse, Cologne, 1928
Gelatin silver print
15.8 x 22.7 cm
Rheinisches Landesmuseum Bonn
Plate 20

90
Mantz, Werner
Tietz department store,
Gelsenkirchen, 1928
Gelatin silver print
22.6 x 17.3 cm
Rheinisches Landesmuseum Bonn

91
Mantz, Werner
Tietz department store, 1929
Gelatin silver print
23 x 17.3 cm
Rheinisches Landesmuseum Bonn

92
Mantz, Werner
Interior, c. 1929
Gelatin silver print, 17.8 x 22.5 cm
Rheinisches Landesmuseum Bonn

93
Mantz, Werner
Façade, 1928
Gelatin silver print, 21.1 x 9.6 cm
Rheinisches Landesmuseum Bonn

94
Moholy-Nagy, László
Photogram No. 1 – The mirror, 1923
Gelatin silver print
21 x 28.1 cm
Manfred Heiting Collection
Plate 29

95
Moholy, Lucia
Franz Roh, 1926
Gelatin silver print
21.8 x 15.8 cm
Manfred Heiting Collection
Plate 42

96
Moholy-Nagy, László
Flower photogram, 1925
Gelatin silver print
23.9 x 17.7. cm
Berlinische Galerie, Landes-
museum für Moderne Kunst,
Photographie und Architektur,
Photography Collection

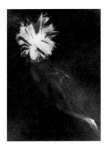

97
Moholy-Nagy, László
Photogram, negative-positive, 1927
Gelatin silver print
17 x 23 cm
Manfred Heiting Collection

98
Moholy-Nagy, László
In Lyon's stadium, c. 1929
Gelatin silver print, 29.2 x 21.5 cm
Manfred Heiting Collection
Plate 24

99
Munkàcsi, Martin
Motorcyclist, Budapest
c. 1923
Gelatin silver print
33.7 x 26.9 cm
Manfred Heiting Collection
Plate 51

100
Munkàcsi, Martin
Spectator, 1928
Gelatin silver print
23.5 x 29.2 cm
Berlinische Galerie, Landes-
museum für Moderne Kunst,
Photographie und Architektur,
Photography Collection

101
Munkàcsi, Martin
Berlin, Wilmersdorf
(women's legs reflected in a
puddle), c. 1928
Gelatin silver print, 21.7 x 29.3 cm
F. C. Gundlach Collection

102
Munkàcsi, Martin
Odd spare wheel (detail), Berlin,
Wilmersdorf, 1929
Gelatin silver print
23.6 x 30 cm
F. C. Gundlach Collection

103
Munkàcsi, Martin
Three boys jumping into the sea,
Berlin, 1929
Gelatin silver print
23.7 x 29.5 cm
F. C. Gundlach Collection

104
Munkàcsi, Martin
Kaiserplatz 14, Berlin,
Wilmersdorf (two cars from
above), 1929
Gelatin silver print, 30 x 24.5 cm
F. C. Gundlach Collection

105
Perscheid, Nicola
Hans Poelzig, architect
(1869–1936), after 1925
Carbon print
24 x 21.3 cm
Museum für Kunst und Gewerbe
Hamburg; Plate 12

106
Peterhans, Walter
Portrait of a man, 1928
Gelatin silver print
28 x 34 cm
Manfred Heiting Collection

107
Peterhans, Walter
Portrait of his beloved, 1929
Gelatin silver print
22 x 35.8 cm
Manfred Heiting Collection
Plate 37

108
Peterhans, Walter
Good Friday mystery, c. 1929
Gelatin silver print, 24.5 x 39 cm
Manfred Heiting Collection

109
Renger-Patzsch, Albert
Reaper, 1925/28
Gelatin silver print
22.7 x 16.8 cm
Rheinisches Landesmuseum Bonn

110
Renger-Patzsch, Albert
Houses in the Ruhr district, 1928
Gelatin silver print
22.2 x 16.3 cm
Rheinisches Landesmuseum Bonn

111
Renger-Patzsch, Albert
Insulator line, 1929
Gelatin silver print
16.6 x 22.7 cm
Rheinisches Landesmuseum
Bonn

112
Renger-Patzsch, Albert
Small tree, 1929
Gelatin silver print
22.3 x 16.3 cm
Rheinisches Landesmuseum Bonn
Plate 48

113
Salomon, Erich
State visit to Berlin by King Fuad,
June 1929,
President von Hindenburg during a
reception at his palace in honour of
King Fuad of Egypt. Taken from the
opposite wing of the palace, at a
distance of 35 metres.
Gelatin silver print
(1937)
33 x 46 cm
Berlinische Galerie,
Landesmuseum
für Moderne Kunst,
Photographie und Architektur,
Photography Collection
Plate 66

114
Sander, August
Man with cigarette, 1924
Gelatin silver print
20.8 x 14.1 cm
Manfred Heiting Collection

115
Sander, August
Abitur candidate, Cologne, 1926
Gelatin silver print
21 x 12.7 cm
Manfred Heiting Collection
Plate 15

116
Sander, August
Cologne "Court Musicians", 1928
Gelatin silver print
23.2 x 16.5 cm
Manfred Heiting Collection
Plate 21

117
Sander, August
The painter Peter Abelen's wife,
c. 1927/28
Gelatin silver print (1978)
26 x 21.4 cm
Rheinisches Landesmuseum Bonn

118
Schad, Christian
Untitled, 1918,
Schadography, 16.3 x 12.5 cm
Kunsthaus Zürich; plate 28

119
Schensky, Franz
Large Wave, c. 1925
Pigment process, 42.1 x 58.7 cm
Museum für Kunst und Gewerbe
Hamburg; plate 11

120
Schmölz, Hugo
Village church in Frielingsdorf by
Dominikus Böhm, north aisle, 1928
Gelatin silver print (1980)
24 x 18 cm
Private collection; plate 84

121
Seidenstücker, Friedrich
Bearing the load, 1928
Gelatin silver print
22.9 x 16.9 cm
Museum Folkwang Essen; plate 22

122
Stern, Grete
Portrait of Walter Peterhans, 1927
Gelatin silver print
22.4 x 16.3 cm
Bauhaus-Archiv, Berlin

123
Stern, Grete
Silk, study done in the Peterhans
class, 1927, Gelatin silver print
(1989), 18 x 24 cm
Bauhaus-Archiv, Berlin

124
Stone, Sasha
Untitled
(high voltage insulator),
c. 1926
Gelatin silver print
21.5 x 16.2 cm
Berlinische Galerie, Landes-

museum für Moderne Kunst,
Photographie und Architektur,
Photography Collection

125
Stone, Sasha
Untitled (insulator),
c. 1926
Gelatin silver print, tinted green
21.1 x 16.2 cm
Berlinische Galerie, Landes-
museum für Moderne Kunst,
Photographie und Architektur,
Photography Collection

126
Stone, Sasha
Technical beauty – High voltage
safety insulator,
c. 1926
Gelatin silver print
21.3 x 16.5 cm
Berlinische Galerie, Landes-
museum für Moderne Kunst,
Photographie und Architektur,
Photography Collection

127
Trump, Georg
Feldmühle, c. 1929
Gelatin silver print
11 x 8.4 cm
Manfred Heiting Collection
Plate 19

128
Umbo
Uncanny street,
1928
Gelatin silver print
29.8 x 22.8 cm
Museum Ludwig, Cologne
Plate 25

129
Umbo
Kindergarten, 1928
Gelatin silver print
26.1 x 20 cm
Manfred Heiting Collection

130
Auerbach, Ellen
Kläre Eckstein with lipstick,
1930
Gelatin silver print
20.4 x 19.5 cm
Museum Folkwang Essen

135
Bayer, Herbert
Lonely city-dweller,
1932
Gelatin silver print
(1968)
34 x 26.9 cm
Museum Ludwig, Cologne,
Gruber Collection

131
Auerbach, Ellen
Kurfürstenstrasse,
1931
Gelatin silver print
35.7 x 28 cm
Museum Folkwang Essen

136
Biermann, Aenne
Geese behind a fence,
c. 1930
Gelatin silver print
17.6 x 23.5 cm
Museum Folkwang Essen

132
Ballhause, Walter
The unemployed in advertising,
1930/33
Gelatin silver print
41.3 x 29.5 cm
Museum Folkwang Essen
Plate 30

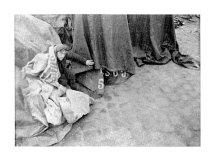

137
Breslauer, Marianne
Man beneath a tarpaulin,
undated
Gelatin silver print
11.3 x 16.8 cm
Courtesy of Galerie Kicken, Cologne

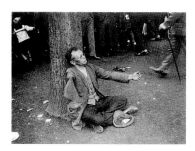

133
Ballhause, Walter
The grateful fatherland,
1930/33
Gelatin silver print
17.1 x 23.2 cm
Staatliche Galerie Moritzburg,
Halle,
Archive Fotokinoverlag

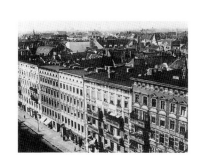

138
Brill, Fritz
Roofs, 1930
Gelatin silver print
16.3 x 21.6 cm
Berlinische Galerie, Landes-
museum für Moderne Kunst,
Photographie und Architektur,
Photography Collection

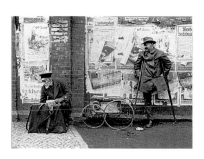

134
Ballhause, Walter
War-invalid begging,
c. 1931
Gelatin silver print
8.7 x 12.1 cm
Museum Folkwang Essen

139
Brill, Fritz
800,000, 1932
Copper gravure process
29 x 23 cm
Berlinische Galerie,
Landesmuseum
für Moderne Kunst,
Photographie und Architektur,
Photography Collection

140
Cavael, Rolf
Photogram 31/F7, 1931
Gelatin silver print
24 x 18 cm
Berlinische Galerie, Landes-
museum für Moderne Kunst,
Photographie und Architektur,
Photography Collection

141
Cavael, Rolf
Photogram 31/F11, 1931
Gelatin silver print
15.3 x 15.3 cm
Berlinische Galerie, Landes-
museum für Moderne Kunst,
Photographie und Architektur,
Photography Collection

142
Clausen, Rosemarie
Gustaf Gründgens as Hamlet,
Berlin, 1936
Gelatin silver print
59.3 x 44.4 cm
Museum für Kunst und Gewerbe
Hamburg
Plate 46

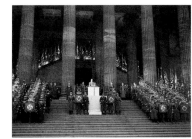

143
Ehlert, Max
Berlin, 30 January 1936
Gelatin silver print
(1997)
30 x 40 cm
Der Spiegel

144
Ehlert, Max
Wehrmacht Day, Nuremberg,
1936
Gelatin silver print (1997)
30 x 40 cm
Der Spiegel

145
Ehlert, Max
Closing ceremony at the Olympic
Games, Berlin 1936

Gelatin silver print (1997), 30 x 40 cm
Der Spiegel; Plate 73

146
Ehlert, Max
NSDAP party rally, Nuremberg, 1937
Gelatin silver print (1997)
30 x 40 cm
Der Spiegel; Plate 72

147
Ehlert, Max
The Danube, Dürnstein, 1938
Gelatin silver print (1997)
30 x 40 cm
Der Spiegel

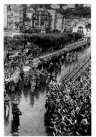

148
Ehlert, Max
Karlsbad, Hitler's invasion of
Czechoslovakia,
10 August 1938
Gelatin silver print (1997), 30 x 40 cm
Der Spiegel

149
Eisenstaedt, Alfred
Graf Zeppelin, 1934
The Graf Zeppelin airship being
repaired above the southern
Atlantic on its flight to Rio de
Janeiro
Gelatin silver print, 28 x 35.2 cm
Rheinisches Landesmuseum Bonn,
Gesellschaft Photo-Archiv
Plate 50

150
Eisenstaedt, Alfred
September 1933
Propaganda Minister Joseph
Goebbels with his private
secretary and Hitler's interpretor
at the 15th General Assembly of
the League of Nations in Geneva,
September 1933
Gelatin silver print, 35 x 28.2 cm
Rheinisches Landesmuseum Bonn,
Gesellschaft Photo-Archiv
Plate 69

151
Eisenstaedt, Alfred
Hindenburg's funeral, Tannenberg,
August 1934, war flag in the
foreground
Gelatin silver print, 33 x 22.5 cm
Rheinisches Landesmuseum Bonn,
Gesellschaft Photo-Archiv
Plate 54

152
Erfurth, Hugo
Captain Hauffe, 1932
Gelatin silver print
57.6 x 40.4 cm
Rheinisches Landesmuseum
Bonn

153
Erhardt, Alfred
Footprints in sand dunes,
undated
Gelatin silver print
48.8 x 33 cm
Manfred Heiting Collection

154
Errell (Richard Levy)
Car light, before 1931
Gelatin silver print
28 x 24 cm
Museum Folkwang Essen

155
Errell (Richard Levy)
The advertisement, 1930
Gelatin silver print,
reproduction proof
29.8 x 22.2 cm
Museum Folkwang Essen
Plate 31

156
Feininger, Andreas
Abstract spiral (sectioned nautilus
shell), undated
Gelatin silver print
32.5 x 26.6 cm
Museum Ludwig, Cologne

157
Feininger, Andreas
Prostitute in Hamburg's
Gängeviertel, 1930/31
Gelatin silver print
23.9 x 18.9 cm
Museum für Kunst und Gewerbe
Hamburg

158
Flöter, Hubs
Racoon jacket, 1939
Gelatin silver print
29.4 x 22.8 cm
Museum Folkwang Essen

159
Gidal, Tim
Kurt Gerron delights in the
efforts – of others, 1930
Gelatin silver print
18 x 13 cm
Berlinische Galerie, Landes-
museum für Moderne Kunst,
Photographie und Architektur,
Photography Collection

160
Gidal, Tim
The confessional, Częstochowa,
Poland, 1932
Gelatin silver print
24 x 17 cm
Museum Folkwang Essen

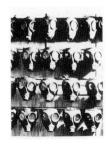

161
Gidal, Tim
Florence, c. 1934
Gelatin silver print, 21 x 15 cm
Manfred Heiting Collection
Plate 61

162
Gorny, Hein
Gas masks, 1936
Gelatin silver print
25.3 x 20 cm
Museum Folkwang Essen

163
Gutmann, John
Class. Olympic high diving
champion, Marjorie Gestring,
Berlin, 1936
Gelatin silver print
20.3 x 20 cm
Manfred Heiting Collection
Plate 59

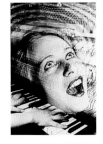

164
Hajek-Halke, Heinz
Katharina, undated
Gelatin silver print
17 x 11.5 cm
Michael Ruetz, Berlin

165
Hajek-Halke, Heinz
Black and white nude,
1936
Gelatin silver print (1977)
60 x 50 cm
Michael Ruetz, Berlin

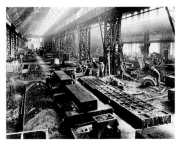

166
Hallensleben, Ruth
Strip steel rolling mill, 1944
Bromoil gelatin silver print
17 x 22.7 cm
Museum Folkwang Essen

167
Hausmann, Raoul
A glance in the shaving mirror,
1930/31
Gelatin silver print
5.7 x 7.9 cm
Manfred Heiting Collection
Plate 33

168
Hausmann, Raoul
Untitled (Vera Broido), c. 1932
Gelatin silver print
17.4 x 24 cm
Berlinische Galerie, Landes-
museum für Moderne Kunst,
Photographie und Architektur,
Photography Collection

169
Hausmann, Raoul
Berlin (Charlottenplatz),
October 1931
Gelatin silver print, 17 x 23 cm
Margotow Archive, Wahlershausen

170
Hausmann, Raoul
Untitled, c. 1930
Gelatin silver print
11.3 x 23.5 cm
Berlinische Galerie, Landes-
museum für Moderne Kunst,
Photographie und Architektur,
Photography Collection
Plate 38

171
Heartfield, John
Forced supplier of human
material, design for the
Arbeiter-Illustrierte-Zeitung (AIZ),
Berlin, no. 10, 1930
Photomontage
39.7 x 29.7 cm
Stiftung Archiv der Akademie der
Künste, Berlin, Kunstsammlung
(John Heartfield Archive)

172
Heartfield, John
SPD crisis party rally,
design for the Arbeiter-Illustrierte
Zeitung (AIZ),
Berlin, no. 24, 1931
Photomontage
38 x 30.5 cm
Stiftung Archiv der Akademie der
Künste, Berlin
Kunstsammlung (John Heartfield
Archive)

173
Heartfield, John
The meaning of the Hitler salute:
Small man asks for large gifts.
Motto: Millions are behind me!
Design for the Arbeiter-Illustrierte
Zeitung (AIZ),

Berlin, no. 42, 1932
Photomontage, 45.8 x 35.7 cm
Stiftung Archiv der Akademie der
Künste, Berlin, Kunstsammlung
(John Heartfield Archive)
Plate 39

174
Hege, Walter
Bamberg Rider,
c. 1937
Gelatin silver print (1960)
28.3 x 21.6 cm
Museum für Kunst und Gewerbe
Hamburg

175
Heilig, Eugen
"Jews are unwanted in our
German forests",
1936
Gelatin silver print (1955)
23.9 x 30.2 cm
Staatliche Galerie Moritzburg,
Halle, Archive Fotokinoverlag

176
Heilig, Eugen
Exchanging potatoes
for coal, 1931
Gelatin silver print
23.9 x 30.2 cm
Staatliche Galerie Moritzburg,
Halle, Archive Fotokinoverlag

177
Heilig, Eugen
Advertising for the *AIZ*,
KPD agitation in Krielow, 1931
Gelatin silver print
23.9 x 30.2 cm
Staatliche Galerie Moritzburg,
Halle, Archive Fotokinoverlag

178
Heilig, Eugen
Homeless destitute man at a
garbage dump in Berlin-Spandau,
1932
Gelatin silver print, 23.9 x 30.4 cm

Staatliche Galerie Moritzburg,
Halle, Archive Fotokinoverlag

179
Henle, Fritz
Munich policeman, 1930
Gelatin silver print
17.6 x 24.9 cm
Courtesy of Galerie Kicken, Cologne

180
Henle, Fritz
Drummer at the Palio in Siena,
1933
Gelatin silver print
33.2 x 25.1 cm
Courtesy of Galerie Kicken,
Cologne; plate 57

181
Henle, Fritz
School in Tokyo, 1936
Gelatin silver print
21.5 x 26.2 cm
Courtesy of Galerie Kicken, Cologne

182
Hoepffner, Marta
Homage to Kandinsky, 1938
Gelatin silver print
37.2 x 29.4 cm
Museum für Kunst und Gewerbe
Hamburg

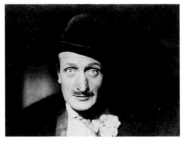

183
Jacobi, Lotte
Hans Albers, c. 1930
Gelatin silver print
15.7 x 21.3 cm
Museum Folkwang Essen

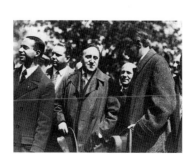

184
Jacobi, Lotte
Carl von Ossietzky with friends, 1932
Gelatin silver print (1983)
17 x 23 cm
Berlinische Galerie, Landes-
museum für Moderne Kunst,
Photographie und Architektur,
Photography Collection

185
Jacobi, Lotte
Karl Radek,
1932
Gelatin silver print
24.2 x 33 cm
Museum Folkwang Essen
Plate 43

186
Jacobi, Lotte
Emil Jannings,
undated
Gelatin silver print
29.8 x 24.7 cm
Berlinische Galerie,
Landesmuseum
für Moderne Kunst,
Photographie und Architektur,
Photography Collection

187
Kesting, Edmund
Limbs and shadows,
1930
Gelatin silver print
35.5 x 30 cm
Manfred Heiting Collection

188
Kesting, Edmund
Steffi Oberhehl, dancer,
1934
Gelatin silver print, negative
montage
40.4 x 27.9 cm
Kupferstich-Kabinett
Dresden

189
Kesting, Edmund
Portrait of Ludwig Gutbier,
c. 1935
Gelatin silver print
(double exposure)
37 x 27.5 cm
Kupferstich-Kabinett
Dresden

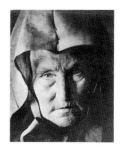

190
Lendvai-Dircksen, Erna
Portrait of an old woman, before 1935
Gelatin silver print, 20.7 x 15.8 cm
Courtesy of Galerie Kicken,
Cologne

191
Lendvai-Dircksen, Erna
Bückeburg, before 1935
Gelatin silver print, 19.7 x 15.2 cm
Courtesy of Galerie Kicken,
Cologne
Plate 56

192
Lendvai-Dircksen, Erna
Portrait of a woman, before 1935
Gelatin silver print, 20.7 x 15.8 cm
Courtesy of Galerie Kicken,
Cologne

193
Lerski, Helmar
Portrait, c. 1930
Gelatin silver print
23 x 15.8 cm
Berlinische Galerie, Landes-
museum für Moderne Kunst,
Photographie und Architektur,
Photography Collection

194
List, Herbert
The spirit of the Likavittos,
Athens, 1937
Gelatin silver print (later)
40 x 30 cm
Herbert List estate, Hamburg

195
List, Herbert
Cleopatra's house and statue,
Delos, 1937
Gelatin silver print (later)
40 x 30 cm
Herbert List estate, Hamburg

196
List, Herbert
Torso of a statue, Corinth,
1937
Gelatin silver print (later)
40 x 30 cm
Herbert List estate, Hamburg
Plate 55

197
List, Herbert
Plaster casts in the Munich
Academy, 1945
Gelatin silver print (later)
40 x 30 cm
Herbert List estate, Hamburg

198
Man, Felix H.
Untitled, c. 1930
Gelatin silver print
22.4 x 17 cm
Berlinische Galerie, Landes-
museum für Moderne Kunst,
Photographie und Architektur,
Photography Collection

199
Man, Felix H.
Mussolini in his office, 1931
Gelatin silver print (1982)
21.4 x 27.2 cm
Berlinische Galerie,
Landesmuseum
für Moderne Kunst,
Photographie und Architektur,
Photography Collection
Plate 68

200
Man, Felix H.
Max Schmeling, 1933
Gelatin silver print
19 x 24 cm
Berlinische Galerie,
Landesmuseum
für Moderne Kunst,
Photographie und
Architektur,
Photography Collection

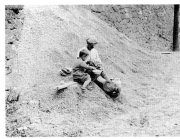

201
Meinhold, Erich
Construction worker at lunch,
c. 1930
Gelatin silver print
17.9 x 23.9 cm
Staatliche Galerie Moritzburg,
Halle, Archive Fotokinoverlag

202
Meinhold, Erich
After a Nazi attack
(Fritz Scharner), 18 February 1933
Gelatin silver print, 24 x 17.9 cm
Staatliche Galerie Moritzburg,
Halle, Archive Fotokinoverlag

203
Munkàcsi, Martin
Skiers, 1930
Gelatin silver print
29.3 x 23.6 cm
Berlinische Galerie, Landes-
museum für Moderne Kunst,
Photographie und Architektur,
Photography Collection

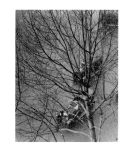

204
Munkàcsi, Martin
Berlin-Wilmersdorf, c. 1930
Gelatin silver print
23.5 x 29.3 cm
F. C. Gundlach Collection

205
Munkàcsi, Martin
Berlin-Wilmersdorf (spectators),
c. 1930
Gelatin silver print, 23.5 x 30 cm
F. C. Gundlach Collection
Plate 62

206
Munkàcsi, Martin
Montage with the actress
Eva Sylt, 1932
Gelatin silver print
29.6 x 23.4 cm
F. C. Gundlach Collection
Plate 63

207
Munkàcsi, Martin
High jumper, 1933
Gelatin silver print
29.3 x 23.4 cm
Manfred Heiting Collection

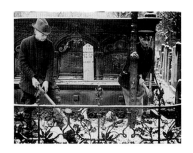

208
Pisarek, Abraham
Max Liebermann's funeral,
February 1935
Gelatin silver print
18.2 x 24 cm
Staatliche Galerie Moritzburg,
Halle, Archive Fotokinoverlag

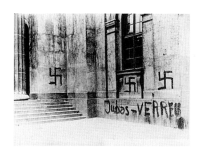

209
Pisarek, Abraham
Slogans smeared on a
synagogue, Berlin,
c. 1938
Gelatin silver print, 17 x 23.3 cm
Staatliche Galerie Moritzburg,
Halle, Archive Fotokinoverlag

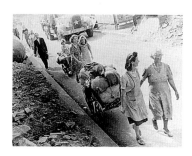

210
Pisarek, Abraham
Re-settlers passing through
Berlin, 1945
Gelatin silver print
18.1 x 24 cm
Staatliche Galerie Moritzburg,
Halle, Archive Fotokinoverlag

211
Pritsche, Willy
After the assumption of power, 1933
Gelatin silver print (later),
31 x 42 cm
Kupferstich-Kabinett Dresden
Plate 71

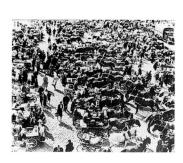

212
Pritsche, Willy
Polish market, 1939–1943
Gelatin silver print (later)
38.7 x 49 cm
Kupferstich-Kabinett Dresden

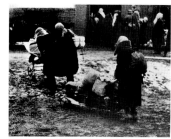

213
Pritsche, Willy
Evacuation, 1941
Gelatin silver print (later)
32 x 40 cm
Kupferstich-Kabinett Dresden

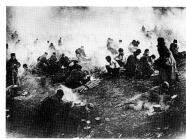

214
Pritsche, Willy
A matter of survival
(prisoner-of-war camp),
1942
Gelatin silver print (later)
34.3 x 48.3 cm
Kupferstich-Kabinett Dresden

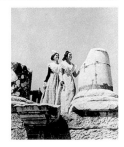

215
Relang, Regina
Arles beauties, 1936
Gelatin silver print
25 x 21 cm
Fotomuseum im Münchner
Stadtmuseum

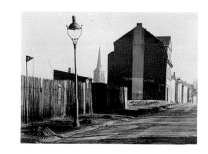

216
Renger-Patzsch, Albert
Oberhausen, 1932
Gelatin silver print
23.8 x 37.5 cm
Manfred Heiting Collection

217
Renger-Patzsch, Albert
Towers and east façade,
Murbach Abbey, Alsace, 1936
Gelatin silver print
38.2 x 28.1 cm
Manfred Heiting Collection
Plate 49

218
Retzlaff, Erich
Blast furnace worker, before
1931
Gelatin silver print, 23.3 x 17.5 cm
Fotomuseum im Münchner
Stadtmuseum; plate 45

219
Retzlaff, Erich
Peasant from Nördlingen,
before 1936
Gelatin silver print
23.5 x 17.8 cm
Fotomuseum im Münchner
Stadtmuseum

220
Riefenstahl, Leni
Film still,
1936
Gelatin silver print
21.7 x 28.3 cm
F. C. Gundlach Collection

221
Rohde, Werner
Mannequins, c. 1930
Gelatin silver print
14.8 x 10.3 cm
Manfred Heiting Collection
Plate 60

222
Roh, Franz
Self portrait, 1930s
Gelatin silver print
4.1 x 2.5 cm
Manfred Heiting Collection

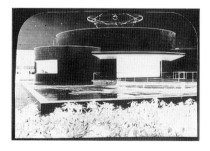

223
Roh, Franz
The philosopher's house,
c. 1940
Gelatin silver print, 14.4 x 21.6 cm
Manfred Heiting Collection

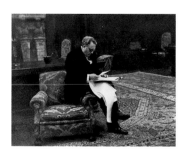

224
Salomon, Erich
William Randolph Hearst retires
after dinner to read
dispatches sent to his home by
the editors of his
newspapers via private mail
service, c. 1930

Gelatin silver print
(1937)
34.2 x 45.0 cm
Berlinische Galerie, Landes-
museum für Moderne Kunst,
Photographie und Architektur,
Photography Collection

225
Salomon, Erich
German and French ministers in
late night
session at the Hague reparation
conference, January 1930
Gelatin silver print (1937)
2-part: 28.8 x 41.2 and
29.5 x 41.4 cm
Berlinische Galerie, Landes-
museum für Moderne Kunst,
Photographie und Architektur,
Photography Collection
Plate 67

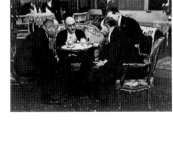

226
Salomon, Erich
Rome, Hotel Excelsior, August 1931
(from left to right)
Mussolini, Reichskanzler Brüning,
Italian Foreign Minister Count Dino
Grandi, German Foreign Minister
Curtius
Gelatin silver print (1937)
34 x 43 cm
Berlinische Galerie, Landes-
museum für Moderne Kunst,
Photographie und Architektur,
Photography Collection

227
Salomon, Erich
Lausanne reparations conference.
Outside Ramsay MacDonald's
room at the Hotel Beau Rivage.
On the left, the hats of the German
Reichskanzler Papen and his
Foreign Minister, and on the right,
the hats of the French delegation,
1932.
Gelatin silver print (1937)
31.7 x 43 cm

Berlinische Galerie, Landes-
museum für Moderne Kunst,
Photographie und Architektur,
Photography Collection

228
Salomon, Erich
Schmeling and Roosevelt,
c. 1936
Gelatin silver print
18.1 x 24 cm
Manfred Heiting Collection

229
Atelier Sandau
Automobilist, c. 1930
Gelatin silver print
23.5 x 16.4 cm
F. C. Gundlach Collection

230
Atelier Sandau
Shadows – double portrait,
undated
Gelatin silver print
22.8 x 16.4 cm
F. C. Gundlach Collection

231
Sander, August
Peasant going to a funeral,
Westerwald, 1930/31
Gelatin silver print
22.9 x 18.2 cm
Manfred Heiting Collection

232
Santho, Imre von
Woman with cat (black and white
evening dress), Gina Falckenberg,
c. 1935
Gelatin silver print
29 x 19.3 cm
F. C. Gundlach Collection

233
Santho, Imre von
Couple, picnic in the woods

(blue beachwear with red
belt),
c. 1935
Gelatin silver print
28.5 x 21.4 cm
Plate 64

234
Santho, Imre von
Black duvetine cape with black
feather, fur,
c. 1935
Gelatin silver print
29 x 22.6 cm
F. C. Gundlach Collection

235
Schmölz, Hugo
Stairwell of the Hochschule für
Lehrerbildung (Teacher
Training College), Bonn, 1933
Gelatin silver print (1980)
24 x 18 cm
Private collection

236
Schurig, Fritz Bernhard
Bridge over the Lahn near
Limburg, 1940
Gelatin silver print
41.5 x 50.2 cm
Schurig-Archiv, Hall, Tyrol

237
Schurig, Fritz Bernhard
Harz forest,
c. 1930
Gelatin silver print
46.9 x 55.6 cm
Schurig-Archiv, Hall, Tyrol

238
Schurig, Fritz Bernhard
Suspension bridge (detail),
1939
Gelatin silver print
56.9 x 45.8 cm
Schurig-Archiv, Hall, Tyrol

239
Schurig, Fritz Bernhard
Harz forest,
c. 1930
Gelatin silver print
56.2 x 46.7 cm
Schurig-Archiv, Hall, Tyrol

240
Seidenstücker, Friedrich
Stationmaster inspecting the
tracks, c. 1930
Gelatin silver print
22.9 x 16.9 cm
Museum Folkwang Essen

241
Seidenstücker, Friedrich
Monday in Berlin,
Oberbaum Bridge, 1930
Gelatin silver print
12.5 x 18 cm
Berlinische Galerie, Landes-
museum für Moderne Kunst,
Photographie und Architektur,
Photography Collection

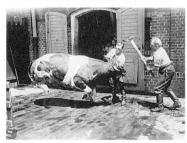

242
Seidenstücker, Friedrich
Abbatoir,
1933
Gelatin silver print
16.9 x 22.9 cm
Museum Folkwang Essen

243
Stankowski, Anton
Paris from above, Notre Dame,
1930
Gelatin silver print, 11.2 x 8.1 cm
Museum Ludwig, Cologne

244
Stankowski, Anton
Chimneys in motion, 1930s
Gelatin silver print
11.9 x 9 cm
Manfred Heiting Collection

245
Stern, Grete
Portrait of Ellen Auerbach,
c. 1930
Gelatin silver print (1979)
23.7 x 17.5 cm
Bauhaus Archiv Berlin

246
Stone, Sasha
Lights of Berlin, c. 1930
Gelatin silver print
10.3 x 13.2 cm
Museum Folkwang Essen
Plate 58

247
Stone, Sasha
Shoes of an unfortunate,
c. 1932
Gelatin silver print
16.5 x 22.9 cm
On loan from the Berlin Ullstein
Bilderdienst to the Museum
Folkwang Essen

248
Strache, Wolf
Gymnast, 1939
Gelatin silver print, 40 x 30 cm
Museum Ludwig, Cologne

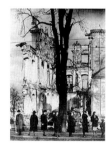

249
Strache, Wolf
Stuttgart, Neues Schloss, 1946
Gelatin silver print
40 x 30 cm
Museum Ludwig, Cologne

250
Weber, Wolfgang
Women's prison in Aichach,
c. 1931
Gelatin silver print, 21.1 x 18 cm
On loan from the Berlin Ullstein
Bilderdienst to the
Museum Folkwang Essen
Plate 70

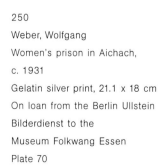

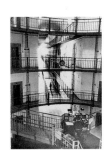

251
Weber, Wolfgang
Women's prison in Aichach,
c. 1931
Gelatin silver print, 24.2 x 17.4 cm
On loan from the Berlin Ullstein
Bilderdienst to the
Museum Folkwang Essen

252
Wolff, Paul
Borkum beach, 1935
Gelatin silver print
18.5 x 23.7 cm
Museum Folkwang Essen

253
Wolff, Paul
Mouson (perfume flacon), 1936
Gelatin silver print
18 x 24 cm
Museum Folkwang Essen

254
YVA
Double portrait, c. 1930
Gelatin silver print
21.9 x 15.6 cm
F. C. Gundlach Collection

255
YVA
Double portrait (in a mirror), 1930
Gelatin silver print
21.3 x 16 cm
F. C. Gundlach Collection

256
YVA
Two playful young women
in beach wear,
c. 1932
Gelatin silver print
22.7 x 17.7 cm
F. C. Gundlach Collection

257
YVA
Lady and gentleman on
stairs with Madonna wall
figure,
c. 1932
Gelatin silver print
22.4 x 16.3 cm
F. C. Gundlach Collection

258
YVA
Lady with a hat,
c. 1933
Gelatin silver print
23.3 x 16.3 cm
F. C. Gundlach Collection

259
YVA
Rear view of two seated
women, c. 1933
Gelatin silver print
23 x 17.7 cm
F. C. Gundlach Collection
Plate 65

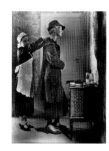

260
YVA
Woman with housemaid,
c. 1934
Gelatin silver print
23.4 x 16.9 cm
F. C. Gundlach Collection

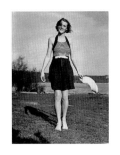

261
YVA
Young woman in summer dress,
outdoors,
c. 1934
Gelatin silver print
22.7 x 17 cm
F. C. Gundlach Collection

262
Zielke, Willy
Collage, c. 1931
Gelatin silver print, mounted
22.6 x 17 cm
Manfred Heiting Collection

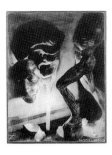

263
Zielke, Willy
Nocturno, 1931/1940
Bromoil print
61.7 x 48 cm
Museum für Kunst und Gewerbe
Hamburg

264
Zielke, Willy
Lemon with green plate, July
1932
Bromoil print
39.3 x 29.7 cm
Museum für Kunst und Gewerbe
Hamburg

265
Zielke, Willy
Still life – Colours in chemistry,
1934
Bromoil print
40.3 x 31.8 cm
Museum für Kunst und Gewerbe
Hamburg
Plate 36

266
Abel, Carl Andreas
Miner, 1951
Gelatin silver print
40.3 x 30.3 cm
Rheinisches Landesmuseum Bonn,
permanent loan

267
Abel, Carl Andreas
Geyser, Iceland, 1960/61
Gelatin silver print
44.6 x 55.8 cm
Rheinisches Landesmuseum Bonn,
permanent loan

268
Abel, Carl Andreas
Crankshaft, 1964
Gelatin silver print
53.3 x 40.3 cm
Rheinisches Landesmuseum Bonn,
permanent loan; plate 91

269
Arnold, Ursula
Wedding, Leipzig,
1956
Gelatin silver print
34.8 x 25.6 cm
Ursula Arnold

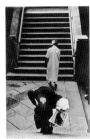

270
Arnold, Ursula
Newspaper woman, Leipzig,
1958
Gelatin silver print
39.4 x 25.5 cm
Ursula Arnold

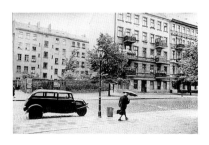

271
Rykestrasse, Berlin,
1965
Gelatin silver print
25.7 x 38.4 cm
Ursula Arnold

272a
Becher, Bernd and Hilla
Kaan-Marienborn,
Schlossblick 17, 1971
Gelatin silver print
8 parts, each 40.8 x 30.6 cm

272b
Birken-Mudersbach
Hauptstrasse 3, 1971
Gelatin silver print
8 parts, each 40.8 x 30.6 cm

272c
Dahlbruch, Hillnhütter Strasse 62,
1971
Gelatin silver print
8 parts, each 40.8 x 30.6 cm

272d
Birlenbach, Abendröthe 3, 1972
Gelatin silver print
8 parts, each
40.8 x 30.6 cm,
Rheinisches Landesmuseum Bonn,
Plate 120

273
Breier, Kilian
Luminogram, c. 1964
Gelatin silver print, 80 x 80 cm
Private collection; plate 118

274
Breier, Kilian
Luminogram, c. 1964
Gelatin silver print, 80 x 80 cm
Private collection

275
Brill, Fritz
Ink in roller printer –
Hostmann & Steinberg, 1951
Gelatin silver print
57.9 x 45.6 cm
Berlinische Galerie, Landes-
museum für Moderne Kunst,
Photographie und Architektur,
Photography Collection
Plate 93

276
Brus, Johannes
Flying cucumbers
(Cucumber party),
1970
Gelatin silver print (1972)
27 parts, each 24 x 30 cm
Ministry for Urban Development,
Culture and Sport, Düsseldorf
Plate 121

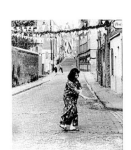

277
Chargesheimer
Morning in the "Nachtjackenviertel",
undated
Gelatin silver print
23.9 x 20.7 cm
Museum Ludwig, Cologne

278
Chargesheimer
Child at a street corner, 1958
Gelatin silver print, 37 x 21.5 cm
Museum Ludwig, Cologne,
Gruber Collection; plate 87

279
Chargesheimer
View from the autobahn access,
Cologne-Deutz,
undated
39.7 x 29.7 cm
Museum Ludwig, Cologne

280
Chargesheimer
Thomas Liessem, New Year's Eve
1955, two minutes to midnight
Gelatin silver print
20.9 x 23.8 cm
Museum Ludwig, Cologne
Plate 83

281
Chargesheimer
Woman in the "Im Auer" tavern,
undated
Gelatin silver print
24.9 x 21.3 cm
Museum Ludwig, Cologne

282
Chargesheimer
Embrace, undated
Gelatin silver print
30.3 x 23.2 cm
Museum Ludwig, Cologne

283
Claasen, Hermann
Ritterstrasse, Cologne, 1943/44
Gelatin silver print
30.3 x 40.3 cm
Rheinisches Landesmuseum Bonn

284
Claasen, Hermann
Wallrafplatz (Hohe Strasse seen
through the window of the Fuss
flower shop), Cologne, autumn
1945
Gelatin silver print, 30 x 40 cm
Rheinisches Landesmuseum Bonn
Plate 76

285
Claasen, Hermann
Cologne, view from the
cathedral, 1948
Gelatin silver print
23.3 x 17.7 cm
Rheinisches Landesmuseum Bonn

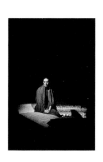

286
Clausen, Rosemarie
Elisabeth Flickenschildt as
Sappho in L. Durrell's "Sappho",
Hamburg 1959
Gelatin silver print, 49.5 x 29.5 cm
Museum für Kunst und Gewerbe
Hamburg

287
Darchinger, Jupp
Foreign Minister Willy Brandt
and former Federal Chancellor
Konrad Adenauer,
8 December 1966
Gelatin silver print, 24 x 30.5 cm
Rheinisches Landesmuseum Bonn
Plate 100

288
Darchinger, Jupp
The ruins of the Reichstag, Berlin,
1955
Gelatin silver print
23.8 x 30.4 cm
Rheinisches Landesmuseum Bonn
Frontispiece

289
Darchinger, Jupp
Traffic jam at the East-West
German border near Helmstedt,
1955
Gelatin silver print
23.8 x 30.3 cm
Rheinisches Landesmuseum Bonn

290
Fischer, Arno
Marlene Dietrich in Moscow,
1964
Gelatin silver print (1990)
35.6 x 24 cm
Berlinische Galerie, Landes-
museum für Moderne Kunst,
Photographie und Architektur,
Photography Collection

291
Fischer, Arno
Marlene Dietrich in Moscow,
1964
Gelatin silver print (1990)
32.2 x 24.2 cm
Berlinische Galerie, Landes-
museum für Moderne Kunst,
Photographie und Architektur,
Photography Collection

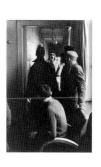

292
Fischer, Arno
Marlene Dietrich in Moscow,
1964
Gelatin silver print (1990)
34.9 x 23.6 cm
Berlinische Galerie, Landes-
museum für Moderne Kunst,
Photographie und Architektur,
Photography Collection

293
Fischer, Arno
Marlene Dietrich in Moscow,
1964
Gelatin silver print (1990)
36.3 x 24.4 cm
Berlinische Galerie, Landes-
museum für Moderne Kunst,
Photographie und Architektur,
Photography Collection
Plate 94

294
Fischer, Arno
East Berlin, 1957
Gelatin silver print (1988)
23.2 x 35.1 cm
Berlinische Galerie, Landes-
museum für Moderne Kunst,
Photographie und Architektur,
Photography Collection

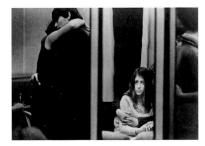

295
Fischer, Arno
West Berlin, 1959
Gelatin silver print (1988)
24 x 35 cm
Berlinische Galerie, Landes-
museum für Moderne Kunst,
Photographie und Architektur,
Photography Collection
Plate 103

296
Flöter, Hubs
Hildegard Knef, 1950
Gelatin silver print
30.5 x 23.9 cm
Fotomuseum im Münchner
Stadtmuseum
Plate 95

297
Flöter, Hubs
View from the Zugspitze,
Bessi Becker, 1954
Gelatin silver print
30.5 x 24 cm
Fotomuseum im Münchner
Stadtmuseum

298
Gillhausen, Rolf
From the series Images of
Postwar Germany, 1957 Election
Campaign: Chancellor Konrad
Adenauer leaving his special
traincar, 1957
Gelatin silver print, 57.5 x 38.7 cm
Museum Folkwang Essen
Plate 101

299
Gillhausen, Rolf
From the reportage "Would you
shoot at Germans?"
Village in the restricted zone,
1963
Gelatin silver print
38.2 x 56.7 cm
Museum Folkwang Essen

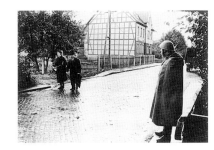

300
Gundlach, F. C.
Christa in front of Schloss
Charlottenburg, Berlin,
c. 1956
Gelatin silver print (1989)
40 x 30.5 cm
Rheinisches Landesmuseum
Bonn
Gesellschaft Photo-Archiv

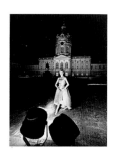

301
Gundlach, F. C.
Rankestrasse, Biggi,
Berlin, 1963
Gelatin silver print
30.8 x 30 cm
Rheinisches Landesmuseum Bonn
Gesellschaft Photo-Archiv
Plate 106

302
Gundlach, F. C.
In the flickering light, Simone
d'Alencourt, Berlin,
1957
Colour gelatin silver print
77 x 75.5 cm
F. C. Gundlach Collection

303
Hallensleben, Ruth
Advertisement for garages,
c. 1958
Gelatin silver print
12.7 x 173 cm
Rheinisches Landesmuseum
Bonn
Plate 99

304
Häusser, Robert
Nescafé, 1954
Gelatin silver print
62 x 76 cm
Robert Häusser
Plate 114

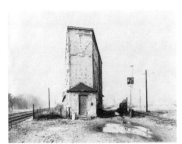

305
Häusser, Robert
Periphery, 1953
Gelatin silver print
44 x 56.5 cm
Robert Häusser

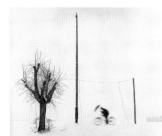

306
Häusser, Robert
Cyclist, 1953
Gelatin silver print
47.5 x 52 cm
Robert Häusser

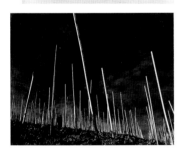

307
Häusser, Robert
Vineyard, 1955
Gelatin silver print
61.5 x 77.5 cm
Robert Häusser

308
Hensky, Herbert
KPD-SPD party rally,
Berlin,
22 April 1946
Gelatin silver print (1990)
38 x 29 cm
Berlinische Galerie, Landes-
museum für Moderne Kunst,
Photographie und Architektur,
Photography Collection

309
Hensky, Herbert
Adolf Hennecke in the coal mine in
Oelsnitz, Erzgebirge, 20 October
1948
Gelatin silver print
29 x 22.4 cm
Berlinische Galerie, Landes-
museum für Moderne Kunst,
Photographie und Architektur,
Photography Collection
Plate 81

310
Hensky, Herbert
Greeting the government, Berlin,
11 October 1949
Gelatin silver print (1990)
26 x 39 cm
Berlinische Galerie, Landes-
museum für Moderne Kunst,
Photographie und Architektur,
Photography Collection
Plate 80

311
Hoepffner, Marta
Movement, 1940
Gelatin silver print (1960)
30.2 x 20.2 cm
Museum für Kunst und Gewerbe
Hamburg

312
Höpker, Thomas
From the GDR series, 4/31
(kissing couples), c. 1966
Gelatin silver print
17 x 25.6 cm
Fotomuseum im Münchner
Stadtmuseum

313
Höpker, Thomas
From the GDR series, 4/31
(soldier), c. 1966
Gelatin silver print, 25.7 x 18.7 cm
Fotomuseum im Münchner Stadt-
museum
Plate 102

314
Jansen, Arno
Big Brother, from the Screw
series, 1968–1974
Negative montage and
photogram, 1969
Gelatin silver print
58.5 x 50.2 cm
Arno Jansen

315
Jansen, Arno
Portent, from the Screw series,
1968–1974
Negative montage and
photogram, 1969
Gelatin silver print
56 x 50.8 cm
Arno Jansen

316
Jansen, Arno
Copier montage, untitled, 1970
Gelatin silver print
50.8 x 49.5 cm
Arno Jansen

317
Jäger, Gottfried
4 perforated screen patterns
3.8.14 F 3.1–3.4,
camera obscura work, 1967
Gelatin silver print
each 51 x 51 cm
Gottfried Jäger

318
Keetman, Peter
1001 faces, 1957
Gelatin silver print
39.4 x 30.3 cm
F. C. Gundlach Collection

319
Keetman, Peter
Garden chairs, Wendelstein, 1950
Gelatin silver print
28.8 x 39.2 cm
Museum Folkwang Essen

320
Keetman, Peter
Untitled, c. 1950
Gelatin silver print
23.2 x 25.5 cm
Museum Folkwang Essen

321
Keetman, Peter
Untitled, 1950
Gelatin silver print, 23 x 17.1 cm
Museum Folkwang Essen

322
Keetman, Peter
Drops of oil, 1956
Gelatin silver print, 40.5 x 50 cm
Manfred Heiting Collection; plate 92

323
Keetman, Peter
Stachus, 1953
Gelatin silver print
30.3 x 23.1 cm
F. C. Gundlach Collection

324
Kesting, Edmund
Self portrait in profile (with one
eye), c. 1955
Gelatin silver print, sandwich
method, negative montage
23.7 x 17.7 cm
Kupferstich-Kabinett Dresden

325
Kesting, Edmund
Self portrait, c. 1955
Gelatin silver print, montage and
photogram, 40.3 x 30 cm
Kupferstich-Kabinett Dresden
Plate 77

326
Kiesling, Gerhard
Adenauer at the Brandenburg
Gate, Berlin, 1961
Gelatin silver print (1989)
24.7 x 34.4 cm
Berlinische Galerie, Landes-
museum für Moderne Kunst,
Photographie und Architektur,
Photography Collection

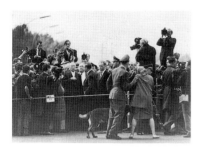

327
Kiesling, Gerhard
LPG Worin, 1955
Gelatin silver print (1989)
24.6 x 34.4 cm
Berlinische Galerie, Landes-
museum für Moderne Kunst,
Photographie und Architektur,
Photography Collection

328
Kiesling, Gerhard
Steelworks, Riesa,
1952
Gelatin silver print (1987)
34.4 x 24.6 cm
Berlinische Galerie, Landes-
museum für Moderne Kunst,
Photographie und Architektur,
Photography Collection

329
Kühn, Fritz
Untitled (supporting wall), 1955
Gelatin silver print
36.8 x 28.7 cm
Berlinische Galerie, Landes-
museum für Moderne Kunst,
Photographie und Architektur,
Photography Collection
Plate 88

330
Kühn, Fritz
Untitled (reeds),
c. 1955
Gelatin silver print
29.9 x 29.7 cm
Berlinische Galerie, Landes-
museum für Moderne Kunst,
Photographie und Architektur,
Photography Collection

331
Kühn, Fritz
Untitled (sunlight in the forest),
c. 1955
Gelatin silver print
37 x 33.7 cm
Berlinische Galerie, Landes-
museum für Moderne Kunst,
Photographie und Architektur,
Photography Collection
Plate 89

332
Kühn, Fritz
Untitled (curtain and chair
shadow),
1958
Gelatin silver print
23.8 x 22.6 cm
Berlinische Galerie,
Landesmuseum
für Moderne Kunst,
Photographie und Architektur,
Photography Collection

333
Lazi, Adolf
Portrait of Eta Lazi,
undated
Gelatin silver print
40 x 29.4 cm
F. C. Gundlach Collection

334
Lazi, Adolf
Portrait, undated
Gelatin silver print
29.7 x 39.3 cm
F. C. Gundlach Collection

335
Lazi, Adolf
Portrait of Willi Baumeister, 1947
Gelatin silver print
29.6 x 40.1 cm
F. C. Gundlach Collection
Plate 97

336
Lebeck, Robert
Returning home, Friedland, 1955
Gelatin silver print
26.8 x 26.8 cm
Rheinisches Landesmuseum Bonn
Gesellschaft Photo-Archiv
Plate 82

337
Mai, Karl Heinz
Identity card photograph, Gerda,
Leipzig, 1948
Gelatin silver print (1988)
39.8 x 26.2 cm
Berlinische Galerie, Landes-
museum für Moderne Kunst,
Photographie und Architektur,
Photography Collection
Plate 79

338

Mai, Karl Heinz
Identity card photograph, Anna,
1948
Gelatin silver print (1988)
39.2 x 26.3 cm
Berlinische Galerie, Landes-
museum für Moderne Kunst,
Photographie und Architektur,
Photography Collection

339

Mai, Karl Heinz
Identity card photograph, Elfriede,
1948
Gelatin silver print (1988)
39.7 x 26.1 cm
Berlinische Galerie, Landes-
museum für Moderne Kunst,
Photographie und Architektur,
Photography Collection

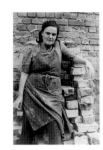

340
Mai, Karl Heinz
"Trümmerfrau", Leipzig,
1949
Gelatin silver print
(1992)
39.9 x 26.8 cm
Berlinische Galerie, Landes-
museum für Moderne Kunst,
Photographie und Architektur,
Photography Collection

341
Mai, Karl Heinz
"Trümmerfrau" (II), Leipzig 1949
Gelatin silver print
(1988)
39.7 x 26.3 cm
Berlinische Galerie, Landes-
museum für Moderne Kunst,
Photographie und Architektur,
Photography Collection
Plate 78

342
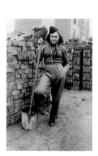
Mai, Karl Heinz
"Trümmerfräulein",
Leipzig 1949
Gelatin silver print (1988)
39.7 x 26.3 cm
Berlinische Galerie, Landes-
museum für Moderne Kunst,
Photographie und Architektur,
Photography Collection

343
March, Charlotte
Model with bathtowel, c. 1960
Gelatin silver print (1962)
39.9 x 28.3 cm
Museum Ludwig, Cologne,
Gruber Collection

344
March, Charlotte
Model with two dogs, c. 1962
Gelatin silver print (1964)
39.8 x 29.2 cm
Museum Ludwig, Cologne,
Gruber Collection; plate 107

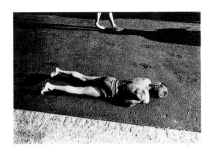

345
McBride, Will
Boy warming himself on asphalt,
Berlin, 1957
Gelatin silver print
37 x 54.5 cm
Rheinisches Landesmuseum
Bonn

346
McBride, Will
War games among the ruins,
Berlin, 1957
Gelatin silver print
53.8 x 36.7 cm
Rheinisches Landesmuseum
Bonn

347
McBride, Will
Wall with a white line, Berlin,
1957
Gelatin silver print
37.8 x 55.5 cm
Rheinisches Landesmuseum Bonn
Plate 85

348
McBride, Will
Lappes and Evi greeting Will,
1959
Gelatin silver print
36.6 x 54.1 cm
Rheinisches Landesmuseum
Bonn

349
Moegle, Willi
Chemist's bottles,
Gral Glassworks, 1954
Gelatin silver print
59.8 x 35.8 cm
Museum Ludwig, Cologne; plate 90

350
Moegle, Willi
Ashtray, Arzberg, 1955
Gelatin silver print
42.6 x 31.8 cm
Museum Ludwig, Cologne

351
Moegle, Willi
Prototypes, c. 1954
Gelatin silver print
59.6 x 48.9 cm
Museum Ludwig, Cologne

352
Moll, Jochen
(Joachim Mollenschott)
"Trümmerfrauen", Berlin, 1952
Gelatin silver print (1990)
40 x 29.7 cm
Berlinische Galerie,
Landesmuseum
für Moderne Kunst,
Photographie und Architektur,
Photography Collection

353
Moll, Jochen
(Joachim Mollenschott)
"Stalin dead", March 1953
Gelatin silver print (1990)
40.1 x 29.7 cm
Berlinische Galerie, Landes-
museum für Moderne Kunst,
Photographie und Architektur,
Photography Collection

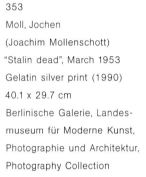

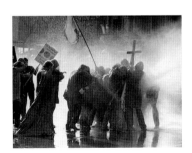

354
Moll, Jochen
(Joachim Mollenschott)
Violence against demonstrators,
Easter 1968
Gelatin silver print (1990)
29.9 x 39.9 cm
Berlinische Galerie, Landes-
museum für Moderne Kunst,
Photographie und Architektur,
Photography Collection

355
Moses, Stefan
Elly Ney, 1964
Gelatin silver print
34.3 x 26. 4
Rheinisches Landesmuseum
Bonn
Plate 105

356
Moses, Stefan
Theodor W. Adorno, 1964
Gelatin silver print
35.3 x 24.9 cm
Rheinisches Landesmuseum Bonn
Gesellschaft Photo-Archiv
Plate 108

357
Neuke, Angela
Demonstration against the
presentation of the Peace Prize
to President Senghor of Senegal,
Frankfurt am Main, October 1968
Gelatin silver print
49.5 x 60.4 cm
Angela Neuke
Plate 116

358
Neuke, Angela
Fritz Teufel and friends after the
demonstration against the
presentation of the Peace Prize
to President Senghor of Senegal,
Frankfurt am Main,
October 1968
Gelatin silver print
45 x 60.6 cm
Angela Neuke

359
Neusüss, Floris M.
Untitled, Body photogram,
Berlin,
1963
Photogram on technical paper
168 x 98 cm
Floris M. Neusüss
Plate 115

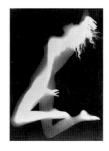

360
Neusüss, Floris M.
Untitled, Body photogram,
Munich, 1964
Photogram on technical
paper
155 x 120 cm
Floris M. Neusüss

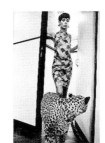

361
Newton, Helmut
Tuffin & Foale, *VOGUE* England,
London 1965
Gelatin silver print
61 x 44 cm
Rheinisches Landesmuseum Bonn

362
Newton, Helmut
Colin Glascoe, *VOGUE* England,
London 1965
Gelatin silver print
61 x 44 cm
Rheinisches Landesmuseum Bonn

363
Newton, Helmut
National Fur Co., *QUEEN,*
London 1967
Gelatin silver print
61 x 44 cm
Rheinisches Landesmuseum Bonn

364
Newton, Helmut
Tigre Royal, *VOGUE* France,
Paris 1969
Gelatin silver print
61 x 44 cm
Rheinisches Landesmuseum Bonn,
permanent loan; plate 110

365
Newton, Helmut
Saga, *VOGUE* France,
Paris 1969
Gelatin silver print
61 x 44 cm
Rheinisches Landesmuseum Bonn
plate 111

366
Nothhelfer, Gabriele and Helmut
Düsseldorf-Benrath, 1970
Gelatin silver print
19.8 x 29.4 cm
Rheinisches Landesmuseum
Bonn
Ill. p. 7

367
Nothhelfer, Gabriele and Helmut
Düsseldorf-Benrath, 1970
Gelatin silver print
19.4 x 28.8 cm
Rheinisches Landesmuseum
Bonn

368
Nothhelfer, Gabriele and Helmut
Düsseldorf-Benrath, 1970
Gelatin silver print
18.9 x 28.8 cm
Rheinisches Landesmuseum
Bonn

369
Orlopp, Detlef
Untitled, 1966
Gelatin silver print
49.8 x 59.5 cm
Courtesy Galerie Karsten Greve

370
Orlopp, Detlef
Untitled, 1967
Gelatin silver print
49.8 x 49.5 cm
Courtesy Galerie Karsten Greve

371
Orlopp, Detlef
Untitled, 1967
Gelatin silver print
49.8 x 49.5 cm
Courtesy Galerie Karsten Greve

372
Orlopp, Detlef
Untitled, 1970
Gelatin silver print
51.2 x 48.2 cm
Courtesy Galerie Karsten Greve
Plate 119

373
Peter sen., Richard
Dresden, Mass grave in an air
raid shelter, 1946

Gelatin silver print (after 1960)
47.2 x 38.3 cm
Kupferstich-Kabinett Dresden
Plate 75

374
Peter sen., Richard
Dresden, Interior of the
Semper Opera House, 1945
Gelatin silver print (after 1960)
49.5 x 39 cm
Kupferstich-Kabinett Dresden
Plate 74

375
Peter sen., Richard
The municipal archives,
1946
Gelatin silver print (after 1960)
39.5 x 46.8 cm
Kupferstich-Kabinett
Dresden

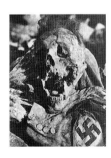

376
Peter sen., Richard
Compass IV, looking south-west,
1945
Gelatin silver print
(after 1960)
58.7 x 48.7 cm
Kupferstich-Kabinett
Dresden

377
Peter sen., Richard
Dead block warden in uniform,
1946
Gelatin silver print
(c. 1960)
38.5 x 29.5 cm
Kupferstich-Kabinett Dresden

378
Polke, Sigmar
4 untitled photographs,
1969
Gelatin silver print
each 60.5 x 50.5 cm
Museum Wiesbaden
Plate 122

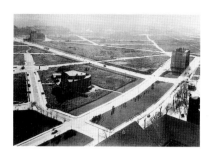

379
Pritsche, Willy
Dresden, 1952
Gelatin silver print (1997)
31.5 x 49.3 cm
Kupferstich-Kabinett
Dresden

380
Relang, Regina
Florence, Simonetta, 1955
Gelatin silver print
37 x 30.5 cm
Fotomuseum im Münchner
Stadtmuseum

381
Relang, Regina
Rome, Capucci, 1957
Gelatin silver print
39.3 x 30 cm
Fotomuseum im Münchner
Stadtmuseum

382
Renger-Patzsch, Albert
Zellenberg in Alsace, 1950
Gelatin silver print
23.3 x 38.4 cm
Manfred Heiting Collection

383
Richter, Evelyn
World Youth Festival, Moscow
(dove), 1957, Gelatin silver print
39.8 x 49.9 cm
Staatliche Galerie Moritzburg,
Halle, Archive Fotokinoverlag

384
Richter, Evelyn
At the linotype, 1959
Gelatin silver print (1988)
19.6 x 30.4 cm
Berlinische Galerie,
Landesmuseum
für Moderne Kunst,
Photographie und Architektur,
Photography Collection

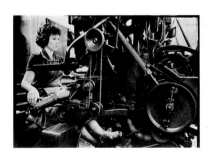

385
Richter, Evelyn
David Oistrach, Berlin, 1962
Gelatin silver print (1988)
19.5 x 30.1 cm
Berlinische Galerie,
Landesmuseum
für Moderne Kunst,
Photographie und Architektur,
Photography Collection

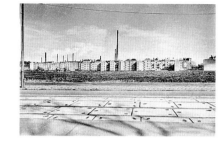

386
Richter, Evelyn
Magdeburg, 1962
Gelatin silver print, 37 x 47.6 cm
Staatliche Galerie Moritzburg,
Halle, Archive Fotokinoverlag

387
Richter, Evelyn
Mstislav Rostropovich, 1968
Gelatin silver print
(c. 1988)
29.4 x 19.2 cm
Berlinische Galerie, Landes-
museum für Moderne Kunst,
Photographie und Architektur,
Photography Collection
Plate 104

388
Richter, Evelyn
Mikhail Petuchov, c. 1970
Gelatin silver print (1988)
19.6 x 30.4 cm
Berlinische Galerie,
Landesmuseum
für Moderne Kunst,
Photographie und Architektur,
Photography Collection

389
Ruetz, Michael
German characters, No. 3,
Rudi Dutschke in the Auditorium
Maximum of the Freie
Universität Berlin, 1967
Gelatin silver print
62.5 x 94.8 cm
Michael Ruetz, Berlin; plate 117

390
Ruetz, Michael
German characters, No. 53,
Herbert Marcuse in the Auditorium
Maximum of the Freie Universität
Berlin, 1968
Gelatin silver print
95.2 x 62.6 cm
Michael Ruetz, Berlin

391
Ruetz, Michael
German characters, No. 57, Protest
march against air traffic noise,
Hahn Air Force Base, Hunsrück,
1969
Gelatin silver print, 62.5 x 95 cm
Michael Ruetz, Berlin

392
Ruetz, Michael
German characters, No. 26,
Fritz Teufel and R. Langhans,
Kommune I, 1968
Gelatin silver print
95.3 x 62.3 cm
Michael Ruetz, Berlin

393
Ruetz, Michael
The unrelated gaze, No. 0031,
The Masses, 1969
Gelatin silver print
62.3 x 94.3 cm
Michael Ruetz, Berlin

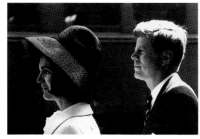

394
Scheler, Max
John and Jackie Kennedy,
Washington 1963
Gelatin silver print, 30 x 40 cm
Max Scheler

395
Scheler, Max
De Gaulle in a bar in Châtillon
(Lyonnais), 1965
Gelatin silver print, 30 x 40 cm
Max Scheler; plate 112

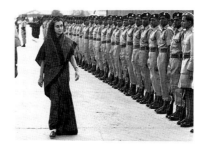

396
Scheler, Max
Indira Gandhi, Ganhati, 1965
Gelatin silver print, 30 x 40 cm
Max Scheler

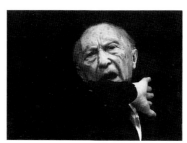

397
Scheler, Max
Konrad Adenauer's election
campaign, Dortmund, 1965
Gelatin silver print
30 x 40 cm
Max Scheler

398
Steinert, Otto
Antiquités, 1949
Gelatin silver print
40.1 x 28.8 cm
Museum Folkwang Essen

399
Steinert, Otto
One-legged pedestrian, 1950
Gelatin silver print
28.8 x 40.4 cm
Museum Folkwang Essen
Plate 86

400
Steinert, Otto
Mask of a dancer, 1952
Gelatin silver print
61 x 47 cm
Museum Folkwang Essen

401
Steinert, Otto
Black nude, 1958
Gelatin silver print, 39.1 x 29.5 cm
Museum Folkwang Essen
Manfred Heiting Collection

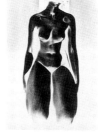

402
Strelow, Liselotte
Gottfried Benn, 1955
Gelatin silver print
22.9 x 24.7 cm
Rheinisches Landesmuseum Bonn

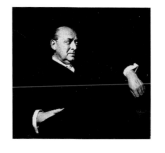

403
Strelow, Liselotte
Oscar Fritz Schuh, 1955
Gelatin silver print
29.1 x 22.2 cm
Rheinisches Landesmuseum Bonn
Gesellschaft Photo-Archiv

404
Strelow, Liselotte
Lea Steinwasser, 1964
Gelatin silver print
25.5 x 23.7 cm
Rheinisches Landesmuseum Bonn
Gesellschaft Photo-Archiv
Plate 109

405
Strelow, Liselotte
Thomas Mann, 1954
Gelatin silver print
26 x 20.7 cm
Rheinisches Landesmuseum Bonn

406
Tobias, Herbert
Andreas Baader, Berlin,
c. 1962
Gelatin silver print
50.4 x 40.3 cm
F. C. Gundlach Collection

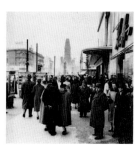

407
Tobias, Herbert
Berlin Kurfürstendamm, 1954
Gelatin silver print
35 x 34.7 cm
F. C. Gundlach Collection

408
Tobias, Herbert
Untitled (street scene), Berlin,
c.1954
Gelatin silver print
34.3 x 34.5 cm
F. C. Gundlach Collection

409
Tobias, Herbert
The Berlin Party is Over, 1960

Gelatin silver print
34.4 x 34.5 cm
F. C. Gundlach Collection
Plate 96

410
Umbo
Bullet shells,
1946
Gelatin silver print
16.9 x 11.7 cm
Museum Ludwig, Cologne

411
Wilp, Charles
Pushkin for real men,
1958
Colour gelatin silver print
40 x 30 cm
Private collection

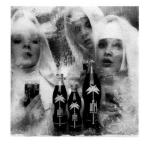

412
Wilp, Charles
Afri Cola,
1967
Colour gelatin silver print
31.5 x 30 cm
Private collection

413
Wilp, Charles
Bosco Tonic, 1969
Colour gelatin silver print
29 x 29.5 cm
Private collection

414
Wilp, Charles
Charles Wilp taken against an
abstract horizon in Düsseldorf
and merged with the geographic
horizon at the Indian Ocean.
Wilp sees his own horizon at
eye level,
1957
Colour gelatin silver print
(c. 1970)
31.5 x 30 cm
Private collection
Plate 113

415
Windstosser, Ludwig
Untitled (industrial complex),
c. 1950
Gelatin silver print
29.9 x 23.6 cm
Museum Folkwang Essen

416
Windstosser, Ludwig
The leaning tower of Pisa, c. 1950
Gelatin silver print
29 x 22.7 cm
Museum Folkwang Essen

417
Windstosser, Ludwig,
Blast furnace, c. 1951
Gelatin silver print
26.5 x 23.5 cm
Manfred Heiting Collection
Plate 98

418
Windstosser, Ludwig
Florence stock exchange, c. 1952
Gelatin silver print
57.5 x 47.8 cm
Manfred Heiting Collection

419
Klauke, Jürgen
I & I
Day drawings and photo
sequences,
October 1970 – February 1971
Self-publication, Cologne, 1972
Jürgen Klauke

420
Rinke, Klaus
Temporal translocation,
documenta 5, Kassel, 1972
Gelatin silver print
220 x 120 cm
Courtesy of Galerie Kicken,
Cologne

421
Rinke, Klaus
4 moments, 1972
Gelatin silver print
4 parts, each 48 x 60 cm
Courtesy of Galerie Kicken,
Cologne

Rolf Sachsse

Biographical and bibliographical notes on the photographers presented in the exhibition

Carl Andreas Abel (Wuppertal 1907–1994 Cologne), photographer.
Lit.: Abel, Carl Andreas: *Der Beobachter hinter der Kamera*, exh. cat., Bonn 1992.

Josef Albers (Bottrop 1888–1976 Orange CT), painter and photographer.
Lit.: Albers, Josef: *Fotografien*, exh. cat., Bottrop 1994.

Erich Angenendt (Castrop 1894–1962 Dortmund), photographer.
Lit.: *50 Jahre GDL*, exh. cat., Hamburg 1969, p. 93; *Angenendt, eine Foto-grafenfamilie*, exh. cat., Dortmund/Heidelberg 1996.

Ottomar Anschütz (Lissa/Posen 1846–1907 Berlin), photographer.
Lit.: Baier, W.: *Geschichte der Fotografie in Quellendarstellungen*. Leipzig 1977, pp. 318, 423.

Dieter Appelt (Niemegk 1935), photographer and performer.
Lit.: *Einstellung 25*, exh. cat., Berlin/London 1994.

Ursula Arnold (Gera 1929), photographer and film-maker.
Lit.: *Nichts ist so einfach wie es scheint: ostdeutsche Photographie 1945–1989*, exh. cat., Berlin 1992, p. 92.

Marta Astfalck-Vietz (Neudamm 1901–1994 Nienhagen), photographer and therapist.
Lit.: *Marta Astfalck-Vietz*, exh. cat., Berlin 1991.

Ellen Auerbach PIT (Ellen Rosenberg) (Karlsruhe 1906).
Lit.: *Fotografie am Bauhaus*, exh. cat., Berlin 1990, p. 340.

Walter Ballhause (Hameln 1911–1991).
Lit.: Ballhause, Walter: *Zwischen Weimar und Hitler*. Munich 1984.

Monika Baumgartl (Prague 1942), photographer and concept artist.
Lit.: *Monika Baumgartl. Zeitpunkte – Zeitlinien*, exh. cat., Bonn 1979.

Herbert Bayer (Haag, Austria 1900–1985 Santa Barbara CA), graphic designer, designer, artist.
Lit.: Bayer, Herbert: *Das künstlerische Werk 1918–1938*, exh. cat., Berlin 1982; Sachsse, Rolf: "Von Österreich aus I: Herbert Bayer". In: *Camera Austria*. 16 (1994), no. 46, pp. 3–11.

Bernhard (Siegen 1931) **and Hilla** (Potsdam 1934) (Wobeser-)**Becher,** concept artists.

Lit.: *Bernd und Hilla Becher, Fotografien 1957–75*, exh. cat., Bonn 1975; *Bernd und Hilla Becher, Tipologie Typologien Typologies*, exh. cat., Venice/Munich 1990; *Bernd und Hilla Becher, Gasbehälter*, Munich 1993; *Bernd und Hilla Becher, Fabrikhallen*, Munich 1995; *Bernd und Hilla Becher, Industriephotographie*, exh. cat., Düsseldorf 1995; *Bernd und Hilla Becher, Fördertürme*. Munich 1996.

Ella Bergmann-Michel (Paderborn 1895–1971 Vockenhausen), graphic designer, photographer and film-maker.
Lit.: *Ella Bergmann-Michels*, exh. cat., Hannover 1990.

Aenne (Sternefeld-)**Biermann** (Goch 1898–1933 Gera), photographer.
Lit.: Roh, Franz: *Aenne Biermann, 60 Fotos*, exh. cat., Munich 1930; *Aenne Biermann, Fotografien 1925–33*, exh. cat., Essen/Berlin 1987.

Thomas Billhardt (1937), photographer.

Karl Blossfeldt (Schielo/Harz 1865–1932 Berlin), modeler and photographer.
Lit.: Blossfeldt, Karl: *Urformen der Kunst*. Berlin 1925; Blossfeldt, Karl: *Wundergarten der Natur*. Berlin 1932; Sachsse, Rolf: *Karl Blossfeldt*. Cologne 1993.

Monika von Boch(-Galhau) (Mettlach 1915), photographer.
Lit.: *Monika von Boch, das fotografische Werk 1950–1980*, exh. cat., Dillingen 1982.

Kilian Breier (Ensheim/Saarbrücken 1931), photographer.
Lit.: *Kilian Breier, Fotografische Arbeiten 1953–1986*, exh. cat., Hamburg 1987.

Marianne Breslauer(-Feilchenfeldt) (Berlin 1909), photographer.
Lit.: Breslauer, Marianne: *Retrospektive Fotografie 2*. Düsseldorf 1979.

Fritz Brill (Hannover 1904), photographer.
Lit.: *Fritz Brill, Grafik Fotografie Analyse*, exh. cat., Berlin 1982.

Johannes Brus (Gelsenkirchen-Buer 1942), artist and film-maker.
Lit.: *Ars viva 1979/80, Arbeiten im Medium Photographie*. Lüneburg 1979.

Max Burchartz (Elberfeld 1887–1961 Essen), graphic designer and educationalist.
Lit.: Burchartz, Max: *Schule des Schauens*. Munich 1962.

Rolf Cavael (Königsberg 1898–1979 Munich), painter and graphic designer.
Lit.: Keller, Horst: *Cavael*. Munich 1984.

Chargesheimer (Karl-Heinz Hargesheimer) (Cologne 1924–1972 Cologne), photographer and stage designer.
Lit.: *Chargesheimer, Zwischenbilanz.* Cologne 1962; *Chargesheimer persönlich*, exh. cat., Cologne 1989; Mißelbeck, Reinhold: *Chargesheimer: Schöne Ruinen.* Cologne 1994.

Hermann Claasen (Cologne 1899–1987 Cologne), photographer.
Lit.: Honnef, Klaus/Müller, Walter: *Hermann Claasen: Nie wieder Krieg!* Cologne 1995; Sachsse, Rolf: *Werkverzeichnis Hermann Claasen, vol. 1 Portraits.* Cologne 1993; *vol. 2 Trümmer.* Cologne 1996; *vol. 3 Experimente.* Cologne 1997.

Rosemarie Clausen(-Kögel) (Berlin 1907–1990 Hamburg), stills and theatre photographer.
Lit.: *50 Jahre GDL*, exh. cat., Hamburg 1969, p. 95.

Edmund Collein (Bad Kreuznach 1906), architect and photographer.
Lit.: *Fotografie am Bauhaus*, exh. cat., Berlin 1990, p. 343.

Erich Comeriner (Vienna 1907–1978 Tel Aviv), photo-journalist.
Lit.: *Fotografie am Bauhaus*, exh. cat., Berlin 1990, p. 343.

Erich Consemüller (Bielefeld 1902–1957 Halle/Saale), architect and photographer.
Lit.: *Erich Consemüller, Fotografien Bauhaus Dessau,* exh. cat., Munich 1989.

Jupp Heinz (Josef Heinrich) **Darchinger** (Bonn 1925), photo-journalist.
Lit.: Darchinger, J. H.: "Fotografie im politischen Tagesgeschehen (1980)". In: *Gegen die Indifferenz der Fotografie.* Fachhochschule Bielefeld (ed.). Düsseldorf 1986, pp. 49–52; Darchinger, J. H./Kaiser, Chr. (ed.): *Die Köpfe.* Bonn 1997.

Minya (Julie Wilhelmine) **Diez-Dührkoop** (Hamburg 1873–1929 Hamburg), photographer.
Lit.: *Kunstphotographie um 1900 in Deutschland,* exh. cat., Stuttgart 1982.

Rudolf Dührkoop (Hamburg 1848–1918 Hamburg), photographer.
Lit.: *Kunstphotographie um 1900 in Deutschland,* exh. cat., Stuttgart 1982.

Max Ehlert (Berlin 1904–1979 Hamburg), press photographer.
Lit.: *Das deutsche Auge,* exh. cat., Hamburg 1996, pp. 136–37.

Alfred Eisenstaedt (Dirschau 1898–1995 Long Island NY), photo-journalist.
Lit.: *Eisenstaedt über Eisenstaedt.* Munich 1985.

Siegfried Enkelmann (Krasnopol 1905–1978 Munich), photographer.
Lit.: *Hugo Erfurth*, exh. cat., Cologne 1992, p. 51.

Hugo Erfurth (Halle 1874–1948 Gaienhofen/Lake Constance), portrait-photographer.
Lit.: *Hugo Erfurth, Fotograf zwischen Tradition und Moderne,* exh. cat., Cologne 1992.

Alfred Erhardt (Triptis/Thuringia 1901–1984 Hamburg), photographer, graphic designer and film-maker.
Lit.: *Fotografie am Bauhaus*, exh. cat., Berlin 1990, p. 344.

Errell (Richard Levy) (Krefeld 1899–1986 Locarno), graphic designer and photographer.
Lit.: Errell, Richard: *Bilderbuch für Vergeßliche.* Frankfurt/M. 1961; *Errell, Fotograf und Grafiker,* exh. cat., Essen 1984.

Frank Eugene (F. E. Smith) (New York 1865–1936 Munich), photographer.
Lit.: *Frank Eugene, The Dream of Beauty,* exh. cat., Munich 1995.

Andreas Feininger (Paris 1906), photographer and educationalist.
Lit.: *Fotografie am Bauhaus*, exh. cat., Berlin 1990.

T. Lux Feininger (Berlin 1910), painter and photographer.
Lit.: *Fotografie am Bauhaus*, exh. cat., Berlin 1990.

Hans Finsler (Heilbronn 1891–1972 Zurich), art historian, photographer and educationalist.
Lit.: *Hans Finsler. Neue Wege der Fotografie,* exh. cat., Halle/Zurich 1991.

Arno Fischer (Berlin 1927), photographer.
Lit.: *Frühe Bilder. Eine Ausstellung zur Geschichte der Fotografie in der DDR,* exh. cat., Leipzig 1985.

Hannes Maria Flach (Cologne 1901–1936 Cologne), businessman and amateur photographer.
Lit.: *Hannes Maria Flach,* exh. cat., Cologne 1983.

Hubs Flöter (Cologne 1910–1974 Munich), fashion photographer.
Lit.: *Vom New Look zum Petticoat,* exh. cat., Berlin 1984.

Walter Frentz (1907), sportsman, cameraman and freelance lecturer.

Georg Gidal (Munich 1908–1931), photographer.
Lit.: Gidal, Tim Nachum: *Chronisten des Lebens. Die moderne Fotoreportage.* Berlin 1993.

Tim Gidal (Ignaz Nachum Gidalewitsch) (Munich 1909–1996 Tel Aviv), photo-journalist.
Lit.: Gidal, Tim Nachum: *Deutschland – Beginn des modernen Fotojournalismus.* Frankfurt/M./Luzern 1972, reprinted Berlin 1993; *Tim Gidal, Bilder der dreißiger Jahre,* exh. cat., Essen 1984; Gidal, Tim Nachum: *Begegnungen mit Karl Valentin.* Munich 1995.

Rolf Gillhausen (Cologne 1922), photographer and picture editor.
Lit.: *Rolf Gillhausen, Film und Fotoreportagen,* exh. cat., Essen 1986.

Baron Wilhelm von Gloeden (Volkshagen/Wismar 1856–1931 Taormina), photographer.

Lit.: Pohlmann, Ulrich: *Wilhelm von Gloeden – Sehnsucht nach Arkadien.* Berlin 1987.

Hein Gorny (Witten 1904–1967 Hannover), industrial and advertising photographer.

Lit.: *Hein Gorny*, exh. cat., Hannover 1972.

Werner Graeff (Wuppertal 1901–1978 Blacksburg VA), photographer, exhibition organizer, author.

Lit.: *Fotografie am Bauhaus*, exh. cat., Berlin 1990, pp. 346–47.

Franz Grainer (Bad Reichenhall 1871–1948 Munich), photographer.

Lit.: *50 Jahre GDL*, exh. cat., Hamburg 1969, p. 98.

Mendel Grossman (1912–1944/45 Poland), painter and photographer.

Lit.: Hoffmann, Detlef: "Ein Bild aus dem Ghetto Lodz". In: *Bilder für Timm.* Marburg 1989, pp. 10–13.

F. C. Gundlach (Heinebach/Hesse 1926), photographer.

Lit.: *ModeWelten FC Gundlach*, exh. cat., Bonn/Berlin 1985.

John (Johann) **Gutmann** (Breslau 1905), photographer and educationalist.

Lit.: Van Deren, Coke: *Avantgarde Fotografie in Deutschland 1919–1939.* Munich 1982.

Helmut Hahn (Mönchengladbach 1928), photographer, textile artist, graphic designer.

Lit.: *Helmut Hahn, Spiel und Wirklichkeit.* Hahn, Helmut/Sachsse, Rolf: *Orte des Sehens, Gepflanzte Räume.* Korschenbroich 1993; Blum-Spieker, Helene: *Helmut Hahn. Textile Kunst.* Stuttgart 1996.

Heinz Hajek-Halke (Berlin 1898–1983 Berlin), artist and photographer.

Lit.: *GDL-Edition Heinz Hajek-Halke.* Leinfelden 1978.

Ruth Hallensleben (Cologne 1898–1977 Cologne), photographer.

Lit.: Peters, Ursula (ed.): *Frauenarbeit in der Industrie.* Berlin 1985; *R. Hallensleben, Industrie und Arbeit*, exh. cat., Essen 1990.

Raoul Hausmann (Vienna 1886–1971 Limoges), artist and author.

Lit.: Haus, Andreas: *R. Hausmann Kamerafotografien 1927–1957.* Munich 1979; Koch, Adelheid: *Ich bin immerhin der größte Experimentator Österreichs, Raoul Hausmann, Dada und Neodada.* Innsbruck 1994; *Raoul Hausmann, Der deutsche Spießer ärgert sich, Monographie 1886–1971*, exh. cat., Berlin/Stuttgart 1994; Sachsse, Rolf: "Von Österreich aus III: Raoul Hausmann". In: *Camera Austria.* 18 (1997), no. 54, pp. 3–11.

Robert Häusser (Stuttgart 1924), photographer.

Lit.: *Robert Häusser, Fotografische Bilder*, exh. cat., Stuttgart 1988.

Wolfgang Haut (Saarbrücken 1927), photographer.

John Heartfield (Helmut Herzfeld) (Schmargendorf/Berlin 1891–1968 Berlin), illustrator and "Fotomonteur".

Lit.: Heartfield, John: *Schnitt entlang der Zeit.* Dresden 1981; *John Heartfield*, exh. cat., Berlin/Bonn/Cologne 1990.

Walter Hege (Naumburg 1893–1955 Weimar), set designer, photographer.

Lit.: Beckmann, Angelika: *W. Hege und das fotografische Abbild der Naumburger Stifterfiguren.* Diss. phil. Berlin 1990; *Dom Tempel Skulptur, Architekturphotographien von Walter Hege*, exh. cat., Cologne 1993.

Heinrich Heidersberger (Linz, Austria 1906), photographer.

Lit.: *Heinrich Heidersberger*, exh. cat., Wolfsburg 1986.

Eugen Heilig (Stuttgart 1892–1975 Berlin), sculptor and worker-photographer.

Lit.: *Eugen Heilig: Arbeiterfotograf.* Berlin 1996.

Walter Heilig (Stuttgart 1925), photo-journalist.

Louis Held (Berlin 1851–1927 Weimar), photographer.

Lit.: Renno, R. & E. (ed.): *Weimar um 1900, Fotografien von Louis Held.* Leipzig 1984.

Fritz Henle (Dortmund 1909–1993 Puerto Rico), photo-journalist.

Lit.: *Fritz Henle 1909–1993*, exh. cat., Dortmund/Heidelberg 1995.

Herbert Hensky (Berlin 1910), photographer.

Lit.: *Frühe Bilder, Eine Ausstellung zur Geschichte der Fotografie in der DDR*, exh. cat., Leipzig 1985.

Jacob Hilsdorf (Bingen 1872–1916 Frankfurt/M.), photographer.

Lit.: *Jacob Hilsdorf 1872–1916, Fotograf im Jugendstil*, exh. cat., Bingen 1984.

Hannah Höch (Gotha 1889–1978 Berlin), painter and photographer.

Lit.: *Hannah Höch Collagen*, exh. cat., Stuttgart 1984.

Marta Hoepffner (Pirmasens 1912), painter, photographer, educationalist.

Lit.: *M. Hoepffner, Das fotografische und lichtkinetische Werk*, exh. cat., Ravensburg 1982.

Theodor (Hamburg 1868–1943 Hamburg) **& Oscar** (Hamburg 1871–1937 Ichenhausen) **Hofmeister,** amateur photographers.

Lit.: Philipp, C. G.: "Theodor und Oscar Hofmeister 'Die Geschwister' und Heinrich Wilhelm Müller 'Elegie' – ein romantisches Freundschaftsbild der Kunstphotographie um 1900". In: *Jahrbuch des Museums für Kunst und Gewerbe.* Hamburg 11/12 (1992/93), pp. 83–96.

Erich Höhne (Dresden 1912), precision engineer and photo-journalist.
Lit.: Kil, Wolfgang: *Hinterlassenschaft und Neubeginn*. Leipzig 1989, pp. 47–69; *Ende und Anfang, Photographen in Deutschland um 1945*, exh. cat., Berlin 1995, pp. 188–91.

Ewald Hoinkis (Görlitz 1897–1960 Bühl), painter, graphic designer and photographer.
Lit.: *Ewald Hoinkis, Fotografien 1924–60*, exh. cat., Essen 1988.

Thomas Höpker (Munich 1936), photographer.
Lit.: *Zeitprofile, 30 Jahre Kulturpreis der DGPh*, exh. cat., Cologne 1988.

Lotte Jacobi (Thorn 1897–1990 Concord NH), photographer, specialized in portraits and theatre.
Lit.: *Lotte Jacobi*, exh. cat., Essen 1990. Beckers, Marion/Mourtgat, Elisabeth: *Atelier Lotte Jacobi Berlin – New York*. Berlin 1997.

Gottfried Jäger (Burg 1937), photographer.
Lit.: Jäger, G.: *Fotoästhetik, Zur Theorie der Fotografie, Texte aus den Jahren 1965–1990*. Munich 1991; *Gottfried Jäger Indizes*, exh. cat., Bielefeld 1996.

Arno Jansen (Aachen 1938), photographer.
Lit.: *Vorstellung und Wirklichkeit*. Leverkusen, Cologne 1980; *Arno Jansen*, exh. cat., Bonn 1990.

Peter Keetman (Wuppertal 1916), photographer.
Lit.: Keetman, Peter: *fotoform*. Berlin 1988; Sachsse, Rolf: *Peter Keetman, Struktur und Bewegung*. Amsterdam 1996.

Edmund Kesting (Dresden 1892–1970 Berlin), painter and art educationalist.
Lit.: Werner, Klaus: *Edmund Kesting, ein Maler fotografiert*. Leipzig 1987.

Gerhard Kiesling (Greiz 1922), photo-journalist.
Lit.: *Das deutsche Auge*, exh. cat., Hamburg 1996, p. 138.

Jürgen Klauke (Kliding/Cochem 1943), concept and performance artist.
Lit.: *Jürgen Klauke, Formalisierung der Langeweile*, exh. cat., Bonn/Cologne 1980: *Jürgen Klauke, Eine Ewigkeit ein Lächeln*, exh. cat., Cologne 1986; *Jürgen Klauke, Prosecuritas*, exh. cat., Bielefeld/Stuttgart 1994.

Barbara Klemm (Münster 1939), photographer.
Lit.: *Barbara Klemm*, exh. cat., Hamburg 1976; *Barbara Klemm*, exh. cat., Essen 1982.

August Kotzsch (Dresden-Loschwitz 1836–1910 ibid.), photographer.
Lit.: Hirsch, E./Griebel, M./Herre, V.: *August Kotzsch 1836–1910*. Dresden 1986; *August Kotzsch (1836–1910)*, exh. cat., Stuttgart 1992.

Hermann Krone (Breslau 1827–1916 Laubegast/Dresden), photographer and lecturer.

Lit.: Schmidt, Irene: "Hermann Krone". In: *Silber & Salz*, exh. cat., Cologne/Heidelberg 1989; Krone, Hermann: *Photographische Landschaftstour "Sächsische Schweiz"*. Dresden 1996.

Ingrid von Kruse (Hamburg 1934), graphic designer and photo-journalist.
Lit.: Kruse, Ingrid von: *Zeit und Augenblick, Photo-Portraits*. Cologne 1988.

Fritz Kühn (Berlin 1910–1967 Berlin), wrought-iron craftsman and photographer.
Lit.: Hanisch, G. (ed.): *Fritz Kühn 1910–1967 in memoriam*. Berlin 1969.

Siegfried Lauterwasser (Überlingen 1913), photographer.
Lit.: *fotoform*, exh. cat., Cologne 1989, n. p.

Adolf Lazi (Munich 1884–1955 Stuttgart), photographer.
Lit.: Lazi, Adolf: *Die bildnerische Großaufnahme*. Stuttgart 1955.

Robert Lebeck (Berlin 1929), photographer.
Lit.: *Augenzeuge Robert Lebeck, 30 Jahre Zeitgeschichte*, exh. cat., Munich 1984; *Robert Lebeck Fotoreportagen*, exh. cat., Stuttgart 1993; *Alles Wahrheit, alles Lüge. Die Fotosammlung Robert Lebeck*, exh. cat., Cologne 1996.

Erna Lendvai-Dircksen (1883–1962), portrait-photographer.
Lit.: Philipp, C. G.: "E. Lendvai-Dircksen. Verschiedene Möglichkeiten, eine Fotografin zu rezipieren". In: *Fotogeschichte*. 3 (1983), no. 7, pp. 39–56.

Helmar Lerski (Strassburg 1871–1956 Zurich), actor, photographer, producer.
Lit.: Lerski, Helmar: *Der Mensch – Mein Bruder*. Dresden 1956; *Helmar Lerski, Lichtbildner*, exh. cat., Essen/Freren 1983; Lerski, Helmar: *Metamorphosen, Verwandlungen durch Licht*. Freren 1984.

Manfred Leve (Trier 1936), lawyer and photographer.
Lit.: *Manfred Leve, Aktionen, Vernissagen und Personen*. Cologne 1982; exh. cat., photo collection Museum Ludwig, Cologne 1986, pp. 278–283.

Herbert List (Hamburg 1903–1974 Munich), photographer and collector.
Lit.: *Herbert List, Fotografien 1930–1970*, exh. cat., Munich 1976.

Karl Heinz Mai (Leipzig 1920–1964 Leipzig), amateur photographer and photo-journalist.
Lit.: Mai, Karl Heinz: *Anfangsjahre. Leipzig 1945 bis 1950*. Berlin 1986.

Felix H. Man (Hans Sigismund Baumann) (Freiburg 1893–1985 London), press illustrator and photo-journalist.
Lit.: *Felix H. Man*, exh. cat., Berlin 1983.

Werner Mantz (Cologne 1901–1983 Eijsden NL), photographer.
Lit.: *Werner Mantz, Fotografien 1926–1938*, exh. cat., Bonn 1978; *Werner Mantz*, exh. cat., Cologne 1982.

Charlotte March (Essen 1934), photographer.

Lit.: *Zeitprofile, 30 Jahre Kulturpreis der DGPh*, exh. cat., Cologne 1988.

Will McBride (Bill MacBride) (St. Louis 1931), sculptor and photographer.

Lit.: McBride, Will: *Adenauer und seine Kinder, Fotografien von 1956–1968*. Berlin 1994; *Will McBride*, exh. cat., Bonn 1995.

Erich Meinhold (Scheibenberg 1908), joiner and worker-photographer.

Lit.: *Arbeiterfotografie 1926–1933*, exh. cat., Duisburg 1987.

Willi Moegle (Stuttgart 1897–1989 Leinfelden), photographer.

Lit.: *Willi Moegle, Die Sachaufnahme*, exh. cat., Essen 1985.

Lucia Moholy(-Schulz) (Karlín/Prague 1894–1989 Zollikon/Zurich), photographer, archivist, critic.

Lit.: Sachsse, Rolf: *Lucia Moholy*. Düsseldorf 1985; *Lucia Moholy, Bauhaus-Fotografin*, exh. cat., Berlin 1995.

László Moholy-Nagy (Bácsbarsod/Hungary 1895–1946 Chicago), designer, multi-media artist and educationalist.

Lit.: *László Moholy-Nagy*, exh. cat., Krefeld 1987; *László Moholy-Nagy*, exh. cat., Kassel/Stuttgart 1991; *László Moholy-Nagy Fotogramme 1922–1943*, exh. cat., Essen/Munich 1996.

Jochen Moll (Joachim Mollenschott) (Berlin 1928), photo-journalist.

Lit.: *Das deutsche Auge*, exh. cat., Hamburg 1996, p. 139.

Stefan Moses (Liegnitz/Silesia 1928), photographer.

Lit.: Moses, Stefan: *Transsibirische Eisenbahn, 26 Photogeschichten*. Munich 1979; *Stefan Moses, Abschied und Anfang, Ostdeutsche Porträts 1989–1990*, exh. cat., Berlin/Stuttgart 1991.

Heinrich Wilhelm Müller (Hamburg 1859–1933 Hamburg), businessman and amateur photographer.

Lit.: Philipp, C. G.: "Theodor und Oscar Hofmeister 'Die Geschwister' und Heinrich Wilhelm Müller 'Elegie' – ein romantisches Freundschaftsbild der Kunstphotographie um 1900". In: *Jahrbuch des Museums für Kunst und Gewerbe*. Hamburg 11/12 (1992/93), pp. 83–96.

Martin Munkàcsi (Martin Marmorstein) (Kolozsvár/Hungary 1896–1963 New York), photographer und author.

Lit.: Marzona, E. (ed.): *Retrospektive Fotografie: Martin Munkàcsi*. Bielefeld/Düsseldorf 1980; *Martin Munkàcsi Retrospective*, exh. cat., New York 1994.

Angela Neuke(-Widmann) (Berlin 1943), photo-journalist.

Lit.: *Angela Neuke, Staatstheater Mediencircus*, exh. cat., Bonn/Nördlingen 1989.

Floris M. Neusüss (Remscheid-Lennep 1937), photographer.

Lit.: Neusüss, Floris M.: *Das Fotogramm in der Kunst des 20. Jahrhunderts*. Cologne 1990; *F. M. Neusüss, Nachtstücke*, exh. cat., Bonn 1997.

Helmut Newton (Berlin 1920), photographer.

Lit.: *Helmut Newton Portraits*, exh. cat., Bonn/Munich 1987; Newton, *Helmut: Aus dem photographischen Werk*. Munich 1996.

Detlef Orlopp (Elbing 1937), photographer.

Lit.: *Detlef Orlopp*, exh. cat., Cologne/Paris 1987.

Hilmar Pabel (Ratibor 1911), photo-journalist.

Lit.: Pabel, Hilmar: *Jahre unseres Lebens*. Munich 1954; *Hilmar Pabel*, exh. cat., Berlin 1985.

Nicola Perscheid (Moselweiss 1864–1930 Berlin), photographer.

Lit.: Scheidemantel, Hermann: *Nicola Perscheids Fotografie in natürlichen Farben*. Leipzig 1904.

Richard Peter sen. (Silesia 1895–1977 Dresden), blacksmith and worker-photographer.

Lit.: Peter, sen., Richard: *Dresden – eine Stadt klagt an*. Dresden 1949/1980.

Walter Peterhans (Frankfurt/M. 1897–1960 Stetten/Stuttgart), photographer, educationalist.

Lit.: *Fotografie am Bauhaus*, exh. cat., Berlin 1990, p. 352.

Christa Peters(-Hall) (1939–1981 London), photographer.

Lit.: *photokina 1972* ('Frauen sehen Frauen'), exh. cat., Cologne 1972.

Abraham Pisarek (Przedborcz 1901–1981 Berlin), photo-journalist in Berlin.

Lit.: Rosenstrauch, Hazel (ed.): *Aus Nachbarn wurden Juden*. Berlin 1988.

Wilhelm Plüschow (Wismar 1852–1930 Berlin), photographer.

Lit.: Pohlmann, Ulrich: "Wer war Guglielmo Plüschow?". In: *Fotogeschichte*. 8 (1988), no. 29, pp. 33–38.

Sigmar Polke (Oel/Silesia 1941), painter.

Lit.: *Sigmar Polke, Biennale di Venezia*, exh. cat., Venice 1986; *Sigmar Polke Photoworks: When Pictures Vanish*, exh. cat., Zurich 1996.

Willy Pritsche (Dresden 1911), photographer, photo-journalist.

Lit.: Kil, Wolfgang: *Hinterlassenschaft und Neubeginn*. Leipzig 1989, pp. 155–73.

Erwin Quedenfeldt (Essen 1869–1948 Bischofswiesen), photographer and educationalist.

Lit.: *Erwin Quedenfeldt*, exh. cat., Essen 1985.

Regi(na) **Relang** (Lang) (Stuttgart 1906–1989 Munich), photographer.

Lit.: *Deutsche Lichtbildner*, exh. cat., Cologne 1987, p. 142.

Albert Renger-Patzsch (Würzburg 1897–1966 Wamel/Soest), photographer.
Lit.: Renger-Patzsch, Albert: *Die Welt ist schön.* Berlin 1928, reprinted Dortmund 1992; *Albert Renger-Patzsch, Der Fotograf der Dinge,* exh. cat., Bonn/Cologne 1977; *Albert Renger-Patzsch, Späte Industriefotografie,* exh. cat., Frankfurt/M./Cologne 1993; *Albert Renger-Patzsch, Das Spätwerk,* exh. cat., Bonn 1995; *Albert Renger-Patzsch, Meisterwerke,* exh. cat., Hannover/Munich 1997; *Albert Renger-Patzsch, Bilder aus der Fotografischen Sammlung und dem Girardet-Foto-Archiv,* exh. cat., Essen 1997.

Erich Retzlaff (Reinfeld 1899–1994 Diessen), portrait-photographer.
Lit.: Retzlaff, Erich: *Antlitz des Geistes.* Berlin 1944/unrevised Stuttgart 1946.

Evelyn Richter (Bautzen 1930), photographer.
Lit.: *Evelyn Richter, Zwischenbilanz,* exh. cat., Halle/Saale 1992.

(Helene) **Leni Riefenstahl** (Berlin 1902), dancer, actress, film director and photographer.
Lit.: Loiperdinger, Martin/Culbert, David: "L: Riefenstahl". In: *Historical Journal of Film, Radio and Television.* 8 (1988), no. 1, pp. 3–38.

Klaus Rinke (Wattenscheid 1939), sculptor and performance artist.
Lit.: *Klaus Rinke retroaktiv: (1954–1991),* exh. cat. with list of works, Düsseldorf 1992.

Peter Roehr (Lauenburg 1944–1968 Frankfurt/M.), "Fotomonteur".
Lit.: Behr, M.: "Archiv und An-Archie: Der Künstler Peter Roehr". In: *Camera Austria International.* 17 (1995), no. 51/52, pp. 3–21.

Franz Roh (Apolda 1890–1965 Munich), art historian and graphic designer.
Lit.: Roh, Juliane: *Retrospektive Fotografie Franz Roh.* Düsseldorf 1981.

Werner Rohde (Bremen 1906–1990 Worpswede), painter, graphic designer and stained glass designer.
Lit.: *Werner Rohde,* exh. cat., Essen 1992.

Renate (Winkler) (Dresden 1929) **& Roger Rössing** (Leipzig 1929), photographers.
Lit.: Kil, Wolfgang (ed.): *Hinterlassenschaft und Neubeginn.* Leipzig 1989.

Dieter Roth (Hannover 1930), artist and author.
Lit.: Schwarz, Dieter: *Auf der Bogen Bahn.* Paris 1984.

Hermann Rückwardt (Löbau/Saxony 1845–1903 Berlin), architect and photographer.
Lit.: Sachsse, Rolf: *Bild und Bau.* Braunschweig/Wiesbaden 1997, pp. 97–101.

Michael Ruetz (Berlin 1940), photographer.
Lit.: *Michael Ruetz, Sichtbare Zeit,* exh. cat., Berlin/Frankfurt/M. 1996.

Willi Ruge (Berlin 1882–1961 Offenburg), photo-journalist.
Lit.: *Revolution und Fotografie Berlin 1918/19,* exh. cat., Berlin 1989, p. 144.

Erich Salomon (Berlin 1886–1944 Auschwitz), photo-journalist.
Lit.: Salomon, Erich: *Berühmte Zeitgenossen in unbewachten Augenblikken.* Berlin 1929, reprinted Munich 1980; *Erich Salomon 1886–1944. Aus dem Leben eines Fotografen,* exh. cat., Bonn/Munich 1981.

Lotte Sandau, photographer.

August Sander (Herdorf 1876–1964 Cologne), mineworker and photographer.
Lit.: Sander, August: *Menschen des 20. Jahrhunderts.* Munich 1979; Sander, August: *Köln wie es war.* Cologne 1988; *Werkverzeichnis August Sander.* Cologne/Berlin 1995 passim.

Imre von Santho, photographer.
Lit.: *Berlin en vogue,* exh. cat., Berlin 1993.

Christian Schad (Miesbach 1894–1982 Aschaffenburg), painter and artist.
Lit.: *Christian Schad,* exh. cat., Berlin 1980; *Christian Schad, Zeichnungen und Einlassungen,* exh. cat., Rottach-Egern 1990.

Theo Schafgans (Bonn 1892–1976 Bonn), portrait-photographer.
Lit.: Schafgans, T.: „Sechs Jahrzehnte hinter der Kamera". In: *Bonner Geschichtsblätter.* 36 (1984), pp. 335–408.

Max Scheler (Cologne 1928), photographer.

Franz Schensky (Helgoland 1871–1957 Schleswig), photographer.
Lit.: *50 Jahre GDL,* exh. cat., Hamburg 1969, p. 105.

Anselm Schmitz (Cologne 1839–1903 Cologne), photographer.

Hugo Schmölz (Sonthofen 1879–1938 Cologne), architectural photographer.
Lit.: Schmölz, Hugo: *Fotografierte Architektur 1924–37.* Munich 1982.

Karl-Hugo Schmölz (Grafertshofen 1917–1986 Lahnstein), photographer.
Lit.: *Deutsche Lichtbildner,* exh. cat., Cologne 1987; Mißelbeck, Reinhold: *Hugo und Karl-Hugo Schmölz, Köln lebt.* Cologne 1995.

Fritz Bernhard Schurig (Grottau 1890–1971 Hückeswagen), photographer.

Friedrich Seidenstücker (Unna 1882–1966 Berlin), photographer.
Lit.: *Friedrich Seidenstücker,* exh. cat., Berlin 1988.

Sven Simon (Sven Axel Springer) (Hamburg 1941–1981 Bonn), photographer.
Lit.: Schlehofer, Ralph: *Karriere mit der Kamera.* Seebruck 1972.

Anton Stankowski (Gelsenkirchen 1906), graphic designer.
Lit.: *Anton Stankowski Fotografie*, exh. cat., Stuttgart 1991.

Otto Steinert (Saarbrücken 1915–1978 Essen), photographer and educationalist.
Lit.: *Otto Steinert und Schüler*, exh. cat., Essen 1990.

Grete Stern RINGL (Elberfeld 1904), photographer and graphic designer.
Lit.: *Fotografie am Bauhaus*, exh. cat., Berlin 1990, p. 355.

Sasha Stone (Aleksandr Serge Steinsapir) (Petersburg 1895–1940 Perpignan); photographer.
Lit.: *Sasha Stone, Fotografien*, exh. cat., Essen/Berlin 1990.

Wolf Strache (Greifswald 1910), photographer and publisher.
Lit.: Strache, Wolf: *Vor fünfzig Jahren.* Stuttgart 1986; *Deutsche Lichtbildner,* exh. cat., Cologne 1987, pp. 146–47.

Liselotte Strelow (Redel/Polzin 1908–1981 Hamburg), photographer.
Lit.: Strelow, Liselotte: *Das manipulierte Menschenbildnis.* Düsseldorf/Vienna 1961; *Liselotte Strelow (1909–1981), Erinnerungen,* exh. cat., Bad Bevensen 1989.

Waldemar Titzenthaler (Laibach 1869–1937 Berlin), photographer.
Lit.: *Waldemar Titzenthaler,* exh. cat., Berlin 1991.

Herbert Tobias (Dessau 1924–1982 Hamburg), photographer.
Lit.: *Herbert Tobias Fotografien.* Berlin 1985.

Georg Trump (Stuttgart 1896–1985 Stuttgart), typographer.
Lit.: Eason, Ron/Rookledge, Sarah: *Rookledge's International Handbook of Type Designers.* Carshalton Beeches 1991, pp. 154–155.

Umbo (Otto Umbehr) (Düsseldorf 1902–1980 Hannover), photographer.
Lit.: *Fotografie am Bauhaus,* exh. cat., Berlin 1990, pp. 34–43, 356; Molderings, Herbert: *Umbo. 1902–1980.* Düsseldorf 1996; *Umbo: Vom Bauhaus zum Bildjournalismus,* exh. cat., Hannover 1996.

Pan Walther (Dresden 1921–1986 Bangkok), photographer and lecturer.
Lit.: Walther, Pan: *Sehen, Empfinden, Gestalten.* Augsburg 1993.

Wolfgang Weber (Leipzig 1902–1985 Cologne), photographer.
Lit.: Gidal, Tim N.: *Chronisten des Lebens. Die moderne Fotoreportage.* Berlin 1993.

Charles Wilp (Witten 1937), photographer.
Lit.: *777,777. Die Fülle und die Leere, Fotografien von Charles Wilp,* exh. cat., Düsseldorf 1974.

Ludwig Windstosser (Munich 1921–1983 Stuttgart), photographer.
Lit.: *GDL 1919–1969,* exh. cat., Hamburg 1969.

Reinhart Wolf (Berlin 1930–1988 Hamburg), photographer.
Lit.: Hess, H. E.: *Reinhart Wolf.* Hamburg 1992.

Paul Wolff (Straßburg 1887–1951 Braunfels), amateur photographer.
Lit.: *Dr. Paul Wolff,* exh. cat., Rüsselsheim 1989.

Ursula Wolff(-Schneider) (Berlin 1906–1977 Chicago), photographer.
Lit.: Dick, J./Sassenberg, M. (ed.): *Jüdische Frauen im 19. und 20. Jahrhundert.* Reinbek 1993, pp. 401–02.

Lothar Wolleh (Berlin 1930–1979 London), photographer.
Lit.: *Szene Rhein Ruhr,* exh. cat., Essen 1972.

YVA (Else Simon-Neuländer) (1900–1942?), fashion photographer.

Willy (Otto) **Zielke** (Lodz 1902–1989 Bad Pyrmont), photographer.
Lit.: *Deutsche Lichtbildner,* exh. cat., Cologne 1987, pp. 149–50.

Heinrich Zille (Radeburg/Saxony 1858–1929 Berlin), graphic artist and photographer.
Lit.: *Heinrich Zille, Fotografien Berlin 1890–1910,* exh. cat., Munich 1975; *Heinrich Zille,* exh. cat., Munich 1995.

Photographic acknowledgements

Abel, Carl Andreas: Trude Abel-Latz, Ruppichteroth

Albers, Josef: VG Bild-Kunst, Bonn

Anschütz, Ottomar: Agfa Foto-Historama, Cologne

Arnold, Ursula: Ursula Arnold, Berlin

Astfalck-Vietz, Marta: VG Bild-Kunst, Bonn

Auerbach, Ellen: Studio ringl + pit, Courtesy Robert Mann Gallery (cat. nos. 130 and 131)

Ballhause, Walter: Rolf Ballhause, Plauen

Bayer, Herbert: VG Bild-Kunst, Bonn

Becher, Bernd and Hilla: Bernd and Hilla Becher, Düsseldorf

Biermann, Aenne: Gershon Biermann, Netanya, Israel

Blossfeldt, Karl: VG Bild-Kunst, Bonn

Breier, Kilian: Kilian Breier, Hamburg

Breslauer, Marianne: Marianne Feilchenfeldt-Breslauer, Zurich

Brill, Fritz: Fritz Brill, Hofgeismar

Brus, Johannes: Johannes Brus, Essen

Burchartz, Max: VG Bild-Kunst, Bonn

Cavael, Rolf: VG Bild-Kunst, Bonn

Chargesheimer: Museum Ludwig, Cologne

Claasen, Hermann: VG Bild-Kunst, Bonn (copy print cat. no. 285: Till Ch. Schläger)

Clausen, Rosemarie: Rosemarie Clausen estate, Hamburg

Comeriner, Erich: Micha Comeriner, Ramat-Gan, Israel

Darchinger, Jupp: Josef Heinrich Darchinger, Bonn

Diez-Dührkoop, Minya: Museum für Kunst und Gewerbe Hamburg

Dührkoop, Rudolf: Berlinische Galerie, Landesmuseum für Moderne Kunst, Photographie und Architektur/ Museum für Kunst und Gewerbe Hamburg

Ehlert, Max: Max Ehlert/DER SPIEGEL, Hamburg

Eisenstaedt, Alfred: Life Magazine, © Time Inc.

Erfurth, Hugo: Rheinisches Bildarchiv, Köln (cat. nos. 64 and 65), Rheinisches Landesmuseum Bonn

Erhardt, Alfred: Manfred Heiting Collection

Errell (Richard Levy): Museum Folkwang Essen

Eugene, Frank: Fotomuseum im Münchner Stadtmuseum, Munich

Feininger, Andreas: Life Magazine, © Time Inc. (cat. no. 156); Andreas Feininger, New York (cat. no. 157)

Feininger, T. Lux: T. Lux Feininger, Cambridge, MA

Finsler, Hans: Staatliche Galerie Moritzburg, Halle

Fischer, Arno: VG Bild-Kunst, Bonn

Flach, Hannes-Maria: Museum Ludwig, Cologne

Flöter, Hubs: Fotomuseum im Münchner Stadtmuseum, Munich

Gidal, Georg (Georg Gidalewitsch): Pia Gidal, Jerusalem

Gidal, Tim (Ignaz Nachum Gidalewitsch): Pia Gidal, Jerusalem

Gillhausen, Rolf: Rolf Gillhausen, Hamburg

Gloeden, Wilhelm von: Staatliche Museen zu Berlin, Kunstbibliothek, Photography Collection

Gorny, Hein: Museum Folkwang Essen

Gundlach, F. C.: F. C. Gundlach, Hamburg

Gutmann, John: John Gutmann, San Francisco

Hajek-Halke, Heinz: Michael Ruetz/ Hajek-Halke estate

Hallensleben, Ruth: Fotoarchiv Ruhrlandmuseum Essen

Hausmann, Raoul: VG Bild-Kunst, Bonn

Häusser, Robert: Robert Häusser, Mannheim

Heartfield, John: VG Bild-Kunst, Bonn

Hege, Walter: Agfa Foto-Historama, Cologne/U. Dörmann, Stuttgart

Heilig, Eugen: Eugen Heilig estate, Berlin

Held, Louis: Galerie Rudolf Kicken, Cologne

Henle, Fritz: by courtesy of Galerie Rudolf Kicken, Cologne

Hensky, Herbert: Bildarchiv Preussischer Kulturbesitz, Berlin

Hilsdorf, Jacob: Berlinische Galerie, Landesmuseum für Moderne Kunst, Photographie und Architektur

Höch, Hannah: VG Bild-Kunst, Bonn

Hoepffner, Marta: Marta Hoepffner, Kressbronn

Hofmeister, Theodor and Oscar: Museum für Kunst und Gewerbe Hamburg

Hoinkis, Ewald: Marion Herzog-Hoinkis, Frankfurt/M.

Höpker, Thomas: Thomas Höpker, New York

Jacobi, Lotte: University of New Hampshire, Photo Department

Jäger, Gottfried: Gottfried Jäger, Bielefeld

Jansen, Arno: Arno Jansen, Cologne

Keetman, Peter: Peter Keetman, Marquartstein

Kesting, Edmund: by courtesy of Galerie Döbele, Dresden

Kiesling, Gerhard: Bildarchiv Preussischer Kulturbesitz, Berlin

Klauke, Jürgen: Jürgen Klauke, Cologne

Kotzsch, August: Kupferstich-Kabinett Dresden

Krone, Heinrich: Rheinisches Bildarchiv, Cologne

Kühn, Fritz: Berlinische Galerie, Landesmuseum für Moderne Kunst, Photographie und Architektur

Lebeck, Robert: Robert Lebeck, Port de Richard, France

Lendvai-Dircksen, Erna: Agfa Foto-Historama, Cologne

Lerski, Helmar (Israel Schmuklerski): Reni Mertens-Bertozzi, Zurich

List, Herbert: Herbert List estate, Hamburg

Mai, Karl Heinz: Berlinische Galerie, Landesmuseum für Moderne Kunst, Photographie und Architektur

Man, Felix H.: Berlinische Galerie, Landesmuseum für Moderne Kunst, Photographie und Architektur

Mantz, Werner: P. Mantz, Maastricht

March, Charlotte: Charlotte March, Hamburg

McBride, Will: Will McBride, Frankfurt/M.

Meinhold, Erich: Erich Meinhold, Raschau

Moegle, Willi: Hansi Müller-Schorp, Leinfelden-Echterdingen

Moholy, Lucia: Lucia Moholy estate, Friedrich Karsten, London

Moholy-Nagy, László: VG Bild-Kunst, Bonn

Moll, Jochen (Joachim Mollenschott): Bildarchiv Preussischer Kulturbesitz, Berlin

Moses, Stefan: Stefan Moses, Munich

Müller, Heinrich Wilhelm: Museum für Kunst und Gewerbe Hamburg

Munkàcsi, Martin: Joan Munkacsi, Woodstock, New York

Neuke, Angela: Angela Neuke, Cologne

Neusüss, Floris M.: Floris M. Neusüss, Kassel

Newton, Helmut: Helmut Newton, Monte Carlo

Nothhelfer, Gabriele and Helmut: Gabriele and Helmut Nothhelfer, Berlin

Orlopp, Detlef: Detlef Orlopp, Krefeld

Perscheid, Nicola: Berlinische Galerie, Landesmuseum für Moderne Kunst, Photographie und Architektur/ Museum für Kunst und Gewerbe Hamburg

Peter, Richard, sen.: Kupferstich-Kabinett, Dresden

Peterhans, Walter: Brigitte Peterhans, Stuttgart

Pisarek, Abraham: Sächsische Landesbibliothek – Staats- und Universitätsbibliothek Dresden, Dezernat Deutsche Fotothek/Abraham Pisarek (all works after 1945)

Plüschow, Wilhelm: Fotomuseum im Münchner Stadtmuseum, Munich

Polke, Sigmar: Sigmar Polke, Cologne

Pritsche, Willy: Foto Pritsche, Graupa

Quedenfeldt, Erwin: Museum für Kunst und Gewerbe Hamburg

Relang, Regina: Fotomuseum im Münchner Stadtmuseum, Munich

Renger-Patzsch, Albert: Albert Renger-Patzsch Archiv/Ann and Jürgen Wilde/VG Bild-Kunst, Bonn

Retzlaff, Erich: Fotomuseum im Münchner Stadtmuseum, Munich

Richter, Evelyn: Evelyn Richter, Neukirch/Lusatia

Riefenstahl, Leni: Leni Riefenstahl, Munich

Rinke, Klaus: by courtesy of Galerie Rudolf Kicken, Cologne

Roh, Franz: Juliane Roh, Mannheim

Rohde, Werner: VG Bild-Kunst, Bonn

Rückwardt, Hermann: Berlinische Galerie, Landesmuseum für Moderne Kunst, Photographie und Architektur

Ruetz, Michael: Michael Ruetz, Berlin

Salomon, Erich: Erich-Salomon-Archiv/Bildarchiv Preussischer Kulturbesitz, Berlin

Sandau, Lotte: F. C. Gundlach, Hamburg

Sander, August: August Sander Archiv/SK-Stiftung Kultur; VG Bild-Kunst, Bonn

Santho, Imre von: F. C. Gundlach, Hamburg

Schad, Christian: Coypright by G. A. Richter, 83700 Rottach-Egern

Scheler, Max: Max Scheler, Hamburg

Schensky, Franz: Museum für Kunst und Gewerbe Hamburg

Schmitz, Anselm: Rheinisches Amt für Denkmalpflege, Abtei Brauweiler (copy print cat. no. 43: S. M. Wolf)

Schmölz, Hugo: VG Bild-Kunst, Bonn

Schürer, Hans: Felizitas Schürer, Munich

Schurig, Fritz Bernhard: Schurig-Archiv, Hall/Tyrol

Seidenstücker, Friedrich: Bildarchiv Preussischer Kulturbesitz, Berlin

Stankowski, Anton: Anton Stankowski, Stuttgart

Steinert, Otto: Stefan Steinert, Essen

Stern, Grete: Grete Stern, Buenos Aires

Stone, Sasha: Serge Stone, NL-Blaricum

Strache, Wolf: Wolf Strache, Stuttgart

Strelow, Liselotte: VG Bild-Kunst, Bonn (copy print cat. nos. 402–405: Till Ch. Schläger)

Trump, Georg: Manfred Heiting Collection

Umbo (Otto Umbehr): Galerie Rudolf Kicken and Phyllis Umbehr, Cologne

Weber, Wolfgang: VG Bild-Kunst, Bonn

Wilp, Charles: Bildarchiv Preussischer Kulturbesitz, Berlin (copy print cat. no. 44: Valentin Piel, Kassel)

Windstosser, Ludwig: Peter Windstosser, Stuttgart

Wolff, Paul: Archiv Dr. Paul Wolff & Tritschler, Offenburg

YVA: F. C. Gundlach, Hamburg

Zielke, Willy Otto: Museum für Kunst und Gewerbe Hamburg/Manfred Heiting Collection

Zille, Heinrich: Berlinische Galerie, Landesmuseum für Moderne Kunst, Photographie und Architektur

Adam Opel AG: p. 148 left

AEG Firmenarchiv, Frankfurt/M.: p. 26 below

Agentur für Bilder zur Zeitgeschichte, Berlin: p. 42, p. 95 right

Agfa Foto-Historama, Cologne: p. 86 above, p. 91, p. 159

AKG, Berlin: p. 27 above

Altonaer Museum in Hamburg – Norddeutsches Landesmuseum: p. 23

Archiv der sozialen Demokratie, Bonn: p. 29 above, p. 43 above, p. 95 left

Archiv Dr. Paul Wolff & Tritschler, Offenburg: p. 89

Bayerische Staatsbibliothek München: p. 72, p. 74

Berlinische Galerie, Erich-Salomon-Archiv/Bildarchiv Preussischer Kulturbesitz, Berlin: p. 46 above, p. 48, p. 69

Bibliothek für Zeitgeschichte, Stuttgart: p. 77

Bildarchiv Preussischer Kulturbesitz, Berlin: p. 24 left, p. 45, p. 73 above, p. 75, p. 76 left, p. 93 above and below, p. 95 right, p. 112, p. 119 left, p. 121 below, p. 123

Bilderdienst Süddeutscher Verlag, Munich: p. 122 right, p. 124 below (Rainer Meissle), p. 124 above

Bundesarchiv, Koblenz: p. 24 right (no. 146/70/96/23), p. 106 (no. 101/187/203/8–11)

Cabinet des Estampes, Strasbourg: p. 25 left

Carl Zeiss, Oberkochen: p. 148 right

Der Krieg gegen die Sowjetunion. Ed. by R. Rürup. Berlin 1991, p. 109: p. 80 above

Die Straße. Berlin 1936, p. 661: p. 76 right

Es gibt keinen jüdischen Wohnbezirk in Warschau mehr. Ed. by A. Kaminski. Neuwied 1960: p. 80 below right

Historisches Archiv der MAN AG, Augsburg: p. 28 above right and below

Historisches Archiv Krupp, Essen: p. 25 right, p. 28 above left

Hochschule für Gestaltung, Ulm, Archive, FA 63/0076: p. 150 below

IBM Deutschland, Düsseldorf: p. 147 right

Internationaal Instituut voor sociaal Geschiedenis, Amsterdam: p. 41, S. 46 below

Jüdisches Museum, Frankfurt/M: p. 104

Landesbildstelle Berlin: p. 50 below, p. 51, p. 116

Landesdenkmalamt Berlin, Wolfgang Bittner: p. 44

Münchner Stadtmuseum, Munich: p. 22

Museen der Stadt Nürnberg, Nuremberg, p. 27 below

Museum für Kunst und Gewerbe Hamburg: p. 35 below, p. 36

Museum für Photographie, Brunswick: p. 87

Rijksmuseum-Stichting, Amsterdam: p. 35 above

Rowenta Werke GmbH, Frankfurt/M.: p. 147 left

Sächsische Landesbibliothek, Dezernat Deutsche Fotothek, Dresden: p. 73 below

Siemens AG: p. 149 left

Staatliche Landesbildstelle Hamburg: p. 26 above

Staatsbibliothek München, Monacensia-Bibliothek, Munich: p. 69, p. 71

Stiftung Archiv der Parteien und Massenorganisationen der DDR im Bundesarchiv (SAPMO): p. 29 below, pp. 127–137

Stiftung AutoMuseum Volkswagen, Wolfsburg: p. 151 right

Time Life Syndication, New York: p. 81

Ullstein Bilderdienst, Berlin: p. 43 below, p. 53, p. 117, p. 122 left, p. 125 above (Rudolf Dietrich), p. 125 below (Joachim Wieczorek)

Verlag Hermann Scherping, Berlin (Dassel): p. 103

Reproductions after the original prints in the Kupferstich-Kabinett Dresden: Herbert Boswank, Dresden

Reproductions after the original prints in the Museum für Kunst und Gewerbe Hamburg: Maria Thrun and Harald Dubau, Christoph Irrgang and Karin Plessing, Hamburg

Reproductions after the original prints in the Rheinisches Landesmuseum and in the Museum Ludwig: Peter Oszvald, Bonn, H. Lilienthal (cat. no. 300)

Reproductions after the original prints in the Berlinische Galerie: Markus Hawlik, Berlin

Reproductions after the original prints in the Galerie Rudolf Kicken, Cologne: Susanne Trappmann, Cologne

Reproductions after the original prints in the Staatliche Galerie Schloss Moritzburg, Halle: Klaus E. Göltz, Halle

While every effort has been made to trace and acknowledge all copyright holders, the publishers would like to apologise should there have been any errors or omissions.